The Work of Art in the World

The Work of Art in the World

Civic Agency and Public Humanities

DORIS SOMMER

Duke University Press Durham and London 2014

Printed in the United States of America on acid-free paper ∞
Designed by Courtney Leigh Baker and typeset in Arno Pro
by Tseng Information Systems, Inc.

Library of Congress Cataloging-in-Publication Data
Sommer, Doris, 1947–
The work of art in the world : civic agency and
public humanities / Doris Sommer.
p. cm.
Includes bibliographical references and index.
ISBN 978-0-8223-5572-4 (cloth : alk. paper)
ISBN 978-0-8223-5586-1 (pbk. : alk. paper)
1. Arts and society. 2. Arts—Political aspects. 3. Creation
(Literary, artistic, etc.)—Social aspects. I. Title.
NX180.S6S623 2014
700.1′03–dc23
2013029330

In memory of Julius Sommer, my first and most memorable maestro.

Contents

Acknowledgments

For their generous advice and forbearance with an evolving project, I am indebted to Ken Wissoker and the readers for Duke University Press, Alice Flaherty, Francesco Erspamer, James Chandler, Carrie Lambert-Beatty, Carlo Tognato, Paolo Vignolo, Toril Moi, Srinivas Aravamudan, Francisco Ortega, Virginie Greene, Diana Taylor, J. Lorand Matory, Kay Shelemay, Evelyn Higginbotham, Henry Louis Gates Jr., Michael Fisher, Amrita Basu, Jackie Bhabha, Jennifer Leaning, Lani Guinier, Jeffrey Schnapp, James Honan, Michele Stanners, Dean Williams, Ute Mehta Bauer, Natalya Sukharnos, Gediminas Urbonas, Nomeda Urbonas, Helen Molesworth, Marcela Mahecha, Jose Falconi, Anitra Grisaldes, Betsy Bard, Alexis Kusy, Codruta Morari, Clara Schejtman, Michael Fisher, Annie S. Kaufman, Sara S. Kaufman, María Acosta López, Kathleen Woodward, Marshall Brown, Jane Brown, Sara Guyer, Ian Baucom, Ángela Pérez Mejía, Celia María Vélez, Laura Hagopian, Julia Leifert, George Lipsitz, and Eben Werber.

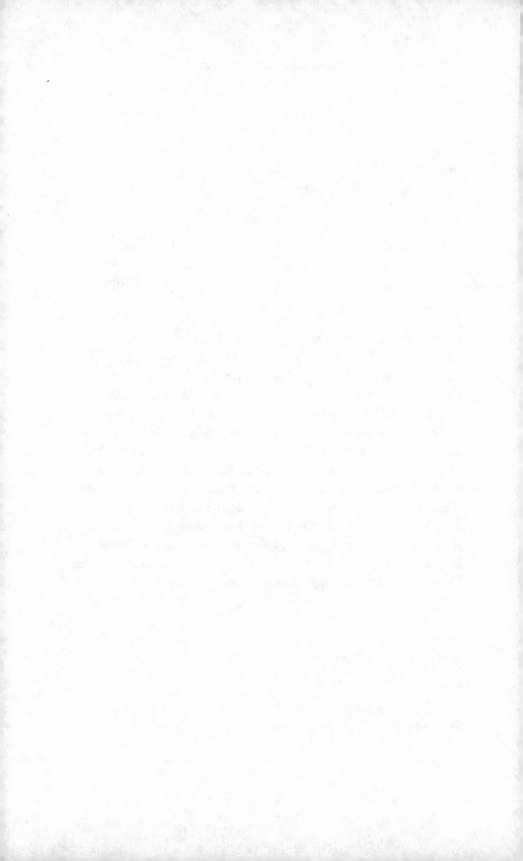

PROLOGUE. **Welcome Back**

Larry Summers was still president of Harvard University but already anxious about keeping his job when I briefed him on the Cultural Agents Initiative to bring civic responsibility back to humanistic education. After he had publicly speculated on women's limited aptitude for science, Larry's presidential days were numbered, and some of us added one worry to another. Besides the sexism, we feared for the future of the humanities. Disputes about careers in science were igniting international scandal, while waning budgets for arts and humanities hardly provoked whimpers. Empirical fields heated up explosively as creative areas cooled dangerously down. Despite what little warmth we could muster for defending arts and interpretation, the corporate climate of higher education stayed discouragingly chill. My gambit with President Summers was to kindle some concern for humanistic education by stoking a dusty pragmatic defense. There was nothing to lose, really, except for academic squeamishness about putting art and accountability in the same sentence. After all, I could count on Larry's respect for effective problem-solving. And I could also depend on a long tradition of democracy that develops side by side with aesthetics.[1]

"You know a lot about Latin America," I began.

"Yes I do," he agreed.

"Good. Now imagine being elected mayor of Bogotá, Colombia, in 1995, then the most violent, corrupt, and chaotic city in the hemisphere. What would you do?"

Larry thought it over: economic stimulation wouldn't work in that chaos, because new investments would end up in the pockets of drug dealers. More armed police wouldn't work either, because corrupt police were also in the dealers' pockets and would raise the level of violence. Conventional remedies were useless, he admitted. And then Larry said something uncharacteristic.

"I don't know what I could have done."

That's when I told him about Bogotá's brilliant mayor Antanas Mockus, and also about Brazil's legendary artist Augusto Boal. Mockus had tackled apparently intractable conditions by thinking creatively: "What would an artist do?" was his motto. If that one failed, a humanist motto came to the rescue: "When you are stuck, reinterpret." First Mockus replaced corrupt traffic police with pantomime artists who turned traffic lights and crosswalks into props for participatory fun. Then he painted roads with fleeting stars to mark traffic deaths. He "vaccinated" citizens against violence and continued to invent collective performances of civic culture. Among the cumulative effects of his citywide invitations to play were the reduction of fatal car accidents by more than half, a drop in homicides by almost 70 percent, and a threefold increase in tax revenues to pay for public works.[2] Mockus is a mayor who turned artist and interpreter in order to revive a major city from the top down.

Boal worked from the bottom up as a theater artist and theorist. Elected to city government, he staged public coproductions of urban life, including "legislative theater." He also multiplied himself internationally by training facilitators for nonactors who perform their worst problems and then improvise solutions for conflicts, mental illness, and unfair laws. In workshops and in books, Boal abstracted the acting lessons into general principles of social and psychological development. Both the top-down mayor and the bottom-up artist linked creativity to humanistic interpretation in ways that make them model cultural agents. They are maestros in the double sense of artist and teacher, creator and philosopher. Mockus and Boal knew how

art and interpretation overlap with civic education when they treated entire cities as their classrooms.

Larry was impressed. I hope that you will be too, not only with artists who promote positive change from the top down or the bottom up, but also with their co-artists in contiguous fields who help to translate good ideas into enduring practices.

A Start

The Work of Art in the World takes inspiration from arts projects that merit more sustained reflection than they have gotten. These are creative works on grand and small scales that morph into institutional innovation. Reflecting on them is a humanistic assignment insofar as the humanities teach interpretation of art (to identify points of view, attend to technique, to context, to competing messages, and evaluate aesthetic effects). Part of the work is to train free, disinterested judgment. This faculty for pausing to step back and take stock is basic to all disciplines. But the best training ground for judgment is the carefree area of aesthetics. The reason is simple: deciding if something is beautiful requires responding to an intense experience but obeying no established principles, and this decision is therefore free from prejudice. Aesthetic judgment is an exercise in unbiased evaluation, a knack that science and civics need as much as art does. That's why humanistic training is a fundamental contribution to general research and to social development.[3] (See chapter 3, "Art and Accountability.") Training free thought is an extension of teaching appreciation for art, along with care for the world that art constructs and enhances. Therefore, interpreting art, appreciating its power to shape the world, can spur and support urgently needed change. This is not a deviation from humanistic attention to the mechanisms of art production and reception. It is a corollary and a homecoming to civic education.

All of us would do well to consider art's ripple effects, from producing pleasure to triggering innovation. And acknowledging art's work makes us cultural agents: those who make, comment, buy, sell, reflect, allocate, decorate, vote, don't vote, or otherwise lead social, culturally constructed lives. But humanists can fulfill a special mission by keeping aesthetics in focus, lingering with students and readers over the charmed moments of freely felt pleasure that enable fresh perceptions and foster new agreements. More apparently practical people may rush past pleasure as if it were a

temptation to derail the progress of reason. We are haunted, it seems, by a Weberian superstition about enjoyment being close to sin and a deterrent to development.[4] But a countervailing lesson learned from Mockus and other cultural agents shows that pleasure is also a necessary dimension of sustainable social change. (See chapter 1, "From the Top.")

The appropriate question about agency is not if we exercise it, but how intentionally we do so, to what end and what effect. "Agent" is a term that acknowledges the small shifts in perspective and practice that Antonio Gramsci described as a war of position in which organic intellectuals — including artists and interpreters — lead moves toward collective change.[5] It won't do to indulge in romantic dreams about art remaking the world. Nor does it make sense to stop dreaming altogether and stay stuck in cynicism. Between frustrated fantasies and paralyzing despair, agency is a modest but relentless call to creative action, one small step at a time.

Art, of course, has no obligation to be constructive, or to be good or bad, ethically speaking. And politically, artists can be progressive, regressive, or in between.[6] Not necessarily useful or useless, art is instead provocative, a bit ungovernable, with a loose cannon kind of energy. It excites many and varied interpretive approaches, which leaves critics free to choose among them, unless extra-artistic considerations interfere. Were the already war-torn world not in urgent need of constructive interventions, and were explosive tensions not pointing toward more conflict (about race, gender, class, religion, language, drugs, borders, banks, water, oil), cultural agency might not occupy my interpretive efforts. In happier circumstances, the arts projects featured here would not even exist, since they respond to apparently incorrigible conditions. But here they are — intrepid projects that interrupt those conditions and stimulate collaborations. I invite you to share some of the burden and the excitement, to accompany the brilliant moves that cross and double-cross nervous checkpoints between art and everything else.

Like Lucy Lippard's art criticism, which shared revolutionary ambitions with New York's Conceptualists, *The Work of Art in the World* keeps company with great artists in order to discover patterns that can inspire creative apprenticeship.[7] And like John Dewey's pragmatic recommendation to promote broad-based art-making in order to shore up democracy, this book acknowledges the creative contributions of many active participants, from philosophers of aesthetics to vegetable farmers on rooftop gardens.[8] But

staying close to the masters can offer new agents useful distillations of trial and error, and also spike humanist interpretation with provocative questions. Many artists today link art to accountability, as in the exemplary cases of Alfredo Jaar, Krzysztof Wodiczko, and Tim Rollins. Admirable maestros such as these consider the practical dimensions of public response to their art. Shouldn't the question also arise for interpretation? If humanists ask after creative processes and recognize interpretation as creative, it makes sense to pause alongside artists and to consider what interpretation does in the world.[9] So much depends on how we read literature, objects, and events that commentary often codetermines art's effects. "There is nothing either good or bad, but thinking makes it so" (*Hamlet*, 2.2).

More than a decade ago, while increasing numbers of talented students were leaving literature to pursue something "useful" (economics, politics, medicine), I paused to think about the disappointments. Bereavement is a familiar feeling for humanists, and stopping to ask why made me wonder about being left behind. Is what we teach useless? Of course we can and do defend literature as serious business. Along with other arts, creative writing shapes our lives by generating assumptions, private desires, and public ambitions. At the core of human practices—from nation building to health care, from intimate relations to human rights and resources—art and interpretation effect practical interests and explore possibilities. These worthy but stock responses were not persuading disaffected students to stay, or administrators to reallocate support.

My subsequent responses are admittedly personal, and they account for the particular shape of this book. The admirable projects that I was fortunate to encounter and the modest forays that I am trying to develop make up this individual exploration of a collective opportunity: to link interpretation to engaged arts and thereby to refresh a civic vocation in humanistic education. Cultural agents are formed individually and I offer my case as one of many. One at a time was Friedrich Schiller's approach to coaching artists and interpreters in the construction of political freedom through indirect aesthetic practices. He addressed his *Letters on the Aesthetic Education of Man* (1794) to a single reader and published the one-on-one mentorship in order to multiply generations of apprentices. I count myself among them. From my first chapter to the last, a thread of theory spins through comments on a variety of projects and winds up with renewed appreciation for maestro Schiller, the artist and teacher. None of this seemed obvious to

students who abandoned the humanities to do more practical work, maybe because art's work in the world is not yet a core concern for an academic field that remains skeptical and pessimistic.

Pessimism has been intellectually gratifying in a world where, admittedly, disparities grow, wars multiply, and natural resources wane. It feels good to be right. But an optimism of the will, beyond the despair of reason, drives life toward social commitments and creative contributions.[10] Teaching despair to young people seemed to me not only tedious but irresponsible compared to making a case for cultural agents. The case includes apprenticeship to risk-taking artists. In one experiment, I pieced together an arts-based literacy program for underserved communities, using literary classics as pre-texts for making a painting, a poem, or a piece of music. Whether the workshops engage grade school children, graduate students, or senior citizens, participants experience how close creativity comes to critical thinking. (See chapter 4, "Pre-Texts.")

Another adventure is a course in Harvard's general education curriculum called Cultural Agents. It hosts a series of speakers who combine art with other professions (medicine, law, business, engineering, and government) to do admirable work.[11] Admiration, I learned from Mayor Mockus, is the basic sentiment of citizenship, a term I use in the sense of participation rather than legal status. (See chapter 1, "From the Top.") A medical doctor and photographer "falls in love again" with her patients through the portraits she takes; a human rights lawyer becomes a landscape artist to create a sustainable alternative to drug-dealing; a biochemical engineer invents an art-science laboratory to signal that the two activities go together. The course includes a fair where local artist-activists and students pitch problems to each other, form collectives, and codesign interventions for law reform, the distribution of local produce, racial profiling, date rape, energy conservation, and so forth.

Humanities-inspired ventures like these are restructuring curricula in Engaged Humanities programs, also in medical schools and business schools, even in fledgling programs in Public Leadership. Evidently, the humanities have important work to do in these and other collaborations throughout universities and civic institutions. Civic life depends on aesthetic training to develop imagination and judgment. This training in free thinking is normally what humanists say they do. It's a good start.

Out of Bounds

The variety of projects that I'll mention (including mimes who direct traffic; legislative theater; classical music orchestras of desperately poor youth; a poster blitz that broke the silence around AIDS; painting a town to revive it; garbage pickers recycled into publishers; among many others that you may add) share a family resemblance. They begin as works of art to arrest attention to particular issues; but they don't stop there.[12] Instead, they ripple into extra-artistic institutions and practices. Humanistic interpretation has an opportunity to trace those ripple effects and to speculate about the dynamics in order to encourage more movement. It will mean participating in activities that stray beyond the "text" or artwork while maintaining the intellectual rigor and the acquired caginess of humanistic close readings. Among the artistic achievements that beg close reading are pragmatic projects (in law, medicine, crime prevention, economic development) that are fueled by the disruptive energy called art. For example, Rigoberta Menchú had been celebrated as an activist, a feminist, a defender of human rights, in entirely thematic or anthropological terms that don't ask why her *testimonio* about civil war in Guatemala, published in 1984, was so politically effective. But reading her rhetorically reveals a formidable literary strategist, a significant dimension of her persuasive leadership. The lesson in style is worth learning.[13]

Necessarily hybrid, conscientious cultural agency requires the collaboration of various skill sets to hitch stale and unproductive social patterns to the motor of unconventional interventions. The mixed media of unpredictable art and extra-artistic institutions that together compose constructive cultural agency obviously don't fit into standard fields of study. On the one hand, the natural and social sciences may recognize effective programs but will probably overlook art as a partner to economic, legal, or health care advances, and therefore will miss a motor of social effectiveness.[14] And on the other hand, humanists concerned with defending art for its own sake are likely to bypass social effects though they attest to aesthetic value.

This discord between pragmatics and aesthetics is doubly debilitating since the "adjacent possible" counts on a combination of art and science.[15] Development needs the imagination and judgment that the arts cultivate; and the arts thrive on adaptive challenges that throw systems into crisis and require new forms. Tracking hybrid creations means stepping beyond established practices and linking onto creative experiments. I want to en-

courage interpretation to take risks, to learn a lesson from art-making about getting one's hands dirty through trial and error. "Try again. Fail again. Fail better," is an artist's mantra (formulated by Samuel Beckett). Real teachers take risks, Paulo Freire urged at the beginning of *Pedagogy of the Oppressed* with a bold quote from Hegel. "It is solely by risking life that freedom is obtained."[16]

An incentive to coax art interpretation out of solitary bounds and into collaborations with other colleagues and with community partners is the potential to build general support for humanistic education. We need it. Humanistic interpretation can serve as an interdisciplinary courtyard (for politics, economics, ecology, medicine, etc.) where particular skill sets are recognized as necessary partners for hybrid collaborations that can produce social change. Success in art and everything else depends on coproduction.

A still-spotty but spirited movement called Engaged Humanities is taking the risk to explore what civics means for liberal education.[17] More than the Public Humanities programs, which bring cultural events and services to surrounding communities, Engaged Humanities and Public Scholarship programs take a cue to collaborate from artists. Now scores of particular college and university programs and also a network of over ninety colleges and universities — coordinated through the national consortium Imagining America: Artists and Scholars in Public Life — promote coproductions with diverse partners.[18] (See also the Community Arts Network as well as Animating Democracy's Project Profile Database.) One departure from convention is to feature arts projects that have real social effects but fit badly into existing academic fields. Another is to learn from those projects in which creative activity — such as teaching — carries consequences that make us accountable.

Open Parentheses

Attention to art's work in the world used to be basic for education. Despite changes in fortune, engaged humanism remained a centerpiece for civics until a recent but prolonged and pessimistic slump. (See chapter 3, "Art and Accountability.") To simplify, about fifty years ago the instrumental effects of art became anathema to many humanists who set aside social concerns in retreat from a nasty postwar world of aggressive interests and ideologies. To safeguard aesthetic freedom, beauty, and disinterest-

edness, the humanities left behind the risky optimism that drives civic responsibility and education. Art's purposelessness became the watermark of its authenticity. Defenders of art for art's sake invoked Immanuel Kant to ground this disinterested appreciation for beauty. But using Kant to cut out purpose truncates his ambitious project. It was finally a civic project in which purposelessness is a first moment on the way to new moments of agreement about collective purpose. For his student Friedrich Schiller, the aesthetic detour was also an invitation/obligation to make new forms when old ones caused conflict. No one, in the unstable modern world, gets away with simply looking on.

The brackets that hold aesthetics back from civic education can open up with provocations from model projects and from classics of humanistic interpretation, starting with Schiller's *Letters*. Written during the French Revolution, the *Letters* warn against running headlong after reason because freedom is attainable only indirectly, through beauty and art. Aesthetic education for all would allow the broad public to imagine, to play, to pause for disinterested judgment, and then to "court agreement."[19] Making and thinking about art could then trump inflexible reason, which is often a cover for ideology. Judicious citizen-artists know how to wrest new creations from conflict. They achieve freedom within constraints and acknowledge the freedom that fellow artists display. A poet and philosopher, Schiller shuttled between art-making and interpretation, imagination and understanding, to weave a collaborative and resilient social fabric. Though I'll mention other mentors and interpreters for the work of art in the world—including Wilhelm von Humboldt, Viktor Shklovsky, John Dewey, Hannah Arendt, D. W. Winnicott, Paolo Freire, Antonio Gramsci, Jürgen Habermas, Edward Said, Jacques Rancière, Martha Nussbaum, Grant Kester, Paul Bloom—it is Schiller who ties up the threads with his daring proposition that creativity and aesthetic judgment are foundations for democracy. Are you ready to apprentice yourself?

The Work of Art in the World might have addressed only fascinating art projects and left interpretation alone. The projects are sure to charm you with the surprise and pleasure that make them socially effective, while commentaries will lack luster by comparison. Attending to humanistic interpretation may seem "unseasonable," to cite Schiller on aesthetic education during the Terror, at a time when departments of humanities downsize or disappear altogether. To compound the external threats of budget cuts, falling enrollments, and slim job pickings, internal campaigns of cultural

and performance studies exacerbate impatience with the formalist (rhetorical, generic, and stylistic) analysis of humanistic interpretation. But if it is useful or interesting to read a book about artistic interventions in social challenges, it is because books can collect cases and abstract general principles, the way Boal does in his books. Good catalogues do that too.

"We lay hold of the full import of a work of art only as we go through in our own vital processes the processes the artist went through in producing the work. It is the critic's privilege to share in the promotion of this active process. His condemnation is that he so often arrests it."[20] These are John Dewey's last words in *Art as Experience*. Why "arrest" that work of creative criticism when it supports democratizing transactions with art? Dewey the pragmatist understood that pragmatism needs education; then he realized that education needs art and that art needs interpretation. Through art we reframe experience, offset prejudice, and refresh our perception of what exists so that it seems new and worthy of attention. And through humanistic interpretation we share the civic effect. Interpretive skills can lead to informed judgments, appreciation of the historical context, and effective communication.

Artists think critically to interpret existing material into new forms. How else can one imagine and then realize a project—including social, political, or economic development? And interpretation is art's agent, tracking irregular paths from artistic freedom to the public good and thereby stimulating more travel. Leading back and forth from creativity to civic purpose, the paths now include digital technologies, applied research, and partnerships with public institutions; they develop novel entry points, routes, and diversions as part of artistic agency in geographies both familiar and unfamiliar to Enlightened Europe.

Critical thinking is both a condition of and a complement to artmaking—world-making in Dewey's pragmatic and democratizing sense of art as experience—that sparks more exploration and more experience. Taking a lead from Schiller, Dewey identified all active citizens as creative artists. This was radical in the eighteenth century and again in the 1930s, when Dewey helped to inspire Franklin Delano Roosevelt's massive employment programs for painters, actors, writers, and musicians. (See chapter 1, "From the Top.") Today, the philosophical line that links art to liberty is recovered by Jacques Rancière, who defends an "aesthetic regime" in politics. By aesthetic regime he means an awareness that human life is

made up of artificial constructions that must continually be adjusted with more and broader-based art-making.[21]

While schools still dedicate significant, if declining, budgets to the humanities, perhaps we can refresh aesthetic education as part of civic development. This civic dimension goes beyond well-established research about the academic advantages of teaching through the arts. At least since Maria Montessori's spectacular achievements with disadvantaged Italian children at the turn of the twentieth century, through recent and impressive educational gains for Finland and South Korea as well as art-making to enhance research universities in the United States, cognitive development has publicly acknowledged the benefits of creativity.[22] Aesthetic education also serves industry by supporting innovation, reorganization, and communication. Business schools are beginning to explore these connections and to understand that management is as much an art as a science.[23] But beyond business and academic learning, aesthetic education has civic work to do.[24] Learning to think like an artist and an interpreter is basic training for our volatile times. Together with professional artists, interpreters are cultural agents when we explore art as "our greatest renewable resource" for addressing the world's fundamental challenges of disease, violence, and poverty.[25]

Go

For readers who may bristle at the boundaries where art meets accountability, zealous to keep at least art free from instrumental purpose, I'll beg some indulgence and ask you to continue for a bit. Perhaps the renewed possibility of central billing for arts and interpretation, or maybe the historical connections between humanism and public life, or possibly a few fascinating nomadic projects that follow from ripples of aesthetic effect will persuade a change of heart. The chapters that follow begin with noteworthy cases of art's work in the world, and they continue with a reflection on civic responsibility before I respond personally to the opportunity/obligation of agency in my everyday work as a teacher. The book ends with Schiller, to seal the disparate cases and considerations by resending his *Letters on the Aesthetic Education of Man*, the "unsurpassable manifesto" for making art work in the world.[26]

Chapter 1, "From the Top," tracks arts projects inspired by high-ranking

political leaders, including Antanas Mockus, Edi Rama, and Franklin Delano Roosevelt. One question here is whether "ungovernable" art can collaborate with government. Another is how to account for the difference between democratic and dictatorial effects of art. Chapter 2, "Press Here," marks points of contact between aesthetic and political innovation by featuring relentless grassroots projects that "melt up" from the sparks of a particular art intervention to ignite large-scale social effects, as in the works of Augusto Boal, ACT UP, and the Pro-Test Lab. Is art enough to produce social change?[27] Chapter 3 takes a pause to consider "Art and Accountability" and casts a backward glance to reconnect aesthetics to civics through the education of taste, otherwise known as judgment. Snapshots of recurring debates between defenders of art's autonomy and promoters of art's responsibility feature judgment as the tiebreaker. In chapter 4, "Pre-Texts," I hold myself accountable as a cultural agent by translating civic responsibility into a quotidian register of classroom teacher. Along with the pleasures of feeling useful through an arts-integration approach to literacy, I learned how close creativity is to criticism and how user-friendly literary theory can be as a reflection on art-making. Finally, chapter 5, "Play Drive in the Hard Drive," circles back to Schiller in order to name the creative-critical faculty as an instinct that makes us human. Goaded by conflicts between unfeeling reason and irrational sensuality, the play drive fuels all arts interventions and humanistic interpretations with the combination of optimism and respect for constraints that can encourage more work for art in the world.

These pages remain open to your criticism and contributions, including nominations of exemplary cultural agents. This is a "Beta," or experimental, version of the project to generate commentary and criticism, as Augusto Boal said of his experiment with *Legislative Theatre*.[28] He asked readers to send in responses to his postal address. Following his lead, I invite you to send suggestions for updates of *The Work of Art in the World* by e-mail to Cultural Agents, cultagen@fas.harvard.edu.

And now, if you want to fast-forward to some issues in this book and defer others, you can press ahead selectively as Boal instructed his readers, though that menu has obviously changed:

For English, stay tuned; *para español presione un traductor.*
If you want
— top down creativity, press 1;

— bottom up interventions, press 2;
— useful humanism, press 3;
— to do something practical, press 4;
— aesthetic education, press 5;
— to talk to the operator, press dsommer@fas.harvard.edu.

In all cases, press here, wherever, because the lines will ultimately connect if you keep pressing.

ONE. **From the Top**
Government-Sponsored Creativity

When I feel trapped, I ask myself, what would an artist do?
—ANTANAS MOCKUS

Mime over Matter

"Professor Mockus, what gave you the idea to replace the traffic police with pantomime artists?" It was an obvious question for the recent mayor of Bogotá, but if the student hadn't asked, I might not have learned that one principle of the mayor's astounding success is his disarming sense of humor. He knows when to take a joke seriously and set off ripples of shared fun. Antanas Mockus and I were co-teaching a graduate course at Harvard University during the fall semester of 2004. Foundational Fictions, a course on the backdrop of nineteenth-century national novels, and the work of other Cultural Agents framed his reflections on creativity during two terms in office (1995–1997 and 2001–2003). Those novels, written by political leaders to fan desire for national consolidation, were background cases for considering art's recent work in public life.[1]

Before Bogotá elected Mockus in 1994 it was the most dangerous city in Latin America, according to the U.S. State Department advisory not to go there. At international airports, official warnings singled out Lagos and Bogotá as places too troubled to traffic in tourism. On this count, Bogo-

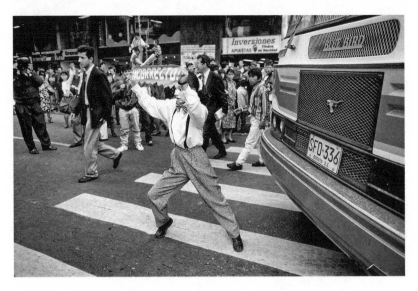

FIGURE 1.1. Mime directs traffic in Bogotá, *El Tiempo*, February 1995.
Source: *El Tiempo* archives. Bogotá, Colombia.

tanos themselves didn't doubt the North American advice to keep a safe distance from the city. Many had lost confidence altogether and emigrated if they could afford to, so that — for example — their children could attend school without personal bodyguards. The city seemed hopelessly mired in a level of corruption that turns almost any investment against itself because conventional cures of money or more armed enforcement would have aggravated, not mitigated, the greed and the violence. Stumped for a while, like the political scientists and economists, including Larry Summers, who admit defeat when I ask what they would have done, the new mayor took an unconventional turn toward art. Mockus had been reluctant to call his creativity by its common name. But by 2006 "Por amor al arte" (For the Love of Art) was the name of his political platform for the presidential elections in Colombia.[2] The next and nearly successful 2010 campaign for the presidency was more cautious, but buoyed by citizens already primed to cocreate projects with Mockus.[3] Then an invitation from the curators of Berlin's 2012 Biennale confirmed his international reputation as a creative artist.[4]

The mimes were only one of the mayor's many arts-inspired interventions or "cultural acupunctures" during his first administration. The therapeutic term customizes "urban acupuncture," coined by Mayor Jaime

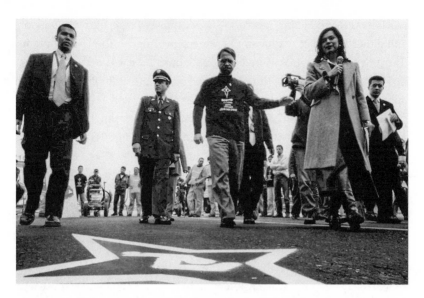

FIGURE 1.2. Fallen star, to commemorate traffic death, Bogotá, 1996.
Source: *El Tiempo* archives. Bogotá, Colombia.

Lerner of Curitiba, Brazil, to highlight social practices that can be pressed
into service for collective healing.[5] If the acupuncture shows even modest
relief, it signals the efficacy of collective action and encourages skeptics to
join the first movers.[6] These treatments included painting city streets with
fifteen hundred fleeting stars/crosses 1.2 meters long to mark the points
where people died in car accidents. It was a caution to pedestrians who
were used to taking "shortcuts" (shorthand for all sorts of corruption in
Colombia).

Citywide contests for the best poster promoting condoms went along
with distributing them in the hundreds of thousands. Gun shafts were sawn
into rings commemorating the violence that was thereby ritually relegated
to the past. "Rock the Parks" concerts every week gave youth a regular
public stage to reclaim their space after dark. "Vaccine against Violence"
was a citywide performance-therapy against domestic aggression that had
reached "epidemic" levels. To follow the medical metaphor, epidemics call
for vaccines, those tiny doses of aggression that inoculate vulnerable vic-
tims against far greater violence. Over several weekends, nearly forty-five
thousand citizens lined up holding balloons on which they painted the
haunting image of the person who had most abused them. And then—on

reaching real and "acting" doctors — they expressed rage, burst the balloon, and either felt relief (catharsis) or were signed up for therapy programs. The mayor's team also printed 350,000 laminated cards with a "thumbs-up" on one side and red "thumbs-down" on the other, for citizens to flash approval or disapproval of traffic behavior and mutually regulate a shared public sphere.[7] They discontinued the game after a season, however, when Mockus conceded to critics that disapproval might interfere with the development of self-esteem and self-efficacy.

Another interruption of murderous routine was "Women's Night Out." Unlike the direct demands for women's rights in Anglo-American "Take Back the Night," Bogotá's feminist project was indirect and playful. It encouraged sociability among women, who took to the streets, the bars, and dance clubs while men stayed home. Seven hundred thousand women went out on the first "Night Out." The men balked but mostly obeyed the order to stay indoors, probably reluctant to be taken for women. Those who insisted on coming out clipped self-authorizing "Safe-Conduct Passes" printed in newspapers. The morning after, headlines reported in bold caps that, astonishingly for Bogotá, there was only one homicide and no traffic deaths.[8] Another initially unpopular measure among men was the time limit on selling alcohol. Bars closed by 1:00 a.m., just when things would have gotten lively, and violent. But once the media regularly reported fewer homicides, resentments abated. For women, their night out showed that respect for life and for the law did not sacrifice fun but instead made it possible. And the men too began to enjoy the liberating effects of renewed civility and improved domestic life.

One important lesson that we learn from Mockus is that without pleasure, social reform and political pragmatism shrivel into short-lived, self-defeating pretensions. Friedrich Schiller knew that by 1793, even before his *Letters*, written in 1794, took single-minded reason to task: "*In order that obedience to reason may become an object of inclination, it must represent for us the principle of pleasure, for pleasure and pain are the only springs which set the instincts in motion.*"[9] Pain and fear of punishment are of course among the incentives for obedience, Mockus also admits; but they generate resentment, along with a destabilizing resistance to law. Unwilling compliance sours subjectivity with opposition to the world, while pleasurable observance sweetens social integration. Mockus doesn't entirely trust pleasure and neither did Schiller, who called it "a very suspicious companion" for morality.[10] But the uneasy partnership can hardly be avoided, Mockus

taught in his seminar Hedonism and Pragmatism: Unhindered hedonism leads from precarious pleasure to lasting pain, as lawlessness provokes scarcity and violence. And pragmatism without pleasure breeds an equally self-defeating distaste for obligations.

Philosopher Mockus may once have overlooked this productive tension between reason and passion so familiar to artists, because the field of philosophy typically discounts Schiller and even abbreviates Kant, leaving out his *Critique of Aesthetic Judgment*.[11] Nevertheless, several essays by Professor Mockus evoke something of Schiller's paean to creative play and to the counterfactual exercise of imagination.[12] Mayor Mockus, however, never doubted the efficacy of art. And on reading Viktor Shklovsky's "Art as Technique" (1913), the formalist manifesto that identifies art as interruption of habit, Mockus conceded that yes, he is an artist too.[13] The mayor's knack for interrupting quotidian corruption and cynicism animated his general platform of *cultura ciudadana*. "Civic culture" combines pedagogy and persuasion to "harmonize" the competing norms of moral, legal, and cultural practices, first by demonstrating the costs of "divorce" among them, and then by cajoling citizens to reconcile formal with informal codes of behavior.[14]

"Antanas sees the city as a huge classroom," his deputy mayor, Alicia Eugenia Silva, used to say.[15] That classroom looked like a vaudeville theater when Mockus dressed up as "Super Citizen" in tights and cape to talk on TV, or when he'd perform civic messages in rap, or proudly wear a toy frog (equivalent to a stool pigeon) to celebrate informants for their courage to condemn a crime. This "croactivity" brought culture close to morality and in line with the law. Think of traffic in this framework of harmonizing formal with informal rules: It had long been legally wrong, sometimes morally indifferent, but culturally cool to cross the street in the middle of a block or at a red light. (Drug-traffic and related violence showed similar asymmetries of legal intolerance, moral ambivalence, and cultural acceptance.) But the mimes who mocked infringements, and the fleeting commemorative stars that intercepted incautious pedestrians, raised moral support for traffic law and cheapened the cultural caché of ignoring the law, bringing all three codes into closer agreement.

Governments will inevitably attempt to direct creativity toward "harmonization," and official preferences can come close to censorship, so artists typically resent the priorities and defend their freedom to dissent or to simply ignore official interest.[16] Among these artists, Víctor Laignelet had

FIGURE 1.3. Super Civico.
Source: *El Tiempo* archives. Bogotá, Colombia.

kept his distance from government until Antanas Mockus made him think
again: "I asked myself what would be gained and what lost by working with
the new mayor in a desperate city. My conclusion was that Antanas was
worth the gamble. He does not instrumentalize art for pre-defined ends, as
standard politicians do, but rather engages debate and polysemic interpre-
tation through art. In any case, full artistic freedom made little sense in a
violent society that lacked freedom of movement and exploration."[17]

Mockus himself would joke about the illusion of uncluttered freedom
in a country as chaotic as Colombia. "In the United States or Canada I'd
probably be an anarchist. My ambition for Colombia is for my grandchil-
dren to have the anarchist option, because right now and for the immedi-
ate future no one here would notice." From this lawless limit condition,
Mockus engaged Jean-François Lyotard during his visit to Bogotá in 1995.
The local philosopher asked the French guest for his opinion about which
disposition best suited contemporary Colombia: one that favored obedi-
ence to the law or one that reserved judgment in order to preserve political
flexibility. The pointed question raised from city hall represented a risk to
Mockus's campaign against "shortcuts" in everything from jaywalking to
buying votes. Lyotard's book, *The Postmodern Condition*, was a fashionable

defense of contemporary skepticism: the book recommends the flexible and pragmatic scientific method to test hypotheses that last only as long as they are useful. Lyotard showed that scientists don't presume to establish fixed laws, and neither should anyone else. But, in the there and then of Colombia's borderline situation as Mockus confronted it, Lyotard conceded that Law was in order.[18]

Risks and Results

If you ask Antanas Mockus how he came to art for civic education he may modestly fail to mention the dissertation he wrote in philosophy, about the power of (art-ifical) representation to mediate between personal perception and interpersonal communication. Published in 1988, the thesis describes an arc from Descartes's achievement of conceptual clarity by using linguistic artifice/representation to Habermas's invitation to communicative action: through representation, conflicting positions can play and construct universally acceptable principles.[19] (Augusto Boal treated all representation as theater, that is, to act and to know that one is acting.)[20]

Whether or not Mockus mentions his significant contribution to philosophy, he will not fail to attribute his initiation in art to his adored mother, a ceramic artist who raised two children on her own strength and talent after her husband's early death. Mrs. Nijole Šivickas Mockus is a Lithuanian immigrant of delicate proportions and solid determination who still produces massive and dynamic ceramic sculptures every day though she is into her eighties. Serving as her assistant from childhood through his young adult years, Antanas would be instructed, for example, to increase the dimensions of a work in progress by 10 percent. Years later, he launched a municipal tax-paying campaign called "110% for Bogotá," which encouraged citizens to pay a tithe in excess of the taxes they owed. The city needed the extra money to unclog and to rebuild itself, Mockus told voters in his first mayoral campaign. He actually promised — not threatened — to raise taxes in order to finance urgent public works, but an intransigent city council refused to approve the increase. Mockus responded with a cleverly contradictory program: "Impuestos Voluntarios" (Voluntary Impositions/Taxes). Almost unbelievably, in a city where corruption had for years dissuaded citizens from paying up, over sixty-three thousand families paid in excess of their obligation. They added 10 percent to fund particular

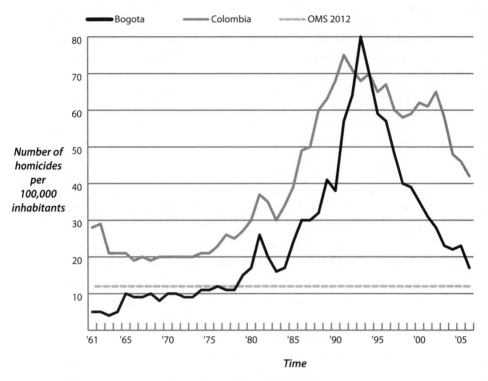

FIGURE 1.4. Homicides Drop. Graph by Sumona Chakravarty.

projects: schools, parks, hospitals, transportation, and so forth, confident that this mayor would not steal the money.

From the time he took office to the time he left his second term, Bogotá's tax revenues had increased astronomically, almost 300 percent. The same period marked a sharp decline in homicides (67 percent) and in traffic deaths (51 percent). Independent studies corroborated the results of the mayor's Observatory of Civic Culture, established in 1995 to collect and analyze surveys of citizens' attitudes and behavior.[21] Programs were designed to address specific survey results, and new surveys provided feedback to determine if the programs should continue, change, or discontinue.[22] Regular reporting of even small incremental results had its own feedback effect, as citizens began to acknowledge a measurable trend which disposed them to participate more fully.[23] Along with the qualitative analyses prepared by sociologists, anthropologists, and political scientists, the Observatory's statisticians and economists produced quantitative reports

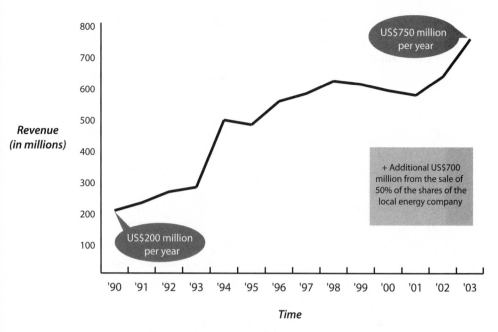

Revenue (in millions)

US$750 million per year

+ Additional US$700 million from the sale of 50% of the shares of the local energy company

US$200 million per year

'90 '91 '92 '93 '94 '95 '96 '97 '98 '99 '00 '01 '02 '03

Time

FIGURE 1.5. Income from Tax Increases. Graph by Sumona Chakravarty.

that have cured me of a humanist's allergy to statistics. Numbers may be the mayor's most eloquent evidence of the aesthetic effects he provoked.[24]

The documented results of cultura ciudadana prove that positive change is possible even in apparently intractable conditions. During a memorable moment of our co-taught course on cultural agents, Mockus made this point with aplomb and understatement. We had invited Homi Bhabha to speak on Frantz Fanon, about whom Bhabha has written brilliantly. The talk made references to Antonio Gramsci, who located opportunities for change at the margins of government, under its radar, in the cracks and contradictions that exist between government and oppositional forces. This was an apt figure for Gramsci's "war of position," waged in historical conditions always "rich with contradictions" in culture.[25] Mockus listened attentively, as he always does, and then made a single comment: "There are cracks and contradictions inside government too where wars of position can gain ground through cultural persuasion and alternative practices." Here was a participant observer who had enough experience and imagination to ground Gramsci's hunches in reformist, rather than revolutionary, politics. Governments need not be eliminated, either by armed force or by

cumulative cultural revolution; they can be reformed through the intrinsic dynamism of programs that coordinate active citizens with creative and transparent leadership.

After the icebreakers of artistic acupuncture, Bogotá's mood changed.[26] Citizens voluntarily collaborated with government and expected good results. The success surprised everyone, including the mayor. There were fiscal reforms (transparency and voluntary tithes), educational improvements (with arts and evaluation), better law enforcement (Mockus and his staff taught at the police academy), new public transportation (the Transmilenio), and water conservation (40 percent reductions that continue today). Despair turns out to be unrealistic or lazy, a failure of determination and creativity.

When admirers from other cities eagerly solicit his advice but stay shy of playing games, Mockus recommends more creativity. And when they simply copy an intervention, as the mimes were copied in more than one hundred Colombian cities without any measurable effect, he urges more serious analysis.[27] Cultura ciudadana is not a recipe but an approach, Mockus consistently tells them. It combines the ludic with the legal and counts on analyses of local conditions. In other cities, programs should be customized or replaced by new games.[28] The Transmilenio, for example, is adapted from "Curitiba's rapid transit bus system, with its trademark clear tubes for same level pre-boarding. . . . Bogotá and Seoul have borrowed from the concept. Los Angeles and Detroit envy it."[29] The point is to think adaptively and creatively. When critics object that Mockus cannot be right because he thinks counterfactually, he agrees with them, but adds that without imagining the counterfactual, change remains unthinkable.

Among the many games that Mockus pioneered, the traffic mimes remain a special first case. The mimes rehearse an entire repertory of possibilities. Twenty made-up artists with no authority to detain people or to issue traffic tickets stopped buses, mocked jaywalkers, and beguiled a growing public. The effective antics encouraged Mockus and his inspired staff to keep playing. Within ten years, traffic deaths decreased from thirteen hundred per year to six hundred. For two weeks each mime would train twenty amateurs — gradually including the homeless and even professional police among the eventual four hundred recruits. Soon the grid of urban space became a massive stage for daily fun poked at offenders of rules about red lights and crosswalks. The spectacle created a public from discreet and defensive residents who during years of lawlessness had been avoiding eye

contact with one another. A public is formed in response to a spectacle, as performance theory makes clear; it is not a pre-constituted body with a general will to see a show.[30] Even a previously formed public counts on previews and publicity as incentives to reconvene. In Bogotá, the pantomime performances reconstituted a res publica that appreciated some pedestrian elements of the law. Now people came together in public to abide the law, with pleasure. Active citizens are not spectators in the conventionally passive sense, nor are they disinterested observers — Kant's *Weltbetrachters*.[31] Instead, the jaywalkers, the laughing crowd, and the corrected crossers at crosswalks were all spect-actors, in Boal's deconstructed neologism that undoes the difference between the doers and the done to.

The idea to replace the traffic police with mimes didn't occur to Mayor Mockus right away. In fact, he spent his first month in office practically paralyzed politically, worried along with everyone else about what to do in a city so hot with crime that the law was going up in smoke. Voters had taken a risk on the unlikely mayor. He was a distinguished professor of philosophy and mathematics and recently the president of the National University, but hardly a career politician.[32] And now they wondered whether they had not made another mistake, along with the increasingly desperate conclusion that staying in Bogotá was a bad idea. It's not that academics are unknown to politics in Colombia, where grammarians became presidents during the nation-building nineteenth century.[33] And voters knew that Mockus had some administrative experience. But neither Colombia's history of scholar-politicians nor the administrative record of the university president could have predicted his success at the polls. For one thing, Mockus doesn't fit the notoriously conservative nineteenth-century mold. He chose to study and teach mathematics, he told me, rather than the humanities because math doesn't depend on deep philological roots acquired over a privileged lifetime; it is an equal-opportunity discipline. Ask any Bogotano how Mockus lost his job as university president to appreciate how surprising he can be, and how close to calamity an inspired risk can run.

Before the (in)famous incident in 1993, Mockus had for three years cleverly managed to facilitate conversations and even accords at the politically volatile National University. How, you may wonder, did he overcome the refusal of administrators to talk to revolutionary students who would not remove their masks? He simply invited both parties into a room and instructed the students to sit with their backs to the administrators so they could speak freely to the wall. Mockus also devised games for players too

intransigent to deliberate. One game was to tie the ends of a string to the wrists of one player and, looping another string through the first, to tie the new ends onto the wrists of a partner. The challenge to untangle the connection engaged the antagonists in physical contact so long that collaboration began to override the enmity.

The fateful affair began when Mockus tried to offer official remarks at the inaugural ceremonies for the new faculty of arts. The dean had already been heckled into silence by the hostile student crowd. But President Mockus was not deterred. He must have counted on his talent for inventing charms to establish civility, even though the students were at their unruly extreme that night, determined to outshout the president and to undermine any new university program. Mockus tried several moves to quell the crowd, but each failed. Then, in a move that no one could have predicted, the future mayor turned around, dropped his pants, and mooned the crowd of noisy students. They were stunned into silence. Satisfied at having won the skirmish, the president resumed a decorous posture and delivered his speech to a quiet audience. The shock for him came later. The next day, Mockus got to see his own bare bum featured on television during the nightly news program. One of the students evidently came prepared to shoot with a video camera. In a single stroke, Mockus became embarrassingly visible to all sectors of Colombian society and inappropriate as president of the National University. Now famous for his former job and available for a new one, Mockus campaigned to become mayor of a desperate city willing to take a risk on the unconventional candidate.

But during that first uneventful month in office, citizens felt disappointed. The new mayor had decided to address the high rate of traffic deaths to show some success before tackling entrenched interests, and he commissioned a study by the Japanese International Cooperation Agency. It turned out that at least 25 percent of the accidental deaths could be prevented by improving behavior among pedestrians and drivers. A follow-up study of the streets pinpointed a single target for his cultural acupuncture: the deadly crosswalks.[34] With the troublesome nerve exposed, Mockus encouraged the Institute of Culture and Tourism to design cultural pressure that would arouse *shame* for ignoring crosswalks, not fear of fines. (Culture and Tourism, by the way, had been an underfunded afterthought for city government before Mockus became mayor; under him it became the hub of cultura ciudadana.) Each day for a month, the mayor asked the institute's frustrated director, Paul Bromberg, for a good idea.

Bromberg finally confided to his father-in-law that he felt discouraged. During dinner one evening he asked the old man for advice. Instead of help Bromberg got a sarcastic dismissal, he told Mockus the next morning. The ironic in-law had snapped: "When there's nothing to be done, it's time to bring out the clowns." After this unhappy report, and a short pause in the conversation, Mockus lit up. "That's a great idea!" He would propose replacing some embarrassingly corrupt traffic police with a few funny mimes poised to make people laugh at lawlessness. Citizens would learn to play together in public space and to love the props of striped crosswalks and red lights. The center city would for a while stop giving traffic tickets and discontinue—for good—the bribes demanded by uniformed officers. As more mimes trained to take over for traffic police, that unfriendly force faced dissolution, nine (gestating) months after the experiment started.

Mockus had purposefully misinterpreted an old man's mockery as a marching order. A metaphor for defeat was realized as an advance in the war of position called Civic Culture. With characteristic and almost impish innocence, like an artist, the mayor chose to hear a literal message on the surface of the familiar figure of speech. Another time that Antanas chose to listen badly on purpose was when he and Adriana Córdoba were planning their wedding, which took place in 1996. The dilemma was where to get married, and the solution was to turn a dead metaphor into living language. Finding a spectacular venue would allow the public to participate. There would be no list of special guests for the celebration but rather a general invitation to the city. Churches were out of the question, because the still devout groom had been excommunicated for marrying and divorcing a previous partner. Antanas asked his fiancée for a recommendation. She teased him: "If you want a three-ring circus, why not get married there?" Antanas and his bride did just that—inside the tigers' cage as the tamer whipped his wards away from the happy couple and from the terrified elephant they rode.

By making the common expression unfamiliar, defamiliarized by an intentional mistake, Mockus made a work of relational art that engaged an entire city on the streets and at the circus. Sometimes, and probably often, creativity follows from purposeful misunderstanding. This is why bilingual and bicultural games are a source of endless fun and wisdom as they track the artful failures of language.[35] Misunderstanding, intentional or not, is also why foreigners help to keep democracy dynamic, by asking unlikely questions that stimulate justification or reform.[36] Antanas Mockus, with

his Lithuanian name and his Colombian allegiance, lives a cultural complexity that matters for democracy. One effect is "learning to listen better," as when he honors literal meanings and also anticipates mistakes in multicultural settings.[37] For example, he wrote an essay on "Cultural Amphibians" to establish the importance of translation as a skill in education; and I am convinced that this keen observation takes advantage of his own bicultural formation that shuttles between languages. Educators, he writes, are fundamentally amphibious because they move material from one register of language and experience to others; without this agility for translation, teachers could not teach. The same ability to interpret elements of one code in terms of another allows cultural amphibians to participate in legal, moral, and cultural expressions without violating their personal integrity. Amphibians help to bridge the dangerous divorce of law from morality and culture by translating the reasons of one into the others. "The idea of modern democracy is inseparable from the possibility that different reasons may back up the same rules."[38]

This is a significant departure from traditional Colombian politics, which had advocated cultural coherence and consistency in legal reasoning. Intolerance for political and ethnic diversity went so far—according to historian Alfonso Múnera—as to sacrifice Panama to the United States in 1903 though the future canal was predicting fantastic incomes. For conservative Colombia, it was apparently worth the price to be rid of the culturally inassimilable and politically radical Afro-Colombians concentrated in Panama.[39] The grammarian-statesmen at the turn of the last century reviled local particularities in language and politics, just as they denounced deviations from Catholic dogma.[40] Well into the twentieth century, non-Catholic immigration was severely limited if not denied. Defending to the letter its linguistic heritage of classical Latin and Castilian Spanish, Bogotá was known as the "South American Athens."[41] By 1886, conservative Rafael Núñez (twice president between 1880 and 1888) had replaced the earlier liberal and secular constitution with a Church-centered document that lasted more than a century. It acknowledged Spain as the mother country, while other Latin American states considered her unnatural, castrating, or insignificant.[42]

On this monocultural background, Mockus advocated the pedagogical and developmental dynamism of amphibious cultures to mark a new procedural modernity for the country. He and other intellectuals helped to draft Colombia's Constitution of 1991 which, for the first time, recog-

nized minority cultural rights and honored local authority. As mayor, Mockus would decentralize the administration of the socially fragmented and sprawling city of almost eight million residents into twenty fairly autonomous locales. Local as well as general human rights would continue to inspire his subsequent political campaigns. Those included another successful bid as mayor of Bogotá in 2001 and three runs for the national presidency, in 1998, 2006, and 2010. Meanwhile he continues to direct Corpovisionarios, a consulting institute for public policy and idea generation.[43]

A Numbers Game

Theories about socially constructive art are still in stages of underdevelopment, given political skepticism about what art is good for and also humanistic defenses against usefulness. Grant Kester makes a significant contribution in "Dialogical Aesthetics: A Critical Framework for Littoral Art," proposing new criteria for collaborative projects that negotiate the boundaries between aesthetic and social values.[44] But taking statesmen into account as "littoral" artists is a stretch.[45] Either creative leaders seem too rare to generate principles, or they appear practically diabolical. More people have heard about Adolf Hitler, for example, than about Antanas Mockus. Hitler, we know, was a mediocre painter and then a devastatingly successful director and lead actor of a historical epic that he made sure to choreograph, decorate, broadcast, and film.[46] Maybe the Spanish conquerors will come to mind as exemplary administrative artists. They were consummate architects and city planners on lands that were already populated but that, as artists, they imagined to be empty canvases wiped clean. Add the pomp of Catholicism, which dazzled believers and dignified violent conversions from the Middle Ages into modern times, and also the general taste for refinement and beauty that justifies privileged classes to take advantage of everyone else, not to mention the devious creativity of financial institutions that have sunk the global economy into a general depression, and you may conclude that the combination of art and power creates an unfair imbalance against civic decency.

But resistance to abuse also uses art: Painters and poets in concentration camps defended their human dignity as creative agents. Antifascist Red Army posters outdid Nazi propaganda in design and impact. Indigenous New Christian artists smuggled old symbols of local cults to keep their chain of worship unbroken. And other popular arts, from slave songs

to graffiti murals, shore up cultural autonomy and self-worth against de-humanizing force and indifference. Nevertheless, in powerful hands, art seems to support unjust advantages. After the Enlightenment — when creativity could get full credit for doing political work — artists have often distanced themselves from government projects even when they have gotten government support. Social commitment for artists more likely means opposition to political authorities than collaboration with them. (See chapter 3, "Art and Accountability.")

Hoping, however, to withhold art from government, or objecting to its use because governments have used art harmfully, is like condemning language because it can curse. Language arts, like others, are born of innate and hardwired human faculties, so abstinence from art is a self-denying and self-canceling caution against living. A more practical response to the dangers would distinguish art that does damage from art that does good. Are there family resemblances among cases? I think there are. Power-brokered art is most harmful when power is concentrated in political elites. An autocrat designs a personalized state that can be realized as long as the general population of nonartists executes the plan and dutifully rehearses the script. The roles, props, and symbols come from agreeable artists. "My idea of an agreeable person is a person who agrees with me," Benjamin Disraeli explained.[47] Improvisation or levity — not to mention contestation — is dangerously out of place in monolithic top-down art. It rejects Schiller's caution against violently molding human material into another's work. (See chapter 5, "Play Drive in the Hard Drive.")

The contrast I want to suggest between this auteur model of political art and more democratic forms is in the numbers. It is a difference of participatory scale in art-making, "a distribution of the sensible" in Rancière's formulation.[48] To borrow Sir Francis Bacon's quip about money, art "is like muck, not good except it be spread."[49] Brazil's ministers of culture Gilberto Gil (2003–2008) and Juca Ferreira (2008–2010) understood the principle when they fertilized networks of local artists in bottom-up programs.[50]

Claire Bishop worries that inclusiveness blunts art's provocative edge when consensus building matters more than aesthetic results. The danger, she says, is double (despite Kester's reassurances): either artists stay fixed on personal projects and merely use the collective to fill in the design; or artistic vision is lost in negotiations.[51] But many distinguished artists hold out for a third possibility: participants are creative whether they stay with the collective project or ripple out into new works. The ACT UP experience

is a model of collaboration without submission to deadening consensus; in cases of disagreement, dissenters added spin-off projects to fuel the shared movement without losing artistic steam. (See chapter 2, "Press Here.")

Artist-citizens become admirable to one another. No single artwork cancels out the value of many others, and each exercises a particular charm for other creators. Another lesson we learned from Mockus during his Harvard stay (along with the pragmatics of pleasure) is that admiration is the feeling that sustains democracy. A much stronger feeling than tolerance, admiration is an aesthetic response of surprise and wonder that Boal, for example, consciously coached on stage and on the street.[52] Merely to tolerate is to continue to count on one's own opinions and simply wait until others stop talking. Tolerant citizens can feel themselves to be the real source of good judgment and imagine that the rights enjoyed by others apparently issue from one's own generosity. Paulo Freire hated this kind of self-celebrating munificence that confirms an imbalance of power between giver and receiver.[53] Admiration shifts the balance of feeling; it favors others without sacrificing self-love. To admire one's fellow (artist) is to anticipate original contributions and to listen attentively. Mockus stimulated admiration by creating, for instance, "The Order of the Zebra" (crosswalks are called zebras). Identifying decent taxi drivers, decent despite the personal dangers and the general divorce of law and morality from culture, he honored them with zebra-shaped lapel pins and car stickers. These insignia of "moral giants" gave admiration a multiplier effect. As business boomed for the Knights of the Zebra, other drivers coveted membership and strove to earn it.[54]

Consider the difference between the chorus effects of fascism and the ripple effects of democracy. *Triumph of the Will* projects the same single voice as do Hitler's newsreels, whereas Bogotá's mimes and the traffic flashcards encouraged each citizen to improvise in games of mutual regulation. Nazi Germany did not promote general arts projects to stimulate debate and deliberation among youth through theater and writing, as Bogotá and Medellín have done with "Youth Weaving Their Futures."[55] Nor did the Nazis issue a call to all children aged six to sixteen, as did Mexico and Colombia, to create posters that bid "Good-bye to Tricks" to denounce corruption at every level.[56] Fascist games targeted uniform results. Hitler himself attacked creative education by closing the Waldorf Schools, which he called "a Jewish method to destroy the normal spiritual state of the people."[57] It is worth wondering whether a country alive with artists—by

FIGURE 1.6. Renewable mimes from student demonstration, Bogotá, 2011.
Source: Guillermo Legaría, Getty Images.

definition nonconformists and risk-takers—is less likely to support dictatorship than a nation of dutiful followers. I've asked this almost rhetorical question to political scientists and political leaders; they generally concur that dictatorship frowns on creativity and embraces censorship.[58] Schiller put it this way: "Art, like science, is emancipated from all that is positive, and all that is humanly conventional; both are completely independent of the arbitrary will of men. The political legislator may place his empire under an interdict, but he cannot reign there."[59]

The difference between dictatorial and democratic arts, then, is formal as much as ideological. Recognizing the citizen as artist promotes rhizomes or networks of civic effervescence, as against a pyramid of creator atop his creation. Logically, Mockus objects to being called a leader: "It is important to develop collective leadership. . . . Millions of people contributed to the results that we achieved."[60] The political appeal of citizen-as-artist is similar to the checks and balances of democratic republics that hope to decentralize executive power but also to coordinate local autonomy with federal structures. New Deal artists and civic leaders would play out this analogy—really a synecdoche of artist (part) to (the whole) democracy—as they negotiated themes and styles of public murals. Sometimes, though,

practical considerations seem to trump this general principle of collective creativity.

Paint the Town

With an urgent pragmatism that demanded quick results, Edi Rama took liberties with democratic principles in Albania's capital city. Voted mayor of Tirana on the Socialist ticket in 2000 for the first of three terms, and chosen International Mayor of the Year in 2004, Rama was voted out by 2011 in a suspiciously close contest against the center-right Democratic Party.[61] His objections to fraud were justified and became a hot issue in his successful campaign to become Prime Minister in 2013. Though Rama had distanced some supporters by staging relentless protests in favor of his own leadership,[62] a winning block of Albanians endorsed his unusual project for national recovery: an aesthetic make-over that moves from decorative surfaces inward toward respect and self-regulation. As mayor, Rama's bold leadership style determined Tirana's priorities and even the designs for painting the facades of depressingly grey buildings. But citizens collaborated too, officially and informally, to an unprecedented degree. Rama seized the groundswell to frame his national campaign as politics from the bottom up, no doubt to allay concern over his earlier and notoriously auteur approach to public art.[63]

> You hear him everywhere: a gravelly basso exhorting the lazy, seducing the skeptics, booming his way through a hip-hop track about Tirana that half the city seems to own. He is inexhaustible. He spends his days repairing the body and soul of a shattered capital and his nights prowling its streets, seeing that the work got done, and that no one has been stealing street lights or dropping beer bottles or cigarette wrappers—that people are behaving like citizens. Rama is a Balkan original, and maybe the most original thing about him is that he isn't really a politician. He is an artist who, you might say, took Tirana for his canvas.[64]

Contemporary journalists observed that the mayor's art projects did what they could, from the top down.

> He claims still to be an artist first and most of all, and activities in public service are an extension of his aesthetic sensibility into the

realm of action and life. He shrewdly appraises the legacy of communism as a cultural and social toxin that cannot be eliminated except over time, and perhaps a very long time. But he is helping restore Tirana society's immune system and positive attitude by, for example, the Return to Identity Programme, ruthlessly razing the haphazard and often environmentally damaging outlaw buildings of all kinds in order to produce a clean slate on which urban planning can occur that will meet the needs of present and future generations.[65]

Mockus too was unfriendly to unauthorized street-life, especially to sidewalk vendors. (What would they think of artist Krzysztof Wodiczko's homeless shelters à la carte: nomadic structures designed in consultation with users in New York City?)[66]

For some critics Rama stretched the possibilities of democracy beyond recognition. "Political analyst Fatos Lubonja says the capital might as well be renamed 'TiRama.'"[67] But the city that for half a century suffered Soviet stagnation, followed by a decade of mob-run speculation and informal building that littered the city and poisoned its river, gave the determined visionary a chance. Citizens let themselves be charmed by his recovery project. Without hesitating, as Mockus had while asking, "What would an artist do?" Rama was already an artist and ready to start. "The first thing he did as mayor was to order paint. He blasted the facades of Tirana's gray Stalinist apartment blocks with color—riotous, Caribbean color—turning buildings into patchworks of blues, greens, oranges, purples, yellows, and reds, and the city itself into something close to a modern-masters sampler."[68] He actually invited modern masters in from 2002 to paint entire blocks and turn Tirana into a gallery worthy of visits by tourists and investors.[69]

Decades of visual blight had left Albanians irritable and "aesthetically challenged," says Rama; but he adds that "they can be calmed by beauty."[70] Streets of newly painted buildings became admired public property and fostered safer commerce. The change encouraged significant international loans and investments.[71] By the time he collaborated with artist Anri Sala on the documentary film *Dammi i colori* (*Give Me Colors*) 2003, Rama could report that there was no other city in all of Europe where citizens had achieved more depth and subtlety in their conversations about color. They would gather in coffee houses, homes, and newly recovered parks to consider the aesthetic qualities or failings of freshly painted buildings,

and to deliberate about designs for new projects on still-drab facades. Deliberating for the pleasure of it, with no apparent personal goal but the free interchange of opinion, renews a taste for politics in the classical sense of the word: a disinterested *vita activa* (see chapter 3, "Art and Accountability"). And this aesthetic education of Tirana—proceeding, as Schiller said it would, from freely admiring art to imagining how to make more—trained citizens to identify freedom as worthy of cultivation.

Rama must have learned from other painters and architects how to transform ugly buildings into beautiful ones. An obvious but unacknowledged teacher is Friedensreich Hundertwasser, whose architectural makeovers in Austria in the 1980s gave new looks to the Rosenthal Factory in Selb and to the Mierka Grain Silo in Krems. For these projects Hundertwasser called himself an "architecture doctor."[72] And though he favored organic lines on buildings and in manifestoes over the geometric patterns that Rama features, the structural use of color on aesthetically ailing buildings is an undeniable family resemblance.[73]

THE EXTENDED FAMILY of color therapists for cities includes painters of Manarola on the Italian Riviera, of Guayaquil in Ecuador's highlands, and Rio de Janeiro's favela Santa Marta.[74] If elsewhere the idea of public color campaigns seems merely decorative and misguided as public policy, it is time to consider the potential of the work of art in the world.

The same citizens of Tirana who debated about color would actively participate in public budget hearings to determine priorities for public works.[75] Other citizens refused to participate, but didn't worry about designs on their lives and freely denounced Rama for his bold interventionist style. "It is unfortunate," even admirers told the mayor, "that everything you have done is so closely linked with your team and to your wisdom and individuality, rather than becoming strongly rooted as well with a working juridical system."[76] After two violent murder attempts, the objection to heavy-handedness didn't scare the mayor. "I don't pretend to be an angel. I'd never become mayor in Switzerland, where you have to have a referendum to go to the toilet," he says. "There I would stay in my studio and paint."[77] Citizens' involvement in decision-making may have been an unscripted development of Rama's projects. A Kantian common sense about color as a constructive element in recovery led to discussions about priorities and programs. Until May 2012 the website tirana.gov.al hosted Rama's

colorful gallery of architectural makeovers, recoveries of public space, and public meetings to debate priorities and allocations. But after losing the mayoral election to Lulzim Basha, the same web address now opens onto a monochrome grid of administrative links and picture galleries that project portraits of the new mayor from practically every frame.

Mockus had made sure to engage the broadest possible base of Bogotá's citizens in co-constructed arts projects; and he delivered the results to Enrique Peñalosa, who realized many of Mockus's construction plans, though they represented competing political parties. Sadly, Mayor Rama didn't relay his work to the dubiously elected new mayor. Nor, presumably, would Basha have received the offer of good practices from the opposition. But now, Prime Minister Rama's bottom-up approach is a sign that the public's developing common-sense, from aesthetics to participatory politics, may insure more continuity in public projects.

Sometimes though, bottom-up creativity can raise cautions even for good governments, because art is unconventional and naughty by nature. Understandably, leaders tread with care, or they waffle between defending artistic freedom and channeling resources toward agreeable artists. Broad-based art-making has to deal with disagreements, differences of perspective, competing designs, and conflicting desires, all of which can derail the goals that voters endorsed when they elected winning candidates.[78] A monumental case of this challenge to coordinate art with government is America's New Deal, which wrestled "to reconcile artistic freedom with the imperatives of bureaucratic control and public accountability."[79]

The Home Front

The exemplary mayors from Bogotá, Curitiba, Tirana, and many other cities earn international admiration for reviving civic commitments in cities jaded by generations of broken promises. Few observers doubt that art played a significant role in these stories of recovery. Perhaps art can work in other difficult cities where citizens value creative practices. This hope prompts quite a few Latin American leaders to request advice from Mockus. Impressed with his results, they imagine similar programs at home; but reluctant to risk failure and their authority, they often hesitate. "There's a trap in this business of advising leaders to play games," Mockus admits, "because respectable officials want good results, and good results are not easy to ensure in games that are daring enough to break bad habits."[80]

First world leaders are even more skeptical. For the same reason that persuaded Rama to become mayor in Albania though he would have refused in Switzerland, his foreign fans and those of Mockus discount the value of art in more stable societies. North Atlantic cultures are different, they say, agreeing with Max Weber, less disposed to creativity than to self-restraint.[81] "Traditionally, Americans harbored an attitude that art was a luxury," made by the talented few and meant for the fewer who could afford to buy it.[82] But a double irony plays out on this demarcation between the rational North and the creative South. The first is that Franklin Delano Roosevelt's New Deal, of course, promoted a massive program of social regeneration through art-making. The second irony is that the U.S. program did learn a lot from Latin America. Though several influences combined to support New Deal arts (Dewey's progressive education, settlement houses, redefinitions of art coming from revolutionary Russia, European Group Theatre),[83] Mexico was the stunning model.

After an exhausting rash of revolutions that lasted from 1910 to 1920, Mexico faced the colossal challenge to reinvent itself. Without a shared culture there would be no general will to do the work, so recovery started in earnest when President Álvaro Obregón appointed José Vasconcelos as minister of education (1921–1924). Leaving his brief stint as rector of the National University, where he had "not come to work for the university but to ask the university to work for the people,"[84] Vasconcelos took up his new job with a missionary zeal that irked many but achieved broad and lasting results. His comprehensive program included (1) public schools for children and adults, where teachers became his "artist-apostles"; (2) the publication of all manner of affordable books to stock a new network of libraries; and (3) murals about Mexico by masterful Mexican painters who helped to revive local arts. The still illiterate masses were heirs to enviable artistic traditions, including Aztec and Mayan murals, and they responded to grassroots creativity that facilitated communication and fueled patriotism. Vasconcelos took a lesson from John Dewey on pragmatic reform, though later he dismissed the North American as a soulless utilitarian, almost by national definition.[85]

The United States, according to Vasconcelos, had missed its chance to become the democracy that Hegel imagined would materialize to the west of Europe. Squandered on an incorrigibly racist society, the spirit of democracy moved even farther west to Mexico. Vasconcelos credited his country with forging a unified "cosmic race" to crown human evolution with

equality. His manifesto, *La raza cósmica: Misión de la raza iberoamericana* (1925), is admittedly equivocal. It rehearses all the old racist attributions (whites are intelligent; blacks are hard workers; Indians are submissive and accommodating) as elements of one new race. But the book also celebrates mixing the attributes, while northern eugenics campaigns were recommending racial purity. *Raza cósmica* became practically required reading all over Latin America, as countries were pulling themselves together, trying to scramble heterogeneous populations into coherent national cultures.

Mexico's accomplishment of an arts-based hybridity to support national reconstruction evidently inspired FDR and his staff to adopt and to outdo the model. With adjustments to taste and scale, the United States followed Mexico's recipe for reviving patriotism: mix aesthetically compelling regional culture with a measure of common heritage to leaven national purpose.[86] One recent account traces FDR's art-making ambitions back to George Washington and Abraham Lincoln, but Roosevelt's advisers looked to contemporary Mexico:[87] "The founders of the PWAP (Public Works of Art Project, 1933–1934) believed it to be a grander and even more promising impetus for the arts than the Mexican mural project of a decade earlier."[88] Even grander would be the sequel, the WPA's (Works Progress Administration) Federal Art Project (FAP, 1935–1939).[89] In visual arts alone the project would employ about five thousand artists and administrators who together produced more than 225,000 works of art and decorated eleven thousand public buildings.[90] The FAP also sponsored performing artists: writers, narrators, playwrights, actors, musicians, composers, film makers, as well as interviewers who recorded and compiled personal memoirs of twenty-three hundred surviving former slaves.[91] Carlos Fuentes apparently thought that the United States did outdo Mexico. He doesn't even mention his own country when he exhorts us all to make a "new New Deal of global governance that must begin like Roosevelt and the American people did from the bottom up."[92]

Instructive ripples from both projects combined in Puerto Rico. ("Comic Race" is Rubén Ríos Avila's version for an island where North and South come together but don't mix.)[93] Throughout the 1950s, the DIVEDCO (División de educación comunitaria) developed variations on the WPA and on programs in Mexico where many Puerto Rican artists studied.[94] Lessons learned from years of frustration in FDR's New Deal prepared Edwin Rosskam to draft the DIVEDCO's founding document, making sure to defend artistic freedom, which supported lasting achievements.[95]

FIGURE 1.7. Panel from the frieze "Construction" in the Bowery Bay Sewage Disposal Plant in Queens, New York, sculpted by Cesare Stea for the Works Progress Administration, 1939. The Granger Collection, New York.

Most accounts of U.S.-government-sponsored art acknowledge the inspiration from Mexico's spectacular muralists, though striking omissions occur.[96] But the accounts hardly mention other Mexican models for the FAP, such as the overhaul of public education to feature the arts, or the massive state publishing project that encouraged local writers. The great Mexican muralists were impossible to ignore; Diego Rivera, David Alfaro Siqueiros, and José Orozco had already dazzled private collectors, and they would fire up government agencies. The messenger between the art world and the administration was George Biddle. Brother of the president's New Deal adviser, Biddle had been FDR's classmate at Harvard Law School before becoming a painter and going to Mexico to apprentice himself to Rivera.[97] Impressed by the public arts programs there, Biddle suggested to the president in 1933 that a mural should embellish the new Justice Department building in Washington, DC. The Treasury Department approved the commission, a first step toward developing the PWAP and then the FAP.[98]

Drawing on John Dewey's exhortation to make art available to all, the director of the FAP, Holger Cahill, said in 1936: "The organization of the Project has proceeded on the principle that it is not the solitary genius but a sound general movement which maintains art as a vital, functioning part of any cultural scheme. Art is not a matter of rare, occasional masterpieces." The Department of the Treasury objected, arguing that the government should commission outstanding artworks, not provide relief to mediocre artists.[99] Cahill knew what was at stake:

The Project has discovered that such a simple matter as finding employment for the artist in his hometown has been of the greatest importance. It has, for one thing, helped to stem the cultural erosion which in the past two decades has drawn most of America's art talent to a few large cities. It has brought the artist closer to the interests of a public which needs him, and which is now learning to understand him. And it has made the artist more responsive to the inspiration of the country, and through this the artist is bringing every aspect of American life into the currency of art.[100]

The partnerships that Cahill brokered between local artists and community leaders through the WPA mural project raised hackles on both sides. Inevitably, the government's offer to artists equivocated between promoting aesthetic value and insisting on the political merit of local lore.[101] But the resulting pride of place and the pleasure in beautified communities helped to sustain patriotism during depressing times, according to WPA leadership. New Deal artists also "saw their art as part of a national movement, a positive force that would further both the acceptance and availability of art in America but also uplift the morale of a depressed nation."[102] Making art demonstrated that national renewal was possible, despite conditions of scarcity. Even the annoying negotiations were constructive, reaffirming the democratic process in each locale.[103]

Most accounts of the reasons to establish the WPA's artwork stop here, at national revival and work relief. But surely there is another, paradoxical, and more Machiavellian reason for supporting so many artists during the worst economic crisis the United States has yet experienced. Biddle had remarked to Roosevelt that "artists have to eat, too."[104] But this argument makes the rather privileged assumption that artists stick to their chosen profession even if it means starving. Biddle had the money to continue painting. But other artists have been known to take up even menial jobs when they are hungry. The government could have hired down-and-out painters and poets to dig ditches and build bridges. (Colombia's most famous living photographer, for example, turned up in a New York City warehouse hauling boxes at the age of eighty-five. Why was he working there? "I miscalculated," Nereo López Meza smirked. "I thought I'd be dead by now so I spent all my money.")

Instead, it seems more credible that artists got support from the government because they might otherwise have used art to agitate (more) against

the government. Why else would a penurious state develop programs, hire administrators, and run political risks about decorous lines being crossed with public monies? True, the allocation for a mural was usually a minuscule 1 percent of the cost for a new building,[105] and the combined expenditures over eight years for Federal Arts Projects came to only $35 million (hardly much of WPA's more than $4 billion per year) for a mere forty thousand employees (barely a dent among 3.3 million WPA workers).[106] Nevertheless, this minority of artists was provocative enough to mire Congress in long sessions of penny-pinching control.

The fact is that many artists *were* left-leaning socialists, or communists, or sympathizers.[107] The times were rife with revolutionary artists, internationally. Strategic disavowals from FAP's administrators didn't convince conservatives who denounced artists as dangerous and unworthy of welfare commissions. Maybe conservatives hadn't heard how much trouble Rivera and Siqueiros had made inside Mexico, leading violent protests in the official Art Academy and reducing capitalists to cartoon characters in communist publications.[108] But the Los Angeles mural by Siqueiros was notorious; it showed an Indian nailed to a double cross topped with U.S. coins and an eagle. More notorious was Rivera's homage to Lenin in the mural he painted for Rockefeller Center.[109] Those works were covered over to avoid more scandal, but conservatives had good reason to remain vigilant.

Perhaps predictably, the noisiest government interference was with theater artists who were making a spectacle of social protest. (The Writers' Project got almost equal harassment in the notorious "Dies Committee."[110]) When WPA director Harry Hopkins hired Hallie Flanagan for the Theatre Project in 1935, he promised there would be no censorship. But he broke that promise six months later.[111] Tensions peaked in 1937 around Marc Blitzstein's *The Cradle Will Rock*. Flanagan wasn't sure she should risk producing the relentless class critique in a climate of violently repressed strikes, though Orson Welles goaded her on, intending later to move the show to Broadway. After the WPA revoked support for the show, and closed the theater where it was to open, Blitzstein and Welles reconvened the crowd in another theater. They also fired up the fired actors to deliver sizzling performances.[112] Liberties like this one led to escalating allegations of communist influence and sometimes to ridiculous accusations.

Congressman Joe Starnes of the House Committee on Un-American Activities, for example, famously grilled Flanagan in December 1938. He was sure that she was protecting a core of communist infiltrators. To sig-

nal a very different, open, and nonideological spirit of the project she portrayed "a certain Marlowesque madness" among the actors and writers. With the Elizabethan reference she hoped to demonstrate a highbrow rather than populist preference. Alongside popular tastes and massive productions (to employ thousands of theater workers) Flanagan had also cultivated friendships with T. S. Eliot, who donated *Murder in the Cathedral* to the Federal Theatre Project,[113] and later with George Bernard Shaw and Eugene O'Neill, who contributed rights to all their plays.[114] Adding Orson Welles's direction of revived classics, Flanagan was describing variety, capaciousness, and a winning combination of high art with broad appeal. But Congressman Starnes heard his suspicions confirmed. "You are quoting from this Marlowe. Is he a Communist?" A bit flustered, Flanagan said she meant Christopher Marlowe. By now Starnes had lost his patience: "Tell us who Marlowe is, so we can get the proper reference."[115] This comedy in Congress recalls an incident that Augusto Boal reports about a Brazilian censor who insisted—after hearing about the seditious staging of *Oedipus Rex*—that the author be brought forth to defend his work.[116]

The New Deal watchdogs were usually less crude; they claimed the contractual rights of a client to approve the services of a provider. Here public monies were allegedly paying troublemakers to make trouble. The strategic question that the government must have considered is whether paying them would control the trouble. Maybe leftists were being funded *because* they made public shows of their opposition to injustice, hunger, and social inequities. That way, revolutionary theater also performed the magnanimity and tolerance of their government sponsor, and the New Deal could capture even antigovernment protest as part of its program. Everything would be possible inside the New Deal but nothing tolerated outside it, to paraphrase Fidel Castro on the Cuban Revolution.[117] If artists had no stake in the state, they would surely have tried harder to destabilize it. But performing protest in official scenarios mitigated the message, as artists confessed in their tormented reflections. Putting them on the payroll during hungry times, the state might arrest—in defense of the American way of life—rebellious energies that would otherwise explode against government.[118]

Roosevelt's reformist rhetoric met the rebels halfway: "In spite of our effort and in spite of our talk, we have not weeded out the over-privileged and we have not effectively lifted up the underprivileged. . . . We have . . . a clear mandate from the people, that Americans must foreswear the concep-

tion of the acquisition of wealth which, through excessive profits, creates undue private power over private affairs and, to our misfortune, over public affairs as well."[119] Public support for creative critics seemed a risk worth taking, and it usually paid off. Artists generally understood "that because the murals were commissioned by the government for the public, 'a lack of controversial political subject matter is certain. Ideas will derive either from history or from the peculiarities of present-day life.'"[120] Mexico had made that bet a decade earlier and continued to support artists in conveniently disarming ways. Commissioned, salaried, and otherwise sustained, Mexican artists have long understood this deal.

The lifeline that channeled artistic energies toward the New Deal would tangle, though, between artistic freedom and the demands of the state. TRAP (Treasury Relief Art Project, 1935–1938) was literally the acronym of a government agency that employed and controlled down-and-out artists to decorate twenty-five hundred public buildings.[121] During an interview in 1965 painter Charles Alston remembered resenting government interference that inevitably compromised his art. But his contemporary, Edward Biberman, bought the deal. Artistic freedom, he admitted, is never absolute.[122] Most art historians take Biberman's side, endorsing the results of moral and financial support for artists during the Depression. However contentious the negotiations became between federal authorities and the Writers' Project, and although Congress closed down the Theatre Project before all the other projects fizzled out just before World War II (officially ending in 1942),[123] scholars today generally conclude that the processes and the products were worth the efforts.[124]

But some cringe at the force-fed patriotic content and the opportunism that allegedly choked aesthetic initiative and finally doomed the collaboration. This difference in judgment runs parallel, I think, to alternative approaches to reading a novel. There are readers who focus on how the novel ends, whether the protagonist wins or loses a quest; and others read for "form," attending more to the complexities of plot and to the variations of language than to resolutions. Is it funny that critics of the government's artistic constraints turn out to care more about the ideological theme of artistic freedom than about the aesthetic forms that responded to constraints? An endgame observation by historian Jane DeHart Mathews concludes that art is inherently incompatible with accountability. Flanagan's "fiery" leadership is Mathews's best case: the same verve that produced admirable theater doomed the Theatre Project to a congressional

death.[125] And since she believes that creativity cannot abide interference, the end of the Theatre Project seems more significant than its years of creative activity. Richard McKinzie is equally skeptical about the benefits of official support to visual arts.[126] By the 1970s most art historians were sure that aesthetic value could not survive official intrusion, and the few who began to linger over the formal qualities of WPA painting were dismissed as iconoclasts or rebels.[127]

But recently, defenders of the WPA underline its contributions to formal experimentation. John O'Connor and Lorraine Brown argue, for example, that the Federal Theatre Project showed how innovative and powerful national theater could be. Among its controversial formal innovations was a genre borrowed from communist agitators in Europe, the "Living Newspaper."[128] (Augusto Boal would use Newspaper Theatre, too.[129]) Large casts, using multimedia, staged contemporary social issues researched by WPA journalists. Some of the Newspaper's experimental techniques became lasting contributions to stagecraft: photographs, projections of animation and film sequences, offstage loudspeakers to add comments, questions, crowd noise. With occasionally local variations, particular "editions" of the Newspapers would often play simultaneously in several cities to create a national buzz. Probably the best-known edition, produced in eleven cities, was *One-Third of a Nation*. It played out FDR's haunting concern for the country: "I see one-third of a nation ill-housed, ill-clad and ill-nourished."[130] Because the WPA's mandate was largely to provide for artists (and maybe to contain them), rather than to yield returns on investment, the government actually enabled a greater level of aesthetic freedom than did risk-averse private funding. "Try-out" theater in New York City, for instance, amounted to a luxury at the time as writers and directors explored new material that they could later pitch to commercial producers. The first experiment was sold to the movies, and the second to a Broadway producer.[131]

In the aftermath of the WPA, the civic promise of aesthetic education apparently met a precocious end. But official interest revived by 1965 when Lyndon Johnson established the National Endowment for the Arts (NEA) and the National Endowment for the Humanities (NEH). The United States had fallen behind the USSR in the competition for space exploration and the government hoped to reenergize learning and creativity, along with national pride. Glenn Seaborg, the head of the Atomic Energy Commission, told a Senate committee: "We cannot afford to drift physically, morally, or esthetically in a world in which the current moves so rapidly perhaps

toward an abyss."[132] The NEA was careful to keep funding decisions free from almost any consideration but artistic excellence.[133] To an important degree, the hands-off policy responded to a developing retreat of art and interpretation into private subjectivity. Art had practically developed an allergy to any strain of usefulness.

The founding NEA language was less about civic capacity than about identifying a great country by its great culture. A section called "Prohibition against Federal Supervision" promised not to meddle.[134] But freedom came with a caveat: "Public funds provided by the Federal Government must ultimately serve public purposes the Congress defines."[135] Ronald Reagan planned to abolish the NEA soon after his election in 1980, but desisted after other conservatives including Charlton Heston defended the agency. Ten years later, scandals about Robert Mapplethorpe's "obscene" photographs and Andres Serrano's "Piss Christ" again threatened the Endowment during debates as acrimonious as the anticommunist WPA hearings.[136] And renewed legislation in 2006 conceded to the religious right that "obscenity" should not be funded.[137] Surviving in the NEA language is an echo of Dewey's defense of art as life lived critically and creatively, but the zeal is gone and so is the connection between art and civic agency.

Many North Americans may know something about Roosevelt's arts initiative, but most don't know its significance. General histories of the period downplay art's accomplishments.[138] If citizens knew more about how art works in this case and in others, they might sense a wealth of resources for social development and demand more creative education as well as extracurricular arts programs. We could learn to anticipate inspired interventions and even coax our imagination to create them. More books like *Art Worked: The New Deal, Art and Democracy* (2009) by Roger Kennedy will help to train expectations. Kennedy celebrates the monumental economic, environmental, and also spiritual effects of New Deal arts, though the case seems exceptional to him rather than a link to others.

A revival of the New Deal's decision to keep art at work during hard times seemed possible in March 2009.[139] With the American Recovery and Reinvestment Act the Obama administration appropriated an extra $50 million to the NEA "to be distributed in direct grants to fund arts projects and activities which preserve jobs in the non-profit arts sector."[140] In August, the NEA's communications director placed a conference call to engaged artists, encouraging them to address the administration's concerns: health care, education, the environment, specifically preventative care,

child nutrition, community cleanups, trail maintenance, reading tutoring, and homelessness. But the effort was aborted in the face of accusations of intended misuse of government funds and misdirected instrumentalism for art. "It was a scandalous breach of the NEA's founding legislation, possibly a violation of lobbying laws and just plain disgusting to anyone who cares about the independence of the arts."[141] The outraged critics accused the administration of narrowly partisan and propagandistic intentions, though the issues were concerns of a country that elected Obama. The president would manage to recover some of Dewey's dedication to art in education, but in the arts he lost ground to right-wing defenders of autonomy.[142] Is it in principle illegitimate to encourage artists to engage issues of social justice? And if autonomy were a sacred value, would Mapplethorpe and Serrano have seemed outrageous?

What Do You Expect?

"Don't worry," assuaged the gracious facilitator at a 2008 meeting of UN Habitat's "Safer Cities." I had commented that the theme of art was missing from the expert discussion on violence prevention, though examples of art filled their presentations. We were in Medellín, Colombia, a model for crime prevention since Mayor Sergio Fajardo reduced the homicide rate by 90 percent. Among his many programs was a system of library-sports complexes built along the divide between rich and poor. "Tomorrow," my host continued, "we will spend the whole day in what had been a violent hotspot and you'll see that all the youth leaders are artists." My worry deepened, of course, because if he already knew that the leaders were artists and didn't put art together with prevention for the expert panel, why would more evidence change his mind or my concern? Evidence is in but decision-makers don't seem to process the information about art's effectiveness. The problem is prejudice rather than a dearth of data.[143] Pragmatists know that empirical facts don't exist until we notice them. And noticing depends on culturally constructed expectations.[144]

"Safer Cities" helps to broker collaborations between at-risk youth and municipal governments. Cities can decide to spend money on art projects, or on armed police. The difference will depend, in part, on arguments for the alternatives. The UN initiative typically engages advice from urban planners, law enforcers, economic developers, and psychologists, none of whom have foregrounded the arts. Maybe art lacks the glamour of gravitas.

Or maybe it competes annoyingly with social scientific agendas, the way successful homeopathic cures compete with professional doctors. Art was the elephant at the Medellín meeting, and informal conversations added more cases of art to the rescue. Jorge Gaviria, who worked for the city, told us about his prison program for ex-combatants, youth who never developed regular work habits and don't expect to live past the age of twenty-five. He asks them what activity they would find exciting. Invariably they answer with some form of art. One prisoner dreams of playing guitar, another of painting, or dancing, or acting. Then Gaviria arranges for instructors in the chosen media to come early, every day, over long periods. He also told us about his arts-based high school for three thousand at risk students. Astoundingly, none of them drops out of school, while dropout rates soar almost everywhere.

Expecting art to work should be part of violence prevention and of education more generally. Otherwise experts continue to overlook a ubiquitous low-cost resource. Everyone noticed the art effect the next day during our visit to Comuna 13 when a band of preteen musicians greeted us with a contagious concert.[145] There is wisdom to cull from Medellín's marginal communities and from Bogotá's civic creativity, Tirana's beautification, the WPA's legacy, and more examples that I won't mention but that perhaps you will. All of them channel hostility into art and thereby into learning. These and other cases can inspire a range of development programs, but the particular relevance for violence prevention and youth development merits urgent consideration worldwide. Postwar chaos and dissolution of families make gang life ever more common. In their search for identity, their indefinite futures, economic scarcity, social inequality, and sometimes undecided genders, youth are nonconformist and rebellious, like artists. Feelings of aggression are normal, especially in unfair conditions, so authorities would do well to stop wishing those feelings away.

Art honors the explosive energy, Hallie Flanagan explained to her congressional interrogators: "It is the very essence of art that it exceed bounds, often including those of tradition, decorum, and that mysterious thing called taste. It is the essence of art that it shatter accepted patterns, advance into unknown territory, challenge the existing order. Art is highly explosive. To be worth its salt it must have in that salt a fair sprinkling of gunpowder."[146] The sprinkling can accumulate dangerously if governments don't provide outlets for artistic "symbolic aggression." Behaviorist research clinches the connection between violence and a lack of creativity

by observing that murderers have a characteristically underdeveloped capacity for play.[147] One takeaway lesson for civic leaders is to multiply opportunities to develop that capacity. Youth generally accept the invitation to play and to make art, for obvious reasons. Art thrives on nonconformity, exploration, expression, and the development of individuality.

Vexed as the national and international debates have been, there is good news at the city level in the United States, and it connects to the good news abroad. Mayors are beginning to acknowledge and to promote sustainable development sparked by art's agency.[148] Jaime Lerner, three-time mayor of Curitiba and twice governor of the state of Paraná, began his TED talk in 2008 by saying that cities are not a problem; they are a solution. Any city can be saved within three years and this will revive entire countries.[149] The lessons can be abstracted, U.S. consultants say, in a manual for civic sustainability.[150] News from Detroit, Chicago, Philadelphia, and Los Angeles continues to link the arts with urban revival, confirming economist Richard Florida's observations in *The Rise of the Creative Class* (2002). Consider practically devastated Braddock, Pennsylvania. At an Ideas Festival in 2010, Mayor John Fetterman spoke "about how art could bring social change to a town" decimated by violence and poverty.[151] The burly giant (6′8″) had spent two years at Harvard's Kennedy School of Government, where he may have gotten the inspirations he acknowledges: Florida's book and the model of urban farming projects in Detroit's wastelands and on South Bronx rooftops.[152] But the "two-pronged approach" of art and agriculture could multiply into an entire menu of techniques if the mayor had also collected tips from international cases. A decade after Fetterman studied education and social policy at the Kennedy School, Antanas Mockus and Edi Rama spoke there about overhauling their complicated cities through visual and performing arts. Professor Elaine Kamarck introduced them, admitting that she often taught that politics was an art but had not taken the connection seriously enough.[153] Perhaps schools of government are now poised to expand student tool kits with more art and more resources from the developing world. There is work to do here at local levels.[154]

From the top, authorities can facilitate safer and more productive cities with more art, collective art-making that enlists citizens as coproducers. The next chapter explores bottom-up coproductions that often begin outside and even in opposition to government.

Cultural Acupuncture and Civic Stimulation

An artist has not always to finish his work . . . so he may succeed in making
the spectator his co-worker. — HAVELOCK ELLIS, *The Dance of Life*

Press the name of your destination on a Paris Metro map and it lights up at
the points between the station you entered and the one you are going to.
The light-up technique now appears in museum displays about science and
history, in business plans, and — no doubt — in military maps. When the
electric pulse sends sidetracks beyond a straight or sinuous line, the con-
stellation of bright paths suggests how a creative act can spark responses
throughout a city. Urban acupuncture is Jaime Lerner's name for pressing
on a collective nerve to illuminate a whole body politic. Antanas calls it cul-
tural acupuncture to underline art's agency.

Some vibrant examples are the tags that teens paint on public walls to
provoke cities that may respond with mural contests and commissions
rather than with repression.[1] As public constituents, the youths press for
recognition; and getting it can rouse them to become leaders, teachers,
and entrepreneurs who mentor other young citizens of say, Philadelphia
or Chicago.[2] Graffiti-inspired murals in the United States stir the imagi-
nation of officials in Paris[3] and set off a street artist to paint and paste por-
traits of angry immigrants at home before taking his "Face to Face" project

to Israel and Palestine.[4] Melbourne's government cashes in on graffiti to attract tourists, which encourages more art-making.[5] But Beijing may be the most stunning site for wall-tagging artists; their mentor is Mao. He holds the record for the longest graffiti piece, four thousand characters of revolutionary slogans that covered public surfaces in the 1920s and ignited momentous change.[6]

Consider also "Eloísa Cartonera" as acupuncturist. Making new books from old cardboard was Eloísa's artistic response to the bankruptcy in Buenos Aires in 2001 when cardboard collectors filled the hungry nights. The storefront publisher may not have intended to ignite a chain reaction, but by now the initiative has inspired over thirty resource-poor collectives to publish literary riches all over Latin America, with new sites opening in Asia and Africa. When the Cartonera in Lima failed to sell its beautiful cheap books, "Sarita" pressed to create more readers with an art-centered pedagogy. The approach moved Harvard University's Cultural Agents Initiative to develop "Pre-Texts" and to train teachers in Boston, Mexico, Colombia, Puerto Rico, El Salvador, Hong Kong, and Zimbabwe among other sites. (See chapter 4, "Pre-Texts.") These responses to art with more art create networks that multiply good practices by pressing a point and stimulating far-flung activities.

Change Artists

Whether or not a work of art intends to change behaviors, its effect is provocative. Art reframes relationships and releases raw feelings that rub against convention. Wall tags raise hackles about invisibility; cheap artisanal books show up elitist ideas about who should read good literature. A fresh feeling and a critical thought can glare at (economic, racial, generational, environmental) predicaments that triggered an artwork. In other words, aesthetic effects are crises of comprehension, breaches between habit and understanding. There are at least two kinds of responses, John Dewey pointed out, to the almost perverse pleasure of losing cognitive control. Either you appreciate the stimulation of emotional and mental faculties as a satisfying re-enchantment of the world and stop there (in the tradition of art for art's sake); or your feeling kindles curiosity and arouses energy for making more art. This second option deserves more attention than it has gotten outside the art world. The very activity of art-making develops skills and imagination; it wrests some creative control over material

and social constraints that might otherwise seem paralyzing. Artists are never simply victims of circumstance. And their agency sets off creative responses: Authorities who reframe graffiti "vandals" as artists are creative agents too, along with the youths who violate decorous invisibility. A publisher who puts her finger on pedagogy as an answer to disappointing book sales links education to art. To follow through from the call of social challenges to the responses of aesthetic innovation is to stimulate collective change.

Some, probably many, artists today harbor ambitions to set off chain reactions from art to social change.[7] Typically, though, they stop at an initial moment of provocation, assuming that their work is done once an art piece goes public. When I convene local artist-activists in "Cultural Agents Fairs" to mentor students, much of the proposed work tends to short-circuit until workshops press toward aftereffects. Short-circuiting is what Ben Davis of *Artnet* unkindly calls the "lazy posturing of the 'my art is my activism' kind."[8] If artists collapse politics into art, rather than turn one or the other onto a connecting tangent, they assume that making art is already a political move. Habermas makes this complaint about surrealism for thinking that absurdity is a straight shot to liberation. (See chapter 5, "Play Drive in the Hard Drive.") Staying off tangents doesn't get us very far. Boal knew that when he developed hybrid "Legislative Theatre." Inspirations may start onstage, but they continue in legal chambers "to follow the normal route for their presentation."[9] Political art turned in on itself winds up "unhappy," Carrie Lambert-Beatty concludes.[10] Her example is the Yes Men whose brilliant impersonations of newscasters and expert witnesses exposed the devastating greed of big business. But their widely broadcast campaign against Dow Chemical, for example, had no practical aftereffect.[11]

Compare similar tactics of falsified news in Argentina's "Tucumán is Burning," a "counter-information" operation of 1968 that ignited participation from growing numbers of journalists and broadcasters. The repressive Argentine government was promoting hype about Tucumán becoming a model "place of prosperity and development" while it approved a transnational takeover of the sugar industry that would bust the unions.[12] Taking advantage of the imminent First Biennial of Avant-Garde Art in Buenos Aires, Roberto Jacoby and fellow artists, sociologists, economists, and technicians from Buenos Aires and Rosario traveled to Tucumán to gather testimonies and data. At the art show, they presented "films, photos, documents, recordings, statistics, graphic propaganda of the unions, audio-

visuals, etc., and gained an unusual degree of popular participation."[13] The next day the army closed down the exhibition, but the experience fueled demands for democracy (soon to be brutally repressed, it is true) and seeded a new "useful" aesthetics that still flourishes in creative collaborations. Jacoby continues to invent joint schemes, including "Venus," a "complementary currency" that looks like play money and bypasses "legal tender" when the law is linked to exploitation.[14] This is Argentina's version of a fast-growing arts alternative to government-issued money.[15]

Nomadic artists like Jacoby and Pedro Reyes (see chapter 3, "Art and Accountability") move from one field to another as they gather forces. They pursue a project from its aesthetic or political starting point onto contiguous maps to recruit professionals in order to achieve real social results. One pressure point leads to a repercussion, and then to others, as the artwork becomes a vehicle for unscripted "melt-ups," as Douglas Rushkoff calls the effect.[16] "Efforts like these scale up in two ways. First, they are shared with or copied by other groups in other communities around the world. Rooftop gardens can work in any city to lower energy bills and clean the air while providing food and jobs. . . . More significantly, the impacts of their highly local efforts trickle up" in what business plans might call interlocking directories of services and government support.[17] Effective innovators press hard to connect strategic dots.

I want to focus on three diverse examples of trickle-up innovation — Theatre of the Oppressed, ACT UP, and the Pro-Test Lab — with mentions of others to encourage more cultural-agent spotting. Multiplying the profiles will identify their family resemblances and invite you to press on.

Stage Conflict

"Why have all you people come tonight?" Augusto Boal asked as he sat on the edge of a stage at Harvard University in December 2003. "Do you know what is going to happen? . . . No? . . . And you came anyway?" He was already an old man but still irresistibly boyish and bubbly five years before he died just shy of eighty. Who else could get a public of professors and students to play "games for actors and nonactors," to loosen up and risk looking ridiculous? This is not a rhetorical question. In fact many of Boal's trainees can perform the contagious magic. Multiplying himself was part of Boal's genius, and Cultural Agents had invited him to multiply during ten days of workshops. To prime participation in the skits his trainees

had prepared, Boal told two stories that night. One was about a peasant leader in Brazil's desperately poor Northeast who was ready to take up arms after young Augusto performed a revolutionary play. The other story stars a sumo-shaped Peruvian woman who huffed and puffed her disapproval of the Brazilian director.[18] Boal had told those stories many times, including the widely read versions in his foundational *Theatre of the Oppressed* (1974), again two decades later in *The Rainbow of Desire* (1995), and then again in his autobiography *Hamlet and the Baker's Son* (2001).[19]

Like traumatic experiences or epiphanies, these pivotal encounters shocked Boal into turning a professional corner, and they haunted him throughout a career as animator, joker, facilitator, therapist, and legislator. Boal was not the first to experiment with interactive theater, but he was the one who abstracted the principles into an infinitely portable and effective practice. By 1932, the Romanian-born psychotherapist Jacob Levy Moreno was settled in the United States and touting "psychodrama" for patients to act out their neuroses and get dramatic relief.[20] Later, movements for political enfranchisement would stage political therapy: in 1959, the San Francisco Mime Troupe began to defend free speech; the Bread and Puppet Theater started in 1961 to protest the war in Vietnam; the Free Southern Theater became the cultural wing of civil rights in 1963; It's All Right to be a Woman Theatre validated feminism in the early 1970s. And El Teatro Campesino was founded in 1965 to build the United Farm Workers Union.[21] The Teatro's experience as partner to a political movement runs parallel to that of Yuyachkani in Peru.[22] In both cases, labor leaders discounted theater as merely representative or entertaining, not constitutive of the movement. But Teatro Campesino's founder Luis Valdez knew how theater played midwife to the nascent union, performing plays about pressing issues on the flatbeds of trucks, improvising with volunteers while insisting on aesthetic quality. The shows stopped, Valdez remembers, because the leaders "were not focused on the arts; they *allowed* the arts to happen. It was viewed as a tool and not a service. So the chaotic birth of our independence began."[23]

Meanwhile in Brazil, theater was also experimenting with collective processes, before the dictatorship (1969–1982) stopped the action. Boal didn't stop directing a radical theater company until he was arrested in 1971 and tortured in a military prison.[24] In exile, he made his most radical move, converting from Marxist director to nonaligned facilitator. The change achieved a distilled simplicity that can do without professional actors or

a shared ideology. Boal's conversion began when Virgilio—that unforget-table northeast peasant—had been moved by the revolutionary actors' chant "Let's spill our blood." Later that night, he invited Boal and his com-rades to join a raid planned for the next morning. Boal explained reluc-tantly that the actors' rifles weren't real but made of plastic, and that—he admitted with deep embarrassment—the members of his troupe were not really fighters. "Oh," said Virgilio, "the blood we spill is my blood"; and the white cast—so very white, Boal remembered with shame—would pack up their phony guns and return to Rio before the violence they incited could explode.

Unmasked and contrite, Boal abandoned his vanguard method for an experiment with what he called "simultaneous dramaturgy."[25] It was basi-cally Playback Theatre with an open end: The director invites an oppressed person to narrate his or her story up to a crisis point. He scripts and stages the story for actors and then asks the audience to suggest solutions, which he writes up on-site for his actors to try out. That approach fell apart in the Andean highlands.

At the beginning of Boal's long exile from Brazil he directed a literacy program in Peru. There, he formed a local theater company which, one eve-ning, staged the dilemma of a woman whose deceitful husband would re-turn the next day. Furious at the man, but afraid to be abandoned and even more vulnerable, the protagonist faced a predicament that the play would try to resolve. From the audience, a woman whom Boal describes as over-powering and menacing interrupted each unconvincing ending: "You have to be very clear with that man," she bellowed. Every timid adjustment the director tried confirmed her scorn for Boal, until she lost patience, turned her back on the stage, and lumbered toward the door. Equally exasper-ated, Boal ran after her with a challenge to show him, onstage, what she meant by "being very clear." Replacing the wife, the lumbering nonactress gave the unfortunate husband figure a blow so smart that it literally floored him. The smack also toppled what remained of Boal's top-down approach to theater.[26] His feeling for this woman, fear mixed with admiration, was close to awe, an unusual aesthetic effect for the veteran director but a foun-dation for ethics.[27]

From then on, Boal would encourage the public to take the stage in what he called "Forum Theatre," an innovation that features the "forum" as part of the play instead of a post-performance discussion. The one-act tragedies that play out dilemmas (about poverty, disease, violence, abuse, exclusion,

homelessness) were no longer composed by a playwright but by groups of local subjects, about their own lives. Boal's lasting contribution is to recognize nonprofessional actors as both subjects and objects of politics, as he would say with a penchant for philosophical registers. One of his charms was to bring higher learning down to dirt level. He made philosophy fertile and available for everybody, like an infectious joke.

Boal was getting perspective on a range of possible paths to social justice from a broad base of creative agents, each one the subject and object of drama. (One-on-one development is a general theme of education for artist-citizens in the company of Schiller, Dewey, and Rancière.) "With Virgilio, I had learnt to see a human being, rather than simply a social class. . . . With the big Peruvian woman, I learnt to see the human being struggling with her own problems, individual problems, which though they may not concern the totality of a class, nevertheless concern the totality of a life."[28] Following these lessons, the venue for Boal's politics could no longer be a stage of trained actors raised above a public to excite one-way *empathy* with heroes. Now nonprofessional actors in any shared space would *sympathize* in an interchange of feelings between spect-actors and their tormented representations.[29]

Instead of training actors to follow directions, Boal began to train facilitators to animate self-representation and reflection among participants who would become new facilitators and continue the multiplication. During his own lifetime, Boal became an international legend, not only because his innovations are brilliant and useful, but also because he practically gave them away, welcoming replication, insisting on it. The ambition of his cultural acupuncture was to make the world throb with pointed, local, creative energies. Facilitators don't presume to know where the pressure points are, but only that they exist and can be brought to crisis onstage. For Boal, the dynamism of the word "crisis" comes out best in the Chinese ideogram; it juxtaposes the character for danger with the one for opportunity.[30] He pressed on the contradiction in crisis as the very stuff of theater, its life's blood. "The essence of Theater is the conflict of free wills!"[31] Boal quoted Hegel—lest readers mistake his lightness of touch for intellectual levity—in order to claim that acting is the best acupressure for stimulating freedom.

"What are your worst problems?" is an opener for facilitators. The site-specific answers and their dramatizations proceed inside favelas, marginal schools, mental hospitals, prisons, community assemblies, practically anywhere. Spect-actors watch the tragedy played by neighbors; they listen ac-

tively for opportunities to interrupt an action that is moving toward disaster. Once the play ends tragically, the facilitator invites the audience to watch a rerun until a volunteer shouts "Stop!" in order to replace a character and improvise a change to the script, which prompts other actors to improvise corresponding changes. Then more replacements follow until time runs out. Inspirations hardly ever do.

Trying out possible scenarios is literally how Dewey described deliberation. He understood it as a theatrical exercise and would have recognized Forum Theatre as an ingenious medium for pragmatic ethics. The imaginative tryouts of various possible actions can explore consequences without doing harm. "Deliberation is a dramatic rehearsal (in imagination) of various competing possible lines of action. . . . [It] is an experiment in finding out what the various lines of possible action are really like. . . . Thought runs ahead and foresees outcomes, and thereby avoids having to await the instruction of actual failure and disaster. An act overtly tried out is irrevocable; its consequences cannot be blotted out. An act tried out in imagination is not final or fatal. It is retrievable."[32] After playing through these tryouts in Forum Theatre, the facilitator may play the "joker"—Dewey might call him ethical philosopher—to goad participants toward ascesis, a classical term for the derivation of general principles from particular conflicts.[33] Theatre of the Oppressed (TO) is an art of the single subject representing the many; it speaks in "the first person plural."[34]

Who said that tragedy means an unavoidable disaster, and that the only good outcome is feeling relieved of the rebelliousness that got the hero into trouble? Was it Aristotle?[35] Well, Boal jabs, what did you expect from someone who practically worked for the State?[36] The clever interventions by spect-actors who set off agile improvisations by the nonprofessional actors show that the truer definition of tragedy is failure, or control, of the imagination. (Leaders of Occupy Wall Street noted the same cause for despair: "It was a lack of imagination. There was too small a repertoire."[37]) Meanwhile, the participants on- and offstage can sense a double dose of magic: insoluble woes morph into artistic challenges that spur healthy competition for creativity as one intervention outdoes another (art is no zero-sum game); and participants experience new admiration for creative neighbors who together invent more moves than any one player can imagine. Admiration for fellow social actors is a leitmotif we learned from Mockus too. It welcomes contributions by the many and supports democracy. Boal gave admiration an aesthetic cast by attending to its formal effect of distancing

one player from another, "its original sense of wondering at, standing back from something in astonishment. . . . Surprise is in itself a rebellion; it says, 'No, I do not accept this as normal.'"[38] Our jaded times need more of this aesthetic effect.[39]

By the time he wrote *The Rainbow of Desire*, subtitled, *The Boal Method of Theatre and Therapy*, Augusto had been living in exile for fifteen years.[40] France became his second home. He went there because he had to leave Portugal once "the Revolution of Carnations withered."[41] He had gone to Portugal in flight from Argentina, where General Videla started his own dirty war after the one in Brazil sent Boal packing. Several Latin American countries were locked down in dictatorship, and artists pressed where they could. The CADA collective in Chile is worth mentioning. Its "No more . . . (fill in your chosen abuse)" graffiti would appear on officially white-washed walls day after day.[42] Young Alfredo Jaar chose exile instead of hide-and-seek with Augusto Pinochet's agents, after provoking them relentlessly with one question on billboards, painted highway lanes, and faceless filmed interviews: Are you happy?[43]

That Europeans were unhappy too shocked Boal, who was living in Paris and traveling in the region. "In Europe, I started hearing about species of oppression not discussed in Latin America: loneliness, isolation, empti-ness, and lack of communication—very different from strikes, shortage of water, hunger and violence. . . . There were more suicides in Scandi-navia, where matters of basic subsistence were resolved, than in the south-ern hemisphere, where dictatorships murdered people, but where fewer people pointed weapons at their own heads."[44] Statistics continue to show a rate of suicide in developed Europe three times that of Latin America.[45]

Suicide was the pressure point that connected theater to therapy for Boal. Until then, he had located his work in Brecht's line of experiments to distance the public from bourgeois ideology, not in the line of Ibsen's psychological drama. But now, Brecht's techniques for dislodging audience sympathy from the action onstage served to develop theater as psychologi-cal therapy. With his wife, psychiatrist Cecilia Thumim, Boal put patients and normally neurotic subjects onstage inside and outside hospitals. The subject of distress would double as the agent of relief. One actor at a time would tease out personal conflicts between desire and fear. Teasing ele-ments apart is just what theater does, Boal explained, simply by staging a problem. More dramatically than ever, he appreciated the "aesthetic space" of theater, where actions are performed and recognized as performance.

Patients are often overwhelmed and trapped in internal conflict. But theater externalizes conflict in ways that the protagonist can explore. Even before a joker invites spect-actors to play out interventions, the very fact of playing oneself doubles the subject's perspective. Actors know that they are acting.

The same person can be both victim and viewer of victimization. More than the entrenched *narrated* content of the tragedy, the protagonist becomes a *narrating* subject at a critical distance from the character.[46] (Emmanuel Lévinas had an ethical preference for narrating, "saying," over inflexible content that is "said."[47]) Boal calls this dynamic doubling "metaxis," which means belonging to two worlds at the same time.[48] With characteristic flair, he announced that therapeutic theater is a "Copernican Revolution," because the subject is no longer the center of his universe but a moveable piece in a dynamic system of stars. Unmoored from habit, he or she can join forces with others, including psychiatrists.[49] The staged process can produce relief, called catharsis. Deliberately and from the hospital ward, Boal liberates this medical term from Aristotle's coercive theater where desire is pathological and relief means purgation of nonconformist energy. Boal instead defines catharsis as the expulsion of the very "cop in the head" that Aristotle had engaged to torment protagonists and to terrify their spectators.[50]

The path from vanguard political theater — that peaked for Boal in the 1960s — to socially interactive Forum Theatre, followed by the Rainbow's subjective drama, came full circle back to politics when Boal returned to Brazil and invented "Legislative Theatre." Having lit up points along his path, Boal produced what amounted to a floodlight on theater's liberating work: from representation to reflection to imagining change. The cumulative effect moved the vice governor of the state of Rio de Janeiro to invite Augusto and Cecilia back to Brazil, to develop theater education in a new statewide network of Centers for Integrated Popular Education.[51] By 1986 oppositional Boal was working for the government! It was a dream come true; he wrote about integrating theater into basic education. But it lasted only until the next election.[52] The following years were a struggle on decreasingly fertile ground. Grassroots TO companies dried up because members couldn't pay bus fares, because facilitators were afraid of the crossfire in favelas, because injustice became so habitual that people were losing the energy of indignation. By 1992, Rio's Center for Theatre of the Oppressed

seemed light years behind the shining moment that brought Boal back. Only foreign visitors were interested in the afterglow.

> Even so, we lived in great hope, which is, as the saying goes, the last thing to die.
>
> It died.
>
> One day we decided to put an end to the Center, to carry out compassionate euthanasia on our moribund dream. How best might we lay this dream to rest, after its death? We didn't want a sad, tearful burial; we preferred something in the New Orleans style. A musical funeral, a funeral which would have a joyful aspect—a bang not a whimper.
>
> By coincidence, 1992 was an election year and elections in Brazil—in marked contrast to many European and North American countries—are an erotic moment in national life.[53]

During the political campaigns that year, TO's tragicomic antics ramped up to a good-bye bash reported in avid media outlets. A spectacular funeral procession for democracy, classroom simulations of materialist history lessons on Ipanema's beach, quick-change artists whose bikinis winked underneath nuns' habits, were all coveted photo ops for newspapers and newscasters focused on a group that seemed poised to win an election. Against genuine or histrionic protests—that he was a man of the theater not of politics, that the funeral and other "invisible theater" events were "only" arts interventions—Boal ran for city councilor on the Workers Party ticket. He won and took office as *vereador* of Rio de Janeiro in January 1993.

Boal fills some funny pages with scenes from that allegedly unintended campaign, including his distress at the possibility of winning. Nevertheless, he took advantage of the office to develop art's potential over the next four years. It was an unprecedented opportunity to create a hybrid of theater and procedural politics called "Legislative Theatre." "As the function of *vereadors* is to create laws and to ensure the proper enactment of those that already exist, the people's participation in this process could be achieved by means of theater: transitive democracy."[54] Democracy in the Greek polis belonged to the few free citizens "the *fasces,* or small bundle of sticks," and in contemporary politics the bundle collapses under abusive "pragmatism."[55] But transitive democracy can engage economically and educationally uneven populations, respecting the rules of each without missing their points of contact.[56]

His autobiography, published in 2001, pinpoints some practices that link art and politics: doubling the protagonist as subject and object of drama, multiplying the effects of theater by training facilitators to animate "rehearsals for life" with nonprofessional actors, cajoling the public to derail tragedy and to admire a range of inspirations, all add up to an expansive aesthetic education in everyday life, in psychiatric therapy, and now also in procedural politics. "We formed nineteen groups doing theater as politics, as opposed to the old political theater; we presented thirty-six bills, and promulgated thirteen laws. Thirteen times, in Rio de Janeiro, the desire of the population became law. Perhaps that has been the Theatre of the Oppressed's main conquest: transforming desire into law."[57]

After publishing the story of his full life, unstoppable Boal launched a new and final adventure in deliberate homage to Paulo Freire, *The Aesthetics of the Oppressed* (2006). The focus here broadens from theater to general arts education.[58] One school-based activity was to paint personalized images of Brazil's national flag. A YouTube video shows an eight-year-old boy painting the standard image and then covering it in shades of gray that deepen to black. "It's because the country feels like a prison to me, dark and airless," he explains to the facilitator while texturing the thick paint into a jail-like grid.[59] Another activity, just to mention one more, was to recycle junk into sculptural self-portraits that explored environmental and personal adaptation and sustainability.[60] (Jaime Lerner's urban acupuncture included teaching children to recycle, so they could teach their parents.)

In some significant way, these stimulations follow from the acupressure that Freire administered. In *Pedagogy of the Oppressed* (1969) he pressed on top-down teaching to level hierarchies into horizontal relationships. Respect without deference would curb authoritarian habits and cultivate student initiative. Freire's best disciple took the theater as his classroom; he brought directors down to the level of jokers. Contemporaries and friends during Brazil's dictatorship, Freire and Boal were tired of revolutions that, true to their literal meaning, go around in circles.[61] Freire chided teachers who bank data in students presumed to be empty depositories; and Boal scorned directors who stage spectacles that pacify the public. Anyone who works *for* the people rather than *with* the people does them a patronizing disservice.[62] In complementary manuals, Freire and Boal orchestrated polyphony in schools and onstage. You can log onto a combined PTO (Pedagogy and Theatre of the Oppressed) website to clinch this relationship.[63] Boal's last father, as he calls Freire, knew how to convene pupils and

teachers, citizens and spectators, for sessions from which everyone takes away more than they brought.[64]

Among the countless contributions of Boal's acupressure (including the collective Jana Sanskriti that just celebrated 25 years of TO in villages around Calcutta, where twelve thousand peasants had gathered to hear Boal speak in 2002) I can report on sequels he sparked close to home: Following Boal's Harvard workshops in 2003, Betsy Bard facilitated a summer theater program at the local high school.[65] After seeing the high school production, doctors Felton Earls and Maya Carlson developed a Forum Theatre approach to AIDS prevention and treatment for youth in Tanzania.[66] Meanwhile, Cultural Agents offered "Pre-emptive Acts" for the Equal Employment Opportunities Commission so that law enforcers and human resources officers could rehearse responses before discrimination explodes into actionable cases. Similar workshops support MIT's Interfaith Fellows Program.[67] Colombia's Ministry of Justice invited cultural agent Carmen Oquendo to facilitate for its LGBT rights campaign.[68] And plans are under way to make Forum Theatre an alternative to just talking about race and gender at Harvard College.

ACT UP

It can be a hard history to tell, hard for the survivors who still choke up when they talk about the losses though they cannot stop telling. Mostly it is hard for historians who are used to holding a narrative together on the anchor of singular heroes and villains.[69] The protagonist of ACT UP is a loose collective of mostly arts activists who fought the AIDS epidemic. Wisely anonymous, their activities would have been short-lived if each artist had taken credit for brilliant work in the homophobic and triumphant corporatist environment of the late 1980s and early '90s. Like Boal's theater and Lope de Vega's Golden Age drama about an entire town that takes responsibility for confronting abuse,[70] ACT UP protected itself from persecution with a "first person plural." Here was no charismatic Martin Luther King Jr., no Mahatma Gandhi, or Harvey Milk, or Cesar Chavez; no icon of leadership, but rather a rush of iconoclastic artworks that disturbed the superficial calm of New York City.

The headless nature of this story keeps ACT UP from making appearances in history books, observers will say. And it is true; there seems to be no one point on which historians might focus to light up a sequence

of events that moved from arts interventions into far-reaching effects in medicine, law, commerce, and public space. A result of this narrative failure is that new generations of citizens won't easily find the information that could trigger their own feelings of outrage, inspire responses, and acknowledge the considerable accomplishments of coordinated arts activism. Citizens have some idea of the civil rights movement and of the feminist movement, but hardly a notion about their sequel in ACT UP, though it impacted health care for everyone in the United States and laid claim to general human rights. While the "plague" of AIDS continues to ravage enormous populations—at least thirty-three million worldwide with a disproportionate numbers of nonwhite citizens in the United States—we need to connect the dots between current disaster and future solutions. Or should we conclude from the decrescendo of U.S.-based activism that the disease and the inequalities it diagnoses don't engage our civic concerns?

In fact, AIDS continues in the spotlight, now that the threat of infection has become universal. What falls out of focus, survivors of the early crisis years complain, is the history of homosexuals as both victims and the vanguard of intervention. The movement, which erupted three hundred members strong after a first call to arms in 1987, may be too particular (in both meanings of minority and queer) for straight readers to take to heart. "They don't give a shit," says popular playwright Larry Kramer.[71]

I am convinced that the majority's reluctance to remember goes even deeper and is overdetermined by another bad habit: not only a refusal to register the experience of a sexually nonconformist population but also an indifference to art as an agent of change. Does one prejudice link onto the other? Perhaps homosexuals are disrespected in the history of AIDS activism because they are associated with art. Would their social capital be greater if they represented, say, finance? The abundant evidence of aesthetically arresting art as the vehicle for ACT UP's effective eight-year campaign doesn't command much attention in standard accounts of the epidemic. And silence about homosexuality is haunting, in good measure, precisely because of the enduring artwork. Think about the relentless leitmotif Silence=Death, plastered on every available wall, stuck on stickers and pins, worn on T-shirts, and projected in neon lights as a window display at the White Columns Art Gallery.

The neon version of the pink triangle pointing upward from a base that spells out Silence=Death was on display at the Carpenter Center for the Visual Arts in the fall of 2009, as part of the exhibition ACT UP New

York: Activism, Art, and the AIDS *Crisis, 1987–1993*. On the opposite wall, a backlit transparency glared: "Call the White House. 1 (202) 456 1414. Tell Bush We're Not All Dead Yet." Helen Molesworth projected this reminder throughout the powerful exhibition that she managed to curate after hunting down artworks that most ACT UP participants considered to be ephemera. The work had use-value, not the exchange-value of collectible art. Yet one of the impressive results of the exhibition is appreciation for the use-value created by art. The call to action came through in the stunning visual quality, the witty turns of phrase, public choreography, and the general aesthetic sophistication of artists who knew how to activate their arts. One display case in particular documents the painstaking development of work by one of the movement's art collectives, Gran Fury, with paste-up drafts of posters, variations on the pink triangle logo, and notes to the printer. Pieces from the New York Public Library, to which ACT UP donated its archives, from Rochester University's Library, and almost-forgotten personal stashes were collected by Molesworth to display once-ubiquitous posters, stickers, MTV-style videos, and hundreds of filmed interviews from the ACT UP Oral History Project.

Together the evidence commemorates artistic agency during plague years that would otherwise have been entirely tragic. On wall text, the gallery displayed precise and escalating numbers of yearly deaths from AIDS adding up to 150,000, more than the number of U.S. soldiers who died in the Vietnam War. The devastation of AIDS never inspired the City of New York to publicly commemorate the dead, Molesworth winces, in contrast to the commemorations of September 11, 2001, though all the victims are innocent. "We Are Innocent" reads an enormous banner that straddled New York streets in 1989. With the exhibition—and gallery talks, conferences, poetry readings, and course development—this engaged curator created a stir against the silence that mutes a movement founded over twenty years ago, forty years since the Stonewall Riots of 1969 set off the gay rights movement in the United States. The exhibition hoped to revive the throb of energy that circulated through ACT UP in order to animate students, teachers, and other visitors who can again act up against indifference.

The show is not nostalgic, Molesworth insisted if anyone asked. Horror years of the epidemic are not magical times to be recovered, she chastened us. But her decision to dedicate the show to the movement, rather than feature particular artists, amounts to framing the exhibition as homage to creativity in difficult times. Unlike the sudden victims of 9/11, the ACT

UP artists had precious and concentrated time to react to disaster and to open routes for continued, sometimes posthumous, action. Molesworth puts her finger on a spectacular convergence between political activism and art, inviting us to press for future results. Her curatorial work is a second-degree activism, a response to the artworks and to their impressive effects, that links interventionist art directly to students, to the spheres that they will develop, to visitors, and even to readers of reviews such as "Blunt Instruments: Collectives' AIDS Art Made an Impact with Just a Few Strong Images."[72] By a subsequent, tertiary ripple effect I feature her work in my courses and in this book on arts interventions that don't give up. Maybe readers will dare to design new arts interventions, or just register the connections between art and activism as voting citizens. In both her case and mine, humanistic interpretation extends art's impact.

"Act up!" was the challenge launched by Larry Kramer at New York's Lesbian and Gay Community Services Center early in March 1987. A crowd had come to hear him talk about his art, but Kramer had tired of talk while the AIDS epidemic raged. He turned his session of the speakers' series into a platform for planning direct action.[73] The audience must have expected the confrontational style; he was famous for it. The angry energy had just been staged in shout-down scenes of his autobiographical play *The Normal Heart* at New York's Public Theater.[74] But that March evening, Kramer's disturbance played more like a Forum Theatre intervention than a scripted drama. His message to the AIDS tragedy was "Stop!" Then he got on history's stage to change the script and set off a new dynamic. Other spect-actors joined to improvise more developments. By March 24, the new AIDS Coalition to Unleash Power was demonstrating on Wall Street against pharmaceutical profiteers. After seventeen arrests and a follow-up infiltration of the New York Stock Exchange, the price of treatment fell by 20 percent and the Food and Drug Administration (FDA) shortened its drug approval process by two years.[75]

The weekly meetings of ACT UP convened in spacious Cooper Union Hall, where the New York 300 put into practice their readings on "radical democracy," which featured Freire's pedagogy along with counter-hegemonic political theory.[76] Anyone could take the floor for ten minutes, only ten. If the speaker wanted to continue, permission was decided by majority vote. All decisions were reached that way. For example, when impressive actions were planned—on Wall Street, in St. Patrick's Cathedral, at the FDA—a minority could not block the action. Instead, dissenters would

design an alternative action and broaden the movement. The spirit of autonomous leadership repeated through specific collectives. Intentionally outrageous names gave an edgy charm to assaults on murderous respectability: Gran Fury, Silence=Death Project, Gang, and Fierce Pussy used guerilla marketing techniques to reach a mass audience. "In subway cars, transit stations, taxi cabs, outdoor billboards, and bus panels, their wheat-pasted posters and crack-and-peel stickers powerfully communicated ACT UP's outrage and were ubiquitous throughout New York City. Pairing text and image with penetrating anger and searing wit, ACT UP's art collectives targeted specific individuals and institutions at the local and national level, advocated for safer sex and gay and lesbian rights, and galvanized broadband support for the AIDS activism movement."[77]

Marginalized in political histories, ACT UP fills pages of art history. (Does this dissuade other historians from taking it seriously?) The visual sophistication of activists commands the attention of art scholars just as it had arrested citizens on the street. Taking techniques from notable contemporary artists, such as blowing up ads the way Richard Prince did with his Marlboro cowboys, citing the tormented doll that Hans Bellmer twisted into a swastika for the poster "AIDS: 1 in 61," and borrowing Barbara Kruger's favorite font for Gran Fury's "Read My Lips," puts ACT UP artists on the crest of a contemporary art wave. Inside the collectives, anonymous ACT UP artists competed with the best advertising talent to outshine commercial messages with bold and often tragicomic visual arrests. "He Kills Me" identifies a portrait of Ronald Reagan. "MEN, Use Condoms, Or Beat It," read the big block letters on a fluorescent yellow background. These strategies of repurposing existing forms, "appropriating," and disrupting visual and verbal regimes became fundamental to the history of postmodern aesthetics, impossible to narrate without addressing Gran Fury, for example. Outside the collectives and under their proper names, the same artists produced first-rate formal and abstract work, doubling between political and nonpolitcal art in a feedback loop that demonstrates the connections between critique and creativity.

Apprenticeship to both civil rights and the women's movement linked ACT UP to a Marxist tradition of "immanent critique," analysis that locates contradictions in the ruling discourses (of citizenship, medical responsibility, equal rights) and demands accountability. The earlier movements had already added performance to political philosophy: civil disobedience for civil rights, bra burning for feminism, and egalitarian circles at

meetings where everyone was expected to speak. This choreography of consciousness-raising was part of Molesworth's show. She filled a gallery with fourteen video monitors that showed concurrent testimonies of activists. Each monitor played seven or eight interviews of about an hour each and then repeated the sequence from morning until the gallery closed. As visitors watched one or another of the testimonies they were aware of thirteen more playing at the same time, and of the total 103 narratives that represent only a third of the core New York collective. The concurrent narrations of discontinuous memories and interpretations constitute an aesthetic and ethical achievement of the exhibition. The gallery performed the radical democracy it commemorated. Standard histories may not have found the appropriate narrative form to frame the movement's hydra-like progress, much less its incursions into medicine, law, and commerce. But two artists, Sarah Schulman and Jim Hubbard, captured the diffuse quality of ACT UP in their Oral History Project. And curator Helen Molesworth designed the simultaneous display, suggesting (as did Boal) that narrative impossibility may be a failure of will or of imagination.[78]

Freire's pedagogy was a turning point away from vanguard stories of progress. He invited activists to pursue analysis but not to stop there, because critique is useful only if it links onto a developing sense of personal and collective potential. The ACT UP women who staged the "Cosmo" affair took Freire's advice when they moved from analysis to action. In January 1988, Cosmopolitan had published a dangerous article by Dr. Robert E. Gould entitled "Reassuring News about AIDS: A Doctor Tells Why You May Not Be at Risk."[79] A few women who had been meeting at "dyke dinners" hoped to engage Gould on scholarly grounds. They pointed out several misleading medical facts, the lack of peer review in the popular women's journal, and the doctor's credentials as a psychiatrist, not an internist. Their research substantiated a demand to retract the article. When he refused, the "dykes" decided to "shut down Cosmo." It was the first time that ACT UP women organized separately, both for the confrontation with Gould and for the 150-person protest at Cosmo. The action got good media attention, and the collected footage appears in the video "Doctors, Liars, and Women." Cosmopolitan finally issued a partial retraction.[80]

Showy and effective actions like this one, and the ones on Wall Street, at the National Institute for Health, and other sites continued, inspiring thousands to join ACT UP in more than seventy cities nationally and worldwide.[81] So it seemed on first blush, to judge from a poster, that the Cana-

dian government joined the movement. The poster warned compatriots not to repeat U.S. mistakes and gave outrageously direct advice not to swallow a certain sexual secretion.[82] But on second and deeper blush, it becomes clear that the ACT UP artists of Gran Fury plagiarized Canada's federal insignia to underwrite the poster. In any case, Canada would be a main stage for the activists. In 1989, hundreds of U.S. participants came to Montreal to interrupt an international AIDS conference. Disconcerted when no arrests followed, ACT UP improvised a new performance. It announced the "first Treatment and Data report calling for a parallel track to speed access to drugs."[83] The pharmaceutical industry capitulated.

> That made the front page and started a round of talks both with government and industry to make expanded access a reality. Bristol-Myers called the ACT UP Treatment and Data Committee and said that they wanted to provide [the drug] ddI through expanded access and, amazingly, wanted the ACT UP members to assist in developing the protocol.
>
> The program provided ddI to over twenty-five thousand people with AIDS at no cost until the drug was approved. Data from the expanded access program provided important safety data. Not only did we succeed in getting the drug out, but we also proved our argument that expanded access programs and working with patient activists could make for better science and faster drug development.[84]

This exemplary case of acquired expertise in medicine, law, and commerce repeated throughout ACT UP's history. Larry Kramer recounts an earlier moment when straight activist Iris Long joined the Treatment and Data committee. Appalled at their lack of scientific information, she trained several members. "And they branched out and met other people in Boston and at the NIH. So that by the time — a few years later — I would take Mark [Harrington] to a meeting, they would think he was a doctor."[85] While ACT UP was a major movement, activists became their own informed and eloquent advocates. The urgency pressed artists into professional service in lieu of doctors and lawyers. The disease may have been too new or too stigmatized to engage reliable professionals, so activists "achieved concrete changes in medical and scientific research, insurance, law, health care delivery, graphic design, and introduced new and effective methods for political organizing."[86] Among the ripples the movement made was the expansion of universal human rights. In academics, ACT UP raised demands for

queer studies, perhaps disability studies too, and it inspires civic humanities through lessons about art's effects through direct action and interpretation.

The members of ACT UP learned a lot from civil rights. They learned to press citizens into action through civil disobedience, to occupy public space on streets, buses, and in buildings. The new movement also multiplied public sites by adding advertising and the virtual space of media. Along with massive demonstrations at strategic locations, ACT UP plastered the public sphere with provocative art that seemed to be selling something (a flip strategy of the advertising campaign that Oliviero Toscani developed for Benetton where selling clothes was a prompt for circulating socially urgent messages).[87] And bold performances by veteran artists were sure to get on TV's universally viewed six o'clock news. For example, the demand inside the stock exchange to "Sell Wellcome"—the pharmaceutical company that kept their AZL treatment prohibitively expensive—floated up on an enormous banner attached to balloons, while bullhorns insisted on the message. Better yet, artists documented the visually arresting actions on newly affordable video cameras. One of the lessons learned from civil rights was that filming arrests makes them safer. Police don't want to play bad guys in the movies.

Perhaps it's unfair to wonder if ACT UP schooled itself in the civil rights form of nonviolent activism, but not enough in the content of racial justice.[88] Of the more than a million HIV infections in the United States today, the rate for African Americans is seven times higher, three times for Latinos, than for whites.[89] It would be tragic to speculate that the decrescendo of the New York movement coincides with the release in 1996 of affordable treatment for the mostly white activists and their younger social classmates. Uncannily, or cynically, the treatment beckons with the name of ART (antiretroviral drug treatments). Art historian Douglas Crimp explains the demise of ACT UP from exhaustion and mourning after the "immediate emergency" became a "permanent disaster."[90] To be fair, the movement had fallen apart from internal pressures by 1993, years before ART was developed. Kramer accounts for the demise more critically, as a case of tragic hubris when the increasingly sophisticated Treatment and Data spokesmen declared independence from the movement. Nevertheless, the current statistics and the paucity of nonwhites in the images of New York AIDS activists suggest that a general feeling of white entitlement helped to fuel ACT UP.[91]

Internationally though, AIDS receives sustained and growing attention, perhaps disproportionate attention from the perspective of women's health, for which AIDS is a complication in the general disaster of gender-based violence. Rape is an epidemic for which medical and legal remedies treat only symptoms; violence against women demands the kind of cultural acupuncture that ACT UP pioneered.

At the end of Molesworth's gallery talk, a young man asked about musical creativity during those ACT UP years. The question stirred a memory of "utopia" for her in clubs like the Paradise Garage, where music mash-ups paralleled the postmodern pastiches of visual artists. The dress, the music, drugs, dancing, the joy and the admiration that her quickened voice evoked certainly seemed nostalgic despite her disavowal, contagiously so. I gave into a reverie about Latin dance halls during those years. They were acupressure sites that made syncopated, socially uneven crowds throb together with the same music. And though I cannot yet follow through to significant reforms and improved social conditions that the clubs must have facilitated, I know that they expanded the interracial space to make new hybrid families. Allow me an irrepressible memory and a few more connections between music and social movement.

Dance-Hall Democracy

"¿De dónde es usted?" I asked the best Latin dancer I ever followed around a floor. It was in "centrally isolated," as the locals say, Ithaca, New York, where a friendly gay club went Latin on Wednesday nights. Once a week we broke up the bucolic boredom that helps to make Cornell University so intellectually restless.

"Sorry. I don't speak Spanish," my partner said.
"Where are you from?" I code-switched.
"From Bosnia. My name is Nedim."

That stopped me short. He had kept me in step through changes in rhythm and turns I only half anticipated, but now he lost me. Confused, I went back to my cultural roots in Brooklyn, where salsa began. Throughout the 1960s and '70s, in this north-of-the-Caribbean island, deterritorialized music was mixing one rhythm with another, guaguancó interrupting rumba to slide into merengue anticipating rumba's return. The weaving created an interethnic fabric that had us all covered. Though the Bronx and Manhattan

must have been spots just as hot for salsa, Brooklyn stays central, maybe because master pianist Larry Harlow—"el niño judío de Brooklyn"—made the musical mixes especially open to cultural chameleons like me. Years later, in 2005, Cultural Agents, the Smithsonian Institution, and the Americas Society would celebrate Harlow and other unlikely *salseros* in "The Jewish Latin Mix: Making Salsa."[92]

From the provisional Latin quarter of Ithaca, my thoughts continued to wander to other clubs in less exotic cities for Latin music where dancers create oases of sociability. A kind of utopian *Jetzeit*, to use Walter Benjamin's word, flashes through memories of dance halls in Monterrey, Montevideo, and Montreal, in Santo Domingo and San Juan (where the guy in a baseball cap and too chubby to be Elvis Crespo turned out to be the real thing), where dance floors are the spaces of urban utopia. By that I mean that everyone fits in, not by looking and acting the same, but by improvising variations on a given theme. Ernesto Laclau might describe the design as "universal" in the contemporary sense, a shared context that accommodates differences. Its saucy name suggests how salsa depends on differences of origin, rhythm, mix. It's an inspiration for democratic politics. Seriously.

"What would a better world look like?" I teased Arjun Appadurai after a scholarly meeting about worldwide equitable development. The obstacles were clear to academics, but the desired vision was not. "Do you want a glimpse of utopia?" I took the urban anthropologist dancing that night, to the Copacabana of glorious memory. The legendary club is no more, but on that night, the Copa was still making its public appeal with a long line of patrons waiting to get in. Like an antechamber to heaven where roughened souls prepare for the exalted other side, the line primed celebrants of neon lights and electrifying music by congregating us in mixed formations. Dark people, light people, every shade of Africa and Asia, combined sometimes with white, some old ones, more young ones, maybe a mother with young girls or a madam with youngish girls, mixed couples and hybrid singles, glamorous gowns and skintight jeans, the lineup seemed as endless in variety as in length. Variety is not informality. Latin dance halls are governed by a tacit contract that Brazilian *gafieiras* make explicit: at the entrance, a list of rights and restrictions insists on exemplary participation. "Gentlemen will be respectful and not get drunk," and "Ladies will accept invitations to dance from gentlemen who ask appropriately."

The democratizing effect of Afro-Latino dance was clear even before the Cuban Wars of Independence, when black leaders got whites to follow

in step. Readers of novels like *Cecilia Valdés* set in the 1830s know that the popular *bailes de cuna*—where classes mixed freely—had already developed a Cuban taste for freestyle partnering. But the revolutionary camps turned dances into a main stage for democratic performance. Campaign diaries tell of two similar incidents where dance was the cipher for democracy. During the Ten Years' War, a black officer was snubbed by a white woman and he threatened anyone who would dance with her. Twenty years later during Cuba's successful war against Spain, a rejected black officer "gave a long speech on valor, patriotism, and equality, and he condemned her refusal as anti-patriotic."[93]

Arjun and I finally passed the bouncers who frisked the men and stared down the women. Then we saw the miracle inside: Beyond the floor-to-ceiling fluorescent palm trees and before the stage where a twenty-piece orchestra alternated with another one just as fabulous, everyone was dancing to the same music, gracefully, with variations that kept partners attentive to each other and aware of admirable neighbors. Liberating for a feminist like me, dance-hall democracy is an appreciation for strong partners and a relief from self-reliance. My freedom is in the counterpoint between voice and exit, deciding whether or not to stay for the next number.

Nedim was an admirable partner, which brought me back to our halting conversation.

"Did you learn salsa in Bosnia?" I asked incredulously.
"No, actually, it was in Germany."

POPULAR MUSIC ALSO primed the struggle in the Prague Spring of 1968. During the permissive 1960s hundreds of "garage" rock bands filled the city and lasting groups like the Plastic People of the Universe made counterculture count for civil disobedience after the Soviet invasion in August 1968. By September, half a million troops from the Soviet Union and four Warsaw Pact countries marched into Prague. Without arms, funds, or friends, the Czechs managed to resist the invaders for eight months. "There are, of course, the Molotov cocktails and human roadblocks," writes artist Paul Chan. But there were wily tactics too: "pornography thrown at young and frightened soldiers patrolling the streets, (to distract them from shooting at pedestrians) and graffiti (like the one that reads, 'Why bother to occupy our State Bank? You know there's nothing in it'). My favorite: Within a few

hours of the invasion, all the street signs in Prague are painted over. The tanks wander directionless through the streets for hours, then days, and then for the rest of the occupation, because all the maps in the city are destroyed as well."[94]

The Plastic People continued to rock in secret and out of town, including at Václav Havel's country house. Several members of the band were put on trial in 1976 and two musicians went to prison. General outrage inspired Havel to draft the human rights manifesto, Charter 77. The notorious trial rippled in waves of solidarity for the persecuted musicians and also for Havel's leadership. The tide would topple the communist government in November 1989, during an uprising called the Velvet Revolution. Why Velvet? The name was borrowed from another rock band. When Lou Reed, founder of the Velvet Underground, came to Prague in 1990, Havel asked him, "Did you know that I am president because of you?"[95]

POPULAR, SOCIALLY MOBILIZING music now includes the classics, counterintuitive though it may seem. As surely as rock resisted the Soviets in Eastern Europe, classical music breaks the ice of class differences in Venezuela, thanks to El Sistema of musical education pioneered by José Antonio Abreu. (Classical music also invites Israeli and Arab youth to play together in the "West-Eastern Divan Orchestra" founded by Daniel Barenboim and Edward Said.[96]) Since 1975, Abreu's youth orchestras are social networks of rigorously trained but otherwise disenfranchised children and teens. By now international offshoots have developed in Latin America, the United States, Britain, and China.[97] One spectacular sequel is Paraguay's recycling of a garbage dump into the space and material resources for the Landfill Harmonic Orchestra.[98] Of the 350,000 current participants in Venezuela (about four million over the years) 90 percent live under the poverty line. They do well in school, don't drop out, and find employment, sometimes as music instructors and internationally coveted professionals. One graduate is Gustavo Dudamel, named director of the Los Angeles Philharmonic in 2009 before he turned twenty-eight years old.

From ages two and three, children attend *núcleos* where they develop friendships through music-making, not gangs. The joy of playing together sustains them during long hours of training. For pragmatic reasons, Abreu placed El Sistema under the Ministry of Family, Health, and Sports, not the Ministry of Culture where support would have been precarious. The aim is

to be in every public school in the country by 2015.[99] At the Inter-American Development Bank where Abreu pressed for loans, there were objections to classical music as an elite and exclusive art. But follow-up studies of more than two million young people concluded that every dollar invested in El Sistema was reaping about $1.68 in social dividends.[100]

Pro-Test Lab

They figured it would be impossible to fight city hall. Authorities in Vilnius had already sold the last movie theater to developers. So two local artists made saving the cinema called "Lietuva" (Lithuania) into an art project. That way Nomeda and Gediminas Urbonas wouldn't measure success on reclaiming the theater but on seeing how far they could go. This aesthetic criterion freed them to launch an impractical project. They also acknowledge another—extra-artistic—reason for pressing past despair. It is an ethical imperative to protect public space. No amount of subsequent blackmail and bullying deterred them from the exhilarating obligation to participate in a free, post-Soviet society. The Urbonas project runs on the double motor of civic responsibility and experimental art. If it were not for civic commitments, Nomeda and Gediminas would not have taken this art assignment. And were it not for this work of art, Lithuanians would not have defended the political right to assembly.[101] Meeting in public space literally sustains the res publica, which was imploding under rampant post-Soviet privatization.[102]

Restrictions on assembly were inherited from Soviet times. Kitchens, where people normally cluster, continue today to accommodate only three people, maximum.[103] By contrast, the beloved "Lithuania" is roomy and welcoming. Built in 1965, while the Soviets developed a people's urbanism inspired by an exhibit in 1958 of U.S. modern architecture in Moscow, the cinema's attractions include its sleek lines and broad access from a popular plaza.[104] The same centrally located plaza had long been the site of demonstrations and meetings, including the anti-Soviet People's Road to Independence. The building seated almost one thousand in the main hall and another eighty-eight in the intimate theater. This is substantial capacity for a city of only half-a-million inhabitants in a country of barely more than three million. The enormous lobby hosted poetry readings, art exhibits, concerts, even "decadent" jazz concerts. Relatively free from official vigilance, the cinema was a safety valve built into a totalitarian Soviet state.

Throughout the 1990s, it showed mostly independent films, becoming the city's art house and home for a successful international film festival. By 2005, when plans for demolition were announced, the Lietuva was about to celebrate its tenth annual festival.

It was technically a private limited liability company, with 93 percent of the shares owned by the Vilnius Municipality and 7 percent acquired by the fourteen cinema employees. The public future of the building and its accompanying plaza had been secured in 1994, when the company signed a State Land Lease that was good until 2093.[105] Scandalously, "Lietuva" was put up for auction to private bidders in 2002. And tragicomically, the municipal government included the cinema among its treasures in a proposal in 2004 to designate Vilnius as Europe's Capital of Culture. Almost everyone felt frustrated. What had been common — libraries, stadiums, concert halls, public swimming pools, and other recreational sites — became private or disappeared altogether along with the collective memories that places embody. During the twenty years of official independence since 1990, nothing public had been built. The only new structures were shopping malls and private housing. But no one protested. The very word "protest" conjured an unpopular Soviet ideology.

A first move was to invent "Vilma," an e-mail list of artists and activists invited by Gediminas and Nomeda to formulate questions for the municipal government. Questions were an innovation akin to art. During Soviet times, questioning anything official was vilified as bourgeois backsliding. Complaints could be registered, but the consequences were either insignificant or unpleasant. By April 2005, "Vilma" spurred a wildly heterogeneous coalition, though few artists joined because political art had long been associated with service to the state.[106] But vegetarians, feminists, alternative educators, students of architecture, new media activists, leftists, nationalists, and neighbors came together "For 'Lithuania'" to create the Pro-Test Lab.

The clever name contains protest in the double sense of inclusion and control. The Lab's activities would be experiments in art-making. Events in public spaces throughout the city included private screenings of sometimes pirated films, rock and folk concerts, milk bars, masquerades, all of which produced almost daily interruptions of neoliberal business. There were more than sixty events in the first half of 2005, a barrage that worried the new owners of "Lietuva" enough to resell the property to "Paradise Apartments," a front for Lithuanian and Russian investors.[107]

The movement started modestly inside the movie house. Gediminas and Nomeda proposed to interview patrons of the final International Film Festival and to produce a documentary called *Cinema Spring* in reference to the Prague Spring of 1968. The cinema staff gave more than permission; they invited the collective to occupy the ticket office that would become headquarters. The challenge became how to "curate" the explosive differences among pro-testers who had huddled in the cinema to shelter particular partisan positions. The solution was to promote a variety of activities that kept the Lab clear of any one ideology. It is a strategy that comes instructively close to the model of autonomous collectives that developed in ACT UP. On April 9, 2005, the mix thickened when the Pro-Test Lab convened a public meeting to change its mission from defending the cinema, "For 'Lietuva,'" to recuperating the country, "For Lietuva without Quotation Marks." The two hundred attendees represented new groups: anarchists, members of the Green Party, true Social Democrats ("the losers"), a good number of heritage experts, passersby, and strangers. The citizens' movement was founded at that meeting.

Among the numerous happenings of this newly national movement was America Will Help Us! (June 2, 2005). It was a photo op of a crowd wearing President Bush masks and eating popcorn. Bush had visited Lithuania in 2002 and famously declared that "from now on any enemy of Lithuania is an enemy of the U.S." The backdrop for the photo was a huge poster of the quote in the style of George Maciunas — the Lithuanian-born founder of Fluxus, New York's playful art movement meant to embarrass bourgeois culture.[108] Had the event been a political demonstration it would have required permission and suffered delays or denials. But as an art project, *America Will Help Us!* and other contentious displays of dissent passed under the legal radar though all the media outlets picked it up.

Another successful event was Fashion Collection for Work and Rebellion (July 12, 2005). A well-known designer and several glamorous models turned the cinema's rooftop into a catwalk and made the show irresistible to the media. It covered the front pages of the newspapers, including *Business News*. This was the last straw for the already harassed VIP developer. Wasn't it enough that a sweet deal with the city had just gone sour and cost him a fortune? Or that the cinema's plaza had hosted a Monopoly-like game called VIP *Market* where architecture students displayed scale models of churches, parks, and an opera house, with offers to turn them into garages, shops, or apartments? (An Internet version in 2007 would

FIGURE 2.1. Pro-Test lab: America Will Help Us! Action at the Lietuva Cinema, Vilnius, 2005. Courtesy Gediminas Urbonas and Nomeda Urbonas.

invite players to "develop" the city as one of four characters—the corrupt mayor, a gas tycoon, a local gangster, a vamp. The trick at the end of the game is that no matter how high a player scores, the Pro-Test Lab destroys the profits.) Now the mogul's own friends and allies were humiliating him with enthusiasm for subversive fashion. (Anarchists tried to undercut the Lab's victory with objections to "collaborating with spectacle.")

The Lab also experimented with a TV talk show to get politicians, architects, human rights activists, and city planners to talk about public space. One show featured the architect of the cinema's replacement building. Another brought in lawyers for the developers. The show also reported on the disastrous gentrification of Oslo as a warning to Vilnius. The cumulative effect was to ground the concept of public space into a concrete demand. Therefore, frustration escalated when the cinema closed in September 2005 to be immediately sold to Paradise Apartments. Citizens' voices had not been heard, so Vilma invited everyone to bring out their dogs and make more noise. *Dogs Barking Will Not Disturb the Clouds* is a Lithuanian folk saying about purposeless complaining. On the square in front of the con-

FIGURE 2.2. Pro-Test Lab archive. Detail from installation view *Fluxus East*, Kunstlerhaus Bethanien, Berlin, 2007. Courtesy Gediminas Urbonas and Nomeda Urbonas.

demned building, the dogs created a media success, and also disagreement with activists who objected to the post-protest message.

Vilma was the Pro-Test Lab's electronic afterlife. One powerful connection that it brokered was an invitation for Gediminas and Nomeda to speak on the state-owned radio station. This got journalist Rasa Kalinauskaite fired; she then joined a private TV show and developed her new passion for heritage. Becoming the Lab's lead spokesperson, Rasa also founded Lithuania's Alternative Heritage Commission to hold government accountable to the law.

By the end of 2005 Paradise Apartments hired media monitors to track the artists' activities. And when another heritage expert spoke on national radio about abuses committed by the developers—collapsed buildings, illegal elimination of a playground—the monitors provided "evidence" of libel. From late 2005 to the present, the company has tried to have the artists' accounts arrested, and in 2008 it sued the heritage expert for damages. No lawyer would defend her, but an artist stepped in as happened in ACT UP. Musician Tomas Bakucionis was only a law student then. He had gotten interested in the law while drafting a 2006 Pro-Test Lab petition to the

national government demanding responses to a series of municipal abuses regarding public space and zoning. A year and a half went by and, astoundingly, the government found four of the seven petition points legitimate. This was a real victory. One of the points was to explore the establishment of a "Public Space Committee" in the Ministry of Culture, though municipal lawyers had argued that the term was bogus because property was private by definition.

A series of suits and countersuits forced Gediminas and Nomeda to investigate their civil rights. They discovered the International Aarhus Convention, which explicitly guarantees the right of citizens to participate in decisions about environmental use.[109] This right was a surprise to Lithuania, though the country had signed the convention, translated from a mistranslated Russian version. For example, "environment" turned into "nature"; "transparency" became "publicity"; "sustainable" translated as "balanced." The document had never been cited in Lithuanian courts and the artists' case depended on approval of their fresh translation, which finally came in January 2009. The developers retaliated with a civil suit to demand compensation for compounded losses, alleging that the Lab experimented with public resources, including the very courts that were judging their pranks. But the artists assured the authorities that they were following the law to the letter, an innovation in Lithuania that evidently had a defamiliarizing effect.

THIS CASE CONJURES UP other grassroots projects to develop shared space, such as the Sustainable South Bronx. Bogotá, by the way, is among Majora Carter's inspirations for revitalizing her polluted neighborhood in Hunts Point, New York.[110] Her project addresses land use, energy, transportation, water, waste, education, and, most recently, design and manufacturing. It "creates opportunities for people to grow vegetables at home, to get paid to do environmental cleanup, and to work through local government to stop New York from using the neighborhood as a dumping site for 25 percent of the city's waste."[111] The main innovation was to develop rooftop gardening to provide high yields of organic vegetables for urban dwellers and local restaurants. Ex-convicts, gang members, and the elderly have together managed to reduce exposure to toxins, curb childhood asthma, and energize the local economy. Newly skilled residents are able to find

work elsewhere; but they don't leave the neighborhood. People stay to become teachers and to invest in the Sustainable South Bronx.[112]

It bears a family resemblance to Aula Verde (Green Classroom), an ecological park and science center for school children in Puerto Rico. The amphitheater's flora, designed to facilitate lessons by practiced guides; the elegant simplicity of the laboratory building that borders the butterfly farm; and the space for arts and crafts are admirable but not unique. The surprise is the staff, all parolees and probationers from an abusive jail nearby. With help from Marco Abarca, a Costa Rican human rights lawyer who won a class action suit for the prisoners, they transformed two acres of mosquito-infested woods into a tropical teaching forest. A side effect through Abarca's law students is applied research into a range of community concerns, including adolescent pregnancy, breast-feeding, school retention, and prevention of drug abuse. Press on any point and the issues connect.

Making Sidetracks
A map of intersections will include lines of influence from one artist to another; but there are more links to plot. Studying "influence" in art often centers on one practice at a time to trace lessons and provocations, as in Shakespeare's influence on Milton, or how Picasso influenced Gris and was influenced by African masks. When we observe influence in art, this usually means a creative appropriation by another artist, an oedipal dynamic that Harold Bloom described as the "anxiety of influence."[113] But you are invited to explore acupunctural art and influence beyond the line of master to disciple, to notice the ripples that art makes elsewhere. Side effects can turn a chain of events into a chart of obstacles, allies, and countercurrents where art provokes responses that no one would have anticipated. The effects can add up to social change, possibly for the good when art connects with accountability.

THREE. **Art and Accountability**

Agent Spotting

Pedro Reyes had an ambitious idea for an art show, but he hesitated. The idea was to fill Harvard University's Carpenter Center galleries during the spring of 2006 with projections about the future. And the hesitation came from thinking about the future, which conjured such bleak visions for the Mexican artist—scenes of violence, scarcity, disease, and death—that he felt stuck between wanting to be honest and hating to spread gloom. Then something happened to revive his faith in art along with his hope in things to come. Reyes met two spectacular cultural agents, "connectionists," to use his neologism for masters of hybrid forms that link art with social development. The first was Antanas Mockus, the mayor who thinks like an artist. The second was Augusto Boal, the artist who acts in city government. Discovering them was an invitation to think otherwise about prospects and about one's own creative contribution to forging a future. It was also a burden of responsibility to be ingenious and accountable.

Cultural agent spotting along the lines that Pedro Reyes recognized is an adventure we can all pursue. It features artists who engage the public as co-

creators, artists such as Alfredo Jaar, Krzysztof Wodiczko, and Tim Rollins. They regularly negotiate "littoral" coproductions with other—perhaps recently recruited—artists to create collective works that generate the by-product of mutual admiration.[1] So after worrying a bit about the alleged bad aesthetic effects of good social intentions, Reyes got back on an active track and recognized many of the artists he most admires as cultural agents.

The new framing of art allowed him to imagine a witty and productive future worth projecting at the Carpenter Center. He called the successful exhibition *ad usum*, "to be used." There was an oversize T-shirt hung like a banner that read: "Turn always to the left, or always to the right, and you go in circles." An enormous top invited visitors to give it a spin that would land on a quote from this or that philosopher, rehearsing the game of chance and interpretation that Mockus had pioneered.[2] Latin America may be unstable politically and poor by economic measures, Reyes admitted, but it is incredibly rich in creativity. That richness can pay off in public gains.

It's not that creative arts should be immediately useful or that they lack intrinsic value. On the contrary, the very autonomy of art allows it to challenge existing arrangements and to exercise freedom. Art triggers fresh perceptions and unclogs procedure in ways that make it a social resource to reckon with.[3] Five years after meeting Mockus, Reyes reflected on his own recent projects, noticing that they begin either as art and end up as social intervention, or they flip the other way around. Take, for example, *Palas por pistolas* (*Guns into Shovels*), created in 2008. It began with a commission to create a sculpture for the Botanical Garden of Culiacán, Mexico. Reyes took the invitation but turned it into a set of collaborations that would transform weapons of death into tools for life. First, Agustín Coppel, who commissioned the work, provided vouchers to his chain of appliance stores in exchange for illegal guns. Through TV spots inspired by soap operas, the public was moved to surrender 1,527 fire arms. Meanwhile, Reyes brokered an agreement with the army—the legal depository for illegal guns—to melt the metal and sell it to a shovel factory. The factory agreed to manufacture 1,527 shovels, destined to plant as many trees. Local youths planted the first trees in the Botanical Garden, where a statue might have stood. The project has traveled to San Francisco, Chicago, and New York; it will be replicated in twenty Mexican cities.[4]

The notoriety of *Palas por pistolas* put Pedro in the curious position of serving as a dumping site for firearms confiscated by the army. Weapons turn out to be more difficult to destroy than to produce, so guns and rifles

FIGURES 3.1–3.2. Mexican Army prepares guns for meltdown (top). Trooper shovel factory (bottom). Both images courtesy Pedro Reyes.

FIGURE 3.3. *Palas por Pistolas* (*Guns into Shovels*) Exhibit. Courtesy Pedro Reyes.

continue to burden public resources even after they stop shooting. The challenge of what to do with the dead weight of disabled arms inspired Reyes to imagine making something new without incurring the cost of melting down the metal. The result is *Imagine* (2012). With advice from musician Edi Kistler, Pedro produced a series of fifty eerily beautiful and hauntingly musical instruments constructed from identifiable hulks of almost seven thousand weapons. "Melted, smelted, welded and beaten into submission; Reyes and his crew transformed the weapons in just two weeks, realizing everything from flutes to drums, bass guitar to xylophone in the process."[5] Pedro invests this alchemy with the power of spiritual transformation. "I wanted to liberate these objects from their demons rather than perpetuating their association to death. When the instruments are played, it is as if some sort of exorcism is performed on them."[6]

Acknowledging the agency of art and interpretation released Reyes from the familiar double bind of radical thinking about the politics of art-making: either expecting too much revolutionary effect or holding out too little hope for change. Agency enabled him to engage with the existing culturally constructed world, instead of summarily discarding its value or despairing altogether.[7] Grand gestures now seemed unnecessary—and irresponsible—while the work of making art in complicated contexts promised real

results, if audacity takes pauses for aesthetic judgment. Judicious pauses in the process of making deserve a theoretical aside, especially since the faculty of judgment guides civic projects including the construction of collective artworks such as democracy.[8]

Training Taste

Judgment matters for all human activities, and the best way to develop it is through aesthetics. Immanuel Kant was sure of this when he insisted that aesthetics was a cornerstone of the philosophical Enlightenment. Science and morality — the true and the good — respond to existing criteria of reason and decency, to established values, desires, and rules; but judging beauty and the sublime have nothing at stake besides judgment itself. It doesn't make you rich, or saintly, or famous. Aesthetics is the only field of passionate engagement that unhinges rules and values surprise. It ignores convention and allows an uncluttered moment for free judgment. No wonder aesthetics developed alongside democracy, which depends on a subjective ability to distance oneself from particular economic, political, or religious interests. A political experiment in fairness needed a new branch of intersubjective philosophy.[9]

Judgment is an innate faculty that has to be exercised. Obtuse people can be erudite, but they cannot judge.[10] And obedient subjects of established rules and authority don't bother to exercise because they don't need to judge. But free-thinking citizens do need to practice judgment in order to consider specific questions. What is the best field for toning the general faculty? Paradoxically, as I said, it is the apparently purposeless area of aesthetics. The reason is simple: thinking about particular instances of the beautiful and the sublime is the one intense human activity that doesn't matter in any practical, intellectual, or moral way. Frequent workouts do no harm because unlike economic, political, academic, or ethical practices, aesthetic judgment has no goal beyond the exercise itself. "That is beautiful which pleases in the mere act of judging it."[11] To take pleasure in a poem for its moral message, or appreciate a play for its politics, or a meal for its nutrition, is not an aesthetic response because it begs returns from the poem, play, and meal. Real beauty disarms us with gratuitous delight and inspires a selfless feeling of love.

Different from scientific reason, which obeys the laws of nature, and from practical reason, which is determined by morality and desire, judg-

ment has no rules or abstract criteria. Difficult to define, "it is a peculiar talent which can be practiced only and cannot be taught."[12] Stanley Cavell captures the word with an inspiration from Wittgenstein. Judgment, he says, is not logic; it is rather a *grammar*, so that usage in communication, not rational argument, develops a sense of right or wrong.[13] Familiarity with the language system, appreciation for its particular uses, contexts, and contingencies allow a seasoned speaker to determine acceptable uses. And when familiarity includes figurative language — the jokes, puns, quibbles, and inconsistencies that make literature a particular language game — judgment can mean tolerating contradiction and refusing to take sides. Intellectuals exercise judgment even when they mistake the activity for reasonable argument. And they can change their minds — learn a new grammar, Antonio Gramsci assured us — though the process is slow for risk-averse intellectuals.

Aesthetic disinterest, I should make clear, is far from indifference. Indifference is a lack of feeling that isolates us from society and from interpersonal obligations. Disinterest, on the contrary, is a condition of freedom that accompanies intense feelings that we can share. A disinterested judgment of beauty excites the feeling of love that lingers on the beautiful form and that assumes others will feel the same. And though an experience of the sublime begins with confusion or fear, it continues through the unpleasantness to achieve a rush of awe that commands our respect. Love and respect are generous responses that demand nothing in return. Indifference is no response at all.

Judging is a second order pleasure, stimulated first by a visceral experience. Was the experience of an object or an event freely felt, with no interests attached; or was it predetermined by existing desires or concepts? Did the form please me rather than the content? Would other people react in the same uncluttered and disinterested way? The questions are subjective but not self-centered. Unburdened of goals or obligations, they predict the same answers from everyone. At least they hold out hope for a "common sense" of intersubjective companionship. This promise of sociability drives the *Third Critique*.[14] You cannot take for granted agreement about the beautiful or insist on your conclusion, because there are no rational or ethical rules that everyone should obey.[15] But "we are suitors for agreement from everyone else, because we are fortified with a ground common to all."[16] This lateral move of individuals who court other individuals to establish agreement is a profound innovation. Until then, philosophy had moved hori-

zontally on objective or at least established axes of truth and morality. Aesthetics is the great leveler. Erudition and social standing give no advantage in this courtship. Granted, there is nothing at stake here, either morally or materially. But aesthetics prepares the ground for interpersonal persuasion in more contentious fields.

Hannah Arendt reads Kant's *Third Critique of Aesthetic Judgment* (1790) as a mature response to a long-standing concern to save sociability from narrow rationalism. Arendt frames Kant's *First Critique* on pure (scientific) reason and his *Second Critique* on (moral) practical reason as setting the limits of what we can know and understand through general principles, in order to appreciate what those principles can and cannot do. Principles cannot judge. They follow determined paths. The *Third Critique* supplements the objective track of reason with a necessary subjective pause for judgment and a new line of questions. Withdrawing from reason to judge the sensible and sentimental world of particulars saves human beings from the excess of rule-driven behavior. Judgment is the "bridge between the abstractions of the understanding and the concreteness of life."[17] It puts "the officious pretension of understanding" in its place with a pause to consider the contingencies and the effects of reasonable thinking (*Third Critique* prologue, part 4). Judgment checks "the scandal of reason," which otherwise leads us astray as surely as tradition and authority do. Without it, reason would reduce thinking to a technical exercise and dismiss feelings altogether.[18] Judgment is therefore a foundation of the Enlightenment, supporting the public exercise of reason that Kant identified as the mature practice of thinking for oneself.[19]

Kant never wrote a political philosophy, as Arendt jokes about her *Lectures on Kant's Political Philosophy*. Maybe he was cautious, as the king's censors grew increasingly vigilant while France heated up for revolution. Perhaps his thinking about politics developed too late in life to write a major treatise. But maybe too, Arendt speculates, it was unnecessary to be dangerously direct, when aesthetics could do the political work of civic development.

Taste was a favorite topic for the Enlightenment because it considers particularity rather than general laws. Taste defies lasting laws that prejudge experience.[20] Though tarnished by associations with frivolity, taste still holds out a hope that can again brighten humanistic interpretation with civic purpose. It is the purpose of developing unbiased judgment. Behind taste, Kant discovered the general faculty of judgment and dedi-

cated the first major work of philosophy to the connection.[21] In this spirit, formalist criticism need not dead-end in art for art's sake. It can revive a Kantian tradition that (1) cultivates aesthetic disinterest to (2) train a general faculty for free judgment that (3) generates a shared or common sense as grounding for political accords. The dynamic that connects examined private pleasures with enhanced public agreement is still news for some scholars, good news for humanists who can explore the contributions of aesthetic judgment to public life. Humanists who defend aesthetics but shun social responsibility, and those who assert responsibility but dismiss aesthetics as elitist or unfashionable, may want to reconsider.[22] Aesthetics is a significant political player precisely because it sidesteps the politics of vested interests. It accomplishes free thinking, through judgments that override predetermined conclusions about values and concepts, personal gain, party lines, or moral argument.

Consider the variety of arguments for humanistic interpretation that faculty and students at Cornell University offered when they asked, "Do the humanities have to be useful?" in a volume published in 2006. The public demands to know, admits the prologue.[23] Eighteen essays respond with reasons to recognize the field's usefulness: The humanities raise questions of meaning and make sense of technical and social change;[24] they appreciate human agency so precious to third world and minority subjects in the face of economic and philosophical determinism.[25] Through figurative language they capture contradictions and therefore create "a common understanding out of uncommon sense."[26] They linger on works of art to slow down a frenetic modern pace that loses touch with human value.[27] They stimulate generosity through open debate and contestation.[28] And they multiply perspectives.[29] All these contributions derive from training aesthetic taste. It is taste that enables dispassionate distance and allows us to linger, to tolerate irony, and to practice self-authorizing agency.

Art to the Rescue

Though Kant found abundant stimuli for aesthetic judgment in nature, his disciple Friedrich Schiller preferred the deliberate charms of man-made beauty. In *Letters on the Aesthetic Education of Man* (1794), Schiller argued for the universal cultivation of judgment in art-making as basic training to achieve political freedom, because art is more reliable than nature; it captures and extends the experience of beauty.[30] (See chapter 5, "Play Drive

in the Hard Drive.") To judge something, you have to care about it. If we don't care, the faculty of judgment will fail us. There's no point in distinguishing free from contingent pleasure, or right from wrong grounds for agreement, if we are inured to suffering or afraid of love. Without delight and surprise, what would stimulate the curiosity that begs questions of aesthetic value? To repair the corrosive effects of not caring, art comes to the rescue as the partner of aesthetic judgment. This is Schiller's contribution to Kant's pursuit of distractions from selfish interests. Unstable and cyclical nature, Schiller explained, doesn't survive our gaze. But art holds its pose as a renewable surprise.[31] Novelty is practically art's definition. When nature fails to refresh perception and to quicken the spirit, art can ignite surprise and stimulate judgment. Russian formalists, starting with Viktor Shklovsky, join Schiller's company when they credit art with interrupting the feeling-fatigue that follows from mindless repetition. Without art, "life is reckoned as nothing. . . . Habitualization devours works, clothes, furniture, one's wife, and the fear of war. . . . And *art exists that one may* recover the sensation of life."[32] I emphasize the commanding subjunctive construction. Art has a purpose. Shklovsky dismissed the academy's sententious defense of art for its great ideas; there are very few great ideas and many great works of art. Content is clearly not the source of artistic power. Art is disarming technique.

For Shklovsky, as for Kant and Schiller, beauty and the sublime have indirect ethical and therefore practical effects, not through ideas but through pleasure. Aesthetic experience rekindles love for a world gone gray from habit. I admit that formalist art education can seem annoyingly outdated to colleagues who have rejected the constraints of text-based interpretation to venture into the multifarious practices that make up culture, the range of cultures.[33] Today, humanistic interpretation necessarily includes reflections on performance beyond the archives and museums of tangible art, on intangible ritual and spectacle as they shape our social lives.[34] The arts projects that I feature here are all of this non-textual nature. But attention to formal devices remains useful, however much the contents change.

The Politics of Aesthetics

Although Theodor Adorno dismissed art's autonomy, calling it a "magic show," he admitted in his dour way that the show was effective enough to create an illusion of freedom and so to enable real critique.[35] This

intervention-effect adds a level of affinity between politics and aesthetics beyond Kant's hands-off "disinterested interest" in the world. The difference between aesthetics as pure contemplation and aesthetics that includes interference goes back to a disagreement between Kant and Schiller, and it prepares a pitched debate about Nazi politics. (See chapter 5, "Play Drive in the Hard Drive.") Kant's disciple, Hannah Arendt, considered the link between politics and art to be contemplative judgment and so she didn't worry, as Bertolt Brecht and Walter Benjamin did, that art would replace politics in a beautiful Nazi state.[36] For Arendt, aesthetics and politics shared a harmless affinity for dispassionate reflection. Aesthetics was practically a protection against the disruptive power of art. "Taste de-barbarizes the world of the beautiful by not being overwhelmed by it."[37] She was paraphrasing Kant: "Taste, like judgment in general, is the discipline (or training) of genius; it clips its wings. . . . If, then, in the conflict of these two properties in a product something must be sacrificed, it should be rather on the side of genius."[38] But, she admitted, the Greeks achieved greatness in both politics and art by muddying the difference and tolerating the contamination of judiciousness with creativity.[39] Brecht and Benjamin recognized that explosive tension while the Nazi "magic show" overwhelmed politics.

The danger was dramatic enough for Arendt to notice the possible vagaries of aesthetic judgment, but she blames artists for the breach of disinterestedness. (Brecht was the worst for his shameful opportunism in poems to Stalin.)[40] "Fabricators," she frets, are so fixed on ends that they employ any means to make art, which is why the Greeks and especially the Romans excluded artists from public life.[41] In antiquity, artists were suspect because they retreated in private to deform materials. The works they create, however, are public and, like politics, they communicate a common sense of the world.[42]

Art implies taking risks and courting danger, but art-avoidance is not an option. Making art is hardwired and constitutive for human beings. Following Friedrich Schiller and running alongside the pragmatism of John Dewey, Jacques Rancière writes that art is indistinguishable from moments of daily life and nevertheless marks moments of freedom unbound by content or rules. (Rancière reveres Schiller but doesn't mention Dewey or Paulo Freire, though Freire's *Pedagogy of the Oppressed* [1969] was an international sensation and bears a close family resemblance to Rancière's *Ignorant Schoolmaster* [1987] and also to his "The Emancipated Spectator"

[2004][43]). (See chapter 4, "Pre-Texts.") "The aesthetic regime . . . simultaneously establishes the autonomy of art and the identity of its forms with the forms that life uses to shape itself."[44] This consciousness of artifice in the everyday distinguishes the aesthetic regime from the "ethical regime" of art (which cares more about content than form) and the "poetic or representative regime of art" (which privileges rules of form). It is aesthetics, he says, that allows us all to take a critical distance from even quotidian activities.

Rancière's shorthand for comparing authoritarianism to democracy is the distinction between exclusive and inclusive experiences of art. The distinction, as noted in chapter 1, "From the Top," is often formal: single-minded masterpieces versus negotiated "littoral" coproductions.[45] In one approach reverence for genius sustains the work; in the other collective admiration among citizen-artists drives it forward. A criterion of good government, "The Distribution of the Sensible" gives the explanatory subtitle to Rancière's *The Politics of Aesthetics* (2004).[46] His point is that democracy needs across-the-board participation in the artful, intentional, human activities that aesthetic judgment considers. Unless it spreads like muck— to remember Francis Bacon's quip about money—art makes trouble by concentrating innovation in a few powerful hands while the masses repeat mindless operations.[47] The advice means to correct a crippling elitism inherited from Plato's *Republic*, where a hierarchy of work keeps artisans too busy to participate in politics, and keeps ungovernable artists entirely out.[48]

Show and Tell

Today humanistic interpretation is free to choose objects and approaches for interpretation. Social scientists may feel that their choices are determined by urgent issues. And historians feel constrained because, as Paul Veyne jokes, compared to novelists who also find, select, and patch together spotty information, historians should tell the truth whether it is interesting or not.[49] But humanists have no fixed curriculum or research agenda outside a few surviving great books programs. Making choices is part of humanistic interpretation, and we are accountable for them. Teachers choose objects and methods that they consider worthy of student attention, whatever the reigning taste may be. To take responsibility for the selection and for the effects of interpretation, humanists would do well to add reflexive questions to research agendas and lesson plans: What, for ex-

ample, are the desired effects and objectives of teaching? Which criteria help us to select materials and approaches? How does interpretation affect the world?

All people make choices. Paradoxically, rational choice adds self-imposed limitations to the "hard" constraints outside of one's control. Limiting your remaining options actually prepares maximum returns. The best way to understand this counterintuitive advice, Jon Elster says, is to notice how artists negotiate between freedom and constraint.[50] Despite all the restrictions of time, money, connections, experience, and so forth, art-making begins with a sense of self-authorizing subjectivity that adds new limitations to existing ones. There is freedom in choosing a long shot, a close-up, a profile, a particular adjective or verb in one language or another, harmony or dissonance, a monologue or a chorus; artists know that judgment forces choice. The constraint of having to choose is a condition of creativity, not its nemesis. Think of a good sonnet inside the prison-house of predetermined numbers and order of lines, syllables, and rhymes; or consider the deaf and mute condition of fine silent films; or a series of jazz riffs that stay tethered to one melody. Creative subjects respond to limitation with self-limitation, to enhance the effect of freedom. Artists know that their own competing values and desires as well as unstable environments make choices subject to change. For related reasons, they have become poster children for a "creative economy" that promises to develop struggling inner cities into civic centers.[51] Artists are realistic about limitations but also ambitious about the effects of their choices. (Behavioral economics adds a twist to this paradox of freedom through constraint by observing a surprising level of reciprocity and confidence between strangers, despite their immediate self-interest.[52] Adam Smith was a pioneer here. He wrote *The Theory of Moral Sentiments* [1759] to warn eager accumulators that narrow interests would undo them; human beings are social animals dependent on their fellows. Arendt added that *inter-est* itself is transactional; it depends on humanistic training to imagine other people's perspectives.[53])

I'll mention a personal choice for research and teaching that made accountability a self-constraint. Mine is a convenient case because I can trace it, though there are many others about whose origins I can only speculate.[54] Several years ago I might well have chosen among topics then popular in Latin American cultural studies: violence, necrophilia, sexism, racism, consumerism, corruption, neoliberalism, human rights abuse, xenophobia. The issues were and remain urgent, but I wondered what academic or social

effect they generated. The purpose was protest, but I had a sense, confirmed later on reading Jacques Rancière and Thomas Pavel, that the resulting courses and books produced more paralyzing pessimism than political change. Protest as the beginning and end of politics was itself a symptom of pessimism.[55] Helpless to explore alternative practices, intellectuals seemed stuck between outrage and resignation. Was this an unintended and perverse complicity with the problems?

I veered away and focused on smaller matters, invoking Mikhail Bakhtin on the power of style to stimulate social change.[56] Instead of documenting and denouncing the intolerance for foreigners and foreign languages that characterized the cultural studies of immigration, I decided to acknowledge the intolerance and to draw countervailing attention to the advantages of foreignness for both newcomers and natives.[57] That is, I turned up the interpretive volume on bilingual writers and speakers who play games with master codes. The objective was to share an appreciation for the linguistic sophistication of even poor immigrants. So I taught a course and wrote a book called *Bilingual Aesthetics*.[58] My preference for emphasizing the compensations for the difficulty of living in two or more languages meant to acknowledge the aesthetic value of alienation, to take seriously the formalist defense of strangeness as art's signature effect.

The project honors the pleasures and self-respect that code-switchers earn by dint of their virtuosity, despite embarrassing and even costly mistakes. Mistakes can also brighten speech with a *sun-risa*[59] or give the pleasure of a found poem. Always, they mark communication with a cut or a tear that produces an aesthetic effect and that demonstrates the contingency of meaning explored in language philosophy. The risk and thrill of speaking or writing anything can sting, every time language fails us. And knowing how language can fail makes success feel like a small miracle. In other words, bilingual aesthetics casts precarious minority subjects as self-authorizing and original agents, sturdy enough to know how ironically disadvantaged the monolingual condition can be.[60] As a case of cultural agency, bilingual aesthetics is an invitation to notice "felicitous" engagements alongside frustrating performances. And since the approach privileges the surprise of ingenious response to constraints, it can sustain the attention of humanists trained to value the uncommon "defamiliarizing" effects of art.

Aside from the endgame of denunciation, humanist agents can play the gambit of interpreting creative moves and their effects. The goal is to recognize and further develop "thick" resourceful subjectivity. Democracy depends

on resourcefulness to wrest rights and opportunities from limited assets. This is one reflection that engaged, or civic, humanities can generate: for artists there may be a change of heart if they had worried (as Reyes had) that aesthetic value decreases when civic responsibility interferes; and for academics, interpretation may get a bit more slack when it moves toward social commitments.[61] Colleagues at over a dozen U.S. universities are now promoting a more public reach for the humanities. And a nationwide network called "Animating Democracy" has since 1999 promoted "civic engagement through arts and culture."[62] The efforts include asking how to define "the public" and how academic work can gain rather than lose intellectual ground when it pursues public purpose.[63] The research rekindles a millennial tradition.

The Long View

Culture is a Roman concept deriving from *colere*, to tame and to cultivate nature, to care for the gods and also the objects that give the past a presence. Unlike Greece, which sought immortality through praiseworthy arts and politics, Rome venerated the past. Its precious memory located current challenges in the context of glories and objects nourished in deep soil and harvested from history. Agriculture was highly respected in Rome as a productive service to nature.[64] The work didn't violate the world but rather enhanced it. (Greece, on the contrary, considered farming to be antagonistic to nature.) For Romans, every human activity was a kind of agriculture, including art and spiritual growth, so that a "cultivated mind" meant the human development of natural capacities. The mind's highest expression was the *vita activa*, dedicated to the free contemplation and judgment of existing events and objects, rather than to making new things. This is Hannah Arendt's cautionary distillation of Rome's world view: an organic continuity that inspired reverence for the past as a context for the present.[65]

Humanism, like culture, is of Roman origin and refers to an educational curriculum that trains students to cultivate freedom from any force, even the force of truth: "In what concerns my association with men and things," Cicero said, "I refuse to be coerced even by the truth, even by beauty."[66] To the ancient saying, "I love Socrates, I love Plato, but hold truth in higher esteem," Cicero countered: "I would rather be in error with Plato."[67] The choice is a question of judgment in which the difference between right and wrong does not depend on reason, but on freedom from both physical and moral necessity. Scientists and most philosophers will hardly agree with

Cicero about the wisdom of subordinating truth to taste, but the alternative "apolitical and inhuman principle" that demands truth at whatever interpersonal cost was foreign to Roman republican culture where human freedom (restricted as it was) trumped other values. And freedom, like everything else worth preserving, required the cultivation of civic virtue. Cicero, for example, prided himself on having been a politically effective orator in the Roman tradition that combined wisdom and eloquence for the public good. This nurturing of freedom through art and philosophy in public service became a foundation of the humanist curriculum.[68]

Nevertheless, the foundation has been repeatedly contested in debates between defenders of politically purposeful education and champions of contemplation. How did aesthetic freedom disconnect from political freedom, if their origins depended on one another? The long view will get lamentably short shrift here, given the many centuries and complexities that make up the history of the humanities.[69] The "accumulated confusion of purposes" could give every defender and detractor a legitimate point.[70] By offering a quick review of both vigorous and vacuous moments for civic education, I want to underline the element of choice, of judgment, regarding the propriety of civics for the humanities today.

Even during Europe's early Middle Ages, while humanism was generally discredited as a vestige of pagan cults and then almost forgotten in the monasteries, Saint Augustine forged a compelling connection between a classic care for the self and a Christian dedication to spiritual salvation. Monastic contemplation of God came close to the character formation later called humanistic education. By the late twelfth century, when humanism made a comeback through classical texts used as exempla of doctrine, rather than as studies in style, cathedral schools offered an alternative to contemplation. The schools trained youth for the priesthood by adapting Peter Abelard's rationalist method of preparing professionals in everything from law to medicine. His popularity attracted students to Paris where the demand for teachers grew. Teachers formed a commercial guild—the *universitas*—that made knowledge and sold it to students through a chain of solvent professionals. Modern universities inherit these cross-purposes: monastic character formation that contemplates a good outside oneself, and commercially self-interested skill building. And though "civic and economic values are not commensurable" they depend on one another.[71]

Meanwhile, vernacular languages were stretching and shaping up as literary media ready for Renaissance writing in a personal key, thanks to late

medieval extracurricular affairs that inspired love, lays, lyrics, and epic adventure.[72] Also, a renewed passion for civic secular philosophy moved, for example, King Alfonso the Wise to establish his Toledo translation workshop where the classics came alive in colloquial "romance," because Muslim and Jewish translators shunned Latin, the Church language.[73]

Fourteenth-century poet Francesco Petrarch would learn from Augustine that the only proper study for human beings was the study of oneself; in the saint's case for the sake of Christian piety, and in the poet's for humanist autonomy from contingencies. This inner focus, along with the recovery of documents from antiquity, developed into the Renaissance reverence for the dignity of man and also supported teachers of increasingly avid disciples. The highest studies for Renaissance humanists were the creative works of human ingenuity, not the Scholastic rationalism that still dominated universities. Revisiting the classics—including the New Testament in original Greek, which would lead to Reformist interpretations—showed a bent toward Aristotle's practical wisdom over Plato's idealism so that persuasion once again overrode logical syllogism.[74] The Renaissance cultivated taste to revive moral philosophy for its application in the real world.[75] A century later, Niccolò Machiavelli embodied that practical bent along with the literary flair that Petrarch promoted as politically efficacious. Machiavelli offered unsentimental lessons to leaders who needed to navigate moral and political maelstroms. To admire him as a "civic humanist" is redundant for this Renaissance man, because one term already implies the other.[76]

If the civic dimension of humanistic interpretation wilted for a while in Italy, where "unbridled subjectivity" had brought it to "deep and general disgrace" in Jacob Burckhardt's nineteenth-century view,[77] newer outposts developed at the turn of the fifteenth to sixteenth centuries with English Thomas More and Dutch Erasmus, followed by Spanish Baltasar Gracián. Then public purpose fully flowered again in the eighteenth century when private interests sustained public projects.[78] Although the Enlightenment inherited brilliant scientific advances by René Descartes and his contemporary Francis Bacon, who felt irritated by unquantifiable humanism, Voltaire—the eighteenth century's best propagandist—reinterpreted scientific rationality as the "good sense," or taste, of classic wisdom. Taste became the appropriate register for reason in the nonmathematical human affairs of public and private life.[79] Voltaire thereby reconnected humanist activities with civic culture, objecting to narrow scholarship that clutters

the mind with pointless accounts of disaster and malice: "If you have no more to tell us than that one barbarian succeeded another barbarian on the banks of the Oxus or the Iaxartes, *what use are you to the public?*"[80] Meanwhile, at some distance from Parisian rationalism, but close to the classics, Giambattista Vico was recovering Italy's tradition of humanist oratory with civic purpose.[81] Voltaire and Vico could hardly be more different in their positions on intellectual activity. They distill the general debates of their time by defending rival interpretations of the humanities. For Voltaire, the arts and philosophy depended on a kind of scientific reason to achieve the unitary and cumulative knowledge that included both natural and moral sciences. For Vico, scientific progress was undeniable but independent of any cultural progression, which was irregular at best. His new intuitive science of history did not pursue knowledge but rather understanding of man's general nature through his particular and contingent works.[82] Nevertheless, their polemic stopped at the purpose of interpretation. Both thinkers argued their opposing cases in defense of humanism's civic usefulness.

This was also Wilhelm von Humboldt's argument when he established the humanities as the core curriculum for Europe's first truly modern university in 1810.[83] By then, Kant's concept of human "subjectivity" seemed naturally identified with judicious citizenship.[84] Kant had convinced enlightened educators to include a gymnasium for aesthetic training to develop judgment for citizenship.[85] The charge of Humboldt's innovative University of Berlin was to prepare active young citizens for a continent on the cusp of republican reform or revolution. Almost simultaneously, Thomas Jefferson's persistent efforts to establish the first public university in the United States, the University of Virginia, survived prolonged objections to costs and secularization.[86] As in Berlin, the liberal arts were the core curriculum for Virginia, stressing personal and civic virtue and dedicated to forming elite and middle-class leaders. Jefferson was a living model of humanist harmony among art, science, and statesmanship, while Humboldt's talents were specifically scholarly and administrative. But Humboldt was smart enough to surround himself with brilliant artists, including Goethe and Schiller, and to persuade the Prussian authorities that creativity and critique were two sides of the same high-yielding coin.[87]

The very success of the modern university derailed humanistic interpretation into shortcuts for cultivating social status. In an inversion of enlightened aesthetics, appreciating disinterestedness in the arts came to serve bourgeois interests. Taste was cultivated to acquire art and faux-aristocratic

refinement, not to arouse feelings of interpersonal freedom. Aggressively arriviste students of the humanities would demonstrate their social worth by confounding disinterest with indifference through aesthetic contemplation. Indifference extended to the *inter-est* of public agreement.[88] For their ambitions, the new rich cultivated "good taste" and earned the slur of Philistines in nineteenth-century German universities. The term had first applied to calculating pragmatists who had no use for art, and then it exposed the next generation of calculators who used art as a catapult to elevated social status.[89]

Useful Uselessness

Was it this self-interested appropriation of aesthetics that gave usefulness a bad name? Is it fair but sad to say that public education paradoxically dismissed the public good? Certainly the avant-garde of the early twentieth century suspected as much, when artists from dynamic middle strata defected and threw utility out with the bathwater of collectible art. "All art is useless," Oscar Wilde confirmed.[90] If literary criticism had developed a strong ethical mission—from Matthew Arnold's mid-nineteenth-century definition of poetry as vital criticism to F. R. Leavis's and Lionel Trilling's lesson that great novels show great seriousness of purpose—artists rankled and refused to relinquish society's last outpost of freedom.[91] Once Dada took up the fight against usefulness during World War I, asserting that nothing was worth saving because all art was child's play, Western art began to doubt the special qualities that distinguished it from other human ephemera. Between one world war and the other, Italian Futurists drew attention to violent events as the only phenomena worthy of the disruptive name of art; and French Surrealists denied that art was distinct from life by dreaming away the difference. But along these and other escape routes from bourgeois good taste, artists had a clear sense that they were intervening in public life, if only to interrupt the craze for getting and spending.

Before many artists themselves succumbed to producing for rich collectors, art had promised to derail the power plays that brought mid-twentieth-century Europe to catastrophe. And some political leaders were willing to risk alliances with artists either to stop the trouble or to make more. Together, they had already made some magic in Mexico, where Minister of Education José Vasconcelos enlisted artists and educators to create national coherence after the revolutions had torn the country to pieces. The

new USSR opted to control the artistic effervescence that had fueled the revolution, but reconstructed Mexico channeled art in ways that helped inspire FDR's ambitious cultural programs to quell communist unrest. Alone during the same interwar years, writing from an Italian fascist prison, Antonio Gramsci was defending humanism against the fad for technical training, because a profound revolution needs the imagination and the interpretive skill to reframe existing structures.[92]

Meanwhile, however, Germany was constructing collaborations that rekindled classic fears about artists. "After Auschwitz," Adorno complained, art had lost the glow that Arnold called sweetness and light.[93] Was this the moment of disconnection between art and civic education? In the United States of the 1940s and '50s, New Criticism in literature was abandoning ethics for the sanctuary of formalism.[94] Nevertheless, a countervailing postwar movement that Geoffrey Harpham tracks rededicated humanistic education in the beleaguered United States as the humanities. Triumphant against fascism and defensive about communism, the humanities cultivated a long tradition to foster free thought and critique.[95]

Or maybe it was in the heady 1960s, as Sartre's Marxist humanism inspired revolutionary commitments, which gave social engagement a bad name.[96] During a "turbulent decade," civil rights, student rebellions, draft resistance, feminism, and anticolonialism, including Cuban campaigns in Latin America, all became foci for humanist reformers.[97] Later, many teachers would become disenchanted with revolutionary purpose and also notice that their students were cautious and conservative. But during the sixties when all manner of social change seemed not only possible but immanent, left-wing humanists developed a confidence in progress that felt like scientific predictability, while science itself was becoming more tentative.[98] The changes go together. After relativity and quantum mechanics shook the public's belief that science would soon resolve its few remaining questions, "certitude was gone" from the natural world, and culture became a compensatory anchor against the anxiety of cosmic instability.[99] By the end of the decade and throughout the following generation, "scientism" had cornered the New Critical formalism into discrediting expectations of change. Nevertheless, a strong countercurrent did demand change, on particular fronts. Ethnic and gender campaigns were effects that rippled out from disappointments with color-blind, masculinist Marxism. "Mimetic inquiry" into racist or sexist elements of the humanist canon cared less about form than about previously marginalized content and proposed

alternative readings to feature underrepresented subjects. But the simultaneous "theory revolution" would again shift attention from content to form.[100]

Structuralism and post-structuralism engaged linguistics to argue that social progress had been impossible because human beings are not free but determined by self-perpetuating linguistic systems. Each in his own way, the "speculative structuralists" (Althusser, Foucault, Derrida, Barthes, and then Lacan too) pioneered an influential antihumanism that was "bursting with elegant despair."[101] It bred a "form of morose but pleasurable political resignation."[102] Subjectivity practically vanished, along with intentionality, so that even Marxism hardened into a penchant for critique rather than for evolution.[103] This profound skepticism about meaning was one response to the fizzled effervescence of failed Marxist programs for universal liberation. It ran parallel to the dismissal of beauty in art-making. Now it is neuroscience, too simply understood as deterministic, that seems to promise scientific answers to questions about human taste and choice, dissuading humanists from thinking beyond inherited patterns.[104] This doesn't deny the burst of identity politics since the 1960s that rescued subjectivity and agency for particular groups (women, LGBT, ethnic minorities, postcolonial nations). But the humanities as a field doesn't yet register the moral and civic ground lost when we gave up a shared focus on the effects of style and taste.

Humanistic inquiry has a habit of closing in on itself. Remember that after Petrarch and other civic-minded pioneers, Renaissance humanism "degenerated" into philology, antiquarianism, or self-centered subjectivity.[105] And following the revived enthusiasm for the classics among Enlightened educators, Greek and Latin literature turned at times into dry subjects that tried students' patience.[106] Today the humanities seem finally free of considerations beyond art for art's sake. The post–World War II generation of academics looked away from the Holocaust, keeping company with artists who favored abstract form over the engagement of art with historical context.[107] This cultural amnesia is complicit with privilege, Jacques Rancière says, because it makes academic capital of despair; it recoils from the responsibility to effect change and instead confirms hopelessness as an intellectual platform. Art interpretation became purposeless, except for the obsolescent purpose of getting an academic job.[108] This is a difficult freedom to defend before budget committees. "The last professor," Stanley Fish, bids the whole purposeless enterprise an unsentimental good-bye.[109]

He speaks for less testy colleagues who basically agree that humanism should part company from usefulness.[110] Fish knows that the field began with a civic mission but says things are different now.[111] Humanism cannot and should not "save us.... To the question 'of what use are the humanities?' the only honest answer is none whatsoever. And it is an answer that brings honor to its subject."[112] What is the result? We lose interpersonal freedom, the basis for agreement among disinterested subjects. Another loss that follows from the first is general respect and support for the humanities. If art and interpretation amount to the same personal liberty, why support both? And if they produce only personal pleasure, why support either? Addressing humanism's usefulness recovers commitments to civic education and distinguishes between two levels of feeling free: the artistic freedom that the public perceives with disinterested pleasure; and the political freedom that art can renew or refresh by developing our judgment.[113] In France, where "theory" with no particular object had been hegemonic since the 1960s and had dictated intellectual trends abroad, fatigue with antihumanism has brought younger philosophers to "a renewed sense of moral and political responsibility."[114]

At the same time in Europe and the Americas artists have been working with apparently no other purpose but to create human connections. "Relational aesthetics" is the name that Nicolas Bourriaud coined for this interactive art.[115] Exemplary for Bourriaud is Rirkrit Tiravanija, an Argentine-born artist of a Thai family who gained notoriety for installations that last no longer than a conversation over dinner. Invited to present at a gallery or museum, Rirkrit would clear out a storeroom, turn it into a camp kitchen, and cook pad thai for the visitors to dine and socialize in a space dedicated to art.[116] Nothing was left once the dishes were cleared, except for the aftereffects of real-time relations.[117] An objection to Bourriaud's self-promotion is not that he's wrong but that he merely repackaged a standard concept as old as Dada and the Situationists. Of course art's ambition is to set sociability in motion.

Do literary critics similarly assume that language arts make community? In fact, the issue hardly comes up, unless the focus is minority writing and the frame is Deleuze and Guattari's reflections on Kafka and other ethnically marked authors.[118] Perhaps more poets, playwrights, and narrators than we have noticed share the relational ambition with visual artists. Sometimes we teachers forget to mention that writers thrive on moments of extraliterary contact, even when we remember to say that poets often

perform to broad publics before they publish, or that they participate in political rallies.

Today, students are again joining a public outside the classroom. The recent rush of Occupy movements rippling out from Wall Street to dozens of campuses and city centers shows that social solidarity is once more on student agendas. The revival had already been felt in service-learning programs and outreach activities. In the best cases, engagement combines with public scholarship to identify underrepresented creative partners who test, stretch, and refine what we learn and teach.[119] From high school on, students now seek opportunities to do public service. Sometimes the incentive is self-interest—it is true—because college admissions officers and prospective employers may prefer candidates who seem selfless. But the preference is itself a sign of social change and a wager that the best candidates will become engaged. Many young people—neither as rebellious as in the 1960s nor as complacent as in the 1980s—acquire a taste for the service that they perform. They find pleasure in producing pleasure for others, turning initial self-interest into a self-sustaining virtuous circle between outreach and inroads.

To See Unseen

A paradox of humanist interpretation is the practically positivist pose it can still strike before a work of art, as if observation could avoid interference. Any good literary or cultural critic can decry this lack of reflexivity in another discipline, say, anthropology. But humanistic criticism doesn't look back as it moves from observation to commentary. Humanists do indeed ask about the effects of teaching and scholarship on the poem or painting they study, a fundamental concern of reader-response criticism,[120] but hardly ever about the ripples interpretation sets off, unless they engage in cultural studies.

Then the answers have been characteristically critical of others and pessimistic. Artists, scholars, and policy makers who try to intervene in social dynamics seem to do more damage than good, because culture is not expedient.[121] On this view, interventions fold back on problems to aggravate them.[122] Although some scholars show that creative practices such as micro-broadcasting or traditional arts and crafts are agents of change,[123] the field has more often dismissed agency as a self-defeating illusion in capitalist society. I confess to less systematic thinking and to admiration

for small initiatives and their aftereffects.[124] Reformism may seem undignified to some scholars, but I remember Rigoberta Menchú's taunt to academics: "I admire your research and scholarship. Understanding problems is very important. But then what do you do? We poor people need to develop solutions."[125]

Since the question of interpretation's social effect hardly comes up it's worth asking, to take a lesson from Pierre Macherey. He identified silence as the indicator of assumptions so basic that they go without saying.[126] Insiders don't notice that something is missing, but outsiders do. Think of literature students today. Do they ask you, as mine do, why James Fenimore Cooper's gallant soldier preferred bland Alice over enchanting Cora in *The Last of the Mohicans,* or what the big deal is if Samuel Richardon's Pamela loses her virginity, or how come the Inca Garcilaso de la Vega reports Old Testament rituals in ancient Peru? The archaeologically reconstructed answers are the clearest indices of ideology, says Macherey. Can we reconstruct the silenced assumptions in humanism today and ask, what happened to civics?

One effect would be to defamiliarize our perspective on what we do as humanists. The silence has amounted to assuming with Stanley Fish that we do not, should not, and probably cannot do much. Instead we ask of an artwork or a cultural process: What rhetorical devices make a poem worth rereading? Or, how do novels make mischief with more properly called literary genres? Where do brushstrokes call attention to the process of painting? Are there real differences between popular practices and professional art? Or, when silent movies ceded to sound, which transnational charms got lost in translation and which were found in new layers of language arts? The range of existing research agendas, and their often fascinating results, stays relatively fixed on an object or practice in order to render observations that have more or less descriptive power, are more or less right or wrong, true or false.

J. L. Austin called this use of language "constative," practically the only use that philosophy had recognized. By naming performatives (e.g., a promise, a vow, a curse, or a blessing), Austin moved language philosophy beyond description toward recognizing interventions. He admitted that the distinction between description and agency would blur, because constative naming has a performative effect, but he proposed the theoretical difference to keep both functions in focus.[127] Words do work in the world, whether we intend it, approve of it, or not. The challenge is to take that

work into account. It can generate shifts in grammar, not only developments of vocabulary. Add hip-hop to musicology, spoken word poetry to belles lettres, graffiti to art history, and scholarship can break out of a lexical ivory tower but stay inside an unexamined presumable indicative grammar. A generation ago, anthropologists noticed the intersections between cultural products and the effects of interpretation; the result was to locate a blurry area where self-ethnographies develop along with collaborations between social scientist and subject.[128] Even earlier, natural science had to consider how observations interfere with objects.[129] Interpreters of art seem strangely stiff alongside these reflexive neighbors.

I am insisting a bit, but the pressing issue of humanism's effects has seemed doubly irrelevant: either the effects are negligible and should remain so, or they are too patent and personal to argue. An outstanding option is to observe that the effects are underexamined, though democratic life depends on the dynamic between art-making and humanistic interpretation. This is no exaggeration. A disposition toward creativity and critique resists authoritarian single-mindedness; it acknowledges different points of view and multiple ways to arrange available material. Constitutional democracies are themselves collective works of art accountable for their constructions.[130] And constitutions remain open to performative interventions, obliging citizens to cultivate their creativity and criticism. It is time to ask what humanism does, especially now that many others are asking the question in order to justify budget cuts that threaten the foundations of free society.

Common Sense

Policy makers, foundations, social scientists, and other fellow citizens train a polite gaze on the humanities while they decrease support. Don't humanists deserve support, almost by birthright, as guardians of artistic and spiritual values? Yet education in arts and interpretation feels the pinch of purse strings drawing closed. This book considers the predicament and possible responses, because simply lodging complaints against ungenerous "corporate-style" university leadership is rather limited and unworthy of humanists who can muster more creativity.[131]

We can refresh a long humanist tradition that puts arts and interpretation at the center of education by joining Pedro Reyes in agent spotting. He has become a guide and a guru. After the international success

of *Palas por pistolas*, and before its musical sequel in *Imagine*, Reyes had created another winning idea. This time he was not a star artist or even the architect of collaborations but rather a curator and facilitator who exercises good judgment on other people's bright ideas. *Atlas de intervenciones* collected socially productive projects throughout Mexico City and offered the municipal government a program in the pedagogy of innovation. The *Atlas* is a brochure of poster-size bifold pages to be distributed throughout the capital's schools as inspirations for creative quotidian practices. Each large folio represents a short description of an admirable project — teaching yoga in prisons, for example, or designing contemporary fashion with the handiwork of decently paid indigenous artisans, or saving money and harmful emissions from gas tanks. Visually arresting, each folio features drawings that trace the project's dynamic from one stage to another, as well as a "recipe" of abstracted principles that help to translate the practice into a range of unforeseen variations. The ideal reader-response is to start cooking.

This curatorial role generates the exercise of judgment and a "common sense" of art as everyday intervention in social challenges. Common sense, as Kant re-signified the popular term for unexamined commonplaces, means shared intersubjective appreciation. The *Atlas* shows that art is common sense as it guides us toward existing interventions and toward their corollaries, which amount to a call to action. Thanks to the *Atlas* the role of cultural agent achieves a quality of the common and shared capacity to make productive change, whether or not one is exceptionally talented in art-making. Just to mention one response to Pedro's display of common creativity I should refer to a change of heart about what counts for distinguished contributions at CONACULTA, Mexico's Ministry of Culture. The ministry's mission to promote international acknowledgement of the country's cultural values expanded beyond counting on a circuit of famous lecturers to include *Atlas*-type innovators. With Pedro's curatorial inspiration, CONACULTA now grants an annual prize in collaboration with Harvard's Cultural Agents Initiative for the best artistic intervention in a particularly difficult city. So far the winners have included *656 Cómics* in Ciudad Juarez,[132] *Torolab* in Tijuana,[133] and *Osimmpe* in Oaxaca.[134] My personal response to this opportunity/obligation includes courses I teach, but also a bolder move inspired by cultural agents. By 2011, Pedro and I were co-facilitating an arts-literacy program called Pre-Texts for Mexico City middle school teachers.[135]

FOUR. **Pre-Texts**
The Arts Interpret

Literature is recycled material, a pretext for making more art. I learned this distillation of lots of literary criticism in workshops with children. I also learned that creative and critical thinking are practically the same faculty since both take a distance from found material and turn it into stuff for interpretation. For a teacher of literature over a long lifetime, these are embarrassingly basic lessons to be learning so late, but I report them here for anyone who wants to save time and stress.

My trainer was twenty-two-year-old Milagros Saldarriaga, cofounder of an artisanal publishing house named for the childish and chaste patron saint of Andean migrants in Lima, Peru. Sarita Cartonera was the first cardboard publisher to replicate Eloísa Cartonera of Buenos Aires.[1] As far as I know, of the more than thirty Cartoneras that have by now followed Eloísa's lead in Latin America and Africa, only Sarita developed a feedback pedagogy to respond to a local challenge.[2] She had to. It was not enough to make beautiful and affordable books if the books were not in demand. Lima looked like distressed Buenos Aires, with its lack of money together with an abundance of good writers and poor paper pickers. Similar con-

FIGURE 4.1. Cartonera books (clockwise from bottom) by Kutsemba Cartão, La Casa workshop at Dartmouth College, Qinti Qartunira, Kutsemba Cartão, and Animita Cartonera. Photograph by Christine R. Choi.

ditions promised similar success for the new Cartonera, until it found indifference to be an obstacle more stubborn than poverty. Unlike Buenos Aires, Lima doesn't read. As for economic crisis, it was chronic for Peru, not the shock it had been in Argentina. It would be foolish, Milagros told me, to invest in publishing without cultivating buyers for the books. So Sarita began to employ its charming products as prompts for producing more readers. What better way to use books!

Even during the economic crash of 2001, haunting photographs of Buenos Aires show people who stare longingly into bookstores and while away unproductive time with books in hand. Just a year after the economy fell apart and long before it recovered, Eloísa Cartonera was responding to the hunger for new reading material with an alternative to the failed book business. Poet Washington Cucurto and painter Javier Barilaro started to use and reuse available materials, pre-owned cardboard and new combinations of words. Cucurto is the stagey name for Santiago Vega who writes sports columns, poems, novels, business plans, and lately lectures for U.S.

universities. Before the crash, he was also a publisher of poetry in a small operation that faced extinction after the price of materials skyrocketed. The solution was to recycle. At their storefront retreat from business as usual, the two artists began to buy cardboard from practically destitute paper pickers at almost ten times the price paid in recycling centers. Soon the *cartoneros* themselves came to the workshop to design and decorate cardboard books.

One of a kind covers announce the original material inside: new literature donated by Argentina's best living writers. Ricardo Piglia and César Aira were among the first, soon followed by Mexican Margot Glantz, Chilean Diamela Eltit, and many others. By now, Harvard University's Widener Library has more than two hundred titles from Eloísa Cartonera, and the University of Wisconsin, Madison, has more. Several of the former paper pickers in Buenos Aires and in Lima later found work in standard publishing houses; others returned to finish high school. All of them managed to survive the economic crisis with dignity. Today Eloísa is a cooperative of ten members who share the work and the income from book sales and from a recent venture in sustainable agriculture. One member, a chubby woman affectionately called "la Osa," sells books on the street as if they were empanadas. Captivated by her hawking, distinguished journalist Tomás Eloy Martínez reported on her pitch to potential customers[3]: Do you want the latest in poetry? No, you don't like poetry? Well, I recommend this memoir. Or, what about a reprint of an out-of-print classic?

Eloísa didn't set out to be the model for an entire continent and beyond, but her example proved irresistible.[4] Rippling throughout Latin America and before reaching Africa or winning the Prince Claus Award for 2012, the Cartonera project reached Harvard University in March 2007 invited by Cultural Agents for a week of talks and workshops.[5] Javier from Eloísa taught us how to make beautiful books from discarded materials, and Milagros from Sarita showed us how to use them in the classroom.

Turn the Page

This was a moment of truth for me and for other teachers of language and literature crouched on the floor cutting cardboard, and hunched over tables covered in scraps, tempera paints, scissors, string, and all kinds of decorative junk. Until then, the Cultural Agents Initiative had been drawn outward, attending to impressive top-down and bottom-up art projects that

humanistic interpretation had been neglecting. We convened, and continue to convene, conferences, courses, and seminars on thinkers who inspire cultural agents of change, and on a broad range of artists who identify their work as interventions in public life.

Even before the major inaugural event of Augusto Boal's Theatre of the Oppressed workshops in December 2003, Cultural Agents had featured photographers who teach desperately poor children to take new perspectives and to reframe their lives. (Nancy McGirr's Fotokids in Guatemala is exemplary, as was Martín Cohen's Ph 15 in Ciudad Oculta on the fringes of Buenos Aires.[6]) The series culminated in two conferences on "Visible Rights" (2006, 2007) where practitioners and theorists from Bogotá to Bangladesh reflected on teaching the art and business of photography from the perspective of children's rights.[7] We brought Antanas Mockus to teach in 2004, between his second term as mayor and his second run for president of Colombia. A special event in 2005 showcased "The Jewish Latin Mix: Making Salsa" with a conference, master class, and concert that featured the mostly unsung collaborations among Latino and Jewish *salseros*, a testimony to the socially binding effects of making music together. Larry Harlow, Martín Cohen, Marty Sheller, and Leon Gast starred on that occasion. We hosted related seminars on the power of student dance troupes (such as Bajucol in East Boston) to consolidate communities of youth and to keep them enrolled in school. Muralists who direct crews of teenagers to occupy public space and to promote a pride of ownership also figured among our guest speakers. A project called "Cultures on the Air" featured indigenous language radio programmers as agents of autochthonous development in conferences of 2005 and 2009. Alfredo Jaar mentored a dozen Harvard and MIT graduate students in 2011–2012.[8] And a partnership with FONCA (Mexico's equivalent to the NEA) celebrates a Mexican Cultural Agent of the Year.[9] A similar award partnership begins in 2012 with Colombia, where the National University in Bogotá and Medellín offers a doctoral concentration in Cultural Agents through the Faculty of Social Sciences.[10]

These activities represent other people's work, and academics like me were taking note for the benefit of colleagues, students, and artists. Then — without anticipating it, but charmed and shamed by two undergraduate maestros at Harvard College — I made a move toward more direct participation. In 2006 Amar Bakshi and Proud Dzambukira had gone to Mussoorie, a small town in India where Amar's mother was raised and where girls are expected to drop out of school by age nine. Determined to raise ex-

pectations and to increase opportunities for more fulfilling futures, the two young men established an NGO that hired local artists to offer after-school workshops. If the girls wanted to make art they had to stay in school. The almost immediate and sustained success of "Aina Arts" in India justified expanding the project to Proud's native Zimbabwe by the following year.[11]

Keeping children in school by brokering art lessons was the kind of cultural agency I could manage. This was a wake-up call to direct action. I understood that agency doesn't require genius or depend on particular professions. It can be a part of modest but mindful lives, my own for example. I am a teacher, after all, and the work of education is urgent almost everywhere, including my university-rich area where poor neighborhood public schools face escalating dropout rates and increasing violence. So I developed a course called Youth Arts for Social Change with Boston's Leadership Institute for after-school instructors.[12] The course became a regular offering at Harvard's Extension School, engaging local artists (in dance, music, painting, theater, photography, etc.) to train teachers in creative techniques for the classroom, any classroom.[13] This was to be my culminating effort as a cultural agent, appropriating lessons I had learned from resourceful undergraduates, from seminars, conferences, and artist workshops. We were bringing art back into schools as the motor and medium for engaged learning.

But the Cartonera brought me further when it returned me to literature. Following Sarita's lead, teaching literature through the arts became the adventure in literacy and citizenship that we call Pre-Texts. "Make up your mind," some potential partners demand. "Is Pre-Texts a literacy program? Or is it arts education? Or maybe civic development?" The answer is yes to all the options because each depends on the others.[14] Let me explain: (1) Literacy needs the critical and creative agility that art develops; and good reading welcomes interpretation from many readers to achieve depth and breadth. (2) Art-making derives inspirations from critical readings of social issues; and it improves with contributions from informants, colleagues in different disciplines, and public responses. (3) Finally, citizenship thrives on the capacity to read thoughtfully, creatively, with co-artists whom we learn to admire. (Jürgen Habermas bases "communicative action" on creativity. See chapter 5, "Play Drive in the Hard Drive.") Admiration, we saw, animates civic life by expecting valuable participation from others. Toleration is lame by comparison; it counts on one's own opinions while waiting for others to stop talking. (See chapter 1, "From the Top.")

Pre-Texts is a hothouse for interpersonal admiration, as a single piece of literature yields a variety of interpretations richer than any one response can be. This integrated approach to literacy, art, and civics develops personal faculties and a collective disposition for democratic life.

Literacy should be on everyone's agenda because it continues to be a reliable indicator for levels of poverty, violence, and disease, and because proficiency is alarmingly low in underserved areas worldwide.[15] Skeptics will question the cause for alarm, alleging that communication increasingly depends on audiovisual stimuli, especially for poor and disenfranchised populations. They'll even say that teaching classic literature reinforces social asymmetries because disadvantaged people lack the background that privileged classes can muster for reading difficult texts. Audiovisual stimuli on the other hand don't discriminate between rich and poor and seem more democratic. But public education in the United States is now returning to "complex texts" and to the (literary critical) practice of "close reading" through newly adopted Common Core Standards that value difficulty as grist for cognitive development.[16] Formalist aesthetics would help to make the transition by adding that difficulty is fun; it offers the pleasure of challenges that ignite the imagination.

Paulo Freire cautioned against the pedagogical populism that prefers easier engagements, because full citizenship requires high-order literacy. His advice in *Teachers as Cultural Workers* was to stress reading and writing in order to kindle the critical thinking that promotes social inclusion. Freire traces a spiral from reading to thinking about what one reads, and then to writing a response to one's thought, which requires more thinking, in order to read one's response and achieve yet a deeper level of thought.[17] Teachers democratize society by raising the baseline of literacy, not by shunning literary sophistication along with elite works of art. The classics are valuable cultural capital and the language skills they require remain foundations for analytical thinking, resourcefulness, and psychosocial development. Without mastery of at least one spoken and written language, youth have little hope for self-realization. Paradoxically, skeptics reinforce the inequality they decry by dismissing a responsibility to foster high-level literacy for all.

By now Pre-Texts has partnered with boards of education, schools, and cultural centers in Boston, Colombia, Puerto Rico, Mexico, Peru, El Salvador, Hong Kong, Zimbabwe, and Harvard's Derek Bok Center for Teaching and Learning (see pre-texts.org). Though developed for underserved schools, the approach is a natural for higher education too. Research univer-

sities now recognize that art-making can raise the bar for academic achievement, and Pre-Texts makes good on that promise.[18] It has significantly improved my teaching at Harvard, for example. A new undergraduate course called Pre-Textos tackles tough texts by Jorge Luis Borges, Juan Rulfo, Julio Cortázar, Alejo Carpentier, and Octavio Paz, though students still struggle with Spanish. The pilot class in 2011 made maps, choreographed, composed music, created storyboards, acted, and remarked on the mutual admiration that art-making generated in an intensely competitive campus. For a final project the group decided to coproduce a film based on the short story "Death and the Compass" by Borges.[19] Each member contributed a talent for acting, or directing, or music, costumes, photography, and so forth; and all wrote accounts of their work as co-artist with Borges. For another example, my graduate course Foundational Fictions and Film offers a creative alternative to the standard essay assignment: compose one chapter of your own nineteenth-century national novel and write a reflection on the process. The new novels and authors' notes almost always surpass the conventional essays, which hardly anyone elects. Creating a novel demands sensitivity to character construction, to registers of language, historical conflict, social dynamics, and intertextual references. Students will risk this "insider" appreciation of literature if teachers allow it.

Pre-Texts is an intentionally naughty name to signal that even the classics can be material for manipulation. Books are not sacred objects; they are invitations to play. Conventional teaching has favored convergent and predictable answers as the first and sometimes only goal of education. This cautious approach privileges data retrieval or "lower-order thinking." But a first-things-first philosophy gets stuck in facts and stifles students. Bored early on, they don't get past vocabulary and grammar lessons to reach understanding and interpretation. Teaching for testing has produced unhappy pressures for everyone. Administrators, teachers, students, and parents have generally surrendered to a perceived requirement to focus on facts. They rarely arrive at interpretive levels that develop mental agility. Divergent and critical "higher-order" thinking has seemed like a luxury for struggling students. However, when they begin from the heights of an artistic challenge, students access several levels of learning as functions of a creative process. Entering at the lower order seldom leads very far, but turning the order upside down works wonderfully. Attention to detail *follows* from higher-order manipulations because creative thinking needs to master the elements at hand.[20] A challenge to make something new of a text

drives even reluctant students to develop an interpretation, which requires understanding, and therefore leads to learning the vocabulary and grammar that had seemed bothersome or out of reach.

With Pre-Texts I finally responded in good faith to my own proposal that we offer our best professional work as a social contribution, the way creative writers do when they donate writing to the Cartoneras. Politics isn't always a pause from one's field of expertise. For me, literary studies became useful for civic development. This dialogue between scholarship and engagement, thinking and doing, is not a double bind, though the self-canceling figure haunts the humanities like a hangover from heady days of deconstruction.[21] With new dedication, I adjusted the Youth Arts course to take literature as the entry point for reading lessons in various academic fields. Whatever the art we facilitated or the discipline we targeted, a creative text launched interpretations, problem solving, research, and design. From the Extension School course we created a portable workshop that follows the model of Boal's Forum Theatre: an interactive approach that adjusts to local circumstances. We train facilitators, the way Boal did, in order to multiply agents and sites for implementation. Complex academic and civic results follow from a simple Pre-Texts approach: (1) Take a text. (2) Spin it using a range of available arts. (3) Reflect on what you did.

After writing, painting, dancing, acting, and so forth, participants sit in a Freirean circle to reflect, like Boal's spect-actors. The question is always the same: what did we do? (Asking what we learned is likely to get unfriendly answers from teens. They sense that teachers want approval or praise and refuse to comply. But if you ask what they did, students will want to justify their work or else they may look foolish.) One reflection follows another, in no set order, until everyone has spoken. After a few sessions the dynamic of universal and brief participation feels natural and necessary. The first few interventions, however brilliant, will not exhaust possibilities. While we wait for more, exercising critical thinking and patience with peers, intellectual and civic skills develop. New facilitators learn to expect original comments from one another and then from students. Participants also notice the democratizing effect of collective reflection; it levels the unevenness between forceful people and shy ones who are worth waiting for.

While readings deepen during the series of visual, literary, and performance interpretations of the same selected text, participants also develop breadth by going "off on a tangent" each week. Choosing a tangential text that they can connect to the shared reading in any way—even if far-

fetched—puts students in command and makes them read widely. They peruse books, magazines, and the Internet, using their own criteria to select something they are proud to bring in. The combined dynamic of inexhaustible interpretation of one text and the practically limitless reach of tangents produces deep and broad readers.

Recycled Words

Literature as recycled material: it had never occurred to me before. The Cartonera book covers made of recycled cardboard became objective correlatives for the recycled material inside. This was my simple summary of Milagros's practice, cutting through sophisticated literary criticism the way that Javier cut through cardboard. A daunting vocabulary of intertextuality, traces, iteration, permutation, point of view, focalization, influence, and reader-response, becomes user-friendly when readers abstract literary functions from their practice of making things with literary prompts. The functions add up to a general principle about literature being made up of reusable pieces, cuts and pastes and pastiches.

During the Harvard Cartonera week, Milagros demonstrated the literary recycling process through a character portrait exercise that I detail below. Here I'll just mention that she arranged us in pairs sitting back to back, while one person described a character from a story (Edgar Allan Poe's "Man in the Crowd") and the other sketched the description. After the first drawing, partners switched roles. When we taped the portraits onto the "gallery" wall, a visible diversity of interpretation for each character demonstrated that everyone had combined the text with extraneous material from personal memories, preferences, and cultural baggage. We could not clearly distinguish between reading—which had seemed passive for some participants—and the active addition of sketched details. Where was the precise division between receiving and making, understanding and imagining, reading and writing?

This was so effective and painless a lesson in deconstruction and in reader-response theory that I giggled out loud. It was positively fun, and I have repeated the activity many times with similarly profound and pleasurable results. When graduate students or colleagues play at this portrait-making, the fun heightens with reflections on the theoretical principles involved. One of my brightest graduate students celebrated Milagros's inaugural workshop with relief: "I don't hate narratology anymore!" Theo-

FIGURE 4.2. Cartonera books by Sarita Cartonera (foreground) and Kutsemba Cartão (background). Photograph by Christine R. Choi.

retical terms don't come up when we work with primary school children but in all cases, the lessons are as clear as they are welcome: Each participant is coauthor and authority of the work produced. Interpretation exercises both critical and creative faculties. And the divergent but plausible interpretations stimulate admiration for everybody.

It is obvious, isn't it? That books and plays and poems are made up of words, motifs, plots, characters, grammatical structures, and elements that already exist in other contexts and that authors borrow and recombine to produce arresting new works. Novelty is in the poaching and the recombination, not in the material which, logically, must already have been used if the new creation hopes to be understood. Wittgenstein wisely dismissed the possibility of private languages because they cannot communicate between one person and another.[22] All language is borrowed or taken over, including the language of literary masters. Every reader of *Don Quixote* knows, for instance, that Cervantes played with chivalric and picaresque

FIGURE 4.3. Cartonera books by La Casa workshop at Dartmouth College, Kutsemba Cartão, Sarita Cartonera, Qinti Qartunira, and Animita Cartonera. Photograph by Christine R. Choi.

sources to write his masterpiece. But the game of literary lifting goes even further; he shamelessly "admits" to picking up the whole manuscript, written by an Arab author, at a flea market. And Shakespeare is notoriously not the author of his plots, but the genius rewriter of appropriated stories. To introduce students to writing through the liberties that great writers take is to demystify the classics. It is to invite young people to try their own hand at altering texts with every new reading. Through artistic play, participants know that the classics of high culture and higher education are within their audacious reach.

The recycled nature of literature is hardly hidden, though we haven't said it so simply. The simplicity can tickle students and teachers of literature while it levels higher-order understanding. Thanks to the jokes generated by Sarita Cartonera's pedagogy—about the fundamental accessibility of literary criticism and also about great literature lifting other people's writing—playful sophistication can have a laugh at elitism. Anyone can get into the fun of writer as robber. Teachers can therefore be more effective and inclusive when they invite students to take pleasure from a text.

Cucu's Capers

Washington Cucurto isn't subtle like Sarita. The founder of Eloísa Carto-
nera writes with in-your-face freshness, flaunting the pleasures of irrever-
ent plagiarism. Cucu, or devil as he likes to be called in honor of his dark
skin, doesn't let you forget Argentina's racism. At home but out of place in
the country's literary tradition, Cucu's iconoclasm is something like graffiti
that tags an elaborate name on publicly sacred property. He smudges offi-
cial histories of Argentina in a mock-historical novel, *1810: The May Revo-
lution as Blacks Lived It*[23] (where the dusky-colored slave-dealing founding
father San Martín is greedy, licentious, and out of the closet) and splatters
sacred fiction with ruthless fun. *1810* works over *El matadero* by Esteban
Echeverría, *Hombres de maíz* by Miguel Angel Asturias, and *Justine* by the
Marquis de Sade. One addendum to the novel rewrites Borges's "Aleph" as
"Phale" (phallic joke intended, always). Another takes on Julio Cortázar's
"Casa tomada" (Haunted House) as "Dama tocada" (Defiled Damsel).

There's no anxiety of influence here, because Cucu figures that the coun-
try is too color-coded to let him pass for the new Borges or Cortázar. So he
just catches his country and everyone else at the same game he enjoys: lit-
erary theft. (Appropriation is the word postmodern art has used since the
time of ACT UP.) "Cucu,"—his alter-ego exclaims as *1810* begins—"this
is a historical discovery: all Argentine literature is stolen stuff. It's crazy!
Shameless!" And by the end of this reckless shuttle from orgy to battlefield
on a double-crossing loom of black and white, hetero and homo but always
over-sexual, it turns out that the recycled stuff that Cucu had stolen "and
all the other Argentine classics were written by descendants of those black
soldiers. That is to say, it's black literature, written by bourgie and bleached
out black-begotten Argentines."[24]

Rewriting is his hobby, Cucurto says, doing more homage than harm
to the greats. In fact, he tells his sports column readers that they too had
better read the classics if they want to play ball: "OK, everybody, get rid of
those PlayStations and read Onetti, or at least Fontanarrosa, read Osvaldo
Soriano, at the very minimum. You can't play good soccer if you haven't
read *Martín Fierro*, or Faulkner. . . . It sounds crazy I know, but let me
tell you that with more cultivated, sensitive ball players, readers of poetry,
Argentine soccer would be a lot better off. And don't let any of those bright
kids get on the field if they haven't read *The Adventures of Huckleberry Finn*
for starters."[25] His literary advice to ball fans, and his hobby of repurpos-

ing literary classics for personal fun, made Cucurto the ideal facilitator for Pre-Texts in April 2010 when Cultural Agents came to Roberto Jacoby's recently established CIA (Centro de Investigaciones Artísticas) in Buenos Aires.[26]

Already and independently, Eloísa Cartonera had set out to educate the neighborhood, sometimes in collaboration with the sculptor Raúl Lemesoff who created the *Weapon of Mass Instruction*. It is a recycled military tank that had participated in terrorizing civilians during the Dirty War (1976–1983). Today the retired but still imposing vehicle is a mobile purveyor of books, flanked on all sides with stacks of fiction, poetry, history, maps, and magazines. It collects books from dumps and rich neighborhoods and then offers them for free throughout the rest of the city. (A similar inspiration in rural Colombia created "Biblioburro," a traveling library fueled by two donkeys who accompany itinerant teacher Luis Soriano.)[27] Ever alive to the arts of turning trouble, like the trauma of armored tanks on city streets, into usable trash, Cucurto and friends mitigate the divide between high and low culture. Cucu takes elite taste by the throat (not to mention other body parts). Before he heard about Sarita's rewriting lessons, Cucurto was there at the forefront of appreciation-by-appropriation. His pleasure in playing with literature, pilfering and redeploying words, plots, and characters, the way all good writers do, is a profound lesson for literary criticism and for education.

Make Readers

Sarita Cartonera calls its literacy project LUMPA (*Libros, un modelo para armar*, or *Books, a Model Kit*, playing on a popular title by Julio Cortázar).[28] LUMPA is a loop between publishing and pedagogy in which books become found material for making endless variations. The program covers standard classroom concepts — author, plot, characters, themes — so that teachers meet required curricular objectives while they go further. Instead of just summarizing a plot, students also distinguish plot from story by arranging and rearranging moments of the narrative; and they recognize that a narrator may be lying (what a clever way to underline the nature of fiction) as they reassign the role of narrator to various characters of a story. In teacher-training workshops and then in classrooms, participants rewrite classics through alternative points of view, different times and places, and

in a range of literary genres, literally becoming authors as they master the vocabulary and techniques of a pre-text. The activities require both a lower-order focus on the found elements and higher-order interpretation.

From June through August 2007, Cultural Agents developed Sarita's pedagogy into the multi-arts approach of Pre-Texts by incorporating the experience of "Youth Arts" where we had painted, danced, sung, sculpted, filmed, cooked, written, acted, and generally played with academic learning. Arts, after all, do more than "express" ideas or emotions; they explore materials and construct meanings. Northrop Frye famously quipped that it was unclear if art imitates nature, but very clear that it imitates other works of art.[29] In our variations on Lima's lessons, literature explodes with renewed energy every time a different artistic medium interprets a selected text. Ablaze with art-making, even at-risk students hardly reckon the difficulties they deal with or the intense effort they expend. But the sophistication they achieve is evident to everyone.

That first summer, we launched three pilot programs in the Boston area (with the Brazilian American Association in Framingham, the Boys and Girls Club in Chelsea, and Zumix, an out-of school music center in East Boston), thanks to support for a student trainer from David Edward's course on creative entrepreneurship (Idea Translation, Engineering Sciences 147, Harvard College). The lessons we taught and learned have become a portable program that counts on local artists and teachers to sustain it. Cultural Agents brings nothing more than an iconoclastic approach to develop skills in critique and creativity. A bit more detail about one activity may illustrate how Pre-Texts builds citizenship through lessons in literacy. Take the portraits by partners mentioned earlier. You are welcome to try it and all the exercises listed below.

When participants sketch the same character and see that each image is different from all the rest, they sense that divergence is not a sign of error. This is a revelation for teachers who had assumed that only convergent answers are correct, one per question. During the reflection, participants will identify each personalized interpretation and skill level as factors that intervene. After the portraits are freshly hung in the "gallery" and the "curator" initiates the exposition by inviting a pair of artists to talk about their collaboration, they are usually reluctant to note differences between the description and the sketch. "Is this the figure you had imagined while you were describing it to your partner?" First responses often deny or diminish divergence in a friendly effort to signal collaboration. Even after the

facilitator probes an alleged convergence to reveal missed communication ("I meant really fat!") and liberties taken ("Purple is my color.") participants prefer agreement. Invariably though, both artists will admit that their interpretations carry references to personal experiences or preferences, or perhaps an embarrassed confession about not drawing very well. With good humor, the facilitator, or "joker" in Boal's vocabulary, can re-signify a simple stick figure as a work of "conceptual art."

Only after the curatorial interviews recur with several more portraits does the group begin to anticipate divergences between the partners and to enjoy each person's particularity. With the recognition that variations are both plausible and pleasant, participants realize that "correct" answers multiply by the number of interpreters. The conclusion amounts to an appreciation for the uncommon genius of each contributor. Variety—even miscommunication and disagreement—enriches the experience of the text, and readers learn to admire peculiarities.

Hip-Hop Signifies Close Reading

Some of Pre-Texts's best facilitators are unlikely teachers by conventional criteria. They are members of an Afro-Colombian hip-hop collective called the Ayara Family. When Cultural Agents trained local artists and librarians to be co-facilitators for a 2008 workshop of almost one hundred educators in Bogotá's main library, the Ayaras emerged as star instructors. No one matched the hip-hoppers as we manipulated metaphors and identified clever turns in Colombia's classic, and difficult, national novel *La vorágine*.[30] The Ayaras knew that young people can turn the challenges of literary masters into dares to outdo the masterpieces. Riffing on found material, or sampling, is the stock-in-trade of rap (rhythm and poetry). Also called appropriation, the combination of homage to sources and irreverence is the spirit of graffiti, urban choreography, musical mash-ups, and theatrical improvisation. These adventures in artistic displacement show the interpretive intelligence of hip-hoppers and recommend them as facilitators of critical thinking for other young people.

Experienced in violence prevention through the arts, the Ayaras know that artistic ingenuity is a powerful antidote to conflict, because art honors nonconformist energies and channels them toward symbolic violence. Otherwise, hostility festers, aggressively. Aggression is natural in children and intense for teens. It is an energy that tests the environment, starting

with the way children test their parents, to see if they are sturdy and don't disappear. If parents pass the test, they merit a child's love. This is Winnicott's formulation for psychic development, advancing through play from hostility to affection.[31] (More on Winnicott in chapter 5, "Play Drive in the Hard Drive.") The Ayaras are a model crew for Pre-Texts. They have by now added high-order literary instruction to hip-hop arts and have done so with the support of the Banco de la República (Colombia's equivalent to the Federal Reserve Bank). The collective facilitates literacy workshops in areas as isolated and underserved as Nariño and Amazonas as well as in the capital's largest prison.[32]

The popularity of rap in Colombia and throughout Latin America (as well as Africa) should be no surprise, since Black Atlantic cultures of improvisation connect the Americas back to Africa. The international appeal of rap is less a phenomenon of U.S. cultural imperialism than an African reconquest. Far-flung performance traditions of dueling and outdoing in duet—irreverent repartee, *signifying* in the United States, *payadas* in Argentina, *debates musicales* in the Caribbean, *contrapunteo* in Colombia, and *repentes* in Brazil[33]—all attest to legacies of the African spirit that flashes through a range of musical and verbal genres. Melville J. Herskovits might have guessed at this north-south vector by 1941 when he showed the connections between U.S. black cultures and continuing practices in Africa. Then Robert Farris Thompson tracked the ties of African-inspired genres from the United States to South America.[34]

In this transatlantic and inter-American context, is it uncanny or predictable that contemporary hip-hop should connect with a folk tradition of performance and writing in Brazil's Northeast? *Literatura de cordel*, or literature on the clothesline, is literally the practice of hanging poems, rhymed news articles, musical challenges, and illustrative woodcuts on a rope, sometimes with clothespins, in order to inform, entertain, and entice the public to purchase a copy of the work. We learned this from ArtsLiteracy and appropriate the practice for Pre-Texts.[35] A Brazilian journalist marvels at the connection between this line of writing and African American arts:

> I have always been impressed with the strange relationship that exists between northeastern improvisational poetry and American rap. They are separated by cultural kilometers, temporal distances, improbably singing the same verses. Nevertheless, they are peers, almost twins. In rap, and in improvised *"repente,"* the verse is a flash,

almost a haiku; it follows a fixed, catchy rhythm that stays in your head; the lyrics are clever, on target, and the listener's mental agility doesn't quite follow all of the words in the song. When *"repente"* poems go on paper, the paper goes onto the clothesline, which in the past might have been called the major newspaper of the Northeast. People from the Sertao knew what was happening thanks to the popular "news-line." They say that when Gétulio died, it wasn't until the *cordelistas* hung up the news that people found out.[36]

The multi-arts approach to interpretation shared by Pre-Texts is as hard-wired in the *cordelista* tradition as it is in the culture of hip-hop. Northeast Brazilian poets are often also the guitar-strumming performers of improvised verse that they can later polish and publish "online." The same artists can double or triple as woodcut masters who call attention to their poetry with clever visual images, sometimes simply to spread news of important events. But other times, they take full freedom as spinners of fiction. For example, J. Borges (whose name evokes another writer who played masterfully with variations on a theme) is both an accomplished woodcut artist and a poet turned theorist. He teases an interviewer with a frank formulation of fiction: "I lie. Let's face it; lies are a quality of all creativity."[37] *Literatura de cordel* is the third moment of our Pre-Texts workshop.

Open Shop

The first moment rehearses the bustle of Cartonera publishers, as participants enter and engage their eyes, hands, and brain in the tangible art of making a book. Sounds of high energy come from people cutting cardboard, choosing materials, and constructing covers to be decorated with markers, glitter, buttons, bottle caps, string, and so forth. Then, when designs are sufficiently advanced and attention focuses on manual details, the second moment begins. A voice starts to read out loud the selected text, and the bustle quiets down. Everyone can hear the reading, even if the piece is difficult. The audible silence is a sign that people are listening; another sign is the frequent request to hear the piece again. This scene simulates another popular practice from Latin America: the reader in tobacco factories. Still alive in Cuba, but barely, our intentional throwback to an earlier period revives challenging literature as an object of collective desire and as a foundation for social interaction.[38]

Readers in tobacco factories were celebrated throughout the Spanish Caribbean during the nineteenth and at least the first half of the twentieth century. The practice rippled into workshops of other cigar centers such as Tampa, Florida, and New York City. The cigar "factory" was practically a popular university for tobacco rollers. Their silent and skilled work rolling tobacco into expensive cigars produced great value and therefore gave workers significant power to press demands in negotiations with factory owners who could not easily replace the skilled workers. One standard and nonnegotiable demand was that cigar makers be allowed to hire a professional reader and to select the reading materials. All the workers, literate and mostly illiterate, would engage with both classic and cutting-edge literature from fiction to newspapers and novels, sometimes including incendiary political treatises as they listened and later discussed the readings. Here is Jesús Colón's memoir of a factory in Cayey, Puerto Rico:

> There were about one hundred and fifty cigarmakers, each one sitting in front of tables that looked like old-fashioned rolltop desks, covered with all kinds of tobacco leaves. The cigarmakers with their heads bent over their work listened intently. In the vast hall of the factory, I looked for the source of the voice to which they were listening. There was a man sitting on a chair on a platform. . . . He was called "El Lector" — the Reader. His job was to read to the cigarmakers while they were rolling cigars. The workers paid fifteen to twenty-five cents per week each to the reader. In the morning, the reader used to read the daily paper and some working class weeklies or monthlies that were published or received from abroad. In the afternoon he would read from a novel by Zola, Balzac, Hugo, or from a book by Kropotkin, Malatesta or Karl Marx, Famous speeches like Castelar's or Spanish classical novels like Cervantes' *Don Quixote* were also read aloud by "El Lector."[39]

Before Pre-Texts facilitators begin their reading, they prompt participants to think of a question as they listen, the way children ask questions of a story that they hear. In conventional classrooms, teachers ask students about details or themes of a text to see if the class listened and understood. This can bore or offend students who may wonder — as I used to wonder — if the teacher thinks they are stupid or if she needs help to understand the story. But here the student participants are invited to demand more than they get. Authorities and interrogators, each participant speculates about

missing details, motivations, background, and so forth and frames an exploration of some interpretive tangent. After hearing everyone's question, the next move is to choose one and to write a possible explanation or imaginative development of the text. Then the intertexts are hung on a *cordel* for instant publication in this third moment of activity. Each author can then read the contributions of others and marvel at the range of responses. People will often take pains to write beautifully, or at least legibly, to welcome passersby.

Civic Self-Efficacy

Pre-Texts works in schools, after-school programs, summer programs, and out of school with young people at all levels, from kindergarten to graduate studies. The most significant benefit of Pre-Texts is surely to stimulate literacy and higher-order (interpretive) thinking. But the corollary effects of free-thinking, imaginative alterations and admiration for the work of others are significant contributions toward civic development. Consider the history of social and political effects from reading literature, philosophy, history, and the news among cigar rollers. Well-informed and deliberative, whether or not they could read themselves, tobacco workers were largely responsible for José Martí's otherwise unlikely success in organizing a cross-class alliance for the Cuban War of Independence.[40] Cigar rollers are also the first movers of organized labor in the United States, in good part because Cuban and Puerto Rican immigrants brought *lectores* with them to U.S. tobacco factories.[41] We sometimes forget that Samuel Gompers, a founder of the American Federation of Labor (AFL) and its president from 1886 until his death in 1924,[42] was first the leader of the Cigar Makers International Union and worked closely with Caribbean colleagues.[43]

Today's "readers" and facilitators for Pre-Texts invite young people to interpret and to deliberate, as the *lectores* did in tobacco workshops. Adding the creative arts identifies appropriation as a social resource. Civic participation depends on creativity, an (aesthetic) knack for reframing experience, and on a corollary freedom to adjust laws and practices in light of ever-new challenges. Without art, citizenship would shrink to compliance, as if society were a closed text. Reading lessons would stop at the factual "what is," rather than continue to the speculative "what if." Toward that imaginative exploration grounded in the "common sense" of shared classics, Pre-Texts proposes:

1 To encourage ownership of classic texts by interpreting creatively.
2 To connect literature to one's own lived experience. Paul de Man put the connection boldly by saying that all (creative) writing is autobiographical.[44]
3 To experience that all texts are open to creative intervention; reading necessarily intervenes through dynamic negotiations rather than impositions.
4 To demonstrate that reading and writing are two moments of a developing process; reading cannot be passive but affords opportunities for coauthorship.
5 To appreciate language itself as an artistic medium, a trigger for other arts.

Implementation

Pre-Texts is an approach, not a detailed recipe. Years ago, Freire warned us against prepackaged pedagogies that urge innovation and deliver exhaustive instructions.[45] In his spirit, we train instructors to liberate their own creativity through variations on activities that we demonstrate, and through new activities they propose. Youth-leaders and collaborating artist-instructors need to "own" their particular version of the program in order to model independence and good humor about mistakes. Learning from participants, we keep adjusting activities and experimenting with new ones.

Ideally, training workshops last for a week. The formula of spinning a difficult text through an artistic practice and then reflecting on what we did is simple enough to learn in one session. The next four provide practice in appropriation as each participant takes a turn to facilitate an arts activity based on the same pre-text. We train teachers and local artists together so that they learn from one another, and overcome possible assumptions about a lack of creativity on one side and a lack of seriousness on another. During the implementation with children and youth, usually for ten to twelve weeks, Pre-Texts generally meets twice a week, facilitated by a classroom teacher or a counselor and in collaboration with artists who rotate through the classrooms to bring both technical expertise and variety to each group. If resources are limited, teachers themselves can pool their talents to vary the arts employed in class. This arrangement satisfies the principle of artistic variety and exposes the students to several adult men-

tors without incurring the costs and administrative complexity of hiring another team of artists.

The compelling reason to work with a distribution of arts is to make good on the principle of "multiple intelligences," coined by Howard Gardner, to develop each participant through a range of talents.[46] Once a young person is acknowledged as someone who can paint, or rap, dance, or act, and so on, he/she gains the recognition and self-esteem that encourages taking risks in other arts. Healthy risk-taking in art is a step toward interpretive reading and writing, critical thinking, persuasion, and deliberation.

A lo Chalco

Chalco is one of the poorest neighborhoods of Mexico City, far enough away from the center along the traffic-clogged highway to Puebla to feel isolated as well as arid most of the year, and inundated the rest of the time. There, migrants from several indigenous and mestizo communities settle alongside one another in precarious arrangements and constructions. Though the government of the Federal District has begun to construct an administrative infrastructure in Chalco, the unpaved streets are still lined with makeshift dwellings put together from any available materials, including cardboard. The art of recycling is no news here. But before the Cartonera came to town, no one had yet made books from found material.[47]

In July 2008, Worldfund hosted Cultural Agents to train a team of educators in Chalco's admirably dedicated Catholic school, Mano Amiga. Mostly local artists worked with us there, as elsewhere, to ensure sustainability of collaborations with the regular teaching staff. We later brought Pre-Texts to other sites in Mexico, including the Museo Amparo in Puebla, the University of Guadalajara, and two public middle schools in the outskirts of Mexico City, as well as to the secretary of education in Puerto Rico, the Chana and Samuel Levis Foundation, and Caribbean University in Bayamón, Puerto Rico.[48] We trained trainers in Bogotá and Medellín, in San Salvador, and Hong Kong. Even before we ventured out, Cultural Agents implemented Pre-Texts in six struggling grade schools in the Boston-Alston area, through Harvard's Achievement Success Initiative in collaboration with Boston's city government. And the Barr Foundation's citywide project in "Culture for Change" engaged Cultural Agents to develop Pre-Texts for youth at risk in a dozen sites throughout Boston. A spectacular success in

Zimbabwe promises important developments after Harvard College student Naseemah Mohamed brought the approach to Bulawayo. There, 85 percent unemployment meant that high school teachers could not motivate students with promises of good jobs, so they routinely resorted to corporal punishment. A season of Pre-Texts showed that pleasure could motivate learning, and it softened even hardened teachers who expressed surprise at the artistic and intellectual talents of their students. Students were correspondingly delighted, and relieved, by the change in teachers. These were the desired effects of Pre-Texts, though they outstripped even Naseemah's contagious optimism. But there were surprising side effects too: English lessons began to admit bilingual games with Ndebele, which had been a punishable offense; and the minister of education plans to replicate the program throughout the region.[49] Pre-Texts in Zimbabwe may someday outshine other sites. But so far, Chalco is the most stunning example of appropriation and sustainability.

Maybe it is the intense dedication of the director of Mano Amiga, Lilia Garelli, and of her devoted faculty that determined the exceptional achievement. Maybe it is also the refreshing contrast of a creative—even iconoclastic—approach to teaching in an otherwise traditional Catholic school where convergent responses had been the standard value. In fact, on the first day of the training workshop we asked the ten teachers and ten artists to say what came to mind after listening to "The Two Kings and the Two Labyrinths" by Jorge Luis Borges. All but one gave the moral of the story, satisfied that their coherence was a sign of understanding. The only outlier, a young Oaxacan painter who took time to warm up to the group, mused, "I wonder, what is the color of the sand?" By the end of the week everyone was taking brilliant risks and multiplying the possibilities of the one-page story. Later, throughout the ten-week implementation and up to the present they have been inspiring innovation in their students. (See the weekly photographic reports from Chalco on the culturalagents.org website.) The latest developments are a partnership with the nearby public high school to integrate Pre-Texts into youth-mentor training, and another with Mano Amiga's sister school in Puebla to offer teacher training. Maybe too the success in Chalco owes to the everyday practices of recycling in a poor neighborhood, giving this scarcity-induced resourcefulness a new legitimacy as art and interpretation.

In her delicate, almost girlish but unflinching voice, Director Garelli would typically address a challenge that required more resources

than she had. Good results would follow from deciding to do whatever was needed *a lo Chalco*, "Chalco style." Room-darkening window shades were an out-of-the-question luxury, but dark crepe paper worked just as well and looked elegant against the clean brick of the new school building. Salaries for five artists, in addition to the five teachers to be paid in these extra-hour collaborations, stretched the school's purse to the tearing point, so two mothers of children at school were invited to donate their skills to complete the design of multiple arts that rotate through the classrooms from third to seventh grades. However one describes the combination of personal, economic, and pedagogical factors, they came magically, or providentially, together in "Amiga Cartonera." On their own initiative, participating children also brought Pre-Texts activities home to siblings and neighborhood friends, a multiplying effect we saw in Puebla's Amparo Museum too. In the words of one sixth-grader, "My imagination woke up more. Sometimes now, others look at me as if I have something funny in me. I have something inside that doesn't let me be, an active imagination. It was always there, but it woke up more. My thoughts are bigger now. The important thing is what someone carries inside them."[50] At Mano Amiga, teachers and artists appropriated the iconoclastic spirit of the program and they continue to cocreate it.

At this writing it is difficult to predict where Pre-Texts will be when you read about it. But do check the culturalagents.org website for updates and for frequent invitations to join a workshop. Why not prepare some clean cardboard and keep it handy? Here's a preliminary list of activities if you want to start one.

Sample Activities

WARM-UPS. These are exercises designed to relax inhibitions, defamiliarize habits, and create a core spirit of trust and cooperation among participants. Many suggestions are described in Augusto Boal's *Games for Actors and Non-Actors*.[51]

BOOK-MAKING. Even before any literature appears in the program, participants begin to make book covers by choosing recycled materials prepared for them, or brought in from home and the street. They design ways to intervene in printed/used cardboard as a preamble for intervening in printed texts.

READING ALOUD. A facilitator invites participants to think of a question to ask of the text while they listen to it as they continue to make individual books. Recent studies have corroborated the relationship between heightened levels of attention and manual activities, overturning a conventional assumption that a doodling student is inattentive.[52]

QUESTION THE TEXT. Each participant poses a question. Instead of putting students on the defensive by asking them to repeat given information, this activity targets the text and casts participants as interrogators. Asking a question of the text also reveals that literature is a product of an author's decisions to include some details and exclude or suggest others. The piece becomes vulnerable to manipulation as soon as participants notice that the story could have been told in different ways.

INTERTEXT. After formulating questions of the text, and sharing them orally, participants respond to a question, theirs or another's, by writing an interpolated paragraph that develops what had been a fuzzy or enticing opportunity in the text.

LITERATURE ON THE CLOTHESLINE. Participants hang their intertexts on a clothesline with clothespins (or tape) for instant "publication." The effects of displaying one's own work and also reading the work of peers include pride in a good piece of writing, greater development of interpretive possibilities, and also admiration for others.

PORTRAITS, BACK-TO-BACK. Participants sit back-to-back while one describes a character from the text and the other draws the description. Gallery conversations follow and participants observe that oral and sketched renderings necessarily interpret the text with personal and culturally specific elements.

RAP, RHYTHM, AND POETRY. Spoken-word artists are unfailingly good guides to explorations of literary figures and indirect communication that produces estrangement, a favorite signature of art in formalist criticism.

MOVIE MUSIC SCORE. To develop interpretation along with music appreciation, invite participants to develop a music score for a film version of the text. The facilitator plays five or six one-minute music fragments and asks participants to mark corresponding numbers on particular passages that the musical fragment could accompany. Then they explain the choices, literarily and musically.

POINT OF VIEW. Photography is an increasingly available art form, thanks to cellular phones. Invite participants individually or in groups to take pictures from a particular character's point of view, or to compose references to a theme. Then project the photos onto a screen for viewing and commentary. The activity makes lessons in perspective and composition quite clear though they seem difficult in literary and social criticism.

LITERARY FIGURES ALIVE. Image Theater is a practice developed by Augusto Boal to create human sculptures that capture a conflict and freeze it long enough to arouse reflections. But in Pre-Texts it can also be an invitation to embody literary figures in small groups of participants. Have each group locate a figure in the text (call them surprising descriptions; the terms metaphor, metonymy, synecdoche, simile, etc. can be offered later to refine readings) and create a collective human sculpture. While each sculpture is staged, participants from the other groups attempt to "read" the figure by locating it in the text. This game of literary charades turns a possibly abstract lesson in rhetoric into entertainment that can be sustained long enough for everyone to master the power of literary devices. Meanwhile, participants read and reread the text to identify the figure.

FORUM THEATRE. Although it is less text-specific than other activities, we often smuggle Boal's Forum Theatre into the program as an opportunity to teach an effective exercise in conflict resolution. Participants identify an apparently intractable problem in the text, and thereby recognize it as familiar, perhaps intimately so. Then groups prepare skits to represent a chosen problem. After each skit is performed, the facilitator invites the spect-actors to intervene, one after another, in ways that can derail the tragedy.

GRANDMOTHER TELLS THE STORY. Pre-Texts can seamlessly develop into a bilingual arts program by adding activities that depend on a language other than the target language. Since the program multiplies approaches to interpretation, it will not seem foreign to ask participants to retell the story from the point of view and the language of a non-English (or Spanish, etc.) speaker. Students will display their virtuosity by performing in another target language; and they can count on family members to contribute to their learning, strengthening bonds of respect and admiration at home.

OFF ON A TANGENT. Participants browse widely in libraries, bookstores, homes, cultural centers, and so forth to find a literary sample that can in some way be related to the core text of the workshop. If the connection is

far-fetched, participants will engage in the amusing mental agility of justi-fying the link. The only specific instruction is that the tangent have at least one challenging word. This activity is the only one repeated each week, to encourage participants to read widely.

WHAT DID WE DO? After every activity, we ask this question. Each par-ticipant is obliged to offer a comment and good civic effects follow: The rule itself levels rights and shares responsibility. Students come to expect interesting responses from everyone, including shy members, so that facili-tators need not single out students for taking over or for holding back. The group learns to self-regulate. Intellectually, "What did we do?" stimulates higher order thinking by deriving theoretical observations from concrete practices. Almost inevitably, comments can be given technical names in lit-erary theory, language philosophy, and group dynamics.

Play with Me

Young people love to learn but hate to be taught.[53] They learn best through guided play. I am convinced along with Winnicott that this is true for adults too because play doesn't stop for human beings. Learning through cre-ative play is not new to education. Over a century ago, Maria Montessori pioneered an arts-based, project-centered pedagogy that managed to edu-cate poor and intellectually limited (today's special education) children in Italy so well that, without teaching for testing, they scored above average grades in national standardized exams. Like later reformers, including Bra-zilian Paulo Freire, French Jacques Rancière, and a North American rogue teacher like Albert Cullum,[54] Montessori's guiding principle was respect for the self-educating capacity of students. "The task of the teacher becomes that of preparing a series of motives of cultural activity, and then refraining from obtrusive interference."[55] Sequels to her approach or parallel projects, such as the Waldorf Schools[56] and the Reggio Emilia project in early child-hood education[57] confirm the evidence of superior results through arts-based education. Engaging children in creativity demonstrably enhances their disposition to learn a range of intellectual and social skills by culti-vating concentration and discipline through pleasurable, even passionate, practices. Yet Montessori and Waldorf schools now serve privileged classes rather than public classrooms. Cynics aren't surprised; they figure that the real mission of public schools is to train obedience, not to educate initia-

tive.[58] Poor districts, overcrowded classrooms, and deflated expectations all conspire against poor children's creative explorations.

To compound the problem, beleaguered teachers under pressure to produce passing grades on standardized tests suppose that engaging in artistic play is a distraction from academic work. As in Montessori's Italy and Freire's Brazil, the United States and many other states need to address the poverty of imagination in underprivileged schools that resentfully submit to standardized testing and remain risk-averse. South Korea and Finland have dramatically improved their ratings through arts-integration.[59] Pre-Texts recovers some lessons in creative learning, not only from modern educators but also from Renaissance masters such as Leonardo Bruni who taught that great writers are our best teachers. "Read only those books written by the best and most esteemed authors of the Latin language, and avoid works which are written poorly and without distinction, as if we were fleeing from a kind of ruin and destruction of our natural talents."[60] Secular classics offered tool kits of useful vocabulary, clever grammatical turns, and a knack for literary figures. Today's classics include modern and contemporary works. Along with passages from Aeschylus and Virgil, Pre-Texts has used pages by Jorge Luis Borges, Gabriel García Márquez, Toni Morrison, Ray Bradbury, Maxine Hong Kingston, Víctor Hernández Cruz, Rabindranath Tagore, Octavio Paz, James Baldwin, Ralph Ellison, Mayra Santos-Febres, and Julio Cortázar, among other masters.

As cocreators and connoisseurs in training, students exercise their critical faculties. They poach elements from the classics for their own writing, learning to admire the found text as rich material for variations. They treat texts as raw material for improvising plots, for constructing characters, or changing the register of language. The challenge to change a text leads young readers to engage their analytic capacities in explorations of the original text so that they can propose a personal twist. Critical readers learn to mine the classics for lexical, grammatical, and structural elements. Texts become palpable for young iconoclasts who poach with creative purpose, demystifying literature into usable stuff that can be appropriated. There is no need to select "relevant" reading materials and thereby to limit literary exposure, because youths can authorize themselves to make any text relevant through their own irreverent versions. Young creators develop mastery of a text by refusing its ultimate authority.

Teachers are show-ers not tellers. Real maestros don't explain; they point out materials and techniques and then let students explore. To ex-

plain is to preempt another's interpretive capacities. I learned from my Montessori-trained daughter that preemptive explanation, "stealing one's learning," is the dreaded error in this child-centered pedagogy. Romance languages capture the spirit of teaching in the verbs *enseñar* and *mostrar*, "to point toward" or "to show."

This Montessori and Freire-like antiauthoritarian understanding of education is the theme of Jacques Rancière's *The Ignorant Schoolmaster*, a biography of a French Revolutionary teacher of philosophy who urgently needed to leave France after the monarchy was restored. Jean Joseph Jacotot accepted a friend's invitation to teach in Belgium, though he knew no Dutch. The desperate exile preferred to risk looking incompetent rather than risk his life. Luckily, a bilingual edition of a popular novel came out that year; and to his delight, Jacotot found that his students could teach themselves French by pouring over that book.[61] Students can teach themselves when teachers give them tools and set high expectations.

Teacher training in Pre-Texts takes this lesson to heart as participants first create particular interpretations and then pause to formulate general observations. Explanations, interpretations that converge and diverge, and admiration for the range of creativity all come from the players in eureka moments that reflect on art-making. They add up to a dynamic civic education that takes the form of aesthetic education and brings us back to Schiller.

FIVE. **Play Drive in the Hard Drive**
Schiller's Poetics of Politics

While the French Revolution was spinning out of control, Friedrich Schiller wrote *Letters on the Aesthetic Education of Man* (1794).[1] He began the night he heard that Louis XVI had been executed.[2] Soon, the very Jacobins who killed the king (after inviting Schiller to be an honorary citizen) would themselves go to the guillotine. The *Letters* don't rail against violence. An aggressive tone would have violated Schiller's conciliatory message that art, not arms, achieves political freedom. It is a promise that has inspired generations of philosophers and activists to explore what art-for-everyone can do for democracy. Pragmatist John Dewey and post-Marxist Jacques Rancière cite Schiller as their mentor for recognizing art as a motor of political development. Liberal philosopher Jürgen Habermas cites him too, for stimulating the imaginative construction of new agreements through "communicative action." A mention of Dr. Winnicott's prescription to play, and of Freire's link between pedagogy and politics, develops this spotty genealogy a bit more but won't amount to an academic contribution. My purpose is more practical, as was Schiller's.[3] It is to prime urgent conversa-

tions with his interdisciplinary, enduring, almost eerily contemporary invitation to loosen up and play.

Today's troubles bring back Schiller's worries about the French Revolution, which had run headstrong behind reason into the "barbarism" of political purges. Specters of that abstract and unfeeling reason brought the United States to war in Afghanistan and Iraq. In the name of reason economic disparity grows, immigration policy stagnates, and public education squeezes out creativity.[4] Schools earnestly bent on practical results add a math class or a prep session, hoping to raise scores on standardized tests. Ironically for educators and tragically for children, the sacrifice of divergent play to convergent correctness has kept scores down, because the tests measure more than data retrieval. They also gauge the critical faculty of interpretation which develops by exercising the imagination, or playing.[5] Schools are failing our children through indifference or excessive caution about creativity.

We should worry again about the connection between play-starved education and eroded mechanisms for political debate, if worry can lead beyond deadlocks. Too often, academic essays pursue analysis and critique but stop short of speculation about remedies, as if intellectual work excluded an element of creativity. In fact, essays that remain risk-averse miss the potential of the genre to "assay," or try out, ideas. I confess my preference for the free play of new possibilities. Freedom to speculate is the condition for "the new humanism," in a recent rehearsal of Schiller's concern about imperious (French Enlightenment) reason that ignores (English Enlightenment) sentiment.[6] Schiller's contribution to the tension was to identify and to coin a third kind of energy that new humanists can play with: the *Spieltrieb* or play drive, our innovative faculty for turning conflict into works of art.

Let's Loosen Up

Our humanity depends on it. Play is the hardwired instinct for freedom and for art, Schiller was sure and neuroscience confirms.[7] It is the drive that can harness man's two other and mutually murderous instincts, the passionate *Sinntrieb* and the rational *Formtrieb*, into the energy for producing aesthetic pleasure. Between the rock of reason and the hard place of mindless sensuality, man is practically a civil war in himself: savage by enslavement to passionate nature, and barbarous by the pitiless exercise of reason (letter

20).⁸ Humans survive, Schiller observed, when they get those drives to play together. Seriousness may address what is true or moral (and intransigent), but play (amoral and disinterested) opens paths toward liberty (letter 15). Other philosophers watched the revolutionary convulsions in France and turned anxiously to political events, where they assumed the "great destiny of man is to be played out" (letter 2, 223); they evaluated competing designs for a State that could construct and preserve civilization. But Schiller mistrusted the cold scrutiny, and he bracketed the big political questions. Instead, he went to the heart of the matter and to the heart of man when he named the political crisis as an abandonment of the imaginative arts and therefore of freedom: "Utility is the great idol of the time, to which all powers do homage and all subjects are subservient. In this great balance of utility, the spiritual service of art has no weight, and, deprived of all encouragement; it vanishes from the noisy Vanity Fair of our time. The very spirit of philosophical inquiry itself robs the imagination of one promise after another, and the frontiers of art are narrowed, in proportion as the limits of science are enlarged" (letter 2, 223). More than two centuries later, the recurring impatience would compel Martha Nussbaum to remind readers why democracy needs the humanities.⁹

Schiller anticipated objections. Perhaps the young reader to whom he addresses these letters would prefer "a loftier theme than that of art," which probably seemed "unseasonable in desperate times" (letter 2, 222). Yet Schiller's brief for the arts is quite practical, he explains, because play can lead indirectly to political liberty while more direct means, including didactic "art," keep missing the mark. "For nothing agrees less with the idea of the beautiful than to give a determinate tendency to the mind" (letter 22). Making something new—something for which there is no prior concept—is the liberating activity that raises man above his dual and dangerous nature.¹⁰ Only playfulness creates multiple perspectives that bypass the mono-vision of sensuousness or of reason.¹¹ The opposite of play is not work or seriousness, not even depression, anthropologist Gregory Bateson would explain for socio-ecological reasons; it is the one-dimensionality or literal-mindedness that leads a species to extinction.¹²

True artists don't deny or avoid conflict; they struggle with it, energized by contending forces. New works of art bear a mark of the freedom that engendered them. And that mark, made visible or audible to the public through a work of art, multiplies the experience of freedom into a shared, or common, sense that supports enlightened politics. By contrast with play

as a path toward liberty, the impulsive and deductive political philosophy of France forfeited the freedom it too desperately pursued. Mere reason underestimated the real dangers of resistance and reprisal, which is why Hannah Arendt preferred the liberal and pragmatic American Revolution.[13] But now in late or postmodernity when liberal routes seem clogged, what path can we take toward political freedom? Schiller would not have been stumped by the question, because his answer has staying power.

It is play understood as artistic creativity that offers the only sure, if indirect, conduit to liberty. Schiller insisted that "this matter of art is less foreign to the needs than to the tastes of our age; nay, that, to arrive at a solution even in the political, the road of aesthetics must be pursued, because it is through beauty that we arrive at freedom" (letter 2, 224). Almost anyone at the time could see that pursuing reasonable shortcuts to liberty, indifferent to human passions and material needs, does violence to the very humanity that reason would set free. Schiller's remedy for revolution is an aesthetic education. To be moved by an aesthetically pleasing effect is to acknowledge freedom in wrestling material into new forms, repairing the damage that flesh and spirit do to one another. At precarious peace in the world, an artist or an admirer—both count as active citizens for Schiller, though real fans play at being artists—achieves freedom and invites others to share and to cultivate the experience. Cultivating this freedom into a general condition of possibilities in collective political life is Schiller's ambition. And since wrestling with matter and circumstance takes discipline and training, he sends *Letters* to encourage and advise us.

Face to Face

Strategically, Schiller addresses himself to one reader, his patron, Prince Friedrich Christian of Schleswig-Holstein-Augustenberg in Denmark. By publishing the letters, Schiller invites each of us to read as if we were the prince himself. (Did Schiller learn the tactic from Machiavelli?[14]) The point was to reform one individual at a time. Even though he concedes that "the establishment and structure of true political freedom" is the most perfect work of art (letter 2, 223), that work needs to prepare appropriate material in the shape of sturdy and judicious citizens. Unlike other arts that can transform raw material beyond recognition into new objects, pedagogy and politics demand a gentler touch; they depend on preserving the integrity of human beings as both the material and the ultimate users of the

product: "The political and educating artist has to treat his material with a very different kind of respect from that shown by the artist of fine art to his work. He must spare man's peculiarity and personality, not to produce a deceptive effect on the senses, but objectively and out of consideration for his inner being" (letter 4, 229). The aesthetic education offers a "subjective" transformation of each person's private war of conflicting drives into a knack for making beautiful public peace offerings.

"To deny the importance of subjectivity in the process of transforming the world and history is naïve and simplistic," Paulo Freire would confirm in response to "scientific" Marxists; "It is to admit the impossible: a world without men."[15] The response repeats in Fredric Jameson's endorsement of aesthetics over the social sciences. Abstract concepts can be taught directly, Jameson admits, but "it is increasingly hard for people to put this together with their own experience as individual psychological subjects in daily life. The social sciences when they try . . . become an ideology. Aesthetics addresses individual experience," and effects a change of heart.[16] This attention to subjectivity and skepticism about rule-generating human sciences characterize Gramsci's project too, as the real revolution will be the achievement of gradual cultural change. Equally skeptical about the pretensions of politics, Jacques Rancière defends the subject-centered, one-on-one approach to social change.[17] No enlightened masterpiece of legislation can move people to identify with the state, unless each participant is already educated in the spirit of freedom that the state presumably represents. "Perhaps there is a vicious circle in our previous reasoning," Schiller teases (letter 9). The discouraging circle is familiar to Freire too: "If the implementation of a liberating education requires political power and the oppressed have none, how then is it possible to carry out the pedagogy of the oppressed prior to the revolution?"[18] Rancière puts it this way: "People were dominated because they were ignorant and they were ignorant because they were dominated."[19]

To break out of the frustrating circle, Schiller coaches, take a step back, away from the conflicting sides. The opening activity or "instrument" that affords some distance for contemplation "is the art of the beautiful" (letter 9). There is really no alternative because without the "disconnection" from habit that art provokes, man stays torn, stuck in material appetites and arrested by strictures of morality.[20] Coaching takes time, Schiller admits, so we should be prepared to spend it. (Gramsci's unorthodox cultural reformism needed time too.[21]) No quick fix will do for human development

because rushing ahead of our "subjective" time-bound bodies to design an "objective" timeless State is sure to suppress a good part of our humanity (letter 4, 229). The best part is our capacity to experiment, to select and rearrange existing materials, to imagine unprecedented combinations; that is, to play.

Symbolic Destruction

Donald Woods Winnicott would come to the same conclusion through his work with children. On the thrilling border between subjective fantasy and objective reality, play is the fundamental activity of human development and of sustained psychic health. Agreement with Schiller may be coincidental. Perhaps Winnicott read Schiller's briefs, though we have no evidence.[22] We do know that Winnicott developed an aesthetics through psychotherapy, one child at a time, early on; and he elaborated his notes on play over a lifetime.[23] Schiller wrote "man is truly human when he plays, and he plays when he is truly human," (letter 15) as if summarizing Winnicott's work.[24] The therapist included his own practice among the playful and creative (that is, human) activities he studied: "Psychotherapy takes place in the overlap of two areas of playing, that of the patient and that of the therapist. Psychotherapy has to do with two people playing together."[25] This means free and nonpurposive communication, which the analyst must not force into reasonable sequences.[26]

The instinct to play surfaces immediately, says Winnicott, with a newborn's search for its mother's breast.[27] The breast materializes because the mother also plays, bending to the baby's will in order to welcome it as creator of its world. The early games multiply throughout life as "play is the continuous evidence of creativity, which means aliveness."[28] People play at affecting the world, not only in a response to hostility or to repair a loss, as Melanie Klein had thought.[29] Play is an innate drive — in Schiller's sense — to achieve tacit control over existing, often conflicting, materials and demands. Riskiness spikes both art and analysis with dangers of unpredictability, dangers that cannot be abolished if work is to proceed. So the work demands a steadiness that can anticipate and survive aggressive surprises meant to unhinge the playmate.[30] "The drive is potentially 'destructive' but whether it is destructive or not depends on what the object is like; does the object *survive*, that is, does it retain its character, or does it *react?* . . . But destruction of an object that survives, that has not reacted or disappeared,

leads on to use."[31] Using people, as Barbara Johnson underlined after reading Winnicott, amounts to loving them.[32]

How do people and things survive destruction and become useful and desirable to each other? They do so when the tussle takes place in the imagination and opens up a border space, neither entirely subjective—because the aggression fixes on something in the real world—nor entirely objective, because the world is framed subjectively. The dangerous and therefore exhilarating contact zone between inner and outer worlds is Winnicott's transitional space dedicated to free play. There the "push and pull, to and fro reaches towards the complex, the subtle-minded, integration of divergent and heterogeneous raw materials" to produce transitional objects,[33] those intimate and ingeniously re-signified playthings that belong to both the internal world of fantasy and to the external world that resists and survives aggressive fantasies. "There is no anger in the destruction of the object to which I am referring, though there could be said to be a joy at the object's survival."[34]

Healthy, symbolic destruction enables the integration of the subject with the objective environment and emotional maturity, while pathological and truly destructive acting-out keeps the immature subject split off from the world. Much of Winnicott's work describes a structural link between healthy living and art-making: "Through artistic expression we can hope to keep in touch with our primitive selves whence the most intense feelings and even fearfully acute sensations derive, and we are poor indeed if we are only sane."[35]

Take the Risk

The unpredictable, disarming quality of art remains the signpost for Schiller's education, as it was for Kant's aesthetics. But Schiller broadens aesthetics beyond Kant's disengaged judgment to include active exploration of artistic processes. His first letter respectfully promises to "rest chiefly upon Kantian principles." Yet he soon leaves the master to become a maestro, artist as well as teacher. Whether or not his use of Kant is philosophically sound, Schiller refused to exercise judgment alone while passions ran high and inflamed whole populations. Difficult times needed outlets for the energy that would otherwise ignite or fester; they needed ever-new experiments to form pleasing works from conflicting matter. "If hitherto truth has so little manifested her victorious power, this has not de-

pended on the understanding, which could not have unveiled it, but on the heart which remained closed to it, and on instinct which did not act with it" (letter 8, 242).

Schiller was not always sure about art's good effects. He tormented himself about his early play, *The Robbers* (1781), which the public loved for its bandit hero who lets his father die, who murders his mistress, and goes on robbing. Schiller hoped that the outlaw's popularity came from his soliloquies about the injustices of far greater but "legal" crimes of exploitation. The poet struggled with Plato's notorious mistrust of artists, and also with Rousseau's sober objections in 1758 to Voltaire's and d'Alembert's recommendation that Geneva sponsor a state theater.[36] By 1784, Schiller took the risk of defending art along Voltaire's lines — to promote civic culture — when he supported a public theater for Germany. The law needs art, he agreed, as a vehicle for both education and subjective embrace of collective norms.[37] But this already conventional argument didn't entirely cancel his concern over art's accountability. It wasn't until he read Kant's *Third Critique* that Schiller would decide the ethical question in favor of art.

Contra Rousseau, who dismissed art as entertainment, Schiller could now argue that aesthetic pleasure is different from amusement: it is the enjoyment of freedom beyond concerns of truth or goodness. This sensation of aesthetic freedom is the precondition for political liberty, Kant suggested in the *Third Critique*. Thinking and feeling intensely without regard for personal or collective interests, without commitments to existing values and ideas, is the condition of Enlightenment philosophy.[38] The challenge was how to prepare a broad population to think freely. The innate faculties of *pure* (scientific) and *practical* (moral) reason are not free; they depend on a priori principles of objectivity and ethics. Only aesthetics escapes determinism because it doesn't depend on reason, but on rule-free judgment. (See chapter 3, "Art and Accountability.") Kant believed that judgment levels differences among citizens because anyone can judge; and he cites Cicero on "how little difference there is between the learned and the ignorant in judging, while there is the greatest difference in making."[39]

Schiller disagreed. Though his *Letters* take Kant's advice to train judgment through aesthetics, they also exhort everyone to imagine and to make beautiful things. Art-making raises the intensity of Kant's discussion of mental faculties (reason, understanding, imagination, and judgment) to a register of raw instincts. The *Formtrieb* (formal drive) lines up more or less with pure abstract reason. On the other side, the *Sinntrieb* (sensual drive)

would burn reason away, if it were not for the third *Spieltrieb* that plays with combustible conflict. "Just as liberty finds itself between the two extremes of legal oppression and anarchy, so also we shall find the beautiful between two extremes, between the expression of dignity which bears witness to the domination exercised by the mind, and the voluptuous expression which reveals the domination exercised by instinct . . . it follows that the third state in which reason and the senses, duty and inclination, are in harmony—will be that in which the beauty of play is produced."[40]

Sublime Modernity

Classic culture could count on continuity between nature and art. But in Schiller's frenzied world, man needs to work continuously to make connections. Moderns cocreate new societies; and new works of art help to negotiate temporary truces between conflicting drives. They are sublimely unstable and honor the dynamic of world-making more than they revere any product. Much as he admires the ageless equilibrium of ancient Greek art, Schiller notes that its very perfection forfeits the freedom to stray from an ideal, so he prefers the tortuous and obsolescent historicity of contemporary arts (letter 16). Experiments trump the timeless enchantment of classic art along with Kant's flat baseline of training taste as civic education.

Schiller the poet relished the effort, the detours, and the self-doubt that art-making demands. He even accepted outright failures, however envious he might have felt about the natural talent that apparently flowed from "naïve" poets.[41] Innate ability paradoxically undercuts their merit, he says, "because it is not the work of their choice. . . . We are free, and they are necessary; we change, they remain the same. . . . We therefore perceive *in them* eternally that which is missing from us, but after which we are required to strive, and which, although we never attain it, we nevertheless may hope to approach in an infinite progress. We perceive *in ourselves* an advantage, which is wanting in them."[42] The advantage is freedom, and its sign is error, the capacity to deviate from nature.

The very success of the ancients is a constraint on creativity and therefore an obstacle to freedom (letter 16).[43] Schiller develops this comparison in *On Naïve and Sentimental Poetry* (1801), a manifesto for modernity's difficult freedom.[44] In any age, noble souls can be childlike and rise above, or stay clear of, contradiction in this simple way. (Schiller's favorite example is Pope Adrian VI [1522–1523] whose upright and transparent char-

acter exposed corruption in the Roman Catholic hierarchy and made a
mess of political affairs.[45]) When, however, nobility of character is achieved
through effort and risk, when sleepless souls reconcile reality with an ideal,
greatness becomes effective and truly praiseworthy. Likewise with art:
oscillation, doubt, failure, and fleeting accomplishments are grander than
God-given perfection.[46] Kant had bet on nature; he understood that form
stimulated aesthetic pleasure and attributed beautiful form to nature. But
Schiller's last words in *On the Sublime* (1801) put nature in its primitive
place: "Because the whole magic of the sublime and the beautiful subsists
only in semblance, art thus possesses all the advantages of nature without
sharing her shackles."[47]

Difficult Freedom

Schiller's preference for insecurity is a taste for freedom. Beauty, he points
out, is constrained by nature and leads to easy pleasure without exciting
the human will. But the sublime is no cheap thrill, and Schiller shares this
preference with Kant. Sublime pleasure begins with fear or confusion. Then
reason comes to the rescue by acknowledging human limitations. "We
therefore experience through the feeling of the sublime that the state of our
mind does not necessarily conform to the state of the senses, that the laws
of nature are not necessarily also those of ours, and that we have in us an
independent principle, which is independent of all sensuous emotions."[48]
Having survived the horror and the perplexity, we feel free, relieved, and
proud to have processed pain into the pleasure of freedom. This shock of a
world independent of us makes the sublime Schiller's entry point into an
ethical politics of care for others.[49]

Probably Schiller's most important improvement on Kant was to stretch
the duration of aesthetic experience beyond the moment of judgment
toward the time-consuming labor of creativity. The stretch had enormous
consequences for philosophy from Hegel on. Making art — which includes
judging, exploring, speculating, and testing possibilities — replaced a serial
notion of history. Now history became a movement of forces in collision,
resolving themselves into new forms which then provoked fresh tensions
to be harnessed into yet newer arrangements. The very distinction between
naïve and sentimental poetry identified epochal changes in form and sen-
sibility, and therefore in the relationship between man and the world. The
realm of appearances that Schiller had safeguarded against both naïve and

cynical detractors is where human faculties thrive. Driven by disagreement itself, the imagination can speculate beyond conflict.

It would have been complicit with disaster—as far as Schiller was concerned—merely to look on as the Revolution whipped practically everyone into destructive activity. When Walter Benjamin remarked that the history of civilization was also the history of barbarism he was glossing Schiller.[50] (Gilberto Freyre would quip that Europe had a "siphilizing" mission in the Americas.[51]) Schiller sometimes sounds shrill and he knows it: "Have I gone too far in this portraiture of our times? I do not anticipate this stricture, but rather another—that I have proved too much by it. You will tell me that the picture I have presented resembles the humanity of our day, but it also bodies forth all nations engaged in the same degree of culture, because all, without exception, have fallen off from nature by the *abuse of reason*, before they can return to it through reason" (letter 6, 232, my emphasis). Returning to reason will need to take passion into account: "Reason is obliged to make this demand, because her nature impels her to completeness and to the removal of all bounds; while every exclusive activity of one or the other impulse leaves human nature incomplete and places a limit in it" (letter 15, 264).

This was a call to action that recruited all citizens as artists and potential artists. Schiller's *Aesthetic Education* demystified the work, while Kant had described artists as rare geniuses. The almost immediate effect of Schiller's pedagogy was far-reaching through Wilhelm von Humboldt. Schiller's student and close friend would establish Europe's first modern and public university in Berlin in 1810, dedicating it to civic education through arts and sciences.[52] In Jena, Humboldt had heard Schiller's lectures on history that developed the line of his *Letters* and took to heart the maestro's exhortation to make new forms: "Soon it will not be sufficient for things to please him; he will wish to please" (letter 27, 309). The public university responded by creating an innovative space for personal excellence and collective accomplishment. There the drama of development would be narrated in the "first person plural," as Boal later identified the agency of individual characters to community theater. "Independently of the use to which it is destined, the object ought also to reflect the enlightened intelligence which imagines it, the hand which shaped it with affection, the mind free and serene which chose it and exposed it to view" (letter 27, 309). When an artistic experiment succeeds, it charms even philistines to recognize, and eventually to emulate, the man-made miracle of new forms:

The gravity of your principles will keep them off from you, but in play they will still endure them. Their taste is purer than their heart, and it is by their taste you must lay hold of this suspicious fugitive. In vain will you combat their maxims, in vain will you condemn their actions; but you can try your molding hand on their leisure. Drive away caprice, frivolity, and coarseness, from their pleasures, and you will banish them imperceptibly from their acts, and at length from their feelings. Everywhere that you meet them, surround them with great, noble, and ingenious forms; multiply around them the symbols of perfection, till appearance triumphs over reality, and art over nature. (letter 9, 247)

This is no romantic brief for feeling contra reason, no advice to aim for the heart instead of the head. Schiller is holding out for enlightened dispassionate taste as a common sense of value. "Their taste is purer than their heart." Cultivate that taste (judgment) with real beauty, he adds in a Kantian spirit, and common sense will overtake pettiness. Since cultivation won't take root under Kant's constraints on world-making, Schiller incites us to play. We can enchant even unwilling subjects with more art than they can resist; that way, reluctant spirits can find freedom instead of blocking the way for others. Reason is quite helpless here because arguments excite counterarguments in the desperate spirals that Foucault would trace.

Play's the Thing

Schiller didn't despair; nor would John Dewey, Herbert Marcuse,[53] Paulo Freire, Antonio Gramsci,[54] Augusto Boal,[55] Antanas Mockus, or Jacques Rancière. These and other exemplary agents of change investigate the spirals of power and passion to locate cracks or weak points where alternatives can open a wedge. In *Pedagogy of the Oppressed* (1968), Freire called these fissures "limit situations" that provoke interventions to derail current procedure.[56] These points of entry become what Mockus calls ambiguous or unfinished moments of a narrative, available for a new twist.[57] Conventional endings go around in circles, Freire warned when he proposed short-circuiting the dialectic of mastery and bondage that Hegel had described: as masters become dependent on their slaves (who change the world through work) newly empowered slaves lord it over their former masters. The loop straightens out by replacing the top-down and bottom-up single-

mindedness with two-way dialogue. By a simple change of preposition, Freire rejected a vanguard leadership style that works *for* the oppressed, and stays in the lead, for collaborations that work *with* the oppressed to interrupt systematic, recurrent unfairness.[58] Liberty lives in the rehearsals of these lateral labor relations.

Freire's appreciation for innovation doesn't exactly depend on art; he hardly mentions it. But the instructions for disarming hierarchies through cultural interventions bring him into direct conversations with artists (Augusto Boal called Freire his "last father") and indirectly with Schiller.[59] The risky collaborative experiments that Freire advocated merit the name of art, even if they are not "purposeless." Like an artist, he is practically indifferent to the substance of lessons but alive to the hierarchical or transactional form of teacher-student relations.

John Dewey wasn't coy about his debt to Schiller. His pragmatic encomium to art is paraphrased from the *Aesthetic Education*: "The existence of art is the concrete proof . . . that man uses the materials and energies of nature with intent to expand his own life, and that he does so in accord with the structure of his organism—brain, sense-organs, and muscular system. Art is the living and concrete proof that man is capable of restoring consciously, and thus on the plane of meaning, the union of sense, need, impulse and action characteristic of the live creature."[60] A fan of Schiller and impatient with Kant's exemption of beauty from any practical purpose, Dewey considered art to be everything done with care, intensity, and satisfaction[61]: "The tense grace of the ball-player infects the onlooking crowd . . . the delight of the housewife in tending her plants. . . . What Coleridge said of the reader of poetry is true in its way of all who are happily absorbed in their activities of mind and body."[62] ("Doing," in Winnicott's similarly broad and basic formulation of human activity, means living creatively; that is, living.[63]) Dewey's democratizing adjustment of registers between the ordinary and the extraordinary specifically rejects categorical distinctions between intellectuals and artists, bringing philosopher Dewey even closer to artist/philosopher Schiller: "The difference between the esthetic and the intellectual is thus one of the places where emphasis falls in the constant rhythm that marks the interactions of the live creature with his surroundings. . . . The odd notion that an artist does not think and a scientific inquirer does nothing else is the result of converting a difference of tempo and emphasis into a difference in kind."[64] Dewey didn't privilege one form over another, but celebrated them all, staying close to Schiller.

"Form is experienced for itself" is Jacques Rancière's shorthand for Schiller's founding and "unsurpassable manifesto" for the "aesthetic regime" of art.[65] Schiller's aesthetic revolution "produced a new idea of political revolution," Rancière says, as the realization of a common and creative humanity. This became the core of German Romanticism "summarized in the rough draft of a program written together by Hegel, Hölderlin, and Schelling." But the political movement failed and tainted the aesthetic model: "Modernity thus became something like a fatal destiny based on a fundamental forgetting."[66] Rancière decries the lost aesthetic road to revolution, not to scold but to jog our cultural memory into rediscovering Schiller and company. It is too soon to declare defeat, he reminds colleagues, while the aesthetic regime still promises to multiply and redistribute instances of art in egalitarian relation to life. Academic defeatists are irresponsibly inactive, he adds, when they complain about collective losses while they live relatively well above the rubble.

The accusation of bad faith recalls Schiller's objection to the willful and humorless dismissal of playfulness by "extreme stupidity and extreme intelligence" (letter 26). The one has no imagination, and the other wants nothing but the truth. They stay boxed in by reality and consequently surrender the freedom that appearance (Schein) can offer. Freedom assumes risks as it plays with possibilities; it anticipates failures as cues for abandoning some experiments and designing new ones. Free play also admits to living the shadow-life of counterfactual "appearances." Mayor Mockus defends counterfactual thinking as if Schiller were coaching him. Philosophically, Mockus understood his administration in rational procedural terms that can generate shared norms and build consensus. This line of thinking is so indebted to Jürgen Habermas that some students affectionately called the mayor Professor Habermockus. But in practice, Mockus achieved consensus and civility by spiking communicative action with the kind of unconventional creativity we call play or art.

Deliberative Differences

"Appearance" is the counterfactual contribution that Habermas receives from Schiller in order to facilitate discursive action. Action assumes that universal values do not yet exist among conflicting parties, but that they can be constructed through communication. The challenge is to imagine

possible points of agreement and to try them out. Under-determined and available for explorations, *Schein* had already drawn John Dewey to Schiller for related ethical reasons. Dewey described ethical deliberation as "dramatic rehearsals" that take place in the imaginary space where artists consider options before making the cut or stroke or rhyme that determines a form. "The instinct of play likes appearance, and directly it is awakened it is followed by the formal imitative instinct" (letter 26). That mental theater of possibilities is where Dewey's deliberation can play out a range of scenarios without defaulting to habit and preconceptions. "We are apt to describe this process as if it were a coldly intellectual one. As a matter of fact, it is a process of tentative action; we 'try on' one or other of the ends, imagining ourselves actually doing them, going, indeed, in this make-believe action just as far as we can without actually doing them."[67]

As a clinic for curing political inflexibility, Habermas defends the room for imaginative rehearsals against the dispiriting matter-of-factness that Schiller called extreme stupidity and extreme intelligence. For Habermas, Surrealism was an example of willful stupidity, and deconstruction a case of perverse intelligence. In the 1920s and '30s, Surrealism had imagined that art could dissolve the tensions between desire and reason by plumbing the irrational depths of the unconscious where life melds indistinguishably with art.[68] By the 1970s, deconstructive philosophy revived this campaign against reasonable distinctions: if meaning is constructed from words and words are artificial abstractions that overshoot or underestimate their marks, then words betray us and undermine communication.[69] Presumptively real information unravels under rigorous scrutiny to lead practically nowhere. Both Surrealists and deconstructionists exposed the fragile differences between data and desire, hoping finally to unhinge the gate between art and life, rhetoric and meaning.

But Habermas hopes to repair the hinge and to protect a space for art as the laboratory for better living. So he takes an "Excursus on Schiller's *Letters on the Aesthetic Education of Man*" to safeguard room for counterfactual "appearances" just after starting *The Philosophical Discourse of Modernity* (1987). Habermas claims this space as his playground for constructing collective agreements: "If art is to be able to fulfill its historic task of reconciling a modernity at variance with itself, it must not merely impinge on individuals, but rather transform the forms of life that individuals share. Hence, Schiller stresses the community-building, solidarity-giving force of

art; its *public character.* The point of his analysis is that . . . particular forces could be differentiated and developed only at the cost of the fragmentation of the totality."[70]

"*Totality* of character [of a society] must therefore be found in a people that is capable and worthy of exchanging the State of need for the State of freedom" (Schiller, letter 4). The side step from reality into art isn't exactly what readers expect from the sober theorist of communicative action. But we should take Habermas at his word. It was Schiller's art-making amendment to Kant's *Third Critique* that taught Habermas to pick his way out of modernity's deadlock between impersonal reason and embodied desire. Kant himself gave art credit for developing intersubjective common sense by communicating feelings and ideas that don't yet have names. Artistic genius can give voice to ineffable (and therefore private, possibly contentious) states of mind to make them "generally communicable."[71] This Kantian connection between art and common sense, amended by Schiller to include a universal faculty for creating connections, underwrites Habermas's long sessions of communicative action.

The amendment also puts Hannah Arendt in Schiller's debt. Despite distrusting him for being an artist, a "fabricator," she evidently learned how to read Kant's political philosophy from reading Schiller's *Letters.*[72] It was Schiller who first interpreted Kant's aesthetics as the "surprising" key to his politics.[73] Arendt's *Lectures* on Kant seem daring to her student and editor who supposes that she overinterpreted Kant in order to argue her own political position.[74] But the blame or praise is too strong, because it was Schiller's bold use of Kant that had clinched the role of aesthetic judgment as a moment in the process of creating political accords. Judgment bridges politics, morality, and the law to the natural and social sciences, as we saw in chapter 3.[75] And that bridge leads back to aesthetic education, which for Schiller cultivates the optimism of creative decision-making.

For Habermas, Schiller's unpretentious shuttle from judging, to making, to pausing again for judgment made good on Kant's enlightened project of disinterested communication:

> Kant's *Critique of Judgment* also provided an entry for speculative
> Idealism that could not rest content with the Kantian differentia-
> tions between understanding and sense, freedom and necessity,
> mind and nature, because it perceived in precisely these distinctions
> the expression of dichotomies inherent in modern life-conditions.

But the mediating power of reflective judgment served Schelling and Hegel as the bridge to an intellectual intuition that was to assure itself of absolute identity. Schiller was more modest. He held on to the restricted significance of aesthetic judgment in order to make use of it for a philosophy of history. He thereby tacitly mixed the Kantian with the traditional concept of judgment, which in the Aristotelian tradition (down to Hannah Arendt) never completely lost its connection with the political concept of common sense. So he could conceive of art as primarily a form of communication and assign to it the task of bringing about "harmony in society": "All other forms of communication divide society, because they relate exclusively either to the private sensibility or to the private skillfulness of its individual members, that is, to what distinguishes between one man and another; only the communication of the Beautiful unites society, because it relates to what is common to them all" (letter 27).[76]

Imagination gets across the otherwise impassable differences that concern Habermas: "The unbridgeable gap Kant saw between the intelligible (realm of duty and free will) and the empirical (realm of phenomena, inclinations, subjective motives, etc.) becomes, in discourse ethics, a mere tension manifesting itself in *everyday communication* as the factual force of counterfactual presuppositions."[77] Without counterfactual appearance and short of the free play that appearance allows—that is, without Schiller—Habermas could hardly incite us to play at bridge-building.

I offer this fundamental connection between aesthetic education and discourse ethics as a tribute to Mayor Mockus and to other public figures who strive to adopt Habermas's political advice.[78] Defending the ever-changing and self-correcting explorations of art, in contrast to the heady ambition of Idealist philosophy, Habermas underlines the debt that dialectical history owes to Schiller for conceiving of progress as an uneven movement between fits and starts through moments of aesthetic accomplishment. With Schiller's advance as a point of departure, Hegel will take on Kant's inflexible categorical ethics of abstract universals to advocate for a more deliberative process and Habermas will follow up with an argument for communicative action. Thanks to the flexibility and the stretch that he learns from Schiller, Hegel can level a critique against the short shrift that Kant gives to the procedure of judgment, and he can offer the remedy of

expanding the moment into a working session of intersubjective deliberation. "Discourse ethics replaces the Kantian categorical imperative by a procedure of moral argumentation."[79] Habermas's reading of Hegel rounds out the circle that Kant had opened when he dislodged "imperious reason" from its deluded self-sufficiency in the first two *Critiques*.

Anxiety of Agency

Schiller encountered resistance, to judge from his irritation with willful stupidity and smug intelligence. His exasperated tone anticipates posthumous trouble too. Paul de Man is a sign of the trouble. I'll mention his objections because de Man can stand in for a whole generation of skeptics who continue to haunt the humanities. Though Gayatri Spivak, for example, takes a bold turn toward intervention and toward Schiller in her recent *An Aesthetic Education in the Era of Globalization* (2012), she stays tied to de Man and to deconstruction through a habit of translating tension into the tormented stasis of double binds. This knot of conflicting demands described particular tight spots for Gregory Bateson, who coined the term.[80] But double bind is generalized in deconstruction to mean a simultaneous possibility and impossibility to say or to do almost anything. It practically amounts to an interdiction against action. Spivak claims to be stuck between dedication to scholarship and the call to engagement.[81] In fact, she pursues both admirably in a syncopated rhythm that artists understand. Schiller described that irregular progress of getting beyond binds. That was his project: to overcome the impasse between reason and passion, time and eternity, obligation and desire, indirectly. Through play, he argued, humans can reconcile conflicting demands into new forms that change the players and change the world in the process.

de Man's animus against Schiller wasn't envy or resentment; he apparently felt no overpowering admiration that might have soured into an anxiety of influence. The contrast with Johan Huizinga's parricidal jab underlines the difference. Huizinga rehearsed the *Letters* in a book that clearly owes Schiller a great but unacknowledged debt, *Homo Ludens: A Study of the Play Element in Culture* (1938). He dismissed Schiller, made him look silly, in a single mention delayed past the middle of the book. The master who taught everyone from Hegel to Habermas to recognize play as the motor of human arts, culture, and society is reduced to a pop-psychologist of doodling: "A theory designed to explain the origin of plas-

tic art in terms of an innate 'play-instinct' (*Spieltrieb*) was propounded long ago by Schiller. As an explanation of the origin of decorative motifs in art, let alone of plastic creation as a whole, a psychic function of this kind must strike us as somewhat inadequate. It is impossible to assume that the aimless meanderings of the hand could ever produce such a thing as style."[82] Huizinga's gesture hopes to establish authorship and authority regarding play; it is a mean-spirited confirmation of Schiller's contribution.

But de Man's hostility is sharper than envy, contemptuous of Schiller's project. His objection rankles at the political ambition of the *Letters*. de Man surely sensed that ambition through Schiller's admirers, Walter Benjamin among them. Benjamin took up Schiller's account of world-making, but reframed the relay between humanity and nature as a dystopian decline rather than an erratic path to freedom. Benjamin named the narrative form of this historical zigzag between art and environment "dialectical allegory." de Man dismissed the term and the implied time it took as a naïve contradiction, so he stopped the movement and straightened out Benjamin's bidirectional form into a standard two-tiered allegorical structure.[83] Targeting Benjamin's defense of change through time, de Man was also aiming at Schiller's social dynamism, especially his optimism about art.[84] A disturbing passage about statesmen using people the way a sculptor uses stone is meant to evoke Schiller. But the quote belongs to Joseph Goebbels.[85] The *Letters* had, on the contrary, admonished political artists not to treat human beings that way. Why authorize Goebbels to speak for Schiller? Perhaps it was to say that the Nazis could construe his invitation to aesthetic politics as a license to kill, because Schiller was the original guilty party for leading the way from art to disastrous agency. de Man's irritation with Schiller's brief for art is probably as historical as it is philosophical, since symbolic destruction — called art — had failed to avert the real thing in World War II. After wartime collaborations that de Man refused to confess, aesthetic pleasure became a scandal to him. "Steeled against the pleasures of art and thought, his criticism is an allegory of denial and deprivation."[86] While all political objectives seemed naïve or dangerous, deconstruction dismissed Schiller for the same socially engaged reasons ("his stress on practicality, on the pragmatic") that prompted Habermas to revive him.[87]

Another way to denigrate Schiller — along with the agency of art — was to call him a monger of lies and false effects, to reduce his notion of play to frivolity and entertainment.[88] Serious people tell the truth, facts, not

counterfactual fantasies (as critics of Mockus would reproach). But without imagination, the work of philosophy shrinks to thinking only about what already exists, which makes change literally unthinkable as we saw in chapter 1. It is a surprising retreat into positivism, as narrow as the philosophy that J. L. Austin mocked for fixing only on true or false statements.[89] To clinch his case against Schiller and imagination in general, de Man resorts to a misogynist corollary: the preference for art with its mass appeal over elite philosophy amounts to a feminine preference for form over a masculine respect for content.[90] Hostile or grumpy, de Man dismisses women, formalism, and Schiller in the same stroke, even if it requires defending the "meanings" that deconstruction would otherwise malign and dismantle.

Schiller was careful to distinguish between appearance and deception: one opens a vista for rehearsing scenarios to act in the world; the other squints at it. The distinction should relax ethical concerns about play. But some skeptics won't respect useful boundaries, Habermas complains. The excessive caution that accompanies a dehumanizing zeal for reality banishes "all the fine arts of which appearance is the essence," tragically sacrificing freedom by ostracizing beauty as "only an appearance" (letter 26, 302). Today, a grim seriousness that has passed for high theory refuses the broad-based seductions of art and eliminates the arts from public education, while the business of art booms. Privileged producers play to curators and collectors who value artworks as measures of acquisitive power. Meanwhile, the fundamental play drive, the faculty that Schiller was sure amounted to our talent for being human, gets too little room for everyday exercise. Weak and underfunded, how will it save us from savage passion and from barbarous reason?[91]

Ready?

Schiller's *Letters* can gird citizen-artists to defend art and to woo skeptics. His book is not so much a training manual as a companion through the oscillations, failures, and temporary successes of art-making in modern times. Schiller is both frank and eloquent about the challenge to charm both technocrats and pessimists. He wants us to win them over to art through a profoundly human susceptibility to beauty, even when reason fails to join us. The *Letters*, seductive and persistent, have set off generations of correspondence with political philosophers, pedagogical reformers, artists, teachers, and citizens.

As moderns who must continually construct connections to each other and to the physical world, the instinct for play drives us toward cultural agency of modest and sometimes momentous social change. So Schiller's invitation to co-create is an opportunity and an obligation. Even when nothing occurs to us at critical moments, when conflict and scarcity demand new forms or a particular skill that we can't muster at the time, frustration can prime a future contribution. Failure can feel "like an itch in the brain," to quote an indigenous facilitator of Forum Theatre in her newly learned Spanish. I hope that this book about great and also small works will suggest a palette or a tool kit to keep handy for inspiring new cases. Apprenticeship to the artists mentioned here—those who work from the top of political power to animate collective creativity, and those who start small and scale up—will share some lessons they learned from trial and error.

Mayor Mockus discovered that wit is essential to art. It is an element of the collective pleasure that cities can generate through collaborative art in order to sustain projects of social change. He also inquired, and then demonstrated statistically, that admiration for co-artists is the foundational feeling for citizenship.[92] Asking after the effects of one's work, pausing from play to measure and to judge before making a next move, Mockus is a maestro worth emulating. His inclusive approach to art multiplies the makers, as does Augusto Boal's recruitment of actors and nonactors into open-ended Forum Theatre. Boal explored tragic determinism as a cop-out, or a cop-in-the-head, an unnecessary bad ending because theater offers space to rehearse a variety of options. Leadership, Boal concluded, is the art of facilitating imaginative interventions by the greatest possible number of spect-actors; it is no vanguardist knack for giving directions. Effective facilitators, Gediminas and Nomeda Urbonas of the Pro-Test Lab experimented with art to drive an ethical agenda without depending on positive outcomes. The pleasure of art-making can be the energy that animates a politically impossible project, for pushing impossibility past one and another checkpoint on a receding horizon, until the project achieves real political success. And ACT UP discovered that collective action can mitigate personal risk; it may also provoke spin-off projects that translate dissidence into renewable energy for the movement. With Pre-Texts, the arts of recycling triggered commonplace creative agency, first through the easily multiplied model of Eloísa Cartonera's publishing project, and then through a pedagogical sequel that appropriates literary classics and high theory for the irreverent fun of advanced literacy.

FIGURE 5.1. Krzysztof Wodiczko, *The Abolition of War*. Courtesy of the artist.

All of these experiments—along with philosophical defenses of artistic trial and error including those by Dewey, Gramsci, Freire, Rancière, and Habermas—lead back to Schiller, to his optimism and to his tolerance for tension and for failure. Schiller's best readers know that freedom doesn't always reach an intended mark. Error is a risk that art takes; it is a sign of unscripted activity. Schiller never promised a direct route to freedom. In fact, he warned against it if the pursuit hoped to avoid self-canceling intransigence. Only the pleasures of indirection and experimentation can sustain the repeatedly unrealized but approximating efforts. After reading Schiller's *Letters* and some of its sequels in art, philosophy, pedagogy, and politics—trials and errors that promise a future for syncopating between failure and new forms—can you resist an invitation to press "play"?

Notes

PROLOGUE. **Welcome Back**

1. See Thomas Docherty, *Aesthetic Democracy* (Stanford, CA: Stanford University Press, 2006). Also Martha Nussbaum, *Not For Profit: Why Democracy Needs the Humanities* (Princeton, NJ: Princeton University Press, 2010); Geoffrey Harpham on "How America Invented the Humanities," http://www.youtube.com/watch?v=Q51AS6FiBuc.

2. Antanas Mockus, "Cultura Ciudadana, programa contra la violencia en Santa Fe de Bogotá, Colombia 1995–1997." Estudio Técnico, Washington, DC, July 2001, no. SOC-120 División de Desarrollo Social, Publicaciones Banco Interamericano de Desarrollo, (accessed July 12, 2010), http://es.scribd.com/doc/63048/Colombia -Cultura-Ciudadana-Experiencia-Bogota.

3. See the reference to Martha Nussbaum in a response by Alexander Nehamas, "An Essay on Beauty and Judgment," *Three Penny Review* 80 (winter 2000): 4–7.

4. Classical philosophy also dismisses pleasure and displeasure as distraction. See Hannah Arendt, *Lectures on Kant's Political Philosophy*, edited with an interpretive essay by Ronald Beiner (Chicago: University of Chicago Press, 1982): 27.

5. See chapter 1 and also Douglas North, *Institutions, Institutional Change and Economic Performance* (Cambridge, MA: Harvard University Press, 1990); also his "A Transaction Cost Theory of Politics," *Journal of Theoretical Politics* 2, no. 4 (1990): 355–367.

6. Communist André Breton and fascist sympathizer Salvador Dalí both identified as Surrealists, along with anarchists and reformists. See Franklin Rosemont, "Introduction," Andre Breton, *What is Surrealism? Selected Writings* edited and introduced by Franklin Rosemont (New York: Pathfinder, 1978) p. 28.

7. Lucy Lippard, ed., *Surrealists on Art* (Englewood Cliffs, NJ: Prentice Hall, 1970); and Lucy Lippard, *Six Years: The Dematerialization of the Art Object from 1966 to 1972* (Berkeley: University of California Press, 1997).

8. John Dewey, *Art as Experience* (New York: Perigree, [1934] 2005).

9. See David Damrosch, *We Scholars: Changing the Culture of the University.* Cambridge, MA: Harvard University Press, 1995.

10. See Antonio Gramsci's 1920 "Discorso agli anarchici," *Prison Notebooks*, vol. 1, edited by Joseph Buttigieg, (New York: Columbia University Press, 1992), pp. 12, 474–75.

11. Taught with Francesco Erspamer.

12. See Mary Schmidt Campbell and Randy Martin, eds., *Artistic Citizenship: A Public Voice for the Arts* (New York: Routledge, 2006), p. 12. The book takes stock of NYU's Department of Art and Public Policy.

13. Doris Sommer, "Rigoberta's Secrets," in *Proceed with Caution When Engaged by Minority Writing in the Americas* (Cambridge, MA: Harvard University Press, 1999).

14. Economist Pier Luigi Sacco reports the denial in "Culture 3.0: A New Perspective for the EU 2014–2020 Structural Funds Programming," for the European Expert Network on Culture (EENC), April 2011. http://www.culturalpolicies.net/web/files /241/en/Sacco_culture-3-0_CCIs-Local-and-Regional-Development_final.pdf.

15. Stuart A. Kauffman, *Investigations* (Oxford: Oxford University Press, 2000), pp. x–xii.

16. Paulo Freire, *Pedagogy of the Oppressed*. New revised twentieth-anniversary edition. New York: Continuum, 1993.

17. Among the founding texts are Ernest L. Boyer's Carnegie Foundation–funded *Scholarship Reconsidered* (1990), the American Council of Learned Societies' task force report on *Scholarship and the Public Humanities* (1990), and Stuart Hall's essay, "The Emergence of Cultural Studies and the Crisis of the Humanities" (*October*, volume 53, 1990, pp 11–23). Michael Bérubé, "MLA Presidential Address, January 2013." Accessed June 14, 2013, http://www.mla.org/pres_address_2013.

18. See Julie Ellison and Timothy K. Eatman, "Scholarship in Public: Knowledge Creation and Tenure Policy in the Engaged University—A Resource on Promotion and Tenure in the Arts, Humanities, and Design," *Imagining America: Artists and Scholars in Public Life*, 2008, http://imaginingamerica.org/wp-content/uploads/2011 /05/TTI_FINAL.pdf, and Gregory Jay, "The Engaged Humanities: Principles and Practices for Public Scholarship and Teaching," *Journal of Community Engagement and Scholarship* 2, no. 1 (2011): 51–63.

19. Immanuel Kant, The Critique of Judgment [1790] part 19, translated with Introduction and Notes by J.H. Bernard (2nd ed. revised) (London: Macmillan, 1914). Online Library of Liberty, 2013. Accessed June 14, 2013, http://oll.libertyfund.org /index.php?option=com_staticxt&staticfile=show.php%3Ftitle=1217&layout=html.

20. Dewey, *Art as Experience*, p. 325.

21. Néstor García Canclini makes a related observation: that art has trespassed the dedicated area of galleries and museums. It is in commerce, fashion, education, and so forth. See Néstor García Canclini *La sociedad sin relato* (Buenos Aires: Katz Editores, 2010). Francine Masiello had defended the politics of aesthetic creativity in *The Art of Transition: Latin American Culture and Neoliberal Crisis* (Durham, NC: Duke University Press, 2001).

22. See "Art-Making and the Arts in Research Universities: Strategic Task Forces," March 2012 Interim Report, *M ArtsEngine National Network*, http://arts-u.org /wp-content/uploads/2012/03/ArtsEngine-National-Strategic-Task-Forces-Interim -Report-March-2012.pdf; and *Arts Practice in Research Universities*, http://arts-u.org /category/research/research/. Also Basmat Parsad and Maura Spiegelman, "Arts Education in Public Elementary and Secondary Schools 1999–2000 and 2009–10," Washington, DC: NCES, IES, U.S. Department of Education, April 2012.

23. See Lane Wallace, "Multicultural Critical Theory At B-School?" *New York Times* Business Section, January 9, 2010, http://www.nytimes.com/2010/01/10/business /10mba.html. Also Robert and Michele Root-Bernstein, "Arts at the Center," plenary talk at UNESCO 2nd World Conference on Arts Education, Seoul, South Korea, May 25–28, 2010, http://www.unesco.org/culture/en/artseducation/pdf/fullpresentation rootbernstein. Also Scott Jaschik, "Besieged Humanities, Worldwide," *Inside Higher Ed*, March 7, 2013, http://www.insidehighered.com/news/2013/03/07/educators -consider-struggles-humanities-worldwide#ixzz2NGRuv1D9.

24. A fledgling program in "Arts and Leadership" at Harvard's Kennedy School of Government is coordinated by Michele Stanners. It hosted a pilot course on Cultural Agents with Dean Williams in fall 2011.

25. Irina Bokova, Director-General of UNESCO, *Global Governance in the 21st Century: The UNESCO Angle*, Kokkalis Center, Harvard University, November 3, 2010, http://www.youtube.com/watch?v=go8yUywEQBQ&feature=channel_video_title.

26. Jacques Rancière, *The Politics of Aesthetics: The Distribution of the Sensible*, trans. Gabriel Rockhill (London: Continuum, 2004), p. 24.

27. Douglas Rushkoff, *How the World Became a Corporation and How to Take It Back* (New York: Random House, 2009). "Melt-Up" is his title for chapter 9, p. 227.

28. Augusto Boal, *Legislative Theatre: Using Performance to Make Politics* (London: Routledge, 1998), p. xiii.

CHAPTER ONE. **From the Top**

1. Doris Sommer, *Foundational Fictions: The National Romances of Latin America*. (Berkeley: University of California Press, 1991).

2. Antanas Mockus, "Por amor al arte: Lineamientos para la campaña presidencial para el gobierno de Colombia 2006–2010." PowerPoint presentation sent to me on July 28, 2005.

3. See the documentary film *La Ola Verde: La ilusión de una generación* (*Antanas' Way*) (2011) directed by Margarita Martínez Escallón, produced by Juanita Leon. See http://www.antanasway.com/, accessed June 14, 2013.

4. Antanas Mockus, "When I Am Trapped, I Do What an Artist Would Do," conversation with Joanna Warsza, in *Forget Fear: 7th Biennale for Contemporary Art*, ed. Artur Zmijewski and Joanna Warsza (Berlin: KW Institute for Contemporary Art; Verlag Der Buchandlung Walter Konig, 2012), pp. 164–170. His installation, "Blood Ties," aims to reduce drug-related deaths in Mexico by inviting visitors to pledge reduced consumption and to donate blood in empathy, http://www.berlinbiennale.de/blog/projekte/%E2%80%9Eblood-ties%E2%80%9D-von-antanas-mockus-23032.

5. Jaime Lerner, *Acupuntura urbana* (Rio de Janeiro: Editora Record, 2003).

6. See Henry Murrain, "Cultura ciudadana como política pública: Entre indicadores y arte," in *Cultura Ciudadana en Bogotá: Nuevas perspectivas*, ed. Efraín Sánchez and Carolina Castro (Bogotá: Cámara de Comercio de Bogotá, Secretaría de Cultura, Recreación y Deporte, Fundación Terpel, Corpovisionarios, 2009).

7. Javier Sáenz Obregón, *Desconfianza, civilidad y estética: las prácticas formativas estatales por fuera de la escuela en Bogotá, 1994–2003* (Bogotá: Instituto para la Investigación Educativa y Desarrollo Pegagógico, 2007), p. 131.

8. The first time was on March 9, 2001. See, for example: Salud Hernández-Mora, "Bogotá organiza una noche 'sólo para mujeres' para combatir la violencia," *El Mundo*, March 11, 2001.

9. Friedrich Schiller, "On Grace and Dignity" (1793), in *Aesthetical and Philosophical Essays* (Middlesex, UK: *Echo Books*, 2006), pp. 127–154.

10. Schiller, "On Grace and Dignity," p. 146.

11. Frederick Beiser, Introduction to *Schiller as Philosopher: A Re-examination* (Oxford: Clarendon Press, 2005).

12. Mockus, "Amfibios culturales" and "La innovación y la extraña frontera que separa escuela y sociedad," *Aleph* 136 (2006): 2–5; "Ampliación de los modos de hacer política," *Aleph* 135 (2005): pp. 2–26.

13. Victor Shklovsky, "Art as Technique" (1917), in *Russian Formalist Criticism, Four Essays*, editor, Lee T. Lemon and Marion J. Reis (Lincoln: University of Nebraska Press, 1965), pp. 3–24.

14. Antanas Mockus, "Cultura ciudadana, programa contra la violencia en Santa Fe de Bogotá, Colombia, 1995–1997."

15. Mark Schapiro, "An Eccentric Mayor with a Flair for the Dramatic Is Bringing Hope to a Notoriously Troubled Capital," *Atlantic*, September 2001.

16. See Susan Quinn, *Furious Improvisation: How the WPA and a Cast of Thousands Made High Art out of Desperate Times* (New York: Walker, 2008).

17. Letter from Víctor Laignelet, October 30, 2009.

18. Conversation with Francois Lyotard, Antanas Mockus, and Amparo Vega, February 3, 2009.

19. Antanas Mockus, *Representar y disponer: Un estudio de la noción de representación orientado hacia el examen de su papel en la comprensión previa del ser como disponibilidad* (Bogotá: Universidad Nacional de Colombia, 1988), p. 72.

20. Augusto Boal, *The Rainbow of Desire: The Boal Method of Theatre and Therapy* (London: Routledge, 1995), p. 13.

21. Fundación Corona's series of publications, "Bogotá, ¿cómo vamos?" was an important watchdog and measure of Mockus's success.

22. Murrain, "Cultura ciudadana como política pública," pp. 7–13.

23. Murrain, "Cultura ciudadana como política pública," p. 12.

24. Reduction of Homicides, fuente base dedatos Policía Nacional, Centro de Investigaciones Criminológicas, 2005 (accessed June 14, 2013 http://pdba.georgetown .edu/Security/citizensecurity/Colombia/evaluaciones/politicasBogota.pdf) p. 244.

25. David Forgacs and Antonio Gramsci. *The Gramsci Reader: Selected Writings, 1916–1935* (New York: New York University Press, 2000), p. 393.

26. See the documentary *Bogotá cambió* (*Bogotá Changed*) 2010 by Andreas Dalsgaard (Danish Film Institute), with footage of arts interventions, http://www .youtube.com/watch?v=32aSCZbWslU.

27. Mockus, "América Latina, consensos y paz social," speech at the 34th Congreso Internacional de Conindustrias, June 30, 2004. See http://w3old.conindustria.org /CONGRES02004/Caracas%20Conindustria%20Antanas%20Mockus%20junio %202004%20versiu%C3%B3n%20fina.pdf.

28. Murrain, "Cultura ciudadana como política pública."

29. Bill Hinchberger, "Curitiba: Jaime Lerner's Urban Acupuncture," Brazilmax. com, February 18, 2006, http://www.brazilmax.com/news.cfm/tborigem/pl_south /id/10. Also Lerner's TED talk, http://www.ted.com/talks/jaime_lerner_sings_of _the_city.html.

30. See Diana Taylor, *Disappearing Acts: Spectacles of Gender and Nationalism in Argentina's "Dirty War"* (Durham, NC: Duke University Press, 1997); and Arvind Singhal and Karen Greiner, "Performance Activism and Civic Engagement through Symbolic and Playful Actions," *Journal of Development Communication* (December 2008): 1–15.

31. Hannah Arendt, *Reflections on Literature and Culture*, ed. and with an introduction by Susannah Young-ah Gottlieb (Stanford, CA: Stanford University Press, 2007), p. xxiv.

32. The year 1994 saw many unconventional candidates in Colombia. See "La hora de los antipolíticos," http://www.semana.com/nacion/articulo/la-hora-de-los -antipoliticos/24098-3.

33. See María Ospina, "Violencia y representación en la narrativa colombiana, 1985–2005," PhD diss., Harvard University, 2009.

34. Murrain, "Cultura ciudadana como política pública: Entre indicadores y arte," pp. 17–20.

35. Doris Sommer, *Bilingual Aesthetics: A New Sentimental Education* (Durham, NC: Duke University Press, 2004).

36. See Bonnie Honig, *Democracy and the Foreigner* (Princeton, NJ: Princeton University Press, 2001).

37. Antanas Mockus, "Ampliación de los modos de hacer política," Colloque CERI, Paris, December 2–3, 2004, p. 15.

38. Antanas Mockus, "Anfibios culturales y divorcio entre ley, moral y cultura," *Análisis político* 1 (January–April 1994): 37–47, p. 38.

39. Alfonso Múnera, *El fracaso de la nación: Región, clase y raza en el Caribe colombiano* (1717–1821) (Bogotá: Banco de la República, 1998).

40. Andrés Bello, cited in Malcolm Deas, *Del poder y la gramática y otros ensayos sobre historia, política y literatura colombianas* (Santafé de Bogotá: Tercer Mundo Editores, 1993), p. 46.

41. Deas, *Del poder y la gramática* p. 31.

42. María Ospina, "Prácticas de memoria" chapter 1.

43. http://www.corpovisionarios.org/index.php/es/.

44. Grant Kester, "Dialogical Aesthetics: A Critical Framework For Littoral Art," *Variant* 9 (2005): pp. 1–8.

45. Jacques Rancière, "The Emancipated Spectator," *Artforum*, March 27, 2007, pp. 271–280.

46. Hans-Jürgen Syberberg, *Hitler—ein Film aus Deutschland* (1977), www.imdb.com/title/tt0076147/. See also John Dreijmanis, "A Portrait of the Artist as a Politician: The Case of Adolf Hitler," *Social Science Journal* 42, no. 2 (2005): 115–127.

47. Benjamin Disraeli's character Hugo Bohn in *Lothair* (1870), chapter 35 (London: Oxford University Press, 1975).

48. Jacques Rancière, *The Politics of Aesthetics: The Distribution of the Sensible*, trans. with an introduction by Gabriel Rockhill, afterword by Slavoj Zizek (London:Continuum, 2004).

49. Sir Francis Bacon, "Of Seditions" (1625), http://www.authorama.com/essays-of-francis-bacon-16.html.

50. See George Yudice, Introduction to Nestor Garcia Canclini, *Imagined Globalization* (Durham, NC: Duke University Press, 2012).

51. Claire Bishop, "The Social Turn," *Artforum*, February 2006.

52. Boal, *Rainbow of Desire*, p. xxiii.

53. Paolo Freire, *Pedagogy of the Oppressed*. New revised twentieth-anniversary ed. New York: Continuum, 1993. p. 39.

54. Antanas Mockus, "América Latina, consensos y paz social: Qué sugiere la experiencia de Bogotá," (PowerPoint) Conindustrias 2004, Caracas, June 30, 2004, slide no. 7, (See note #27).

55. Frank Pearl et al., "Tejer el camino, Guía conceptual y metodológica Componente de convivencia y reconciliación: Estrategia de reintegración basada en comunidades," Banca de Proyectos, Alta Conserjería Presidencial, May 2010.

56. "Adiós a las trampas," Colombia, 2004, Ministerio de Cultura, Ministerio de Educacion, http://isites.harvard.edu/fs/docs/icb.topic38521.files/AdiosALasTrampas .pdf.

57. Deborah Salazar, "What Every Jewish Parent Should Know about the Waldorf Philosophy," *Jewish Parenting*, Spring 1999, p. 35. See also Bruce Uhrmacher, "Uncommon Schooling: A Historical Look at Rudolf Steiner, Anthroposophy and Waldorf Education," *Curriculum Inquiry* 25, no. 4(winter 1995). p. 381.

58. Stephen Nachmanovitch, "This Is Play," *New Literary History* 40, no. 1 (winter 2009): 11.

59. Schiller, *On the Aesthetic Education of Man, in a Series of Letters*. Rare Masterpieces of Philosophy and Science. (New Haven, CT: Yale University Press, 1954). Letter 9.

60. Antanas Mockus, "When I Am Trapped," 168; and Maria Cristina Caballero, "Academic Turns City into a Social Experiment," *Harvard Gazette*, March 11, 2004.

61. Besar Likmeta, "Eight Indicted for Fraud in Albanian Elections: Prosecutors in Lezha on Tuesday Indicted Eight Poll Commissioners for Rigging the Elections in the Commune of Dajc on May 8, 2011," *Balkan Insight*, March 15, 2012, http://www.balkaninsight.com/en/article/eight-indicted-for-fraud-during-albania-s-local-elections.

62. David L. Phillips, "Less Drama from Albania's Socialist Leader: Edi Rama's Strategy of Confrontation and Gridlock Ill-Serves His Party and His Country," *Balkan Insight*, June 28, 2011, http://www.balkaninsight.com/en/article/less-drama -from-albania-s-socialist-leader.

63. Edi Rama, "Take Back Your City with Paint," http://www.ted.com/talks/edi _rama_take_back_your_city_with_paint.html, May, 2012, Thessaloniki, Greece (Accessed June 29, 2013).

64. Jane Kramer, "Painting the Town," *New Yorker*, June 27, 2005, p. 50.

65. Nick Swift, "Edi Rama, Mayor of Tirana," http://www.worldmayor.com /worldmayor_2004/rama_winner04.html.

66. Dick Hebdige, "The Machine Is Unheimlich: Krzysztof Wodiczko's Homeless Vehicle Project." Walker Art Magazine August 30, 2012 (Accessed June 14, 2013) http://www.walkerart.org/magazine/2012/krzysztof-wodiczkos-homeless-vehicle -project.

67. Vivienne Walt, "A Mayoral Makeover," *Time*, October 2, 2005, http://www.time .com/time/magazine/article/0,9171,1112793,00.html.

68. Kramer, "Painting the Town."

69. Antmen, Ahu, et al, curators, *Tirana Biennale 1: Escape*, with an introduction by Edi Rama and Gezim Qendro (Milan, Giancarlo Politi Editore, 2001).

70. Kramer, "Painting the Town."

71. Tumi Makgetia, "A New Face for a Tired City: Edi Rama and Tirana, Albania, 2000–2010," *Innovations for Successful Societies* (Princeton, NJ: Trustees of Princeton University, 2010), pp. 1–10, http://www.princeton.edu/successfulsocieties.

72. Pierre Restany, *Hundertwasser: The Painter-King with the Five Skins* (Koln: Taschen, 2001), p. 48.

73. At least one art critic noticed what Rama's leadership owes to his art education. "A montage of buildings, with motifs that hint at a number of designers. Some seem to resemble the odd-shaped Hundertwasser apartment buildings in Vienna, though this might be a trick of the colour scheme." Signed PH, review of Anri Sala's video "Dammi i colori" about Rama, at the Tate Gallery, London.in 2003. http://www .artvehicle.com/events/172.

74. Isabella Mara, "Color Is a Key to Transforming a City," Sustainable Ideas, November 28, 2011, http://www.sustainableideas.it/2011/11/28/color-is-a-key-to -transforming-a-city/ and http://photography.nationalgeographic.com/photography /photo-of-the-day/manarola-italy-coast/. For more photos of Guayaquil, Cerro Santa Ana, see https://www.google.com/search?q=guayaquil+cerro+santa+ana&hl =en&rlz=1C1RNPN_enUS421&prmd=imvns&source=lnms&tbm=isch&ei=hdDYT -r7GeqJ6AHo1u2yAw&sa=X&oi=mode_link&ct=mode&cd=2&sqi=2&ved=0CEgQ _AUoAQ&biw=1024&bih=488.

75. "During the years 2007–2008, there have been twenty-two public hearings, which have been characterized by an active participation of the citizens of Tirana, and which have also been reflected in the priorities and projects financed during the year 2008 that have come to life day after day." *Tirana News* Archive, November 28, 2008, http://www.tirana.gov.al/?cid=2,62,2420 (site disabled).

76. "Edi Rama replies to questions from an international audience," http://www .worldmayor.com/worldmayor_2004/interview_rama.html.

77. Walt, "Mayoral Makeover."

78. Roy Rosenzweig and Barbara Melosh, "Government and the Arts: Voices from the New Deal Era," *Journal of American History* 77, no. 2 (September 1990): 598.

79. Rosenzweig and Melosh, "Government and the Arts," p. 596.

80. Conversation with Antanas Mockus, September 5, 2009.

81. Max Weber, *The Protestant Ethic and the Spirit of Capitalism* (original German 1905), trans. Talcott Parsons (New York: Scribner, 1930).

82. Virginia Mecklenburg, *Public as Patron: A History of the Treasury Department Mural Program* (College Park: University of Maryland, 1979).

83. George J. Mavigliano, "The Federal Art Project: Holger Cahill's Program of Action," Art Education 37, no. 3 (May 1984): 26–30. Also Don Adams and Arlene Goldbard, "New Deal Cultural Programs: Experiments in Cultural Democracy, 1986, 1995."

84. José Vasconcelos, *Discursos: 1920–1950* (Mexico City: Ediciones Botas, 1950), p. 9, quoted in http://www.ibe.unesco.org/publications/ThinkersPdf/vasconce.pdf.

85. Claude Fell, *José Vasconcelos: Los años del águila, Educación, cultura e Ibero- americanismo en el México postrevolucionario. 1920–1925*, Serie de historia moderna y contemporánea, vol. 21. (Mexico D.F.: Universidad Nacional Autónoma de México, 1989), pp. 153–156.

86. Rosenzweig and Melosh, "Government and the Arts: Voices from the New Deal Era." p. 596.

87. Roger Kennedy and David Larkin, *Art Worked: The New Deal, Art and Democracy* (New York: Rizzoli, 2009).

88. Francine Carraro, *Jerry Bywaters: A Life in Art* (Austin: University of Texas Press, 1994), p. 82.

89. "History of the New Deal Arts Project," http://www.wpamurals.com/history.html.

90. Encyclopedia Britannica, "WPA Federal Art Project" http://www.britannica.com/EBchecked/topic/649339/WPA-Federal-Art-Project. See also Carraro, *Jerry Bywaters*, p. 87.

91. *Born in Slavery: Slave Narratives from the Federal Writers' Project, 1936–1938*, 2,300 first-person accounts of slavery and 500 photographs, http://memory.loc.gov/ammem/snhtml/snhome.html.

92. "Fuentes Fires Up Crowd," *University of California at San Diego Daily News*, April 28, 2008, http://ucsdnews.ucsd.edu/thisweek/2008/04/28_carlos_fuentes.asp.

93. Rubén Ríos Avila, *La raza cómica: Del sujeto en Puerto Rico* (San Juan, PR: Ediciones Callejón, 2001).

94. See Catherine Marsh Kennerly, *Negociaciones culturales: Los intelectuales y el proyecto pedagógico del estado muñocista* (San Juan, PR: Ediciones Callejón, 2009).

95. Edwin Rosskam, "Program of People's Education and Information," Comisión de Parques y Recreos, San Juan, División de Cinema y Gráfica, Archivo General de Puerto Rico, 1946, pp. 5–6. Quoted in Kennerly, *Negociaciones culturales*, p. 30. René Marqués, Lorenzo Homar, and Rafael Tufiño are among the DIVEDCO artists.

96. Will Bradley and Charles Esche, eds., *Art and Social Change: A Critical Reader* (London: Tate Pub. in association with Afterall New York, 2007). See review by Brian Holmes and Marco Deseriis, http://www.metamute.org/en/content/discussing_art_and_social_change.

97. Barbara McCloskey, *Artists of World War II* (Westport, CT: Greenwood, 2005), p. 183.

98. Donald Adams and Arlene Goldbard. *Creative Community: The Art of Cultural Development*. Lulu.com, 2005.

99. 1936, http://www.britannica.com/EBchecked/topic/649339/WPA-Federal-Art-Project. Debate about Dewey in Alison Kadlec, *Dewey's Critical Pragmatism* (Lanham, MD: Lexington Books, 2007).

100. Holger Cahill, "American Resources for the Arts (1939)," *Art for the Millions: Essays from the 1930's by Artists and Administrators of the WPA Federal Art Project*, ed. Emanuel Mervin Benson and Francis V. O'Connor (Boston: New York Graphic Society, 1973), p. 41.

101. Carraro, *Jerry Bywaters*, p. 81.

102. Carraro, *Jerry Bywaters*, p. 83.

103. Mavigliano, "Federal Art Project."

104. Francis V. O'Connor, *The New Deal Art Projects: An Anthology of Memoirs* (Washington DC: Smithsonian Institution, 1972), p. 457.

105. Adams and Goldbard, *Creative Community*.

106. The Gilder Lehman Institute of History, http://www.historynow.org/03_2009 /historian2.html. See also Britannica, http://www.britannica.com/EBchecked/topic /649339/WPA-Federal-Art-Project.

107. Rosenzweig and Melosh, "Government and the Arts," 605.

108. Rosario Encinas, "José Vasconcelos (1882–1959)." http://www.ibe.unesco.org /publications/ThinkersPdf/vasconce.pdf Accessed June 20, 2013. Originally published by UNESCO (Paris) in *PROSPECTS XXIV*, nos. 3–4.

109. Donna Sussman, "The Influence of Mexican Muralists on WPA Art," Yale National Initiative to Strengthen Teaching in Public Schools, May 2, 2009, http:// teachers.yale.edu/curriculum/search/viewer.php?id=initiative_05.02.09_u.

110. The House Committee to Investigate Un-American Activities (HUAC, also known in the thirties as the "Dies Committee," after its chair Martin Dies). In Adams and Goldbard., *Creative Community: The Art of Cultural Development*.

111. Hallie Flanagan, *Arena* (New York: Duell, Sloan and Pearce, 1940), p. 28, cited in Adams and Goldbard, *Creative Community*.

112. Quinn, *Furious Improvisations*, pp. 172–183.

113. Quinn, *Furious Improvisations*, p. 90.

114. Quinn, *Furious Improvisations*, pp. 155–156.

115. Rosenzweig and Melosh, "Government and the Arts." p. 596.

116. Augusto Boal, *Theatre of the Oppressed*. (originally published in Spanish as *Teatro del oprimido*, 1974), trans. Charles A. and Maria-Odilia Leal McBride (New York: Theatre Communications Group, 1995).

117. Fidel Castro, *Palabras a los intelectuales* (Havana: Ministerio de Cultura, 1961).

118. Carraro, *Jerry Bywaters* p. 83.

119. FDR, Second Inaugural Address, January 4, 1935, quoted in Basil Rauch, *The History of the New Deal* (New York: Creative Age Press, 1944), p. 146.

120. Carraro, *Jerry Bywaters* p. 81.

121. Rosenzweig and Melosh, "Government and the Arts." p. 578. In 1938 TRAP became part of the Federal Arts Project.

122. Rosenzwig and Melosh, "Government and the Arts." pp. 604–605.

123. Don Adams and Arlene Goldbard, "Problem of Censorship" http://www .wwcd.org/policy/US/newdeal.html#CENSOR (accessed June 14, 2013).

124. Rosenzweig and Melosh, "Government and the Arts: Voices from the New Deal Era." p. 598.

125. Jane DeHart Mathews, *The Federal Theatre, 1935–1939: Plays, Relief, and Politics* (Princeton, NJ: Princeton University Press, 1967), pp. 313–314, cited in Rosenzweig and Melosh, "Government and the Arts," p. 598.

126. Richard D. McKinzie, *The New Deal for Artists* (Princeton, NJ: Princeton University Press, 1973), p. 188.

127. See Barbara Rose, *American Art since 1900* (New York: Praeger, 1975): and Matthew Baigell, *The American Scene: American Painting of the 1930s* (New York, MW Books, 1974).

128. Douglas McDermott, "The Living Newspaper as a Dramatic Form," *Modern Drama* (1965) vol. 8 no. 1. in Quinn, *Furious Improvisation*, p. 62.

129. Augusto Boal, *Legislative Theatre: Using Performance to Make Politics* (London: Routledge, 1998), p. 3.

130. Adams and Goldbard, "New Deal Cultural Programs."

131. Adams and Goldbard, "New Deal Cultural Programs."

132. National Endowment for the Humanities. "How NEH Got Its Start," http://www.neh.gov/about/history.

133. National Endowment for the Arts. "National Foundation on the Arts and the Humanities Act of 1965," http://www.nea.gov/about/Legislation/Legislation.pdf.

134. 20 U.S.C. § 953: c. "Prohibition against Federal Supervision"

135. National Foundation on the Arts and the Humanities Act of 1965, 20 U.S.C. § 951 # 5, http://www.nea.gov/about/Legislation/Legislation.pdf.

136. Wendy Steiner, *The Scandal of Pleasure: Art in an Age of Fundamentalism* (Chicago: University of Chicago Press, 1995).

137. NEA legislation defines "obscene" as "(1) the average person, applying contemporary community standards, would find that such project, production, workshop, or program, when taken as a whole, appeals to the prurient interest." See "Definitions" 20 U.S.C. § 952.

138. Rosenzweig and Melosh. "Government and the Arts," p. 600. "Most broad synthetic cultural histories of the 1930s have little to say about the role of government programs for the arts . . . strikingly little to locate government-sponsored art . . . on New Deal photography perhaps the single exception . . . to assess it as art and cultural history."

139. "NEA Reassigns Communications Director following Uproar over Obama Initiative," FOX News, September 11, 2009.

140. http://www.irs.gov/uac/The-American-Recovery-and-Reinvestment-Act-of-2009:-Information-Center. Also "Arts Groups Happy to Have a Friend in White House," posted by Phil Crosby on Wednesday, December 9, 2009, see http://foundationcenter.org/pnd/news/story.jhtml?id=276800014.

141. Michael F. Shaughnessy, Senior Columnist, EducationNews.org, "An Interview with Andrew Klavan: N.E.A. and the Arts?"—http://www.educationnews.org/articles/-an-interview-with-andrew-klavan-nea-and-the-arts.html#sthash.JRtepMYk.dpuf, September 29, 2009 The analogy to Obama's proposed use of art is to Hitler's use of Leni Reifenstahl.

142. "Reinvesting in Arts Education," President's Committee on the Arts and the Humanities (2011), http://www.pcah.gov/sites/default/files/PCAH_Reinvesting_4web_0.pdf.

143. Economist Pier Luigi Sacco reports the denial, "Culture 3.0: A New Perspective for the EU 2014–2020 Structural Funds Programming," for the European Expert Network on Culture (EENC), April 2011.

144. Richard Rorty, "Cultural Politics and the Question of the Existence of God," chapter 1 in *Philosophy as Cultural Politics* (Cambridge: Cambridge University Press, 2007), pp. 3–26.

145. See, for example, Así viven jóvenes 'salvavidas' de la conflictiva comuna 13 de Medellín," *El Tiempo*, April 26, 2011, http://www.eltiempo.com/colombia/medellin /jovenes-ensenan-hip-hop-en-m_9227720-4.

146. Hallie Flanagan, Speech before American Federation of Arts, Washington, DC, May 12, 1937, cited in Quinn, *Furious Improvisation* p. 168.

147. Nachmanovitch, "This Is Play," *New Literary History* 40, no. 1 (2009): 1–24. pp. 11–12. See also Stuart Brown, "Play as an Organizing Principle: Clinical Observations," in *Animal Play: Evolutionary, Comparative and Ecological Perspectives*, ed. Marc Bekoff and John A. Byers (Cambridge: Cambridge University Press, 1998), p. 256.

148. Megan Whilden, *Creative Pittsfield*, January 12, 2009, http://www.pittsfield-ma .org/Detail.asp?sid=377.

149. http://www.ted.com/talks/jaime_lerner_sings_of_the_city.html.

150. Thomas Wolf and Gigi Antoni, *Collaboration and Community: A Manual for Sustainability* (New York: National Guild for Community Arts Education, 2012).

151. Sue Halpern, "Mayor of Rust," *New York Times Magazine*, February 13, 2011, pp. 30–35, http://www.nytimes.com/2011/02/13/magazine/13Fetterman-t.html.

152. A recent case of a creative mayoral candidate is Gery Chico, hoping the revive the Loop area of Chicago through art; http://articles.chicagotribune.com/2011-02-17 /entertainment/chi-mayor-candidate-gery-chico-arts-20110217_1_theater-district -arts-and-culture-mayoral-candidates.

153. http://www.youtube.com/watch?v=6kSQuCod-JY.

154. Douglas Rushkoff recommends local grassroots projects. See *Life Inc.: How the World Became a Corporation and How to Take It Back* (New York: Random House, 2009).

CHAPTER TWO. **Press Here**

1. Norman Mailer and Jon Naar, *The Faith of Graffiti* (New York: HarperCollins, 2009). Also Banksy, *Wall and Piece* (New York: Random House, 2005).

2. Jane Golden's programs for Philadelphia make it internationally recognized as the "City of Murals." See Lauren Silverman, "On Philly's Walls, Murals Painted with Brotherly Love," *All Things Considered*, NPR, August 23, 2010, http://www.npr.org /templates/story/story.php?storyId=129281658.

3. Melissa Dribben, "1.5 Million Philadelphians Can't Be Wrong: Parisians Look to Copy City's Mural Program," *Philadelphia Inqirer*, May 8, 2009, p. B2.

4. "JR" is a semi-anonymous French street artist. See his TED talk, "One year of turning the world inside out," 2011, http://www.ted.com/talks/jr_s_ted_prize_wish_use_art_to_turn_the_world_inside_out.html.

5. Rennie Ellis, *The All New Australian Graffiti* (Melbourne: Sun Books, 1985), http://en.wikipedia.org/wiki/Graffiti.

6. http://news.bbc.co.uk/2/shared/spl/hi/picture_gallery/07/asia_pac_graffiti_artists_in_beijing/html/1.stm.

7. See for example, Lucy Lippard, *Get the Message? A Decade of Art for Social Change* (New York: E. P. Dutton, 1984).

8. Ben Davis, "Rancière for Dummies," review of *The Politics of Aesthetics*, Artnet, http://www.artnet.com/magazineus/books/davis/davis8-17-06.asp.

9. Augusto Boal, *Aesthetics of the Oppressed*, trans. Adrian Jackson (London: Routledge, 2006).

10. Carrie Lambert-Beatty, "Twelve Miles: Boundaries of the New Art/Activism," *Signs: Journal of Women in Culture and Society* 2008, vol. 33, no. 2. 309–327.

11. See Liza Weisberg, "The Yes Men Fix the World One Prank at a Time," *Huffington Post*, July 27, 2009, http://www.huffingtonpost.com/liza-weisberg/the-yes-men-fix-the-world_b_244727.html.

12. Luis Camnitzer, "Tucumán Arde: Politics in Art," chapter 7 in *Conceptualism in Latin American Art: Didactics of Liberation* (Austin: University of Texas Press, 2007), p. 64.

13. Clemente Padín, "Latin American Art in Our Time" and "Tucumán Arde: Paradigm of Revolutionary Cultural Action," chapters 1 and 4 in *Art and People*, trans. Harry Polkinhorn. http://www.concentric.net/~Lndb/padin/lcpcintr.htm (web publication: 1997) and http://www.concentric.net/~lndb/padin/lcptuc.htm.

14. Jacoby also directs community arts projects such as Proyecto Matanzas and recently opened a multipurpose arts center, the CIA, in Buenos Aires. See http://es.wikipedia.org/wiki/Roberto_Jacoby.

15. Douglas Rushkoff, *Life Inc.: How the World Became a Corporation and How to Take It Back* (New York: Random House, 2009), pp. 234–239.

16. Rushkoff, "The Melt-Up," title of chapter 9, in *Life Inc.*, p. 227.

17. Rushkoff, *Life Inc.*, p. 234.

18. Mady Schutzman and Jan Cohen-Cruz, *Playing Boal: Theatre, Therapy, Activism* (New York: Routledge, 1994), p. 22.

19. Augusto Boal, *Hamlet and the Baker's Son: My Life in Theatre and Politics*, trans. Adrian Jackson and Candida Blaker (London: Routledge, 2001), pp. 194–200.

20. J. L. Moreno, *The Essential Moreno: Writings on Psychodrama, Group Method and Spontaneity*, ed. Jonathan Fox (New York: Springer, 1987).

21. Schutzman and Cohen-Cruz, *Playing Boal*. p. 110.

22. Ana Correa, "Yuyachkani over Thirty Years," presentation at Harvard University, April 12, 2009.

23. http://www.communityarts.net/readingroom/archivefiles/2002/09/el _teatro_campe.php. Also, Yolanda Broyles-González, *El Teatro Campesino: Theater in the Chicano Movement* (Austin: University of Texas Press, 1994).

24. Augusto Boal, *Theatre of the Oppressed* (originally published in Spanish as *Teatro del oprimido*, 1974), trans. Charles A. and Maria-Odilia Leal McBride (New York: Theatre Communications Group, 1995), p 156.

25. Boal, *Theatre of the Oppressed*, p. 132.

26. Boal, *Theatre of the Oppressed*, chapter 4.

27. Emmanuel Lévinas, *Totality and Infinity: An Essay on Exteriority*. Martinus Nijhoff Philosophy Texts, vol. 1. The Hague, the Netherlands: M. Nijhoff Publishers, 1979.

28. Augusto Boal, *The Rainbow of Desire: The Boal Method of Theatre and Therapy*. London: Routledge, 1995, p. 7.

29. Boal, *The Rainbow of Desire*, pp. 26–27.

30. Boal, *The Rainbow of Desire*, p. 59; *Legislative Theatre: Using Performance to Make Politics*. London: Routledge, 1998., p. 56.

31. Boal, *Legislative Theatre*, p. 57.

32. John Dewey, *Human Nature and Conduct*, quoted in Steven Fesmire, *John Dewey and Moral Imagination: Pragmatism in Ethics* (Bloomington: Indiana University Press), p. 69.

33. Boal, *The Rainbow of Desire*, p. 27.

34. Boal, *The Rainbow of Desire*, p. 45.

35. Boal, *Theatre of the Oppressed*, chapter 1.

36. In *Theatre of the Oppressed*, Boal summarizes Arnold Hauser's argument in *The Social History of Art* (London, 1951). See also George Thompson, *Aeschylus and Athens* (London: Lawrence and Wishart, 1941).

37. Nathan Schneider, "Paint the Other Cheek," *Nation*, April 2, 2012, http://www .thenation.com/article/166820/paint-other-cheek.

38. Adrian Jackson, Introduction to *The Rainbow of Desire*, p. xxiii.

39. Néstor García Canclini. Globalización imaginada (Narrativas Históricas) (Buenos Aires: Paidós, 1999) p. 115.

40. Boal, *Legislative Theatre*, pp. 3–4.

41. Boal, *Legislative Theatre*, p. 6.

42. Camnitzer, *Conceptualism in Latin American Art*, p 89.

43. Alfredo Jaar, "Conversaciones en Chile, 2005." In *Jaar SCL 2006*, edited by Adriana Valdés, 67–88. (Barcelona, New York: Actar Ediciones 2006).

44. Boal, *Hamlet and the Baker's Son*, p. 324.

45. Matthew K. Nock, Guilherme Borges, and Yutaka On, *Suicide: Global Perspectives from the Who World Mental Health Surveys* (Cambridge: Cambridge University Press, 2012).

46. Boal, *Rainbow*, p. 25.

47. Emmanuel Lévinas, *Otherwise Than Being, or Beyond Essence*, trans. Alphonso Lingis (Dordrecht: Kluwer Academic Publishers, [1974] 1991), pp. 5–6.

48. Boal, *Rainbow*, p. 43.

49. Boal, *Rainbow*, p. 26.

50. Boal, *Rainbow*, pp. 70–72.

51. Roberto Schwarz in *Pai de família e outros ensaios* (Rio de Janeiro: Paz e Terra, 1980) had also celebrated Boal as an alternative to Tropicalismo, which allegedly romanticized rather than developed Brazil.

52. Boal, *Legislative Theatre*, pp. 6–8.

53. Boal, *Legislative Theatre*, p. 11.

54. Boal, *Legislative Theatre*, p. 15.

55. Boal, *Legislative Theatre*, pp. 21–22.

56. Boal, *Aesthetics of the Oppressed*, p. 6.

57. Boal, *Hamlet and the Baker's Son*, p. 325.

58. Boal, *Aesthetics of the Oppressed*, p. 6.

59. http://www.youtube.com/watch?v=KK0Z7n-w97Y&feature=related. "A Estética do Oprimido nas Escolas."

60. "May the trash be with you," is the slogan of the collective Basurama. See their website, http://www.basurama.org/b08_may_the_trash_be_with_you_trondheim .htm.

61. Paolo Freire, *Pedagogy of the Oppressed*. New revised twentieth-anniversary ed. New York: Continuum, 1993, p. 28.

62. Freire, *Pedagogy*, pp. 39–40.

63. http://ptoweb.org/.

64. Boal, *Legislative Theatre*, pp. 21–22.

65. Betsy Bard facilitated these very successful programs at Cambridge Rindge and Latin High School from 2004 to 2008 with a combination of techniques from Boal and from Anna Deavere Smith.

66. See Norifumi Kamo, Mary Carlson, and Felton Earls "Young Citizens as Health Agents: Use of Drama in Promoting Community Efficacy for HIV/AIDS," *American Journal of Public Health* 98, no. 2 (February 2008): 201–204.

67. EEOC New York regional director Spencer H. Lewis Jr. and Joseph Alvarado, state and local program manager, hosted a Cultural Agents workshop for the Boston EEOC office on March 21, 2006, and at a national TAPS meeting of EEOC directors in Stamford, Connecticut, in September 2006. The workshops for MIT's Addir Interfaith Program took place during the Fall Retreats of 2007, 2008, and 2009.

68. Carmen Oquendo-Villar and Lisa Pic-Harrison, "Acting Up in Colombia: Police Accountability and Anti-Transgender Violence," *e-misferica* 3, no. 2 (November 2006).

69. See a recent contribution with popular appeal: Linda Hirshman, *Victory: The Triumphant Gay Revolution* (New York: HarperCollins, 2012).

70. Lope de Vega, *Fuente Ovejuna*, Biblioteca clásica, vol. 54. Barcelona: Crítica, 1993 (first published in Madrid in 1619).

71. Sarah Schulman and Jim Hubbard, *Act Up Oral History Project*, http://www.actuporalhistory.org/about/bios.html 35, p. 34. http://www.actuporalhistory.org/interviews/video/kramer.html.

72. Sebastian Smee, "Blunt Instruments: Collectives' AIDS Art Made an Impact with Just a Few Strong Images," *Boston Globe*, October 30, 2009, http://www.boston.com/ae/theater_arts/articles/2009/10/30/aids_art_made_a_big_impact_with_just_a_few_strong_images/.

73. Kramer had cofounded Gay Men's Health Crisis (GMHC) in January 1982 but resigned by 1983.

74. Larry Kramer, *The Normal Heart*. The Royal Court Writers Series. London: Methuen in association with the Royal Court Theatre, 1986.

75. "ACT UP Capsule History," http://www.actupny.org/documents/cron-87.html.

76. Claire Grace, "The AIDS Crisis Is Not Over: Activism and Collective Art Practice in ACT UP New York." Exhibition Essay for *ACT UP New York: Activism, Art, and the AIDS Crisis, 1987–1993*, published by Harvard Art Museum, 2009, p. 3. See Ernesto Laclau and Chantal Mouffe, *Hegemony and Socialist Strategy: Towards a Radical Democratic Politics* (2nd ed. London: Verso, 2001).

77. From Harvard's VES website: http://www.ves.fas.harvard.edu/ACTUP.html.

78. On their open-source website, Schulman and Hubbard include transcripts of the interviews accompanied by short video clips. See http://www.actuporalhistory.org/interviews/index.html.

79. Douglas Crimp, *AIDS Demographics* (San Francisco: Bay Press, 1990).

80. Maria Maggenti, interview with Sarah Schulman and Jim Hubbard, ACTUP Oral History Project, February 16, 2005; MIX: The New York Lesbian and Gay Experimental Film Festival, December 11, 2005, http://www.actuporalhistory.org/interviews/images/maggenti.pdf.

81. "ACT UP Capsule History."

82. I am grateful to Michele Stanners for her reading.

83. David Barr, "Enemies at the Gate: Storming Montréal's Palais de Congrès, and Makeshift Battle Stations in Fortress San Francisco," December 2002, Index of Articles From The Treatment Action Group (TAG), http://www.thebody.com/content/art1720.html.

84. Barr, "Enemies at the Gate."

85. Act Up Oral History Project, interview no. 35. p. 14.

86. http://www.actuporalhistory.org/index1.html.

87. Oliviero Toscani worked with Tibor Kalman on AIDS posters; they would cocreate *Colors* to provide social context for the photographic campaigns. See Tibor Kalman, Peter Hall, Michael Bierut, *Tibor Kalman: Perverse Optimist* (Princeton: Princeton Architectural Press, 1998) and Steven Heller's "Biography" for AIGA, http://www.aiga.org/medalist-tiborkalman/.

88. Grace, "The AIDS Crisis Is Not Over," p. 6.

89. Grace, "The AIDS Crisis Is Not Over," p. 7.

90. Douglas Crimp "Right On, Girlfriend!," in *Fear of a Queer Planet: Queer Politics and Social Theory*, ed. Michael Warner (Minneapolis: University of Minnesota Press, 1993), p. 304.

91. Act Up Oral History Project, interview no. 35, p. 22. Kramer doesn't deny it.

92. On October 1, 2005 Cultural Agents, Harvard University hosted the conference, "The Jewish-Latin Mix: Making Salsa" to feature master pianist Larry Harlow, known admiringly as "el judío maravilloso"; Leon Gast, who filmed Our Latin Thing (1973), Salsa (1976), and won an Oscar for When We Were Kings (1996); Martin Cohen, photographer and founder/president of Latin Percussion, the company that developed the major source of Afro-Latino percussion instruments, and Marty Sheller, composer, arranger, and Grammy winning producer of Jazz, Latin Jazz, and Salsa. Scholars included Robert Farris Thompson whose books on tha African cultural heritage in the Americas include *Tango: The Art History of Love* (New York: Pantheon Books, 2005) http://www.fas.harvard.edu/~cultagen/academics/academics_conferences.html.

93. Ada Ferrer, "The Silence of Patriots: Racial Discourse and Cuban Nationalism, 1868–1898" in José Martí *"Our America": From National to Hemispheric Cultural Studies*, editors Jeffrey Belnap and, Raúl Fernandez, pp. 228–252. (Durham: Duke University Press, 1998) p. 243.

94. Paul Chan, "Fearless Symmetry," *Artforum*. New York: Mar 2007. Vol. 45, Iss. 7; pg. 260.

95. http://www.prague-life.com/prague/plastic-people.

96. See http://www.west-eastern-divan.org/the-orchestra/the-orchestra/.

97. Ed Vulliamy, "Strings Attached: What the Venezuelans Are Doing for British Kids," *Observer*, October 2, 2010.

98. http://www.youtube.com/user/LandfillHarmonic.

99. http://en.wikipedia.org/wiki/El_Sistema.

100. José Cuesta, "From Economicist to Culturalist Development Theories: How Strong Is the Relation between Cultural Aspects and Economic Development?," *European Journal of Development Research* 16, no. 4 (2004): 868–891.

101. An article from *City I Q Journal*, the Lithuanian version of *Intelligent Life*, October 2009, acknowledges that the public versus private debate originated in the controversy around the Lietuva Cinema, beginning in 2005. See Andrius Uzkalnis (2009) Sava ir Privatu: Visai Nepriesiska Bendruomenei ir Viesumai. *Miesto IQ: Tarp Vieso ir Privataus*. Rugsejis-Spalis 17, pp. 6–9.

102. Independence was declared on March 11, 1990, though recognition came a year later, first from Iceland, then the United States and others. See http://en.wikipedia.org/wiki/Act_of_the_Re-Establishment_of_the_State_of_Lithuania.

103. In the famous "Kitchen Debate" on July 24, 1959, Richard Nixon argued the virtues of capitalism, showing American kitchen appliances for the convenience of

housewives. Nikita Khruschev countered that keeping "housewives" happy was keeping them from careers. See transcript: http://teachingamericanhistory.org/library/index.asp?document=176; and BBC review: http://news.bbc.co.uk/onthisday/hi/dates/stories/july/24/newsid_2779000/2779551.stm.

104. Nomeda Urbonas and Gediminas Urbonas, "pro-test lab dossier: / 2005" http://www.nugu.lt/nugu_pdf/urbonas_2005_protestlab.pdf.

105. The State Land Lease Agreement, operative until 2093 (Lease number N001194–1745). Article 8.1 determines the primary purpose of the land use: "the land lot can only be used for economic activities, associated with the mission of the cinema theater."

106. Urbonas and Urbonas, "pro-test lab dossier: / 2005."

107. It is impossible to know who they are because the identity of corporate shareholders is protected from public scrutiny.

108. In 1963, Maciunas composed the first Fluxus Manifesto "to purge the world of bourgeois sickness."

109. "United Nations Economic Convention on Access to Information, Public Participation in Decision Making and Access to Justice in Environmental Matters." Aarhus, Denmark, on 25 June 1998. http://www.unece.org/env/pp/treatytext.html.

110. http://www.ssbx.org/index.php?link=2. Her TED talk: http://www.ted.com/index.php/talks/majora_carter_s_tale_of_urban_renewal.html.

111. Rushkoff, *Life Inc.*, p. 234.

112. Rushkoff, *Life Inc.*, p. 234. See also Detroit's Heidelberg Project: http://www.readymade.com/blogs/readymade/hands-up-for-detroit/?utm_source=feedburner&utm_medium=feed&utm_campaign=Feed%3A+readymade+%28ReadyMade%29.

113. Harold Bloom, *The Anxiety of Influence: A Theory of Poetry* (London: Oxford University Press, 1973).

CHAPTER THREE. **Art and Accountability**

1. Grant Kester, "Dialogical Aesthetics: A Critical Framework for Littoral Art," *Variant* 9 (2005): 1–8.

2. Harvard University Art Forum, David Rockefeller Center for Latin American Studies. "Pedro Reyes: Ad usum: to be used," accessed September 8, 2013. http://www.artforumdrclas.com/pedro-reyes/.

3. See Kevin F. McCarthy et al., *Gifts of the Muse: Reframing the Debate about the Benefits of the Arts* (Santa Monica, CA: Rand Corporation, 2004).

4. Featured in Ken Johnson, "When Life Becomes Art," *New York Times Magazine*, September 29, 2011, http://www.nytimes.com/2011/09/30/arts/design/living-as-form-at-essex-street-market-review.html?_r=0. Accessed June 15, 2013.

5. http://www.weheart.co.uk20121109imagine-pedro-reyes.

6. Jose Esparza, *Domus* 962 (October 2012). See also http://www.domusweb.it

/en/art/gun-politics/; http://www.designboom.com/weblog/cat/8/view/24291 /an-orchestra-of-musical-instruments-made-from-weapons-by-pedro-reyes.html; http://www.designindaba.com/news-snippet/sounds-redemption; http://www .trendhunter.com/trends/imagine-by-pedro-reyes.

7. Conversation with Pedro Reyes, June 8, 2005.

8. Eric Thomas Slauter, *The State as a Work of Art: The Cultural Origins of the Constitution* (Chicago: University of Chicago Press, 2009).

9. Thomas Docherty, *Aesthetic Democracy* (Stanford, CA: Stanford University Press, 2006).

10. Hannah Arendt, *Lectures on Kant's Political Philosophy* (Chicago: University of Chicago Press, 1989), p. 4.

11. Immanuel Kant, *The Critique of Judgement* [1790] translated with Introduction and Notes by J.H. Bernard (2nd ed. revised) (London: Macmillan, 1914) part 7. See also Arendt, *Lectures*, p. 67.

12. Arendt, *Lectures*, p. 4.

13. Stanley Cavell, "Aesthetic Problems of Modern Philosophy," chapter 2, in *Judgment, Imagination, and Politics: Themes from Kant and Arendt*, editors Ronald Beiner and Jennifer Nedelsky (Lanham, MD: Rowman and Littlefield, 2001), p. 42.

14. Arendt, *Lectures*, p. 8.

15. This lack of agreement is not a failure of Kant's aesthetics but instead an opportunity to court agreement. Typically, Alexander Nehamas writes that "beauty beckons" engagement, but on individual terms. See his "An Essay on Beauty and Judgment," *Three Penny Review* 80 (winter 2000): 4–7.

16. Kant, *The Critique of Judgement* [1790] part 19.

17. Ronald Beiner and Jennifer Nedelsky, eds., *Judgment, Imagination, and Politics: Themes from Kant and Arendt* (Lanham, MD: Rowman and Littlefield, 2001), p. viii.

18. Arendt, *Lectures*, p. 32.

19. Immanuel Kant, "What Is the Enlightenment?," *Kant: Political Writings*, ed. Hans Siegbert Reis (Cambridge: Cambridge University Press, 1970), pp. 54–60.

20. Arendt, *Lectures*, p. 10.

21. Arendt, *Lectures*, p. 4.

22. Paul Jay and Gerald Graff, "Fear of Being Useful," *Inside Higher Ed*, January 5, 2012, http://www.insidehighered.com/views/2012/01/05/essay-new-approach -defend-value-humanities#ixzz1jGzJMNw1.

23. G. Peter Lepage, Carolyn (Biddy) Martin, and Mohsen Mostafavi, eds. *Do the Humanities Have to Be Useful?* with a preface by Mostafavi (Ithaca, NY: Cornell University, 2006).

24. Laura Brown et al., "Twenty-First Century Humanities at the Core of the University," in Lepage, Martin, and Mostafavi, *Do the Humanities Have to Be Useful?*, pp. 13–18, quote on p. 14.

25. Biodun Jeyifo, "Humanities—with or without Humanism?" in Lepage, Martin, and Mostafavi, *Do the Humanities Have to Be Useful?*, pp. 61–65, p. 64.

26. Rayna Kalas, "Poetry and the Common Sense," in Lepage, Martin, and Mostafavi, *Do the Humanities Have to Be Useful?*, pp. 67–73, quote on p. 71.

27. Caroline (Biddy) Martin, "On the Question of Value," in Lepage, Martin, and Mostafavi, *Do the Humanities Have to Be Useful?*, pp. 91–96. See also David Roochnik, "The Useful Uselessness of the Humanities," *Expositions* 2, no. 1 (2008): 19–26, who has Aristotle speak to the importance of filling leisure time with arts, to divert citizens from violence and war.

28. Dominick LaCapra, "What Is Essential to the Humanities?," in Lepage, Martin, and Mostafavi, *Do the Humanities Have to Be Useful*, pp. 75–85.

29. Brett de Bary, "Against Transparency," in Lepage, Martin, and Mostafavi, in Lepage, Martin, and Mostafavi, *Do the Humanities Have to Be Useful*, pp. 35–40. See also, Pauline Yu, "The Course of the Particulars: Humanities in the University of the Twenty-First Century," (1997): 5, http://archives.acls.org/op/op4oyu.htm.

30. Martha Nussbaum, *Cultivating Humanity: A Classical Defense of Reform in Liberal Education* (Cambridge, MA: Harvard University Press, 1997).

31. Friedrich Schiller, "On the Sublime (1801)," in *Essays*, ed. Walter Hinderer (New York: German Library, New York University Press, 1993), pp. 22–44.

32. Victor Shklovsky, "Art as Technique" (1917), in *Russian Formalist Criticism, Four Essays*, trans. with an introduction by Lee T. Lemon and Marion J. Reis (Lincoln: University of Nebraska Press, 1965), p. 12.

33. See Douglas Kellner's useful review of work at the intersection of "Cultural Studies and Ethics," http://pages.gseis.ucla.edu/faculty/kellner/essays/cultural studiesethics.pdf.

34. See Diana Taylor, *The Archive and the Repertoire: Performing Cultural Memory in the Americas* (Durham, NC: Duke University Press, 2003). Also her *Disappearing Acts: Spectacles of Gender and Nationalism in Argentina's Dirty War* (Durham, NC: Duke University Press, 1997); and *Theatre of Crisis: Drama and Politics in Latin America.* (Lexington: University Press of Kentucky, 1991).

35. Theodor Adorno, *Aesthetic Theory* (1970), trans. R. Hullot-Kentor (Minneapolis: University of Minnesota Press, 1997), p. 8.

36. Susannah Young-ah Gottlieb, introduction to Hannah Arendt, *Reflections on Literature and Culture* (Stanford, CA: Stanford University Press, 2007), p. xiii.

37. Arendt, "The Crisis in Culture: Its Social and Its Political Significance," in Beiner and Nedelsky, *Judgment, Imagination, and Politics*, pp. 3–26, quote on p. 23.

38. Kant, *The Critique of Judgment*, paragraph 50.

39. Arendt, "Crisis in Culture," pp. 16, 17.

40. Arendt, "What Is Permitted to Jove . . . : Reflections on the Poet Bertolt Brecht and His Relation to Politics," in *Men in Dark Times*, pp. 207–249 (New York: Harcourt, Brace and World, 1968); and Arendt, *Reflections on Literature*, pp. 223–256.

41. Hannah Arendt, "Culture and Politics," Young-ah Gottlieb, *Reflections on Literature and Culture*, p. 185.

42. Arendt, "Culture and Politics," pp. 190–191, 197.

43. Jacques Rancière, "The Emancipated Spectator," *Artforum*, March 27, 2007, pp. 271–280.

44. Rancière, *The Politics of Aesthetics: The Distribution of the Sensible*. Translated by Gabriel Rockhill. London: Continuum, 2004, pp. 23–24.

45. Kester, "Dialogical Aesthetics."

46. See also Rancière, "The Emancipated Spectator."

47. Sir Francis Bacon, "Of Seditions" (1625), http://www.authorama.com/essays-of-francis-bacon-16.html.

48. Rancière, "Emancipated Spectator."

49. Paul Veyne, *Writing History: Essay on Epistemology* (Middletown, CT: Wesleyan University Press, 1984), p. 11.

50. Jon Elster, *Ulysses Unbound: Studies in Rationality, Precommitment and Constraints* (Cambridge: Cambridge University Press, 2000), chapter 3.

51. Richard Florida, *The Rise of the Creative Class and How It's Transforming Work, Leisure, Community and Everyday Life*. New York: Basic Books, 2004.

52. Antanas Mockus directed me to Joseph Patrick Henrich et al., eds, *Foundations of Human Sociality: Economic Experiments and Ethnographic Evidence from Fifteen Small-Scale Societies* (Oxford: Oxford University Press, 2004).

53. Hannah Arendt, *The Human Condition* (Chicago: University of Chicago Press, [1958]1998), p. 182.

54. See David Damrosch, *We Scholars: Changing the Culture of the University* (Cambridge, MA: Harvard University Press, 1995).

55. Rancière, "The Emancipated Spectator."

56. Mikhail Bakhtin, "Discourse and the Novel," in *The Dialogical Imagination: Four Essays*, ed. Michael Holquist, trans. Caryl Emerson (Austin: University of Texas Press, 1981).

57. Bonnie Honig, *Democracy and the Foreigner* (Princeton, NJ: Princeton University Press, 2003).

58. Doris Sommer, *Bilingual Aesthetics: A New Sentimental Education* (Durham, NC: Duke University Press, 2004).

59. Víctor Hernández Cruz, "You Gotta Have Your Tips on Fire," *Mainland: Poems* (New York: Random House, 1973), pp. 3–4.

60. Samuel P. Huntington, Who Are *We? The Challenges to America's National Identity* (New York: Simon and Schuster, 2005).

61. Civic humanities is the title of a new secondary field at the Harvard Graduate School of Arts and Science.

62. "Animating Democracy," http://animatingdemocracy.org/.

63. Questions raised at the Duke Public Humanities Conference, April 2011.

64. See Richard Thomas, *Reading Virgil and His Texts: Studies in Intertextuality* (Ann Arbor: Michigan University Press, 1999).

65. Arendt, "Crisis in Culture," p. 14.

66. Arendt, "Crisis in Culture," p. 14.

67. Arendt, "Politics and Culture," p. 201. See also Robert E. Proctor, *Defining the Humanities: How Rediscovering a Tradition Can Improve Our Schools*, 2nd ed. (Bloomington: Indiana University Press, 1998), p. 156.

68. See Proctor, *Defining the Humanities*.

69. Proctor comments on the surprising lack of full histories of humanism, *Defining the Humanities*, p. 87.

70. Stanley Chodorow, "Taking the Humanities Off Life-Support," American Council of Learned Societies, Occasional Paper no. 40, 1997, part 4, http://archives .acls.org/op/op40ch.htm.

71. Charles Homer Haskins, *The Renaissance of the Twelfth Century* (New York: Meridian Books, [1927]1955) and Robert Louis Benson and Giles Constable, eds., *Renaissance and Renewal in the Twelfth Century* (Cambridge, MA: Harvard University Press, 1982).

72. For a recent overview of sacred and secular lyric, see John E. Stevens, *Words and Music in the Middle Ages: Song, Narrative, Dance, and Drama, 1050–1350* (Cambridge: Cambridge University Press, 1986).

73. Stephen Gersh and Bert Roest, eds., *Medieval and Renaissance Humanism: Rhetoric, Representation and Reform* (Leiden: Brill, 2003), p. x.

74. Robert Black emphasizes the debates in *Humanism and Education in Medieval and Renaissance Italy: Tradition and Innovation in Latin Schools from the Twelfth to the Fifteenth Century* (Cambridge: Cambridge University Press, 2001) pp. 14, 17. See also "Massachusetts Arts Curriculum Framework," Massachusetts Department of Education, November 1999, http://www.doe.mass.edu/frameworks/arts/1099.pdf xiii; and R. W. Southern, *Scholastic Humanism and the Unification of Europe* (Oxford: Blackwell, 1995), p. 19.

75. Proctor, *Defining the Humanities* p. 164 and throughout.

76. Frederick G. Whelan, *Hume and Machiavelli: Political Realism and Liberal Thought* (Lanham, MD: Lexington Books. 2004), p. 4. The most prominent of the civic humanists were Leonardo Bruni (1370–1444) and Leon Battista Alberti (1404–1472), who is more famous in the modern age for his treatise on architecture.

77. Jacob Burckhardt, *The Civilization of the Renaissance in Italy*, trans., S. G. C. Middlemore (New York: Penguin Books, 1990), p. 17.

78. Paul Anthony Rahe, ed., *Machiavelli's Liberal Republican Legacy* (Cambridge: Cambridge University Press, 2006).

79. Isaiah Berlin et al., *The Proper Study of Mankind* (New York: Farrar, Straus and Giroux, 2000), pp. 334–335.

80. My emphasis, in Berlin et al., *Proper Study* (2000), p. 336. (Voltaire, Letter to Maurice Pilavoine, April 23, 1760.)

81. http://plato.stanford.edu/entries/vico/; Berlin, "The Divorce between the Natural Sciences and the Humanities," in Berlin et al., *The Proper Study of Mankind*, pp. 6–358, pp. 350–353.

82. Isaiah Berlin rues the separation and reaffirms a credo of rational pursuit of questions.

83. Some will contest this distinction, giving it, for example, to the Halle in 1694, or to the more cautious University of Gottingen in 1737. See Charles E. McClelland, *State, Society and University in Germany, 1700–1914* (Cambridge: Cambridge University Press, 1980), p. 33.

84. Robert B. Pippin, *The Persistence of Subjectivity: On the Kantian Aftermath* (Cambridge: Cambridge University Press, 2005).

85. Bill Readings, *The University in Ruins* (Cambridge, MA: Harvard University Press, 1996), p. 60. Also Peter Gilgen, "Structures, but in Ruins Only: On Kant's History of Reason and the University," CR: *The New Centennial Review* 9, no. 2 (fall 2009):165–194, p. 175.

86. http://www.nps.gov/history/NR/twhp/wwwlps/lessons/92uva/92facts1.htm. Also Garry Wills, *Mr. Jefferson's University* (Washington, DC: National Geographic Society, 2002); and McClelland, *State, Society and University in Germany*, p. 112.

87. Daniel Fallon, *The German University: A Heroic Ideal in Conflict with the Modern World* (Boulder: Colorado Associated University Press, 1980), pp. 14–15. See also McClelland, *State, Society and University in Germany*, pp. 109–110.

88. Arendt, *Lectures*, p. 182.

89. Arendt: "Crisis in Culture," pp. 6–8.

90. Oscar Wilde, preface to *Dorian Gray*, cited in Cleanth Brooks and William Kurtz Wimsatt, *Literary Criticism: A Short History* (New York, Routledge Kegan Paul 1970), p. 486.

91. Brooks and Wimsatt, *Literary Criticsim*, p. 447. Also Terry Eagleton, *Literary Theory: An Introduction*, 2nd ed. (Oxford: Blackwell, 1996), p. 27.

92. Antonio Gramsci, *The Antonio Gramsci Reader: Selected Writings 1916–1935*, ed. David Forgacs, with a new introduction by Eric Hobsbawm (New York: New York University Press, 2000), p. 377.

93. Matthew Arnold, *Culture and Anarchy.*Oxford World's Classics (Oxford: Oxford University Press, 2006). For Adorno's often-cited phrase, see the anthology of his work, *Can One Live after Auschwitz? A Philosophical Reader*, ed. R. Tiedemann, trans. R. Livingstone (Stanford, CA: Stanford University Press, 2003).

94. Elaine Showalter, *Teaching Literature* (Oxford: Wiley-Blackwell, 2003), p. 23.

95. Geoffrey Harpham on "How America Invented the Humanities." A videotaped lecture, http://www.youtube.com/watch?v=Q51AS6FiBuc. The purpose survives the period.

96. Thomas Pavel's *The Spell of Language: Poststructuralism and Speculation* (Chicago: University of Chicago Press, 2001), p. 3.

97. Diana Sorensen, *A Turbulent Decade Remembered: Scenes from the Latin American Sixties* (Stanford, CA: Stanford University Press, 2007).

98. Jean-François Lyotard, *The Postmodern Condition: A Report on Knowledge*.

Theory and History of Literature, vol. 10 (Minneapolis: University of Minnesota Press, 1984).

99. Alfred North Whitehead, *Dialogues of Alfred North Whitehead, As Recorded by Lucien Price*, (Boston: Little, Brown, 1954), p. 7.

100. Showalter, *Teaching Literature*, p. 23.

101. Pavel, *Spell of Language*, p. 5.

102. Kristin Ross, "Kristin Ross on Jacques Ranciere" *Artforum*, Vol. 45, Issue 7, March 2007. p. 254. http://findarticles.com/p/articles/mi_m0268/is_7_45/ai _n24354910/.

103. Biodun Jeyifo, "Humanities with or without Humanism?," pp. 61–66.

104. Paul Bloom, *How Pleasure Works: The New Science of Why We Like What We Like* (New York: W. W. Norton, 2010).

105. Proctor, *Defining the Humanities* p. 88.

106. J. W. Hales, "The Teaching of English," in F. W. Farrar, *Essays on a Liberal Education*, (London-Macmillan, 1968), pp. 302–303; cited in Proctor, *Defining the Humanities* p. 99. See also Nietzsche, New Deal/WPA History." Accessed November 4, 2012. Friedrich Wilhelm Nietzsche, *On the Genealogy of Morals*. translated by Walter Arnold Kaufmann. New York: Vintage Books, 1967 vol. 3, p. 2.

107. Benjamin H. D. Buchloh, *Neo-Avantgarde and Culture Industry: Essays on European and American Art from 1955 to 1975* (Cambridge, MA: MIT Press, 2000).

108. Pavel, *Spell of Language*, p. xii.

109. Stanley Fish, "The Last Professor," *New York Times*, January 18, 2009, http://fish.blogs.nytimes.com/2009/01/18/the-last-professor/.

110. Shawkat Toorawa, admits a standard visceral rejection in "In Praise of Nuance," in Lepage, Martin, and Mostafavi, *Do the Humanities Have to Be Useful?*, pp. 107–110.

111. Contra Anthony T. Kronman, *Education's End: Why Our Colleges and Universities Have Given Up on the Meaning of Life* (New Haven, CT: Yale University Press, 2007).

112. http://fish.blogs.nytimes.com/2008/01/06/will-the-humanities-save-us /#more-81.

113. See Stanford University's civic invitation to the humanities, https://human experience.stanford.edu/what?q=why/.

114. Pavel, *Spell of Language*, pp. 2, 5.

115. Nicolas Bourriaud, *Relational Aesthetics* (Paris: Les Presses du réel, 2002).

116. Jerry Saltz, "A Short History of Rirkrit Tiravanija—Thai Artist Who Cooks Meals as Installation Art," *Art in America* 84, no. 2 (February 1996), p. 82.

117. See Claire Bishop, "Antagonism and Relational Aesthetics," *October* 110 (fall 2004): 51–79.

118. Gilles Deleuze and Felix Guattari, *Kafka: Toward a Minor Literature* (Minneapolis: University of Minnesota Press, 1986).

119. See James Quay and James Veninga, introduction to *Making Connections: The*

Humanities, Culture and Community, ACLS National Task Force on Scholarship and the Public Humanities. American Council of Learned Societies, Occasional Paper No. 11 New York, New York. 1990.

120. See LaCapra, "What Is Essential to the Humanities?" pp. 75–85.

121. George Yúdice, *The Expediency of Culture: Uses of Culture in the Global Era* (Durham, NC: Duke University Press, 2003).

122. See Ien Ang, *Watching Dallas* (New York: Metheun, 1985); and John Fiske, "British Cultural Studies and Television," in *Channels of Discourse*, ed. Robert Clyde Allen (New York: Routledge, 1992) pp. 254–289.

123. Jesús Martín Barbero, *De los medios a las mediaciones: Comunicación, cultura y hegemonía* 5th ed. Bogotá: Convenio Andrés Bello, 1998. Also, Néstor García Canclini, *Hybrid Cultures: Strategies for Entering and Leaving Modernity* (Minneapolis: University of Minnesota Press, 2005).

124. See Nicholas Kristof, "D.I.Y. Foreign Aid Revolution," *New York Times Magazine*, October 20, 2010, on the wave of small contributions today, mostly by women. http://www.nytimes.com/2010/10/24/magazine/24volunteerism-t.html?pagewanted =4&_r=1.

125. Rigoberta Menchú's address in LASA, Washington DC, September 4, 2001.

126. Pierre Macherey, *Pour une théorie de la production littéraire* (Paris: Maspero, 1966).

127. J. L. Austin, *How to Do Things with Words* 2nd ed. Oxford: Clarendon Press, 1975. The William James Lectures, 1955.

128. James Clifford, *The Predicament of Culture: Twentieth-century Ethnography, Literature, and Art* (Cambridge: Harvard University Press, 1988); see also various edited volumes by Michael Fischer, George Marcus, and James Clifford. Also *Anthropology and the Colonial Encounter*, edited by Talal Asad (London: Ithaca Press, 1973).

129. Heisenberg's uncertainty principle is basically that observation itself affects the outcome. For discussion of Heisenberg's paper published in 1927, see William Charles Price, Seymour S. Chissick, and Werner Heisenberg, eds., *The Uncertainty Principle and the Foundations of Quantum Mechanics: A Fifty Years' Survey* (New York: Wiley, 1977).

130. Slauter, *State as a Work of Art*.

131. Stanley Chodorow observes a "culture of complaint" and recommends a series of creative adjustments in "Taking the Humanities Off Life-Support."

132. 656 Comics, "Sobre 656 Comics." Accessed September 8, 2013. http://www .656comics.org/p/sobre-656-comics_7919.html.

133. Torolab, "Transdisciplinary Projects." Accessed September 8, 2013. http:// torolab.org/.

134. http://www.tuugo.com.mx/Companies/osimmpe-org-soc-indigena-mixteca -del-mpo-de-penoles/0200004075885. See http://ciudadania-express.com/2011/08 /08/sedesol-impulsa-el-rescate-de-lenguas-indigenas-y-fomenta-la-educacion/. "Recuperación de la lengua Mixteca del municipio de Santa María Peñoles, con la finalidad de contribuir al fortalecimiento cultural de la población mixteca de las locali-

dades de Santa Catarina Estetla y Cañada de Hielo del municipio de Santa María Peñoles y mantener viva la lengua mixteca como lengua materna." Also cultural-agents.org.

135. "Texto de partida" is the program name in Mexico City. See http://www .textodepartida.org/.

CHAPTER FOUR. Pre-Texts

1. Ksenija Bilbija, and Paloma Celis Carbajal. *Akademia Cartonera: A Primer of Latin American Cartonera Publishers=Un abc de las editoriales cartoneras en América Latina* (Madison: Parallel Press, University of Wisconsin-Madison Libraries, 2009).

2. Kutsemba Cartão in Mozambique is a recent ripple, after Luis Madureira from the University of Wisconsin, Madison, went to teach there and found a need for books. See http://kutsemba.wordpress.com/, the official website for the publisher in Mozambique.

3. Tomás Eloy Martínez, "Las editoriales cartoneras: Creadores ante la crisis," *La Nacion*, (Buenos Aires: Sábado 28 de febrero de 2009) http://www.lanacion.com.ar /1103987-creadores-ante-la-crisis.

4. Bilbija and Celis Carbajal, *Akademia Cartonera*.

5. http://www.princeclausfund.org/en/programmes/awards. "More than 60 independent Cartonera publishers are currently operating in countries across Latin America and one has started in Mozambique."

6. "For over 20 years Fotokids, originally called Out of the Dump, has worked as a non-profit organization breaking the cycle of poverty through training in visual arts and technology." Fotokids, http://www.fotokids.org/. Martín Cohen founded but is no longer active in Fundacion Ph 15, http://www.ph15.org.ar/.

7. Shahidul Alam's project Drik in Bangladesh: http://www.drik.net. And Colombia's Fundación Disparando Cámaras para la Paz: http://disparandocamarasparalapaz .blogspot.com/.

8. Cosponsored with Artists in Context http://www.artistsincontext.org/.

9. The prize for 2010 was awarded to 656 Comics in Ciudad Juárez; the prize in 2011 went to Torolab in Tijuana.

10. Paolo Vignolo directs the Cultural Agents track of the Centro de Estudios Sociales. See http://www.unal.edu.co/ces/index.php/nosotros/areas.

11. Aina Arts, "Aina Arts-Projects." http://www.hcs.harvard.edu/ainaarts/projects /index.htm.

12. Gil Noam of the Harvard Medical School and Daishon Mills of Boston Public Schools both direct the Leadership Institute, associated with PEAR (Program in Education, Afterschool, and Resiliency).

13. www.extension.harvard.edu/2008–09/courses/syllabi/ . . . /stare130.pdf.

14. Kevin Lynch explores the effects of aesthetics on civic life in *The Image of the City* (Cambridge, MA: MIT Press, 1960).

15. "Today 125 million children do not get any formal education at all; the majority of them are girls. Even more children do not get sufficient schooling because they drop out before they learn basic literacy skills. Children throughout the world are being denied their fundamental right to education. In developing countries, one in four adults — some 900 million people, are illiterate. The human costs of this education crisis are incalculable." "Education: Tackling the Global Crisis," Oxfam International, April 2001, http://www.oxfamamerica.org/files/OA-Education_Tackling _Global_Crisis.pdf.

16. The emphasis on natural and social sciences seems to relegate the humanities; but the approach to reading and interpretation returns to humanistic operations. http://www.corestandards.org/.

17. Paulo Freire, *Teachers as Cultural Workers: Letters to Those Who Dare Teach* (Boulder, CO: Westview Press, 1998), p. 2.

18. "Art-Making and the Arts in Research Universities: Strategic Task Forces," Interim Report, ArtsEngine National Network, March 2012, http://arts-u.org /wp-content/uploads/2012/03/ArtsEngine-National-Strategic-Task-Forces-Interim -Report-March-2012.pdf; and "Arts Practice in Research Universities," Harvard University Task Force on the Arts, 2008, http://www.provost.harvard.edu/reports /ArtsTaskForce-Report_12-10-08.pdf.

19. "La muerte la brujula," YouTube, http://www.youtube.com/watch?v=lAH3yt EFJpk&feature=youtu.be.

20. See Liz Gruenfeld, "Evaluation of Amparo Cartonera," internal document, Museo Amparo, Puebla, Mexico. 2008. p. 18. "Museo Amparo Program students were positively impacted in terms of attention to detail, reading comprehension, and student interpretation of stories, as seen by teachers and artists: Students place more attention in details now. As with the 'hypertexts,' they pay more attention to details in the story to be able to reverse the order of events and say what else might happen instead. Another teacher added that program students learned more words, resulting in a richer vocabulary."

21. Gayatri Chakravorty Spivak, *An Aesthetic Education in the Era of Globalization* (Cambridge, MA: Harvard University Press, 2012). Alongside the familiar Spivak of old is a contemporary Spivak who offers a pressing sense of an ongoing dilemma that has only grown increasingly urgent and which she cannot quite resolve even as she articulates it: the double bind that marks the difference between the writing of books to be published for the academy and the teaching of a global citizenry who take their learning beyond the classroom. The abstraction of philosophy is always, for Spivak, as pragmatic an activity as protesting the intellectual property rights of the indigenous, but it is only in thinking about the idea of teaching itself that one reconciles that which has its "place in an essay prepared for the impatience of publisher's deadlines" and that which takes "its place outside my classroom here."

22. Ludwig Wittgenstein, *Philosophical Investigations*, trans. G. E. M. Anscombe (New York: Macmillan, [1953] 1968), sections 244–271.

23. Washington Cucurto, *1810: La revolución de mayo vivida por los negros* (Buenos Aires: Emecé Editories, 2009).

24. Cucurto, *1810*, pp. 11, 189. My translations.

25. Washington Cucurto, "Libros si, playstation no! Se viene la Feria preferida de los lectores, una oportunidad para futbolistas jóvenes," ESPN Deportes, April 22, 2009, http://espndeportes-assets.espn.go.com/news/story?id=797885&s=fut&type =column.

26. Centro de Investigaciones Artisticas, http://www.ciacentro.org/node/814.

27. Luis Soriano is the teacher-creator. See Simon Romero, "Acclaimed Colombian Institution Has 4,800 Books and 10 Legs," *New York Times*, October 19, 2008, http:// www.nytimes.com/2008/10/20/world/americas/20burro.html.

28. "Libros, un modelo para armar" (LUMPA). Accessed September 8, 2013, http:// proyectolumpa.blogspot.com/.

29. Northrop Frye, *Anatomy of Criticism, Four Essays* (Princeton, NJ: Princeton University Press, 1957), p. 158.

30. José Eustacio Rivera, *La vorágine* (Bogotá: Cromos, 1924); and José Eustasio Rivera, *The Vortex*, trans. Earle K. James (New York: G. P. Putnam, 1935).

31. D. W. Winnicott, "The Use of an Object in the Context of *Moses and Monotheism*" (1969), in *Psychoanalytic Explorations*, ed. C. Winnicott, R. Shepherd, and M. Davis (Cambridge, MA: Harvard University Press, 1989), p. 245.

32. "The workshop proved how important it is to encourage young people to read literature, because it will give them the bases for writing their own texts through which they express themselves." http://www.ayara.org/news/jun/eng.

33. See Henry Louis Gates Jr., *The Signifying Monkey: A Theory of African-American Literary Criticism* (New York: Oxford University Press, 1988).

34. Melville J. Herskovits, *The Myth of the Negro Past*, (New York: Harper Brothers, 1941); Robert Farris Thompson, *Flash of the Spirit: African and Afro-American Art and Philosophy* (New York: Random House, 1983) and *Tango: The Art History of Love* (New York: Pantheon Books, 2005).

35. Formerly in Providence, Rhode Island, ArtsLiteracy has regrouped as HABLA in Mérida Mexico. See http://www.habla.org/en/about-us/merida-mexico/.

36. Gétulio Vargas, dictator from 1934 through 1954 when he committed suicide.

37. http://www.youtube.com/watch?v=4xuzg51HzzQ&feature=related.

38. Michael Voss, "Reading While Rolling Cuba's Famous Cigars," BBC, December 10, 2009, http://news.bbc.co.uk/2/hi/americas/8406641.stm. "Instead of canned music, many cigar factories in Cuba still rely on the ancient tradition of employing a reader to help workers pass away the day. Gricel Valdes-Lombillo, a matronly former school teacher, has been this factory's official reader for the past 20 years. In the morning she goes through the state-run newspaper Granma cover to cover. Later in the day she returns to the platform to read a book. It's a job Gricel Valdes-Lombillo claims she has never tired of. 'I feel useful as a person, giving everyone a bit of knowledge and culture. The workers here see me as a counsellor, a cultural adviser, and

someone who knows about law, psychology and love.' Once the newspaper reading is over workers have a say in what they would like to listen to. There's a mix of material ranging from classics to modern novels, like the Da Vinci Code, as well as the occasional self-help books and magazines. On the day I visited the factory Gricel was reading Alexandre Dumas' classic, the *Count of Monte Cristo*, a long-time favourite here."

39. Jesús Colón, *A Puerto Rican in New York and Other Sketches* (New York: Mainstream Publishers, 1961). P. 1.

40. See Gerald E. Poyo, *With All, and for the Good of All: The Emergence of Popular Nationalism in the Cuban Communities of the United States, 1848–1898.* (Durham, NC: Duke University Press, 1989).

41. See Eric Arnesen, *Encyclopedia of U.S. Labor and Working-Class History* (New York: Routledge, 2007), pp. 333–334.

42. Gompers had a one-year hiatus of leadership from 1894 to 1895.

43. Arnesen, *Encyclopedia of U.S. Labor and Working-Class History*, p. 333. U.S. syndicalism develops, Arnesen says, at the "intersection between anarchist internationalism and Cuban nationalism."

44. Paul de Man, "Autobiography as Defacement," MLN 94, no. 5 *Comparative Literature* (December 1979). Reprinted in Paul de Man, *Rhetoric of Romanticism* (New York: Columbia University Press, 1984), pp. 67–82.

45. Freire, *Teachers as Cultural Workers*, p. 8.

46. Howard Gardner, *Frames of Mind: The Theory of Multiple Intelligences* (New York: Basic Books, 2011).

47. Pre-Texts retains its original name of Cartonera here.

48. The workshops for Mexico City's Secretariat of Education began in March 2011 and for Boston in July 2011. See http://www.textodepartida.org/.

49. See Naseemah Mohamed's undergraduate thesis, "The Art of Literacy: A Post-Colonial Pedagogical Intervention in Zimbabwe," for Social Studies and the Department of African and African American Studies, Harvard College, 2012.

50. Gruenfeld, "Evaluation of Amparo Cartonera."

51. Augusto Boal, *Games for Actors and Non-Actors* (London: Routledge, 1992).

52. Jackie Andrade, "What Does Doodling Do?," *Applied Cognitive Psychology* (2009), published online (www.interscience.wiley.com), doi: 10.1002/acp.1561; Charles Tijus, "Interpreting for Understanding," *Conference Interpreting: Current Trends in Research*, ed. Yves Gambier, Daniel Gile, and Christopher Taylor (Amsterdam: John Benjamins, 1994), p. 46.

53. Alison Gopnik, "Explanation as Orgasm," *Minds and Machines* 8, no. 1 (February 1998): 101–118.

54. See *A Touch of Greatness*, http://www.pbs.org/independentlens/touchof greatness/teacher.html.

55. http://en.wikipedia.org/wiki/Maria_Montessori#cite_note-search.ebscohost .com-4.

56. Developed by Rudolf Steiner in 1919, http://www.whywaldorfworks.org/02 _W_Education/index.asp.

57. Louise Boyd Cadwell, *Bringing Learning to Life: A Reggio Approach to Early Childhood Education* (New York: Teachers College Press, 2003); and Cathy Weisman Topal and Lella Gandini, *Beautiful Stuff! Learning with Found Materials* (Worcester, MA: Davis Publications, 1999).

58. See Basil B. Bernstein, *Class, Codes and Control* (London: Routledge and Kegan Paul, 1971).

59. On Korea: http://education.stateuniversity.com/pages/1400/South-Korea -educational-system-overview.html; and Finland: http://www.culturalpolicies.net /web/finland.php?aid=831. See Lane Wallace, "Multicultural Critical Theory. At B-School?," *New York Times* Business Section, January 9, 2010, http://www.nytimes .com/2010/01/10/business/10mba.html. Also Robert and Michele Root-Bernstein, "Arts at the Center," plenary talk at UNESCO 2nd World Conference on Arts Education, Seoul, South Korea, May 25–28, 2010, http://www.unesco.org/new/fileadmin /multimedia/hq/clt/clt/pdf/Arts_Edu_SeoulConf_KeynotePrestation_en.pdf.

60. Quoted in Robert E. Proctor, *Defining the Humanities: How Rediscovering a Tradition Can Improve Our Schools, with a Curriculum for Today's Students,* 2nd ed. (Bloomington: Indiana University Press, 1998), p. 6.

61. Jacques Rancière, *The Ignorant Schoolmaster: Five Lessons in Intellectual Emancipation,* trans. with an introduction by Kristin Ross (Stanford, CA: Stanford University Press, [1987]1991).

CHAPTER FIVE. **Play Drive in the Hard Drive**

1. Friedrich von Schiller, *Letters on the Aesthetic Education of Man,* in *Literary and Philosophical Essays: French, German and Italian,* vol. 32, Harvard Classics (New York: PF Collier and Son, 1910): pp. 221–313. http://www.archive.org/stream/literaryand philooounknuoft/literaryandphilooounknuoft_djvu.txt.

2. January 16, 1793. I thank James Chandler for this note.

3. See a narrower, spatial interpretation of Schiller's freedom in Wolfgang Düsing, *Friedrich Schiller: Über die ästhetische Erziehung des Menschen in einer Reihe von Briefen, Text, Materialien, Kommentar* (Munich: C. Hanser, 1981). Also see Benjamin Bennett, *Aesthetics as Secular Millenialism:Its Trail from Baumgarten and Kant to Walt Disney and Hitler* (Lewisburg, PA: Bucknell University Press, 2013).

4. President Obama's State of the Union address in January 2011 stressed the importance of technical and scientific education with no mention of arts and humanities. See http://www.whitehouse.gov/state-of-the-union-2011. But his new initiative "Turnaround Arts" promises to redress the exclusion. See http://turnaroundarts .pcah.gov/.

5. Sir Ken Robinson, "Do Schools Kill Creativity?" (2006). See http://www.ted .com/talks/view/id/66.

6. David Brooks, "The New Humanism," *New York Times*, March 7, 2011. http://www.nytimes.com/2011/03/08/opinion/08brooks.html.

7. "The more you study the brain, the actual physical brain, the more you realize everybody has the creative hardware, but some people find it easier to access it." Alvin Powell, "Harnessing Your Creative Brain," *Harvard Gazette*, March 3, 2011, http://news.harvard.edu/gazette/story/2011/03/harnessing-your-creative-brain.

8. See also letter 4, 229–30.

9. Martha Nussbaum, *Not For Profit: Why Democracy Needs the Humanities* (Princeton, NJ: Princeton University Press, 2010).

10. Albert Rothenberg and Carl R. Hausman, eds., *The Creativity Question* (Durham, NC: Duke University Press, 1976), p. 3. I thank Natalya Sukhonos for this reference.

11. See Albert Rothenberg, "The Process of Janusian Thinking," in Rothenberg and Hausman, *Creativity Question*, p. 313.

12. Stephen Nachmanovitch, "This Is Play," *New Literary History* 1, no. 40 (2009): 11.

13. Hannah Arendt, *On Revolution* (New York: Penguin Books, 2006).

14. Schiller mentions Machiavelli in the play *The Revolt of the Netherlands*, where he remarks of his hero William the Silent that his patron Charles V had no need to read Machiavelli because he embodied those teachings. See Fred Bauman, "Two Friendships: Schiller's Don *Karlos* and Letters on *Don Karlos*," in *Love and Friendship: Rethinking Politics and Affection in Modern Times*, ed. Eduardo A. Velásquez, (Lanham, MD: Lexington Books, 2003), p. 424. See also Frederick C. Beiser, *Schiller as Philosopher: A Re-examination* (Oxford: Oxford University Press, 2005), pp. 125, 151.

15. Paulo Freire, *Pedagogy of the Oppressed*, new revised twentieth-anniversary ed. (New York: Continuum, 1993), p. 35.

16. Fredric Jameson, "Cognitive Mapping," in *Marxism and the Interpretation of Culture*, ed. Lawrence Grossberg and Cary Nelson (Urbana-Champaign: University of Illinois Press, 1988), p. 358.

17. Jacques Rancière, "The Politics of Aesthetics, Roundtable," on Eyal Weizman's Blog, www.roundtable.keinorg/node/463. Rancière comments on a "one-seater" contemplative theater project that earned the scorn of critics who imagine that political art needs to address particular issues. Rancière develops his idea about the personal effects of theater in "The Emancipated Spectator."

18. Freire, *Pedagogy*, p. 39.

19. Rancière, interview with Sudeep Dasgupta. "Art Is Going Elsewhere: And Politics Has to Catch It," *Krisis* 1 (2008): 70–76; http://www.krisis.eu/content/2008–1/2008–1–09-dasgupta.pdf.

20. Disconnection is Rancière's preferred term for the aesthetic effect. See interview in *Krisis*.

21. Beiser, *Schiller as Philosopher*, p. 132.

22. For example, Lesley Caldwell, *Art, Creativity, Living* (London: Karnac Books, 2001), p. 16.

23. "As I look back over the papers that mark the development of my own thought and understanding I can see that my present interest in play in the relationship of trust that may develop . . . was always a feature of my consultative technique." D. W. Winnicott, "Playing: Its Theoretical Status in the Clinical Situation," *International Journal of Psycho-Analysts*, 49 (1968): 48.

24. Carl Jung kept the mantra in focus for Winnicott's readers: "The dynamic principle of fantasy is play, a characteristic also of the child, and as such it appears inconsistent with the principle of serious work. But without this playing with fantasy no creative work has ever yet come to birth. The debt we owe to the play of imagination is incalculable." Jung, C. G., & Baynes, H. G. *Psychological Types, or, The Psychology of Individuation*. London: Kegan Paul Trench Trubner, (1921). (Collected Works Vol. 6) volume 6. P. 93. Quoted, for example, in Ellen Y. Siegelman, *Metaphor and Meaning in Psychotherapy* (New York: Guilford Press, 1990), p. 172.

25. D. W. Winnicott, *Playing and Reality* (London: Tavistock Publications, 1971), p. 38. Cited in Siegelman, *Metaphor and Meaning in Psychotherapy*, p. 172.

26. D. W. Winnicott, "Playing: Creative Activity and the Search for Self" *Playing and Reality* (1971): 54–55.

27. Freud invokes the authority of Schiller to describe the opposition of the ego and the id. See Paul-Laurent Assoun, *Freud and Nietzsche* (London: Continuum Collection, 2002; originally in French, Paris: Presses Universitaires de France, 1980), p. 84. In 1908 Freud wrote: "Might we not say that every child at play behaves like a creative writer, in that he creates a world of his own, or, rather, rearranges the things of his world in a new way which pleases him?" Sigmund Freud, "Creative Writers and Daydreaming" (1908), in *The Standard Edition of the Complete Psychological Works of Sigmund Freud*, vol. 9, ed. J. Strachey (London: Hogarth Press, 1955), p. 14.

28. Jan Abram and Knud Hjulmand, *The Language of Winnicott: A Dictionary of Winnicott's Use of Words* (London: Karnac Books, 1996), p. 121.

29. Winnicott, *Playing and Reality*, p. 70.

30. Mihai Spariosu, *Dionysus Reborn: Play and the Aesthetic Dimension in Modern Philosophical and Scientific Discourse* (Ithaca, NY: Cornell University Press, 1989), p. 185.

31. D. W. Winnicott, "The Use of an Object in the Context of *Moses and Monotheism*," in *Psycho-Analytic Explorations*, ed. Clare Winnicott, Ray Shepherd, and Madeleine Davis (Cambridge, MA: Harvard University Press, 1989), p. 245.

32. *Barbara Johnson, "Using People*: Kant with Winnicott," in *The Turn to Ethics*, ed. Marjorie B. Garber, Beatrice Hanssen, and Rebecca L. Walkowitz (New York: Routledge, 2000), pp. 47–64.

33. Caldwell, *Art, Creativity, Living*, p. 16.

34. Winnicott, "Use of an Object," p. 93.

35. D. W. Winnicott, "Primitive Emotional Development," *International Journal of Psychoanalisis* (1945) 26:137–143.

36. Jean-Jacques Rousseau, *Politics and the Arts: Letter to M. d'Alembert on the Theatre*, with an introduction by Allan Bloom (Glencoe, IL: Free Press, 1960).

37. Beiser, *Schiller as Philosopher*, 195.

38. See Immanuel Kant, "What Is the Enlightenment?," *Kant: Political Writings*, ed. Hans Siegbert Reis (Cambridge: Cambridge University Press, 1970).

39. Kant, quoted in Hannah Arendt, *Lectures on Kant's Political Philosophy*, edited with an interpretive Essay by Ronald Beiner. Chicago: University of Chicago Press, 1982, p. 64.

40. Friedrich Schiller, "Grace and Dignity," in *Aesthetical and Philosophical Essays* (Middlesex, UK: Echo Books, 2006), pp. 127–154, 146. Ernst Cassirer would spell out that wresting a form depends on stimulating or assaulting the senses. Thanks to Schiller, Cassirer reworks the Kantian relationship between morality and desire by insisting on a "formal drive," which he calls representation (*Repräsentation/Darstellung*). See also how Susanne Langer *Feeling and Form: A Theory of Art* (White Plains, NY: Longman, 1977) continued Ernst Cassirer's line of thinking. Michael Polanyi's project of "skillful knowing" relies heavily on Cassirer's *The Philosophy of the Enlightenment* (Princeton: Princeton University Press, 1951).

41. Friedrich Schiller, "On the Sublime," trans. William F. Wertz, Jr. See http://www.schillerinstitute.org/transl/trans_on_sublime.html.

42. Schiller, "On Naïve and Sentimental Poetry," (1795) http://www.schiller institute.org/transl/schiller_essays/naive_sentimental-1.html (accessed June 16, 2013) part 5. See also part 25.

43. Lyndon Larouche's "Schiller Institute" misreads this preference by alleging that Schiller promoted classical culture for contemporary life. See http://www.schiller institute.org/biographys/meet_larouche.html.

44. Emmanuel Levinas, *Difficult Freedom: Essays on Judaism*, trans. Seán Hand (Baltimore: Johns Hopkins University Press, 1990).

45. Schiller, "On Naïve and Sentimental Poetry," part 18.

46. Arendt would import Schiller's distinction between naïve and sentimental greatness to America, where she contrasted the beautiful innocence of Melville's Billy Budd with tormented Captain Vere, whose duty to the collective good compels him to condemn angelic Billy. Arendt, *On Revolution*, pp. 78–79.

47. http://studiocleo.com/librarie/schiller/essay.html.

48. Schiller, "On the Sublime," part 11.

49. See María del Rosario Acosta López, "'Making Other People's Feelings Our Own': From Aesthetics to the Political in Schiller's Letters," where she quotes from Schiller's essay "Concerning the Sublime" (1796): http://www.filosofiaytragedia.com /cursos/schillercalifornia.pdf.

50. "There is no document of civilization which is not at the same time a document of barbarism." Walter Benjamin, "Theses on the Philosophy of History," in *Illuminations*, ed. Hannah Arendt, trans. Harry Zohn (New York: Schocken Books, 1969), p. 256.

51. Gilberto Freyre, *The Masters and the Slaves (Casa-Grande and Senzala): A Study in the Development of Brazilian Civilization*. Translated by Samuel Putnam (New York: Alfred A. Knopf, 1946.).

52. Daniel Fallon, *The German University: A Heroic Ideal in Conflict with the Modern World* (Boulder, CO: Colorado Associated University Press, 1980), pp. 13–15.

53. See Herbert Marcuse, *Eros and Civilization: A Philosophical Inquiry Into Freud* (Boston: Beacon Press, 1955); Richard Van Heertum, "Marcuse, Bloch and Freire: Reinvigorating a Pedagogy of Hope," *Policy Futures in Education* 4, no. 1 (2006): 45–51. In footnote 1, the author addresses Marcuse's direct debt to Schiller as he develops the idea of an aesthetic education.

54. Paulo Freire wrote that during his time in exile: "I read Gramsci and I discovered that I had been greatly influenced by Gramsci long before I had read him." Freire quoted in Peter Mayo, *Gramsci, Freire, and Adult Education: Possibilities for Transformative Action* (London: Zed Books, 1999), p. 7.

55. Augusto Boal followed Schiller's disciple Brecht. Boal's *Theatre of the Oppressed* dedicates chapter 3 to "Hegel and Brecht" in order to outdo them by turning the public into spect-actors. Brecht is equally reluctant to acknowledge what he learned from Schiller. See John Fuegi, *Bertolt Brecht: Chaos, According to Plan* (Cambridge: Cambridge University Press, 1987).

56. Freire, *Pedagogy*, p. 89.

57. Antanas Mockus, interview with author, February 27, 2008.

58. Freire, *Pedagogy*, p. 40.

59. See Paulo Freire, *Cultural Action for Freedom*. Harvard Educational Review Monograph Series, vol. 1 (Cambridge, MA: Harvard Educational Review, President and Friends of Harvard College, 2000).

60. John Dewey, *Art as Experience* (New York: Perigree, [1934] 2005), p. 25.

61. Dewey, *Art as Experience*, p. 281. Dewey gives a friendly acknowledgment to Schiller on pp. 252–254.

62. Dewey, *Art as Experience*, p. 5.

63. Winnicott: "Living Creatively," pp. 39–40: Cited in Abram and Hjulmand, *Language of Winnicott*, p. 121.

64. Dewey, *Art as Experience*, p. 15.

65. Jacques Rancière, *The Politics of Aesthetics: The Distribution of the Sensible*, trans. Gabriel Rockhill (London: Continuum, 2004), pp. 24, 27.

66. Rancière, *The Politics of Aesthetics*, p. 27.

67. John Dewey, *The Early Works of John Dewey, Volume 4, 1882 – 1898*. Edited by Jo Ann Boydston (Chicago; Southern Illinois University Press, 2008) p. 251; in Steven Fesmire, *John Dewey and Moral Imagination: Pragmatism in Ethics* (Bloomington: Indiana University Press, 2003), p. 74.

68. Habermas, *The Philosophical Discourse of Modernity: Twelve Lectures*. Studies in Contemporary German Social Thought. (Cambridge, MA: MIT Press, 1987), p. 49.

69. Habermas, *Philosophical Discourse*, p. 53.

70. Habermas, *Philosophical Discourse*, p. 46.

71. Kant, *The Critique of Judgment*, paragraph 46; Arendt, *Lectures*, p. 63.

72. Gottlieb comments that throughout her writings on literature "Arendt refines

and revises one of the foundational documents of modern German culture, namely, Friedrich Schiller's *Letters*, which argues for the establishment of an 'Aesthetic State' as the prerequisite for a non-violent transition from the rule of brute force to the reign of moral freedom. . . . For Arendt, the 'pros' and 'contras' of culture can be derived from these [Schiller's] basic political-cultural theses." Introduction, xxiv. In footnote 19, p. 306: "Schiller was clearly on Arendt's mind when she wrote 'Culture and Politics,' since she quotes from his poems 'Ode to Friends.'"

73. Arendt, *Lectures*, p. 64.

74. Ronald Beiner, "Rereading Hannah Arendt's Kant Lectures," in Ronald Beiner, and Jennifer Nedelsky, eds. *Judgment, Imagination, and Politics: Themes from Kant and Arendt* (Lanham, MD: Rowman and Littlefield, 2001), p. 93.

75. Beiner and Nedelsky, *Judgment, Imagination, and Politics* p. vii.

76. Habermas, *Philosophical Discourse*, pp. 48–49. After lecture 2, "Hegel's Concept of Modernity," is an "Excursus on Schiller's 'Letters on the Aesthetic Education of Man.'"

77. Jürgen Habermas, "Morality and Ethical Life: Does Hegel's Critique of Kant Apply to Discourse Ethics?" *Northwest University Law Review* 83, no. 1–2 (1988–1989): 38.

78. Perhaps Dewey would deepen Habermas's approach by counting on experience as a ground for deliberation. See Alison Kadlec, *Dewey's Critical Pragmatism* (Lanham, MD: Lexington Books, 2007). She argues that Habermasian critical theory dismisses the life-world as saturated with ideology.

79. Habermas, "Morality and Ethical Life."

80. Gregory Bateson et al., "Towards a Theory of Schizophrenia," *Behavioral Science* 1 (1956): 251–264.

81. Gayatri Chakravorty Spivak, *An Aesthetic Education in the Era of Globalization* (Cambridge, MA: Harvard University Press, 2012).

82. Johan Huizinga, *Homo Ludens: A Study of the Play Element in Culture* (Boston: Beacon Press, 1955), p. 168. Gregory Bateson was unimpressed with the book, too literalist and Eurocentric. See "Gregory Bateson on Play and Work," letter to Phillip Stevens, *Association for the Anthropological Study of Play Newsletter* 5, no. 4. (1979): 2–4.

83. Doris Sommer, *Foundational Fictions The National Romances of Latin America*. Latin American Literature and Culture, vol. 8. Berkeley: University of California Press, 1991, p. 44.

84. See Paul de Man, "Kant and Schiller," in *Aesthetic Ideology* (Minneapolis: University of Minnesota Press, 1996), pp. 129–162, esp. p. 152.

85. de Man, "Kant and Schiller," p. 154.

86. Wendy Steiner, *The Scandal of Pleasure: Art in an Age of Fundamentalism* (Chicago: University of Chicago Press, 1995), p. 206.

87. de Man, "Kant and Schiller," p. 140.

88. de Man, "Kant and Schiller," p. 150.

89. J. L. Austin, *How to Do Things with Words*. 2nd ed. Oxford: Clarendon Press, 1975. The William James Lectures, 1955.

90. de Man, "Kant and Schiller," p. 154.

91. Robin Marantz Henig, "Taking Play Seriously," *New York Times Magazine*, February 17, 2008. See Eric Slauter, *The State as a Work of Art: The Cultural Origins of the Constitution* (Chicago: University of Chicago Press, 2008).

92. Doris Sommer, "Aesthetics is a Joke," in *Bilingual Aesthetics: A New Sentimental Education* (Durham, NC: Duke University Press, 2004), pp. 29–71.

Bibliography

Abram, Jan, and Hjulmand, Knud *The Language of Winnicott: A Dictionary of Winnicott's Use of Words*. London: Karnac Books, 1996.

Acosta López, María del Rosario. "Making Other People's Feelings Our Own": From Aesthetics to the Political in Schiller's Letters. Accessed June 15, 2013. http://www.filosofiaytragedia.com/cursos/schillercalifornia.pdf.

Adorno, Theodor. *Aesthetic Theory* (1970), trans. R. Hullot-Kentor. Minneapolis: University of Minnesota Press, 1997.

———. *Can One Live After Auschwitz? A Philosophical Reader*, ed. Rolf Tiedemann. Trans. Rodney Livingstone. Stanford, CA: Stanford University Press, 2003.

Allen, Robert Clyde. *Channels of Discourse: Television and Contemporary Criticism*. New York: Routledge, 1992.

Ang, Ien. *Watching Dallas*. New York: Metheun, 1985.

Animating Democracy. "Animating Democracy Homepage." Accessed November 5, 2012. http://animatingdemocracy.org/.

"Antanas Documental Mockus 1/7 Bogotá Cambió," YouTube, posted by "Felipe Acevedo M," April 1, 2010, http://www.youtube.com/watch?v=5OdhD5D5its.

"Antanas Mockus and Edi Rama – Dialogue in Cultural Diplomacy and Urban Transformation," YouTube, posted by "KokkalisProgram," January 26, 2010, http://www.youtube.com/watch?v=6kSQuCod-JY.

Antmen, Ahu, et al., curators, *Tirana Biennale 1: Escape*, with an introduction by Edi Rama and Gezim Qendro. Milan, Giancarlo Politi Editore, 2001.

Appadurai, Arjun. *Globalization*. Millennial Quartet. Durham, NC: Duke University Press, 2001.

Arendt, Hannah. *The Human Condition*. 2nd ed. Chicago: University of Chicago Press, 1998.

———. *Men in Dark Times.* New York: Harcourt, Brace and World, 1968.

———. *Lectures on Kant's Political Philosophy,* edited with an interpretive essay by Ronald Beiner. Chicago: University of Chicago Press, 1982.

———. *On Revolution.* New York: Penguin Books, 2006.

———. *Reflections on Literature and Culture,* ed. and with an introduction by Susannah Young-ah Gottlieb. Stanford, CA: Stanford University Press, 2007.

Arnesen, Eric. *Encyclopedia of U.S. Labor and Working-Class History.* New York: Routledge, 2007.

Arnold, Matthew. *Culture and Anarchy.*Oxford World's Classics. Oxford: Oxford University Press, 2006.

ArtsEngine. "Art-Making and the Arts in Research Universities: Strategic Task Forces, March 2012 Interim Report." Accessed July 22, 2013. http://arts-u.org/wp-content /uploads/2012/03/ArtsEngine-National-Strategic-Task-Forces-Interim-Report -March-2012.pdf.

Asad, Talal, ed. *Anthropology and the Colonial Encounter.* London: Ithaca Press, 1973.

Association of Waldorf Schools of North America. "Why Waldorf Works." Accessed November 6, 2012. http://www.whywaldorfworks.org/02_W_Education/.

Assoun, Paul-Laurent. *Freud and Nietzsche.* Athlone Contemporary European Thinkers. London: Continuum, 2002.

"A Touch of Greatness: The Teacher." Directed by Leslie Sullivan. PBS Independent Lens. Accessed November 6, 2012. http://www.pbs.org/independentlens/touchof greatness/teacher.html.

Austin, J. L. *How to Do Things with Words.* 2nd ed. Oxford: Clarendon Press, 1975. The William James Lectures, 1955.

Bacon, Sir Francis. "Of Seditions" (1625). Accessed November 3, 2012. http://www .authorama.com/essays-of-francis-bacon-16.html.

Baigell, Matthew. *The American Scene: American Painting of the 1930s.* New York: MW Books, 1974.

Bakhtin, Mikhail. "Discourse and the Novel," in *The Dialogical Imagination: Four Essays,* ed. Michael Holquist, trans. Caryl Emerson. Austin: University of Texas Press, 1981.

Banksy, *Wall and Piece.* New York: Random House, 2005.

Barr, David. "Enemies at the Gate: Storming Montréal's Palais de Congrès, and Makeshift Battle Stations in Fortress San Francisco." In Index of Articles From The Treatment Action Group (TAG). December 2002, http://www.thebody.com /content/art1720.html.

———."Enemies at the Gate." TheBody.com. December 2002. Accessed November 5, 2012. http://www.thebody.com/content/art1720.html.

Bashkia Tiranës. "Bashkia e Tiranës." Accessed July 22, 2013. http://www.tirana.gov .al/sq/Ballina.

Bateson, Gregory et al., "Towards a Theory of Schizophrenia," *Behavioral Science* 1 (1956): 251–264.

———. "Gregory Bateson on Play and Work," letter to Phillip Stevens, *Association for the Anthropological Study of Play Newsletter* 5, no. 4. (1979).

BBC. "In Pictures: Graffiti Artists in Beijing, Graffiti Tradition." Accessed November 4, 2012. http://news.bbc.co.uk/2/shared/spl/hi/picture_gallery/07/asia_pac_graffiti_artists_in_beijing/html/1.stm.

———. "Reading While Rolling Cuban Cigars." Accessed November 6, 2012. http://news.bbc.co.uk/2/hi/8406641.stm.

———. "1959: Khrushchev and Nixon Have War of Words." Accessed July 22, 2013. http://news.bbc.co.uk/onthisday/hi/dates/stories/july/24/newsid_2779000/2779551.stm.

Beiner, Ronald, and Jennifer Nedelsky, eds. *Judgment, Imagination, and Politics: Themes from Kant and Arendt*. Lanham, MD: Rowman and Littlefield, 2001.

Beiser, Frederick C. *Schiller as Philosopher: A Re-examination*. Oxford: Oxford University Press, 2005.

Bekoff, Marc, and John A. Byers, eds. *Animal Play: Evolutionary, Comparative and Ecological Perspectives*. Cambridge: Cambridge University Press, 1998.

Bender, Thomas, Stanley Chodorow, and Pauline Yu. "The Transformation of Humanistic Studies in the Twenty-first Century: Opportunities and Perils." Accessed November 6, 2012. http://archives.acls.org/op/40_Transformation_of_Humanistic_Studies.htm#Intro.

Benjamin, Walter. *Illuminations*. Edited by Hannah Arendt. New York: Schocken Books, 1969.

Bennett, Benjamin. *Aesthetics as Secular Millennialism: Its Trail from Baumgarten and Kant to Walt Disney and Hitler*. Lewisburg, PA: Bucknell University Press, 2013.

Benson, Emanuel Mervin, and Francis V. O'Connor. *Art for the Millions: Essays from the 1930s by Artists and Administrators of the WPA Federal Art Project*. Greenwich, CT: New York Graphic Society, 1973.

Benson, Robert Louis, and Giles Constable, eds. *Renaissance and Renewal in the Twelfth Century*. Cambridge, MA: Harvard University Press, 1982.

Berlin, Isaiah, et al., *The Proper Study of Mankind*. New York: Farrar, Straus and Giroux, 2000.

Bernstein, Basil B. *Class, Codes and Control*. Primary Socialization, Language and Education, vol. 4. London: Routledge & Kegan Paul, 1971.

Bérubé, Michael. "MLA Presidential Address, January 2013." Accessed June 14, 2013. http://www.mla.org/pres_address_2013.

Bilbija, Ksenija, and Paloma Celis Carbajal. *Akademia Cartonera: A Primer of Latin American Cartonera Publishers: Un abc de las editoriales cartoneras en América Latina*. Madison: Parallel Press, University of Wisconsin-Madison Libraries, 2009.

Bishop, Claire. "Antagonism and Relational Aesthetics." *October* 110 (fall 2004): 51–79.

———. "The Social Turn: Collaboration and Its Discontents." *Artforum*, February 2006. Accessed November 3, 2012. http://www.artforum.com/inprint/id=10274.

Black, Robert. *Humanism and Education in Medieval and Renaissance Italy: Tradition and Innovation in Latin Schools from the Twelfth to the Fifteenth Century*. Cambridge: Cambridge University Press, 2001.

Bloom, Harold. *The Anxiety of Influence: A Theory of Poetry*. London: Oxford University Press, 1975.

Bloom, Paul. *How Pleasure Works: The New Science of Why We Like What We Like*. New York: W. W. Norton, 2010.

Boal, Augusto. "A Estética do Oprimido nas Escolas," YouTube, posted by "Roni Valk," September 29, 2007, http://www.youtube.com/watch?v=KK0Z7n-w97Y &feature=related.

———. *Aesthetics of the Oppressed*, trans. Adrian Jackson. London: Routledge, 2006.

———. *Games for Actors and Non-Actors*. London: Routledge, 1992.

———. *Hamlet and the Baker's Son: My Life in Theatre and Politics*, trans. Adrian Jackson and Candida Blaker. London: Routledge, 2001.

———. *Legislative Theatre: Using Performance to Make Politics*. London: Routledge, 1998.

———. *Theatre of the Oppressed*. (originally published in Spanish as *Teatro del oprimido*, 1974), trans. Charles A. and Maria-Odilia Leal McBride. New York: Theatre Communications Group, 1995.

———. *The Rainbow of Desire: The Boal Method of Theatre and Therapy*. London: Routledge, 1995.

Bogotá Cómo Vamos. "Inicio Bogotá Cómo Vamos." Accessed November 3, 2012. http://www.bogotacomovamos.org.

"Born in Slavery: Slave Narratives from the Federal Writers Project, 1936–1938." The Library of Congress. Accessed November 4, 2012. http://memory.loc.gov/ammem /snhtml/snhome.html.

Born, Kathryn. "Book Review: The Faith of Graffiti." *Chicago Art Magazine*, February 3, 2010. Accessed July 22, 2013. http://chicagoartmagazine.com/2010/02/book -review-the-faith-of-graffiti/.

Bourriaud, Nicolas. *Relational Aesthetics*. Paris: Les presses du réel, 2002.

Boyer, Ernest L. *Scholarship Reconsidered: Priorities of the Professoriate*. Princeton, NJ: Carnegie Foundation for the Advancement of Teaching, 1990.

Bradley, Will, and Charles Esche. *Art and Social Change: A Critical Reader*. London: Tate, 2007.

Brooks, Cleanth, and William K. Wimsatt. *Literary Criticism: A Short History*. New York: Routledge & Kegan Paul, 1970.

Brooks, David. "The New Humanism." *New York Times*, March 7, 2011. Accessed November 6, 2012. http://www.nytimes.com/2011/03/08/opinion/08brooks .html?_r=0.

Broyles-Gonzáles, Yolanda. *El Teatro Campesino: Theater in the Chicano Movement*. Austin: University of Texas Press, 1994.

Buchloh, Benjamin H. D. *Neo-Avantgarde and Culture Industry: Essays on European and American Art from 1955 to 1975*. Cambridge, MA: MIT Press, 2000.

Burckhardt, Jacob. *The Civilization of the Renaissance in Italy*, trans. S. G. C. Middlemore. New York: Penguin Books, 1990.

Buttigieg, Joseph A. and Antonio Gramsci. *Prison Notebooks, European Perspectives*. New York: Columbia University Press, 1992.

Caballero, Maria Cristina. "Academic Turns City into a Social Experiment." *Harvard Gazette*, March 11, 2004. Accessed November 3, 2012. http://www.news.harvard.edu/gazette/2004/03.11/01-mockus.html.

Cadwell, Louise Boyd. *Bringing Learning to Life: The Reggio Approach to Early Childhood Education*. Early Childhood Education Series. New York: Teachers College Press, 2003.

Caldwell, Lesley, ed. *Art, Creativity, Living*. London: Karnac Books, 2001.

Camnitzer, Luis. *Conceptualism in Latin American Art: Didactics of Liberation*. Austin: University of Texas Press, 2007.

Campbell, Mary Schmidt, and Randy Martin. *Artistic Citizenship: A Public Voice for the Arts*. New York: Routledge, 2006.

Carraro, Francine. *Jerry Bywaters: A Life in Art*. Austin: University of Texas Press, 1994.

Carter, Majora, "Majora Carter: Greening the Ghetto," TED.com video. February 2006. http://www.ted.com/talks/majora_carter_s_tale_of_urban_renewal.html.

Cassirer, Ernst. *The Philosophy of the Enlightenment*. Princeton: Princeton University Press, 1951.

Castro, Fidel. *Palabras a Los Intelectuales*. Havana: Ediciones del Consejo Nacional de Cultura, 1961.

Castro Samayoa, Andres, et al. *Harvard Senior Honors Theses from the Committee on Degrees in Studies of Women, Gender, and Sexuality, 2008–2012*. Cambridge, MA: Collections of the Harvard University Archives.

Cavell, Stanley. "Aesthetic Problems of Modern Philosophy," in *Judgment, Imagination, and Politics: Themes from Kant and Arendt*, edited by Ronald Beiner and Jennifer Nedelsky, 27–46. Lanham, MD: Rowman and Littlefield, 2001.

Centro De Investigaciones Artísticas. "Home | Centro De Investigaciones Artísticas." Accessed November 6, 2012. http://www.ciacentro.org/.

Chan, Paul. "Fearless Symmetry," *Artforum*. Vol. 45, Issue 7 (2007): 260–61.

Chico, Gery. "Mayoral Candidates on the Arts." *Chicago Tribune*, February 17, 2011. Accessed November 4, 2012. http://articles.chicagotribune.com/2011-02-17/entertainment/chi-mayor-candidate-gery-chico-arts-20110217_1_theater-district-arts-and-culture-mayoral-candidates.

Chodorow, Stanley. "Taking the Humanities Off Life-Support," American Council of Learned Societies, Occasional Paper no. 40, 1997, part 4. http://archives.acls.org/op/op40ch.htm.

Clifford, James. *The Predicament of Culture: Twentieth-Century Ethnography, Literature, and Art*. Cambridge, MA: Harvard University Press, 1988.

Cohen-Cruz, Jan. *Playing Boal: Theatre of the Oppressed Anthology*. New York: Psychology Press, 1993.

Colón, Jesús. *A Puerto Rican in New York and Other Sketches*. New York: Mainstream Publishers, 1961.

Correa, Ana. "Yuyachkani over Thirty Years," presentation at Harvard University, April 12, 2009.

Costelloe, Timothy. "Giambattista Vico," in *The Stanford Encyclopedia of Philosophy*. ed. Edward N. Zalta. Last modified Feb. 14, 2012. Accessed November 5, 2012. http://plato.stanford.edu/entries/vico/.

Crimp, Douglas. "Right On, Girlfriend!" In *Fear of a Queer Planet: Queer Politics and Social Theory*, edited by Michael Warner, p. 304. Minneapolis: University of Minnesota Press, 1993.

————. *AIDS Demo Graphics*. San Francisco: Bay Press, 1990.

Cruz, Victor Hernandez. *Snaps: Poems*. New York: Random House, 1969.

Cucurto, Washington. *1810: La revolución de mayo vivida por los negros*. Buenos Aires: Emecé Editores, 2008.

Cuesta, José. "From Economist to Culturalist Development Theories: How Strong Is the Relation between Cultural Aspects and Economic Development?" *European Journal of Development Research* 16, no. 4 (2004): 868–891.

Cultural Agents. "Cultural Agents Initiative: Programs." Accessed November 3, 2012. http://www.culturalagents.org/programs/programs.html.

Dahlstrom, Daniel O. *Essays: Friedrich Schiller*. New York: Continuum International, 1993.

d'Alembert, Jean Le Rond, and Jean-Jacques Rousseau. *Politics and the Arts: Letter to M. d'Alembert on the Theatre*, with an introduction by Allan Bloom. Ithaca, NY: Cornell University Press, 1968.

Damrosch, David. *We Scholars: Changing the Culture of the University*. Cambridge, MA: Harvard University Press, 1995.

Davis, Ben. "Rancière, for Dummies." *Artnet Magazine*, July 17, 2006. Accessed November 4, 2012. http://www.artnet.com/magazineus/books/davis/davis8 -17-06.asp#.

Deas, Malcolm D. *Del poder y la gramática y otros ensayos sobre historia, política y literatura colombianas*. Santafé de Bogotá, Colombia: Tercer Mundo Editores, 1993.

de Bary, Brett. "Against Transparency," in *Do the Humanities Have to Be Useful*, edited by G. Peter Lepage, Carolyn Martin, and Mohsen Mostafavi, Ithaca, NY: Cornell University Press, 2006. pp. 35–40.

De Hart, Jane Sherron. *The Federal Theatre, 1935–1939: Plays, Relief, and Politics*. New York: Octagon Books, 1980.

Deleuze, Gilles and Felix Guattari. *Kafka: Toward a Minor Literature*. Minneapolis: University of Minnesota Press, 1986.

de Man, Paul. *Aesthetic Ideology*. Theory and History of Literature, vol. 65. Minneapolis: University of Minnesota Press, 1996.

———. "Autobiography as De-facement." MLN 94, no. 5 (1979): 919–930.

de Montaigne, Michel, et al. *Literary and Philosophical Essays: French, German and Italian, with Introduction and Notes*. Harvard Classics, vol. 32. New York: P. F. Collier, 1910.

Deseriis, Marco and Brian Holmes. "Concerning Art and Social Change." *Mute*. February 4, 2009. http://www.metamute.org/editorial/articles/concerning-art-and -social-change.

Dewey, John. *Art as Experience*. New York: Perigee Books, 2005.

———. *The Early Works of John Dewey, Volume 4, 1882 – 1898*. Edited by Jo Ann Boydston. Chicago; Southern Illinois University Press, 2008.

Disraeli, Benjamin. *Lothair*. London: Oxford University Press, 1975.

Docherty, Thomas. *Aesthetic Democracy*. Stanford, CA: Stanford University Press, 2006.

Dreijmanis, John. "Erratum to 'A Portrait of the Artist as a Politician: The Case of Adolf Hitler'" *Social Science Journal* 42, no.1 (2005): 115–127. doi:10.1016/j.soscij .2004.11.010.

Dribben, Melissa. "Parisians Look to Copy City's Mural Program 1.5 Million Philadelphians Can't Be Wrong." Philly.com, May 8 2009. Accessed November 4, 2012. http://articles.philly.com/2009-05-08/news/25274020_1_philadelphia-s-mural -arts-program-mural-projects-graffiti-writers.

Eagleton, Terry. *Literary Theory: An Introduction*. Minneapolis: University of Minnesota Press, 1983.

"El 'arma de instrucción masiva' Recorre Rutas De Argentina," YouTube, posted by "afpes," May 18, 2010, http://www.youtube.com/watch?v=nLzJ6oNckmg.

Ellis, Havelock. *The Dance of Life*. Boston: Houghton Mifflin, 1923.

Ellis, Rennie. *The All New Australian Graffiti*. Melbourne: Sun Books, 1985.

Elster, Jon. *Ulysses Unbound: Studies in Rationality, Precommitment, and Constraints*. Cambridge: Cambridge University Press, 2000.

Encinas, Rosario. "Jose Vasconcelos (1882–1959)." PROSPECTS: Quarterly Review of Comparative Education vol. XXIV, no. 3–4 (1994): 719–29. Accessed June 20, 2013. http://www.ibe.unesco.org/publications/ThinkersPdf/vasconce.pdf.

"Entrevista Raúl Lemesoff," YouTube, posted by "educarargentina," May 14, 2009, http://www.youtube.com/watch?v=FDyK3-G7K68.

Fallon, Daniel. *The German University: A Heroic Ideal in Conflict with the Modern World*. Boulder, CO: Colorado Associated University Press, 1980.

Farrar, F. W. *Essays on a Liberal Education*. 2nd ed. London: Macmillan, 1868.

Fell, Claude. *José Vasconcelos: Los años del Águila, 1920–1925, Educación, cultura e Iberoamericanismo en el México postrevolucionario*. Serie de historia moderna y contemporánea, vol. 21. México, D.F.: Universidad Nacional Autónoma de México, 1989.

Ferrer, Ada. "The Silence of Patriots: Racial Discourse and Cuban Nationalism, 1868–

1898" in *José Martí's "Our America": From National to Hemispheric Cultural Studies*, edited by Jeffrey Belnap and, Raúl Fernandez. 228–252. Durham, NC: Duke University Press, 1998.

Fesmire, Steven. *John Dewey and Moral Imagination: Pragmatism in Ethics*. Bloomington: Indiana University Press, 2003.

Fish, Stanley. "The Last Professor." *New York Times*, January 18, 2009. Accessed November 6, 2012. http://opinionator.blogs.nytimes.com/2009/01/18/the-last-professor/.

———. "Will the Humanities Save Us?" *New York Times*, January 6, 2008. Accessed November 6, 2012. http://opinionator.blogs.nytimes.com/2008/01/06/will-the-humanities-save-us/.

Flanagan, Hallie. *Arena*. New York: Duell, Sloan and Pearce, 1940.

Florida, Richard L. *The Rise of the Creative Class and How It's Transforming Work, Leisure, Community and Everyday Life*. New York: Basic Books, 2004.

Forgacs, David, and Antonio Gramsci. *The Gramsci Reader: Selected Writings, 1916–1935*. New York: New York University Press, 2000.

Fox News. "NEA Reassigns Communications Director Following Uproar Over Obama Initiative." September 11, 2009. Accessed November 4, 2012. http://www.foxnews.com/politics/2009/09/11/nea-reassigns-communications-director-following-uproar-obama-initiative/.

Freire, Paulo. *Pedagogy of the Oppressed: 20th Anniversary Edition*. New York: Continuum, 1993.

———. *Teachers as Cultural Workers: Letters to Those Who Dare Teach*. The Edge, Critical Studies in Educational Theory. Boulder, CO: Westview Press, 1998.

———. *Cultural Action for Freedom*. Harvard Educational Review Monograph Series, vol. 1. Cambridge, MA: Harvard Educational Review, President and Friends of Harvard College, 2000.

Freud, Sigmund, James Strachey, and Anna Freud. *The Standard Edition of the Complete Psychological Works of Sigmund Freud*. London: Hogarth Press, 1955.

Freyre, Gilberto. *The Masters and the Slaves (Casa-Grande and Senzala): A Study in the Development of Brazilian Civilization*. Translated by Samuel Putnam. New York: Alfred A. Knopf, 1946.

Frye, Northrop. *Anatomy of Criticism: Four Essays*. Toronto: University of Toronto Press, 2006.

Fuegi, John. *Bertolt Brecht: Chaos, According to Plan*. Directors in Perspective. Cambridge: Cambridge University Press, 1987.

Fusco, Coco. *English Is Broken Here: Notes on Cultural Fusion in the Americas*. New York City: New Press, 1995.

Garber, Marjorie B., Beatrice Hanssen, and Rebecca L. Walkowitz, eds. *The Turn to Ethics*. Culture Work. New York: Routledge, 2000.

García Canclini, Néstor. *Hybrid Cultures: Strategies for Entering and Leaving Modernity*. Minneapolis: University of Minnesota Press, 2005.

————. *La sociedad sin relato*. Madrid: Katz Editores, 2010.

————. *Globalización imaginada (Narrativas Históricas)*. Buenos Aires: Paidós, 1999.

Gardner, Howard. *Frames of Mind: The Theory of Multiple Intelligences*. New York: Basic Books, 2011.

Gates, Henry Louis, Jr. *The Signifying Monkey: A Theory of Afro-American Literary Criticism*. New York: Oxford University Press, 1988.

Gersh, Stephen, and Bert Roest, eds. *Medieval and Renaissance Humanism: Rhetoric, Representation and Reform*. Brill's Studies in Intellectual History, 0920–8607, vol. 115. Leiden, the Netherlands: Brill, 2003.

Gilgen, Peter. "Structures, but in Ruins Only: On Kant's History of Reason and the University." CR: *The New Centennial Review* 9, no. 2 (2009): 165–194.

Google. "Guayaquil Cerro Santa Ana Images from Google Search." Accessed June 20, 2013. https://www.google.com/search?q=guayaquil+cerro+santa+ana&hl=en &rlz=1C1RNPN_enUS421&prmd=imvns&source=lnms&tbm=isch&ei=hdDYT -r7GeqJ6AHo1u2yAw&sa=X&oi=mode_link&ct=mode&cd=2&sqi=2&ved =0CEgQ_AUoAQ&biw=1024&bih=488.

Habermas, Jürgen. *The Philosophical Discourse of Modernity: Twelve Lectures*. Studies in Contemporary German Social Thought. Cambridge, MA: MIT Press, 1987.

————. "Morality and Ethical Life: Does Hegel's Critique of Kant Apply to Discourse Ethics?" *Northwest University Law Review* 83, no. 1–2 (1988–1989): 38.

Hall, Stuart. "The Emergence of Cultural Studies and the Crisis of the Humanities." *October* 53 (1990): 11–23. Accessed November 3, 2012. http://www.jstor.org/stable /778912.

Halpern, Sue. "Mayor of Rust," *New York Times Magazine*, February 13, 2011. Accessed November 4, 2012. http://www.nytimes.com/2011/02/13/magazine/13Fetterman-t .html.

Hardy, Henry, Roger Hausheer, and Isaiah Berlin. *The Proper Study of Mankind: An Anthology of Essays*. London: Chatto and Windus, 1997.

Harpham, Geoffrey Galt. *The Humanities and the Dream of America*. Chicago: University of Chicago Press, 2011.

————. "How America Invented the Humanities," YouTube, posted by "UCBerkeleyEvents," February 7, 2011, http://www.youtube.com/watch?v =Q51AS6FiBuc.

Harris, Phil. "Artvehicle 8 Review: Anri Sala's *Dammi i colori*." Accessed June 14, 2013. http://www.artvehicle.com/events/172.

Haskins, Charles Homer. *The Renaissance of the Twelfth Century*. Cambridge, MA: Harvard University Press, 1955.

Hauser, Arnold. *The Social History of Art*. New York: Vintage Books, 1963.

Healy, Patrick. "The Anguish of War for Today's Soldiers, Explored by Sophocles." *New York Times*, November 12, 2009. Accessed November 4, 2012.

Hebdige, Dick. "The Machine Is Unheimlich: Krzysztof Wodiczko's Homeless Vehicle Project." *Walker Art Magazine*. August 30, 2012. Accessed June 14, 2013.

http://www.walkerart.org/magazine/2012/krzysztof-wodiczkos-homeless-vehicle -project.

Heller, Steven. "Tibor Kalman." Accessed July 22, 2013. http://www.aiga.org/medalist -tiborkalman/.

Henig, Robin Marantz. "Taking Play Seriously." *New York Times*, February 17, 2008. Accessed November 7, 2012. http://www.nytimes.com/2008/02/17/magazine /17play.html?pagewanted=all&_r=0.

Henrich, Joseph Patrick, et al. *Foundations of Human Sociality: Economic Experiments and Ethnographic Evidence from Fifteen Small-Scale Societies.* Oxford: Oxford University Press, 2004.

Herder, Johann Gottfried, and Wolfgang Pross. *Johann Gottfried Herder, Abhandlung über den Ursprung der Sprache: Text, Materialien, Kommentar.* Munich: C. Hanser, 1978.

Hernández Cruz, Víctor. "You Gotta Have Your Tips on Fire," *Mainland: Poems.* New York: Random House, 1973.

Hernández-Mora, Salud. "Bogotá organiza una noche 'sólo para mujeres' para combatir la violencia," *El Mundo*, March 10, 2001. Accessed November 3, 2012. http:// www.elmundo.es/elmundo/2001/03/10/sociedad/984263629.html.

Herskovits, Melville J. *The Myth of the Negro Past.* Harvard Anthropology Preservation Microfilm Project, 00221. New York: Harper and Bros., 1941.

Hinchberger, Bill "Curitiba: Jaime Lerner's Urban Acupuncture," Brazilmax.com, February 18, 2006, http://www.brazilmax.com/news.cfm/tborigem/pl_south /id/10.

Hirshman, Linda. *Victory: The Triumphant Gay Revolution.* New York: HarperCollins, 2012.

Honig, Bonnie. *Democracy and the Foreigner.* Princeton, NJ: Princeton University Press, 2001.

Huizinga, Johan. *Homo Ludens: A Study of the Play Element in Culture.* Boston: Beacon Press, 1955.

Huntington, Samuel P. *Who Are We? The Challenges to America's National Identity.* New York: Simon and Schuster, 2005.

"Irina Bokova – Global Governance in the 21st Century: The UNESCO Angle," YouTube, posted by "KokkalisProgram," November 5, 2010, http://www.youtube.com /watch?v=go8yUywEQBQ&feature=channel_video_title.

Jaar, Alfredo. "Conversaciones en Chile, 2005." In *Jaar SCL 2006*, edited by Adriana Valdés, 67–88. Barcelona: Actar Ediciones, 2006.

Jackson, Adrian. Introduction. In *The Rainbow of Desire: The Boal Method of Theatre and Therapy.* London: Routledge, 1995.

Jaschik, Scott. "Besieged Humanities, Worldwide." *Inside Higher Ed*, March 7, 2013. Accessed July 22, 2013. http://www.insidehighered.com/news/2013/03/07 /educators-consider-struggles-humanities-worldwide#ixzz2NGRuv1D9.

Jay, Gregory "The Engaged Humanities: Principles and Practices for Public Scholar-

ship and Teaching," *Journal of Community Engagement and Scholarship* 2, no. 1 (2011): 51–63.

Jay, Paul and Gerald Graff. "Fear of Being Useful," *Inside Higher Ed*, January 5, 2012. Accessed July 22, 2013. http://www.insidehighered.com/views/2012/01/05/essay -new-approach-defend-value-humanities#ixzz1jGzJMNw1.

Johnson, Ken. "When Life Becomes Art," *New York Times Magazine*, September 29, 2011. Accessed June 15, 2013. http://www.nytimes.com/2011/09/30/arts/design /living-as-form-at-essex-street-market-review.html?_r=0.

JR. "JR's TED Prize Wish: Use Art to Turn the World Inside Out," TED.com video. March 2011. http://www.ted.com/talks/jr_s_ted_prize_wish_use_art_to_turn _the_world_inside_out.html.

Jung, C. G., & H. G. Baynes. *Psychological Types, or, The Psychology of Individuation.* Collected Works, Vol. 6. London: Kegan Paul Trench Trubner, 1921.

Kadlec, Alison. *Dewey's Critical Pragmatism.* Lanham, MD: Lexington Books, 2007.

Kalman, Tibor, Peter Hall, and Michael Bierut. *Tibor Kalman: Perverse Optimist.* Princeton: Princeton Architectural Press, 1998.

Kamo, Norifumi, Mary Carlson, Robert Brennan, and Felton Earls, "Young Citizens as Health Agents: Use of Drama in Promoting Community Efficacy for HIV/ AIDS," *American Journal of Public Health* 98, no. 2 (February 2008): 201–204.

Kant, Immanuel. *Foundations of the Metaphysics of Morals and, What Is Enlightenment?* 2nd rev. ed. Library of Liberal Arts. New York: Macmillan, 1990.

———. "What Is the Enlightenment?" *Kant: Political Writings*, edited by Hans Siegbert Reis. Cambridge: Cambridge University Press, 1970.

———. *The Critique of Judgement* [1790], translated with Introduction and Notes by J.H. Bernard. 2nd rev. ed. London: Macmillan, 1914. Accessed June 14, 2013. Online Library of Liberty. http://oll.libertyfund.org/index.php?option=com_staticxt &staticfile=show.php%3Ftitle=1217&layout=html.

Kauffman, Stuart A. *Investigations.* Oxford: Oxford University Press, 2000.

Kellner, Douglas. "Cultural Studies and Ethics." Accessed July 23, 2013. http://pages .gseis.ucla.edu/faculty/kellner/essays/culturalstudiesethics.pdf.

Kennedy, Roger and David Larkin. *Art Worked: The New Deal, Art and Democracy.* New York: Rizzoli, 2009.

Kennerly, Catherine Marsh. *Negociaciones culturales: Los intelectuales y el proyecto pedagogico del estado Muñocista.* San Juan, Puerto Rico: Ediciones Callejon, 2009.

Kester, Grant. "Dialogical Aesthetics: A Critical Framework For Littoral Art." *Variant* 9 (Winter 1999/2000): supplement, 1–8. Accessed November 3, 2012. http://www .variant.org.uk/pdfs/issue9/Supplement9.pdf.

Kiderra, Inga. "Fuentes Fires Up Crowd," *University of California at San Diego Daily News*, April 28, 2008. Accessed November 4, 2012. http://ucsdnews.ucsd.edu /thisweek/2008/04/28_carlos_fuentes.asp.

Kramer, Jane. "Painting the Town." *New Yorker*, June 27, 2005.

Kramer, Larry. *The Normal Heart*. The Royal Court Writers Series. London: Methuen in association with the Royal Court Theatre, 1986.

Kristof, Nicholas D. "The D.I.Y. Foreign-Aid Revolution." *New York Times Magazine*, October 20, 2010. Accessed November 6, 2012. http://www.nytimes.com/2010/10 /24/magazine/24volunteerism-t.html?pagewanted=4&_r=1.

Kronman, Anthony T. *Education's End: Why Our Colleges and Universities Have Given Up on the Meaning of Life*. New Haven, CT: Yale University Press, 2007.

Lambert-Beatty, Carrie. "Twelve Miles: Boundaries of the New Art/Activism," *Signs: Journal of Women in Culture and Society* vol. 33, no. 2 (2008): 309–327.

Langer, Susanne *Feeling and Form: A Theory of Art*. White Plains, NY: Longman, 1977.

Lemon, Lee T. et al., eds. *Russian Formalist Criticism: Four Essays*. Lincoln: University of Nebraska Press, 1965.

Lepage, G. Peter, Carolyn Martin, and Mohsen Mostafavi, eds. *Do the Humanities Have to Be Useful?* Ithaca, NY: Cornell University Press, 2006.

Lerner, Jaime. *Acupuntura Urbana*. Rio de Janeiro: Editora Record, 2003.

————. "Jaime Lerner Sings of the City," TED.com video. March 2007. http://www .ted.com/talks/jaime_lerner_sings_of_the_city.html.

Lévinas, Emmanuel. *Difficult Freedom: Essays on Judaism*. Johns Hopkins Jewish Studies. Translated by Seán Hand. Baltimore: Johns Hopkins University Press, 1990.

————. *Totality and Infinity: An Essay on Exteriority*. Martinus Nijhoff Philosophy Texts, vol. 1. The Hague, the Netherlands: M. Nijhoff Publishers, 1979.

Likmeta, Besar. "Eight Indicted for Fraud in Albanian Elections: Prosecutors in Lezha on Tuesday Indicted Eight Poll Commissioners for Rigging the Elections in the Commune of Dajc on May 8, 2011." In *Balkan Insight*, March 15, 2012. Accessed November 3, 2012. http://www.balkaninsight.com/en/article/eight-indicted-for-fraud-during-albania-s-local-elections.

Lippard, Lucy R. *Get the Message? A Decade of Art for Social Change*. New York: E. P. Dutton, 1984.

————. *Six Years: The Dematerialization of the Art Object from 1966 to 1972*, Berkeley: University of California Press, 1997.

————. *Surrealists on Art*. Englewood Cliffs, NJ: Prentice-Hall, 1970.

Lope de Vega. *Fuente Ovejuna*. Biblioteca clásica, vol. 54. (First published in Madrid in 1619). Barcelona: Crítica, 1993.

Lynch, Kevin. *The Image of the City*. Cambridge, MA: MIT Press, 1960.

Lyotard, Jean-François. *The Postmodern Condition: A Report on Knowledge*. Theory and History of Literature, vol. 10. Minneapolis: University of Minnesota Press, 1984.

Macherey, Pierre. *Pour une théorie de la production littéraire*. Théorie, vol. 4. Paris: F. Maspero, 1966.

Madison, Gary Brent. *The Logic of Liberty*. Contributions in Philosophy, 0084–926X, vol. 30. New York: Greenwood Press, 1986.

Mailer, Norman, and Jon Naar. *The Faith of Graffiti*. New York: HarperCollins, 2010.

Marcuse, Herbert. *Eros and Civilization: A Philosophical Inquiry into Freud*. Boston: Beacon Press, 1966.

Martín Barbero, Jesús. *De los medios a las mediaciones: Comunicación, cultura y hegemonía*. 5th. ed. Cultura y comunicación. Bogotá: Convenio Andrés Bello, 1998.

Martínez, Tomás Eloy. "Las editoriales cartoneras: Creadores ante la crisis," *La Nación*, Buenos Aires: Sábado 28 de febrero de 2009. http://www.lanacion.com .ar/1103987-creadores-ante-la-crisis.

Masiello, Francine. *The Art of Transition: Latin American Culture and Neoliberal Crisis*. Latin America Otherwise. Durham, NC: Duke University Press, 2001.

Massachusetts Department of Education. "Massachusetts Arts Curriculum Framework." Accessed July 23, 2013. http://www.doe.mass.edu/frameworks/arts/1099 .pdf.

Mass Humanities. "The Humanities." Accessed November 5, 2012. http://www .masshumanities.org/the_humanities.

Mavigliano, George J. "The Federal Art Project: Holger Cahill's Program of Action." *Art Education* 37, no. 3 (May 1984): 26–30. Accessed November 4, 2012.

Mayo, Peter. *Gramsci, Freire, and Adult Education: Possibilities for Transformative Action*. Global Perspectives on Adult Education and Training. London: Zed Books, 1999.

McCarthy, Kevin F., et al., *Gifts of the Muse: Reframing the Debate about the Benefits of the Arts*. Santa Monica, CA: Rand Corporation, 2004.

McClelland, Charles E. *State, Society, and University in Germany, 1700–1914*. Cambridge: Cambridge University Press, 1980.

McCloskey, Barbara. *Artists of World War II*. Westport, CT: Greenwood, 2005.

McDermott, Douglas. *The Living Newspaper as a Dramatic Form*. Ann Arbor: Xerox University Microfilms, 1975.

McKinzie, Richard D. *The New Deal for Artists*. Princeton, NJ: Princeton University Press, 1973.

Mecklenburg, Virginia M. *The Public as Patron: A History of the Treasury Department Mural Program, Illustrated with Paintings from the Collection of the University of Maryland Art Gallery*. College Park: University of Maryland, Department of Art, 1979.

Mockus, Antanas, Efrain Sánchez Cabra, and Carolina Castro Osorio, eds. *Cultura ciudadana en Bogotá: Nuevas perspectivas*. Bogotá: Secretaría de Cultura, Recreación y Deporta, 2009.

———. "América Latina, consensos y paz social." Speech at the 34th Congreso Internacional de Conindustrias, June 30, 2004. Accessed November 3, 2012. http:// w3old.conindustria.org/CONGRESO2004/Caracas%20Conindustria%20Antanas %20Mockus%20junio%202004%20versiu%C3%B3n%20fina.pdf.

———. "Amfibios culturales" and "La innovación y la extraña frontera que separa escuela y sociedad," *Aleph* 136 (2006): 2–5; "Ampliación de los modos de hacer política," *Aleph* 135 (2005): 2–26.

———. "Ampliación de los modos de hacer política," Colloque CERI, Paris, December 2–3, 2004.

———. "Cultura Ciudadana, programa contra la violencia en Santa Fe de Bogotá, Colombia 1995–1997." Estudio Técnico, Washington, DC, July 2001, no. SOC-120 División de Desarrollo Social, Publicaciones Banco Interamericano de Desarrollo. Accessed July 12, 2010. http://es.scribd.com/doc/63048/Colombia-Cultura-Ciudadana-Experiencia-Bogota.

Mockus, Antanas. *Representar y disponer: Un estudio de la noción de representación orientado hacia el examen de su papel en la comprensión previa del ser como disponibilidad.* Bogotá: Universidad Nacional de Colombia, Centro Editorial, 1988.

———. "When I Am Trapped, I Do What an Artist Would Do," conversation with Joanna Warsza, in *Forget Fear: 7th Biennale for Contemporary Art,* ed. Artur Zmijewski and Joanna Warsza (Berlin: KW Institute for Contemporary Art; Verlag Der Buchandlung Walter Konig, 2012), pp. 164–170.

Mohamed, Naseemah. "The Art of Literacy: A Post-Colonial Pedagogical Intervention in Zimbabwe," Senior thesis for Social Studies and the Department of African and African American Studies, Harvard College, 2012.

Moreno, J. L. *The Essential Moreno: Writings on Psychodrama, Group Method and Spontaneity,* ed. Jonathan Fox (New York: Springer, 1987).

Morrison, A. J. W., and Friedrich Schiller. *History of the Revolt of the Netherlands; Trial and Execution of Counts Egmont and Horn; and the Siege of Antwerp.* New York: Harper, 1855.

Mouffe, Chantal, and Ernesto Laclau. *Hegemony and Socialist Strategy: Towards a Radical Democratic Politics.* 2nd ed. London: Verso, 2001.

Múnera, Alfonso. *El fracaso de la nación: Región, clase y raza en el Caribe Colombiano (1717–1821).* Bogotá: Banco de la República, 1998.

Murrain, Henry "Cultura ciudadana como política pública: Entre indicadores y arte," in *Cultura Ciudadana en Bogotá: Nuevas perspectivas,* ed. Efraín Sánchez and Carolina Castro Bogotá: Cámara de Comercio de Bogotá, Secretaría de Cultura, Recreación y Deporte, Fundación Terpel, Corpovisionarios, 2009.

Nachmanovitch, Stephen. "This Is Play." *New Literary History* 40, no. 1 (2009): 1–24.

National Center for Education Statistics. "Arts Education in Public Elementary and Secondary Schools: 1999–2000 and 2009–10." Accessed July 22, 2013. http://nces.ed.gov/pubsearch/pubsinfo.asp?pubid=2012014rev.

National Endowment for the Humanities. "How NEH Got Its Start." Accessed November 4, 2012. http://www.neh.gov/about/history.

National Park Service. "Reading 1: Education as the Keystone to the New Democracy." Accessed November 6, 2012. http://www.nps.gov/nr/twhp/wwwlps/lessons/92uva/92facts1.htm.

Nehamas, Alexander. "An Essay on Beauty and Judgment." *Threepenny Review* 80 (winter 2000): 4–7.

Nelson, Cary, and Lawrence Grossberg, eds. *Marxism and the Interpretation of Culture*. Urbana: University of Illinois Press, 1988.

Nemo, Philippe, and Emmanuel Lévinas. *Ethics and Infinity*. Pittsburgh, PA: Duquesne University Press, 1985.

Nietzsche, Friedrich Wilhelm. *On the Genealogy of Morals*, translated by Walter Arnold Kaufmann. New York: Vintage Books, 1967.

Nock, Matthew K., Borges, Guilherme and On, Yutaka. *Suicide: Global Perspectives from the Who World Mental Health Surveys* (Cambridge: Cambridge University Press, 2012).

North, Douglass C. "A Transaction Cost Theory of Politics." *Journal of Theoretical Politics* 2 vol. 4 (1990): 355–367.

———. *Institutions, Institutional Change and Economic Performance*. Political Economy of Institutions and Decisions. Cambridge: Cambridge University Press, 1990.

Nussbaum, Martha. *Cultivating Humanity: A Classical Defense of Reform in Liberal Education*. Cambridge, MA: Harvard University Press, 1997.

———. *Not For Profit: Why Democracy Needs the Humanities*. Princeton, NJ: Princeton University Press, 2010.

Obama, Barack. "State of the Union 2011," January 25, 2011. Accessed November 6, 2012. http://www.whitehouse.gov/state-of-the-union-2011.

O'Connor, Francis V. *The New Deal Art Projects: An Anthology of Memoirs*. Washington, DC: Smithsonian Institution, 1972.

Ospina, Maria. "Prácticas de memoria o cómo resistir el acabóse: Violencia y representación en la narrativa colombiana, 1985–2005," PhD diss., Harvard University, 2009.

Padin, Clemente. *Art and People, 1*. Light and Dust @ Grist Mobile Anthology of Poetry, 1997. Accessed November 4, 2012. http://www.concentric.net/~Lndb/padin/lcpcintr.htm.

Parsad, Basmat and Maura Spiegelman. "Arts Education in Public Elementary and Secondary Schools 1999–2000 and 2009–10," Washington, DC: NCES, IES, U.S. Department of Education, April 2012.

Pavel, Thomas G. *The Spell of Language: Poststructuralism and Speculation*. Chicago: University of Chicago Press, 2001.

Pearl, Frank, et al. "Tejer el camino, Guía conceptual y metodológica Componente de convivencia y reconciliación: Estrategia de reintegración basada en comunidades." Banca de Proyectos, Alta Conserjería Presidencial, May 2010. Accessed November 3, 2012. http://mediacionartistica.files.wordpress.com/2012/11/convivencia_y_reconciliacion-guia-colombia.pdf.

Phillips, David L. "Less Drama from Albania's Socialist Leader: Edi Rama's Strategy of Confrontation and Gridlock Ill-Serves His Party and His Country." *Balkan Insight*, June 28, 2011. Accessed November 3, 2012. http://www.balkaninsight.com/en/article/less-drama-from-albania-s-socialist-leader.

Pioneers of Change. "Welcome to Pioneers of Change." Accessed November 6, 2012. http://pioneersofchange.net/.

Pippin, Robert B. *The Persistence of Subjectivity: On the Kantian Aftermath*. Cambridge: Cambridge University Press, 2005.

Pluhar, Werner S., John Rawls, and Immanuel Kant. *Critique of Judgment*. Indianapolis, IN: Hackett, 1987.

Polanyi, Michael. *The Logic of Liberty: Reflections and Rejoinders*. Indianapolis, IN: Liberty Fund, 1998.

——. *Science, Faith and Society*. Riddell Memorial Lectures, 18th ser. London: Oxford University Press, 1946.

Powell, Alvin. "Harnessing Your Creative Brain." *Harvard Gazette*. March 3, 2011. Accessed November 6, 2012. http://news.harvard.edu/gazette/story/2011/03/harnessing-your-creative-brain/.

Poyo, Gerald Eugene. *With All, and for the Good of All: The Emergence of Popular Nationalism in the Cuban Communities of the United States, 1848–1898*. Durham, NC: Duke University Press, 1989.

President's Committee on the Arts and the Humanities. *Reinvesting in Arts Education: Winning America's Future Through Creative Schools*, Washington, DC, May 2011. Accessed November 4, 2012. http://www.pcah.gov/sites/default/files/PCAH _Reinvesting_4web_0.pdf.

Price, William Charles, Seymour S. Chissick, and Werner Heisenberg, eds. *The Uncertainty Principle and Foundations of Quantum Mechanics: A Fifty Years' Survey*. New York: Wiley, 1977.

Proctor, Robert E. *Defining the Humanities: How Rediscovering a Tradition Can Improve Our Schools, with a Curriculum for Today's Students*. 2nd ed. Bloomington: Indiana University Press, 1998.

Quay, James and James Veninga. "Making Connections: The Humanities, Culture and Community," ACLS National Task Force on Scholarship and the Public Humanities. American Council of Learned Societies, Occasional Paper No. 11. New York, New York. 1990.

Quinn, Susan. *Furious Improvisation: How the WPA and a Cast of Thousands Made High Art Out of Desperate Times*. New York: Walker, 2008.

Rahe, Paul Anthony. *Machiavelli's Liberal Republican Legacy*. Cambridge: Cambridge University Press, 2006.

Rama, Edi. "Edi Rama: Take Back Your City with Paint," TED.com video. May 2012. http://www.ted.com/talks/edi_rama_take_back_your_city_with_paint.html.

Rancière, Jacques. *The Emancipated Spectator*. London: Verso, 2009.

——. "The Emancipated Spectator," *Artforum*, March 27, 2007, p. 271–280.

——. *The Ignorant Schoolmaster: Five Lessons in Intellectual Emancipation*. Translated with an introduction by Kristin Ross. Stanford, CA: Stanford University Press, 1991.

————. *The Politics of Aesthetics: The Distribution of the Sensible*. Translated by Gabriel Rockhill. London: Continuum, 2004.

————. "The Politics of Aesthetics, Roundtable," on Eyal Weizman's blog. Accessed June 16, 2013.www.roundtable.keinorg/node/463.

Rauch, Basil. *The History of the New Deal, 1933–1938*. 2nd ed. New York: Octagon Books, 1975.

Rawls, John, and John Dewey. *Human Nature and Conduct: An Introduction to Social Psychology*. New York: Modern Library, 1930.

Readings, Bill. *The University in Ruins*. Cambridge, MA: Harvard University Press, 1996.

Restany, Pierre. *Hundertwasser: The Painter-King with the 5 Skins: The Power of Art*. Revised ed. Koln: Taschen, 2004.

Ríos Avila, Rubén. *La Raza cómica del sujeto en Puerto Rico*. Colección en fuga. Ensayos. San Juan, PR: Ediciones Callejón, 2001.

Rivera, José Eustacio. *La vorágine*. Bogotá: Cromos, 1924.

————. *The Vortex*, trans. Earle K. James. New York: G. P. Putnam, 1935.

Robinson, Ken. "Ken Robinson Says Schools Kill Creativity," TED.com video. June 2006. http://www.ted.com/talks/ken_robinson_says_schools_kill_creativity.html.

Rojas, Juan Fernando."Jóvenes Enseñan Hip Hop En Medellín." *El Tiempo*, April 26, 2011. Accessed November 4, 2012. http://www.eltiempo.com/colombia/medellin /ARTICULO-WEB-NEW_NOTA_INTERIOR-9227720.html.

Romero, Simon. "Acclaimed Colombian Institution Has 4,800 Books and 10 Legs." *New York Times*, October 20, 2008. Accessed November 6, 2012. http://www .nytimes.com/2008/10/20/world/americas/20burro.html.

Roochnik, David. "The Useful Uselessness of the Humanities," *Expositions* 2, no. 1 (2008): 19–26.

Rorty, Richard. *Philosophy as Cultural Politics*. Cambridge: Cambridge University Press, 2007.

Rose, Barbara. *American Art since 1900*. Rev. and expanded. New York: Praeger, 1975.

Rosenzweig, Roy, and Barbara Melosh. "Government and the Arts: Voices from the New Deal Era." *Journal of American History* 77, no. 2 (1990): 596–608. Accessed November 4, 2012.

Ross, Kristin. "Kristin Ross on Jacques Ranciere" *Artforum*, Vol. 45, Issue 7, March 2007.

Rothenberg, Albert, and Carl R. Hausman. *The Creativity Question*. Durham, NC: Duke University Press, 1976.

Rushkoff, Douglas. *Life Inc.: How the World Became a Corporation and How to Take It Back*. New York: Random House, 2009.

Sacco, Pier Luigi. "Culture 3.0: A New Perspective for the EU 2014–2020 Structural Funds Programming." Accessed July 23, 2013. http://www.culturalpolicies.net

/web/files/241/en/Sacco_culture-3-0_CCIs-Local-and-Regional-Development
_final.pdf.

Sáenz Obregón, Javier. *Desconfianza, civilidad y estética: Las prácticas formativas esta-*
tales por fuera de la escuela en Bogotá, 1994–2003. Bogotá: Instituto para la Investiga-
ción Educativa y Desarrollo Pedagógico, 2007.

Salazar, Deborah. "What Every Jewish Parent Should Know about the Waldorf Phi-
losophy," *Jewish Parenting*, Spring 1999, p. 35.

Saltz, Jerry. "A Short History of Rirkrit Tiravanija." *Art in America* 84, no. 2 (1996): 82.

Schapiro, Mark. "An Eccentric Mayor with a Flair for the Dramatic Is Bringing Hope
to a Notoriously Troubled Capital," *Atlantic*, September 2001.

Schiller, Friedrich. *Essays Aesthetical and Philosophical: Including the Dissertation on*
the "Connexion between the Animal and Spiritual in Man." Bohn's Standard Library.
London: G. Bell, 1905.

———. *Letters on the Aesthetic Education of Man*, in *Literary and Philosophical Essays:*
French, German and Italian, vol. 32, Harvard Classics (New York: PF Collier and
Son, 1910): 221–313. Accessed June 16, 2013 http://www.archive.org/stream
/literaryandphilooounknuoft/literaryandphilooounknuoft_djvu.txt.

———. "On Grace and Dignity" (1793), in *Aesthetical and Philosophical Essays*
(Middlesex, UK: Echo Books, 2006), 127–154.

———. "On Naïve and Sentimental Poetry," (1795). Accessed June 16, 2013. http://
www.schillerinstitute.org/transl/schiller_essays/naive_sentimental-1.html.

———. "On the Sublime (1801)," in *Essays*, ed. Walter Hinderer. New York: German
Library, New York University Press, 1993.

Schiller Institute. "Meet Lyndon Larouche." Accessed June 16, 2013. http://www
.schillerinstitute.org/biographys/meet_larouche.html.

———. "Translations of Works by Schiller: On the Sublime." Accessed November 7,
2012. http://www.schillerinstitute.org/transl/trans_on_sublime.html.

Schneider, Nathan. "Paint the Other Cheek." *Nation*, March 14, 2012. Accessed
November 4, 2012. http://www.thenation.com/article/166820/paint-other-cheek.

Schulman, Sarah and Jim Hubbard. "Act Up Oral History Project." Accessed July 23,
2013. http://www.actuporalhistory.org/about/bios.html.

———. "ACTUP Capsule History 1987." Accessed September 8, 2013. www.actupny
.org/documents/cron-87.html.

Schutzman, Mady, and Jan Cohen-Cruz. *Playing Boal: Theatre, Therapy, Activism* New
York: Routledge, 1994.

Schwarz, Roberto. *O pai de família e outros estudos.* São Paulo: Companhia das Letras,
2008.

Shaughnessy, Michael F. "An Interview with Andrew Klavan: N.E.A. and the Arts?"
September 29, 2009. http://www.educationnews.org/articles/-an-interview-with
-andrew-klavan-nea-and-the-arts.html#sthash.JRtepMYk.dpuf.

Shklovsky, Victor. "Art as Technique" (1917), in *Russian Formalist Criticism, Four*

Essays, trans. with an introduction by Lee T. Lemon and Marion J. Reis (Lincoln: University of Nebraska Press, 1965.

Showalter, Elaine. *Teaching Literature*. Malden, MA: Blackwell, 2003.

Siegelman, Ellen. *Metaphor and Meaning in Psychotherapy*. New York: Guilford Press, 1990.

Singhal, Arvind, and Karen Greiner. "Performance Activism and Civic Engagement through Symbolic and Playful Actions." *Journal of Development Communication* (December 2008): 43–53. Accessed November 3, 2012. http://utminers.utep.edu /asinghal/Articles%20and%20Chapters/Singhal-Greiner-2008-JDC-Performance %20Activism-1.pdf.

Slauter, Eric Thomas. *The State as a Work of Art: The Cultural Origins of the Constitution*. Chicago: University of Chicago Press, 2008.

Smee, Sebastian. "Blunt Instruments." *The Boston Globe*, October 30, 2009. Accessed November 5, 2012. http://www.boston.com/ae/theater_arts/articles/2009/10/30 /aids_art_made_a_big_impact_with_just_a_few_strong_images/.

Sommer, Doris. *Bilingual Aesthetics: A New Sentimental Education* (Public Planet Books). Durham, NC: Duke University Press, 2004.

———. *Foundational Fictions: The National Romances of Latin America*. Latin American Literature and Culture, vol. 8. Berkeley: University of California Press, 1991.

———. *Proceed with Caution When Engaged by Minority Writing in the Americas*. Cambridge, MA: Harvard University Press, 1999.

Sorensen, Diana. *A Turbulent Decade Remembered: Scenes from the Latin American Sixties*. Cultural Memory in the Present. Stanford, CA: Stanford University Press, 2007.

Southern, R. W. *Scholastic Humanism and the Unification of Europe*. Oxford: Blackwell, 1995.

Spariosu, Mihai. *Dionysus Reborn: Play and the Aesthetic Dimension in Modern Philosophical and Scientific Discourse*. Ithaca, NY: Cornell University Press, 1989.

Spivak, Gayatri Chakravorty. *An Aesthetic Education in the Era of Globalization*. Cambridge, MA: Harvard University Press, 2012.

Steiner, Wendy. *The Scandal of Pleasure: Art in an Age of Fundamentalism*. Chicago: University of Chicago Press, 1995.

Stevens, John E. *Words and Music in the Middle Ages: Song, Narrative, Dance, and Drama, 1050–1350*. Cambridge Studies in Music. Cambridge: Cambridge University Press, 1986.

Sussman, Donna. "The Influence of Mexican Muralists on WPA Art." Yale National Initiative to Strengthen Teaching in Public Schools. May 2, 2009. Accessed November 4, 2012. http://teachers.yale.edu/curriculum/search/viewer.php?id =initiative_05.02.09_u.

Swift, Nick. "Edi Rama, Mayor of Tirana." Accessed November 3, 2012. http://www .worldmayor.com/worldmayor_2004/rama_winner04.html.

Syberberg, Hans Jürgen. *Hitler, a Film from Germany*. New York: Farrar, Straus and Giroux, 1982.

Taylor, Diana. *The Archive and the Repertoire: Performing Cultural Memory in the Americas*. Durham, NC: Duke University Press, 2003.

———. *Disappearing Acts: Spectacles of Gender and Nationalism in Argentina's "Dirty War."* Durham, NC: Duke University Press, 1997.

———. *Theatre of Crisis: Drama and Politics in Latin America*. Lexington: University Press of Kentucky, 1991.

TeachingAmericanHistory.org. "The Kitchen Debate." Accessed November 5, 2012. http://teachingamericanhistory.org/library/document/the-kitchen-debate/.

Thomas, Richard F. *Reading Virgil and His Texts: Studies in Intertextuality*. Ann Arbor: University of Michigan Press, 1999.

Thompson, George. *Aeschylus and Athens*. London: Lawrence and Wishart, 1941.

Thompson, Robert Farris. *Flash of the Spirit: African and Afro-American Art and Philosophy*. New York: Random House, 1983.

———. *Tango: The Art History of Love*. New York: Pantheon Books, 2005.

Thomson, George Derwent. *Aeschylus and Athens: A Study in the Social Origins of Drama*. 2nd ed. London: Lawrence and Wishart, 1946.

Tijus, Charles "Interpreting for Understanding," *Conference Interpreting: Current Trends in Research*, ed. Yves Gambier, Daniel Gile, and Christopher Taylor (Amsterdam: John Benjamins, 1994), 29–49.

Topal, Cathy Weisman, and Lella Gandini. *Beautiful Stuff! Learning with Found Materials*. Worcester, MA: Davis Publications, 1999.

Uhrmacher, P. Bruce. "Uncommon Schooling: A Historical Look at Rudolf Steiner, Anthroposophy, and Waldorf Education." *Curriculum Inquiry* 25, no. 4 (Winter 1995): 381–406. Accessed November 3, 2012. http://www.jstor.org/stable/1180016.

"United Nations Economic Convention on Access to Information, Public Participation in Decision Making and Access to Justice in Environmental Matters." Aarhus, Denmark, June 25, 1998. Accessed July 23, 2013. http://www.unece.org/env/pp/treatytext.html.

Urbonas, Nomeda and Gediminas Urbonas. "Pro-Test lab dossier," 2005. http://www.nugu.lt/nugu_pdf/urbonas_2005_protestlab.pdf.

Uzkalnis, Andrius (2009) Sava ir Privatu: Visai Nepriesiska Bendruomenei ir Viesumai. *Miesto IQ: Tarp Vieso ir Privataus*. Rugsejis-Spalis 17, 6–9.

Van Heertum, Richard "Marcuse, Bloch and Freire: Reinvigorating a Pedagogy of Hope," *Policy Futures in Education* 4, no. 1 (2006): 45–51.

Vasconcelos, José. *Discursos: 1920–1950*. Mexico City: Ediciones Botas, 1950, http://www.ibe.unesco.org/publications/ThinkersPdf/vasconce.pdf.

Velásquez, Eduardo A, ed. *Love and Friendship: Rethinking Politics and Affection in Modern Times*. Lanham, MD: Lexington Books, 2003.

Veyne, Paul. *Writing History: Essay on Epistemology*. Middletown, CT: Wesleyan University Press, 1984.

Vulliamy, Ed. "Strings Attached: What the Venezuelans Are Doing for British Kids," *Observer*, October 2, 2010.

Wallace, Lane. "Multicultural Critical Theory. At B-School?" *New York Times*, January 10, 2010. Accessed November 3, 2012. http://www.nytimes.com/2010/01/10/business/10mba.html.

Walt, Vivienne. "A Mayoral Makeover." *Time*, October 2, 2005. Accessed November 4, 2012. http://www.time.com/time/magazine/article/0,9171,1112793,00.html.

Warner, Michael. *Fear of a Queer Planet: Queer Politics and Social Theory*. Cultural Politics, vol. 6. Minneapolis: University of Minnesota Press, 1993.

Weber, Max. *The Protestant Ethic and the Spirit of Capitalism* (original German 1905), trans. Talcott Parsons. New York: Scribner, 1930.

Weisberg, Liza. "The Yes Men Fix The World One Prank at a Time." *Huffington Post*, July 27, 2009. Accessed November 4, 2012. http://www.huffingtonpost.com/liza-weisberg/the-yes-men-fix-the-world_b_244727.html.

Whelan, Frederick G. *Hume and Machiavelli: Political Realism and Liberal Thought*. Lanham, MD: Lexington Books, 2004.

Whilden, Megan. *Creative Pittsfield*, January 12, 2009. Accessed November 4, 2012. http://www.pittsfield-ma.org/Detail.asp?sid=377.

Whitehead, Alfred North. *Dialogues of Alfred North Whitehead, As Recorded by Lucien Price*, Boston: Little, Brown, 1954.

Wikipedia. "Act of the Re-Establishment of the State of Lithuania." Accessed November 5, 2012. http://en.wikipedia.org/wiki/Act_of_the_Re-Establishment_of_the_State_of_Lithuania.

———. "El Sistema." Accessed November 5, 2012. http://en.wikipedia.org/wiki/El_Sistema.

———. "George Maciunas." Accessed November 5, 2012. http://en.wikipedia.org/wiki/George_Maciunas.

———. "Graffiti." Accessed November 4, 2012. http://en.wikipedia.org/wiki/Graffiti.

———. "Maria Montessori." Accessed November 6, 2012. http://en.wikipedia.org/wiki/Maria_Montessori.

———. "Roberto Jacoby." Accessed November 4, 2012. http://es.wikipedia.org/wiki/Roberto_Jacoby.

Wills, Garry. *Mr. Jefferson's University*. Washington, DC: National Geographic, 2002.

Winnicott, D. W. "Primitive emotional development," *International Journal of Psychoanalysis* (1945) 26:137–143.

———. *Playing and Reality*. New York: Basic Books, 1971.

———. "Playing: Its Theoretical Status in the Clinical Situation." *International Journal of Psychoanalysis*, Vol. 49 (1968): 591–599.

———. "The Use of an Object in the Context of *Moses and Monotheism*" (1969), in *Psychoanalytic Explorations*, edited by Clare Winnicott, Ray Shepherd, and Madeleine Davis. Cambridge: Harvard University Press, 1989.

Wittgenstein, Ludwig. *Philosophical Investigations.*, trans. G. E. M. Anscombe. New York: Macmillan, [1953] 1968.

Wolf, Thomas and Gigi Antoni. *Collaboration and Community: A Manual for Sustainability* New York: National Guild for Community Arts Education, 2012.

World Health Organization. "Suicide Rates Per 100,000 by Country, Year and Sex (Table)." Accessed November 4, 2012. http://www.who.int/mental_health /prevention/suicide_rates/en/.

World Mayor. "Edi Rama replies to questions from an international audience." Accessed November 4, 2012. http://www.worldmayor.com/worldmayor_2004 /interview_rama.html.

WPAmurals.com. "History of the New Deal Arts Project." Accessed July 22, 2013. http://www.wpamurals.com/history.htm.

Yúdice, George. *The Expediency of Culture: Uses of Culture in the Global Era.* Post-Contemporary Interventions. Durham, NC: Duke University Press, 2003.

Zmijewski, Artur and Joanna Warsza, eds. *Forget Fear: 7th Berlin Biennale for Contemporary Art.* 2nd ed. Köln: König, 2012.

Index

art (*continued*)

capacity of to inspire patriotism, 37, 38, 40, 98; collectible, 63, 98, 154; concept of the deliberate uselessness of, 8–9, 98, 100–101; Dewey's definition of, 147; effects of on thinking, 111, 113–14; as fuel for pragmatic social projects, 7, 48; graffiti, 30, 49–51, 57, 71–72, 104, 121; importance of risk-taking in, 8, 127, 143–44, 154–56; as a preventative against violence, 2, 17, 46–47, 121; provocative power of, 4, 19, 36, 47, 89, 141–42; ripple effects of on society, 3, 7, 11, 38, 67–68, 79; as a tool of resistance to oppression, 29–30, 57, 104

artistic freedom, 10, 19–20, 36, 43–45, 98. *See also* aesthetic freedom

artists: and artistic genius, 39, 91, 143, 150; case of ACT UP, 61–68; case of Edi Rama (Tirana), 33–37; case of Pedro Reyes (Mexico), 81–84; case of the Pro-Test Lab (Lithuania), 73–78; citizen-, 9, 31, 34, 50, 55, 101; citizens as, 32, 56, 109, 145; civic role of, 40, 45–46, 51–52, 59, 94, 155; collaboration among, 30–31, 91; collaboration of with institutions, 8, 40, 43, 51, 98–99; critical thought processes of, 3, 9–11, 50, 88, 94, 127; maligned as fabricators, 90, 150; muralists, 39, 41, 50; pantomime, 2, 16, 19, 24–25, 27, 31–32; rebellious tendencies of, 31–32, 40–43, 57, 71–72, 91; risk-taking character of, 4–5, 8, 92, 137–38, 148–49; as teachers, 110–11, 120–23, 126–27; under the New Deal, 38–44

art-making: as a collective undertaking, 36, 48, 50, 74; importance of to cognitive development, 11, 50, 88, 92, 113, 120; importance of in teaching judgment, 85, 104, 105, 111; importance of trial, error, and failure to, 120, 143; as an inherent human drive, 90, 141; intellectual connection of to freedom, 138–39; as a means of promoting civic consciousness, 4, 30–31, 37, 50–51, 134, 155; as a product of reason and passion, 12, 19, 136–37, 145; and psychological stability, 8, 46–47, 90, 141, 142–43, 150; role of individuality in, 47–48; as a tool to prevent violence, 47–48, 111, 121

Ayara Family, 121–22

beauty: created versus natural, 88–89, 138, 143–45; disinterested appreciation of, 9, 35, 86; ethical significance of, 8–9, 84, 89; and human judgment, 85–86, 88, 138, 144, 146

Biddle, George, 39, 40

Boal, Augusto: on arts education, 60; and concept of the spect-actor, 25, 56–58, 131, 155; as a cultural agent, 52–53, 61, 110, 114, 145; experiments with interactive theater, 53–55; Legislative Theatre, 51, 58–59; on the need for mutual admiration, 56–57; Newspaper Theatre, 44; political career of, 53, 57, 59; work in theater, 2, 21, 31, 58

Bogotá, Colombia: art-inspired intervention in, 16–25, 28, 36, 121; as a model for other cities, 24, 36, 78; municipal tax campaign in, 21–22, 23; socio-economic problems of, 15–16; solution to traffic problems in, 2, 16*f*, 17*f*, 18, 26–27, 31

books. *See* Cartoneras; classics; Pre-Texts

Boston, Massachusetts, 50, 110–12, 120, 127

Brazil, 53–54, 58–60, 70, 122–23

Buenos Aires, Argentina, 50, 107–8, 109, 110, 119

Cartonera, Eloísa (Buenos Aires), 50, 108–9, 118–19, 155

Cartoneras, 50, 107–8, 114–17, 123, 127, 183n20. *See also* literacy; Pre-Texts; reading; writing

Cartonera, Sarita (Lima), 108, 116*f*, 119

Cahill, Holger, 39–40

change. *See* cultural agency; interventions; social change

cigar factories as an educational force, 124–25, 184n38

citizenship. *See* civic education; collective action

civic education: aesthetic judgment as a basis for, 2–3, 6, 34–35, 87–88; as the basis for collective action, 9, 10, 11, 19, 111–12, 132; and the humanities, 8–9, 93–97, 100–101, 114, 125; role of art in, 48, 73, 134, 138–39, 142, 145

classics: musical as a medium for social bonding, 72–73; repurposing of literary to promote literacy, 107, 112–20, 133, 155. *See also* literacy; Pre-Texts; reading; writing

collective action: ACT UP, 61–69; and the acupuncture effect, 16–17, 24, 49–50, 55, 60–61, 155; and democracy, 85, 91, 104, 112, 114, 123; mutual admiration as basic to, 6, 31, 43–44, 86–87, 111, 144; problem of public ambivalence, 19, 28; Pro-Test Lab, 73–78; ripple effects of, 17, 30–31, 51, 60, 61; to solve socio-economic problems, 9, 17, 32, 48, 53, 138; versus tolerance or vanguardism, 31, 91, 147. *See also* interventions; social change

color, influence of on morale and social reform, 34–35

common sense: civic, 88, 90, 104–5, 137, 142, 149; as intersubjective appreciation, 35–36, 105, 125, 146, 150–51

communism, 29, 34, 40, 41, 44, 99

creativity: and bilingualism, 27, 93; bottom-up, 36; as a conduit to human freedom, 138; connection of critique to, 65, 66, 86–87, 97, 104, 136; and criticism, 10, 12, 88, 98, 102; dependence of on higher-order mental process, 6, 113–14; literary, 112–21, 133; musical, 69, 72–73; suppressed by authoritarian governments, 32, 53, 57; as a tool to foster education, 132–33; as a tool for preventing violence, 47–48, 111, 121

critical thinking: link of to creativity, 6, 113–14; use of literary classics to induce, 112–20, 124, 184n38

criticism. *See* aesthetic experience; creativity

Critique of Aesthetic Judgment (1790), 86–87, 142, 150, 152

Cuba, 42, 70–71, 99, 123, 125, 184n38

Cucurto, Washington (Santiago Vega), 108, 118–19

cultural agency: bilingual aesthetics as, 93; hybrid nature of, 7, 8, 81; role of interpretation in, 11, 93

cultural agents: agent-spotting to find, 51, 81–82, 104–5; artists as, 4, 7, 82, 110–11, 114; Cultural Agents Initiative, 1, 12, 50, 105, 109–10, 120–21; interpreters as, 11, 104–5; librarians as, 119, 121; need of the ability to tolerate risk, 5–6; teachers as, 12, 37, 50, 63, 111–13, 126; varying roles of, 2–3, 28, 51, 81–82, 127, 146

dance: dance-hall democracy, 69–71; salsa, 69–70, 71, 110, 173n92; as a tool to support intellectual development, 110, 120, 127

deconstruction theory, 149, 152, 153, 154

de Man, Paul, 152–54

democracy: art as a tool to support, 4, 29–30, 57, 104; compared to authoritarian government, 29, 31–32, 91; dependence of on high-order literacy, 111–12; dependence of on judgment, 9, 28, 85, 93–94, 120–21; as a necessary product of collective action, 31, 56, 59, 69–71, 111–12, 125–26; role of rules in, 19, 28, 59. *See also* freedom

Dewey, John: on art-based education, 4, 39, 44, 50, 149; *Art as Experience* (1934), 10; pragmatism of, 10, 37, 56, 147

education: aesthetic, 9, 11, 35, 134, 138–39, 150; American public, 112–13, 136, 154; anti-authoritarian, 60, 126, 128, 134; art in, 45, 46, 47, 104; arts-based, 6, 10, 47, 60, 132, 143; at-risk students, 47, 72, 110–11, 120, 133; civic, 3, 8–9, 101, 145; experiment in Zimbabwe, 128; humanistic, 5, 8, 94, 99, 100; humanities-based universities, 95, 97–98; limitations of audiovisual stimuli in, 112; Montessori schools, 132, 134; music, 72, 130; negative impact of testing on, 113, 133; passion as an ingredient of learning, 132; play as a tool for, 132–33, 136; Pre-Texts experiment in Chalco, Mexico, 128–29; ripple effect of, 129; science, 79, 145; student-teacher relationship, 60, 91–92, 114, 124–25, 133–34, 147; theater, 58, 60, 142; traveling libraries, 119; *universitas*, 95; Waldorf Schools, 31, 132

Enlightenment: association of creativity with civic action, 30, 136, 142; concepts of humanism, 96–97, 100; discussions of judgment and taste, 85, 87, 96

experiments: social change, 6–7, 27, 56, 73–76, 148; theater, 44, 53–54, 57

facilitators, 2, 55–56, 60, 105, 114, 120–21. *See also* jokers

Federal Theatre Project, 41–44

Flanagan, Hallie, 41–43, 47–48

Forum Theatre, 54, 56, 58, 61, 114, 155

freedom: aesthetic, 8, 86, 88, 135, 138, 142; artistic, 10, 19–20, 36, 38, 43–45, 98; art as a stimulus to, 37–38, 40, 82, 89, 154; humanist approach to, 94–95, 101, 136–38, 190–91n72; the individual as the basis for, 5, 138–39; intellectual connection of to art, 9, 138–39, 142; interpersonal, 9, 35, 146–47, 150; interrelationship of with risk-taking, 8, 92, 136, 143–46, 148, 156; *Naïve and Sentimental Poetry* (1801), 143–44; theater as a stimulus to, 41–42, 53, 54, 55; vacillating relationship between aesthetics and political, 95–98. *See also* democracy

Freire, Paulo: on human interrelationships, 31, 64, 66, 136, 139; on the implementation of social change, 146–47; theory of pedagogy, 8, 60, 112, 126, 134

French Revolution, 9, 135, 136

Gramsci, Antonio, 4, 23, 86, 99, 139, 156

Guns into Shovels (*Palas por pistolas*), 82, *83f*, *84f*

Habermas, Jürgen, 21, 51, 111, 135, 148–52

Hegel, Georg Wilhelm Friedrich, 8, 55, 146

humanism: as a basis for establishing common sense, 92, 104–5; capacity of to expose contexts, 100, 103–4; civic, 8–9, 11; as a counterpoint to technology, 99; damaged by cultural amnesia, 100–101, 148; and the human instinct for play, 136–43; Marxist, 65, 99–100; modern revival of, 101; pedagogy of, 94–95; versus the despair of Structuralism, 100–101; Western European tradition of, 94–97, 100

humanities: civic value of the, 6, 68, 93–97, 101, 113–14; deconstructionists' misunderstanding of the, 152; educational role of the, 3, 8, 88, 97, 99–100; Engaged Humanities programs, 6, 8; loss of educational funding for the, 1, 9–10, 44–45, 104; misconstrued by arriviste students, 97–98, 100–101; pragmatics' misunderstanding of the, 5–6; in vanguard against totalitarian thinking, 99

illiteracy and social problems, 108, 112, 182–83n15

imagination: as the basis for interventions and change, 45, 49, 56, 66, 99; cathartic character of the, 144–45; as a complement to judgment, 6–7; counterfactual approach and the, 19, 141, 154; damaged by educational testing, 133, 136; developed by art-making, 50, 141, 142; facilitated by difficulty, 112, 133, 145, 151

improvisation: cultural traditions of, 70, 121–23; literary, 123, 133; as a tool for solving problems, 2, 30, 31, 53, 56

interpretation: in the arts, 3, 123, 130; as an exercise of the intellectual faculties, 5, 107, 111–21, 115–16, 133–34, 183n20; and the human instinct for play, 12, 136; humanistic, 8–10, 87–88, 89, 91–92, 103–4; literary, 111–15; Pre-Texts exercises to develop skills in, 129–31; as a product of individual thinking, 91, 93, 116, 120–21, 124–25, 130; ripple effect of, 102–4; role of in civic education, 3, 5, 7–8, 10, 96–97

interventions: artistic to initiate social reforms, 12, 62–64, 82, 105; constructive, 4, 16, 98, 104, 147, 155; dangers of, 102; improvisational by spect-actors, 56, 58, 61; in poor and underserved areas, 110, 112; using art-making, 47–48, 111, 121; using interactive theater, 54–58; using music, 47, 72–73. *See also* collective action; poverty; social change; violence

jokers, 56, 58, 60, 121. *See also* facilitators

judgment: aesthetic, 3, 87, 88, 144; as a bridge between the abstract and the material, 87; as a cornerstone of democracy, 9, 86, 88, 91, 94, 101; development of through aesthetics, 7, 12, 85, 97; disinterested, 3, 6, 9, 90, 141–42, 146; dynamics underlying, 85–89; as an intellectual bridge, 150–51; interrelationship of with choice, 92; as a leveling force among humans, 142. *See also* taste as a precursor of judgment

Kant, Immanuel: concept of human subjectivity, 97; on the development of judgment through taste, 85, 87, 142; on the disinterested appreciation of beauty, 9, 90, 143, 147; Schiller's theoretical divergences from, 89, 90, 141–42, 144, 145, 150; theory of common sense, 35, 104, 146, 150; theory

of disinterested interest in life, 90, 150;
Third Critique of Aesthetic Judgment (1790),
87–88, 142, 150
Kramer, Larry, 62, 64, 67, 68

learning. *See* education; Pre-Texts; thinking
Letters on the Aesthetic Education of Man
(1794), 9, 11, 88, 147; messages of, 137–42,
145, 150–54; purpose of, 5, 9, 135
libraries, 37, 46, 119, 131
Lima, Peru, 50, 107–8, 109, 120
literacy: absence of as an indicator of socio-
economic problems, 112; LUMPA project,
112–20; Pre-Texts exercises to facilitate,
129–32; recycling of classics to promote,
112–21, 133, 183n20; and rigorous thinking,
111–12; use of literary criticism to develop,
115, 117, 119, 130, 131. *See also* Cartoneras;
classics; Pre-Texts; reading; writing
Lithuania, 73–78, 155, 173n101
Lyotard, Jean-François, 20–21

Mexico: artist-revolutionaries of, 41; col-
laboration of government with artists,
37–38, 43, 98–99, 105; literacy programs
in, 112, 127–28; *Palas por pistolas (Guns into
Shovels)* project, 82–83; tradition of mural
painting, 37, 39
Middle Ages, 29, 95–96
Mockus, Antanas: as mayor of Bogotá, 2,
15, 18–25, 29, 31; and National University
of Colombia, 25–26; political activism of
in Colombia, 28–29, 32, 56; use of arts-
inspired social interventions, 16, 21, 26–27,
33–34, 148, 155
Molesworth, Helen, 63, 64, 66, 69
Montessori, Maria, 11, 132, 134
murals as a socio-cultural force, 30, 37–41, 43,
49–50, 110
music: and collective dancing, 69–70; hip-
hop, 104, 121–22; *Imagine* project instru-
ments, 84; as an impetus to the Prague
Spring, 71–72; orchestras, 71, 72
music-making: democratizing effect of the
classics, 72–73, 110; as a healthy alternative
to violence, 47, 72

National Endowment for the Arts (NEA),
44–46

Nazi constraints on freedom, 29, 31
New Deal arts programs: arguments over
which artists to support, 39–40; to con-
trol potentially volatile artists, 40–42;
Federal Art Project (FAP) (1935–1939),
38–39; Federal Theatre Project, 41–44;
Latin American connections of, 37–38,
39; to promote cultural pride and patriot-
ism, 38, 40, 45; Public Works of Art Project
(PWAP) (1933–1934), 38; scale of, 38, 41,
43; Treasury Relief Art Project (TRAP)
(1935–1938), 43; Works Progress Admin-
istration (WPA), 38, 39f, 41, 44; Writers'
Project, 41, 43
newspapers: clothesline, 122, 123; as litera-
ture in cigar factories, 124, 184n38; Living
Newspaper, 44; as tools of change for cul-
tural agents, 18, 59, 75
New York City, 34, 44, 61–68

pantomime art as a tool to facilitate social
change, 2, 16, 19, 24–25, 27, 31–32
passion as a productive foil against reason, 19,
136, 145, 152, 154
pedagogy: art-centered, 50–51, 138–39;
Dewey's theory of, 10, 37, 50–51, 55–56, 147,
149; as an element of civic culture, 19; as
employed in Pre-Texts programs, 113–15;
feedback, 108; Freire's theory of, 60, 66; of
humanism, 94; of innovation, 105, 117, 119–
20; project-centered, 132; Schiller's theory
of, 5, 9, 136–39, 142–43, 145–46
Pedagogy of the Oppressed (1968), 8, 60, 90,
139, 146
Peru, 53–54, 108, 112
philosophy: Classical, 94–95; deconstruction,
149, 152, 153, 154; Enlightenment, 85, 86–87,
96–97, 137–38, 142; language, 93, 103,
151–52; moral, 56, 96, 99, 142, 151; political,
65–66, 138, 150
Plastic People of the Universe (Prague),
71–72
play: as an amoral activity, 137; as artistic cre-
ativity, 18, 137–38, 145–46, 152–53; basic
human need for, 47–48, 140; civic revivi-
fying powers of, 2, 9, 18, 24, 27, 152; as a
conduit to political liberty, 137–38, 143,
148, 155; as imagination and experimenta-

play (*continued*)
tion, 139–40, 140–41, 149, 188n24; power of
to balance reason and passion, 12, 136–37,
142–43, 188n27; power of to fight antipa-
thy, 25–26; Schiller on, 136–38, 140; as a
tool for learning, 132–33, 136; Winnicott
on, 121–22, 135, 140–41, 187–88n23
pleasure: as a basis for socio-political consen-
sus, 18, 35, 40, 88–89, 102, 155; emotionally
mediating power of, 19, 136, 142; human
fear of, 3–4, 18, 144, 153; power of to moti-
vate learning, 117–18, 128, 156; role of in
forming judgment, 86, 112
politics: art and, 59–60, 84, 88, 137–38; art as
politics argument, 51; concept of the aes-
thetic regime, 10–11; connection of to aes-
thetics, 34–35, 36, 89–91
poverty: arts interventions against, 7, 46–47,
110–11; interactive theater as an interven-
tion against, 53; literacy-promotion inter-
ventions against, 50, 127–28. *See also* inter-
ventions; social change; violence
pragmatism: in arts-based interventions, 7, 33,
56; embraced by Dewey, 4, 10, 90, 136, 147;
as related to pleasure, 18, 19
Pre-Texts: as a citizenship-building tool, 120–
21; demands of on participants' thought
processes, 119–20, 122, 124–26, 129; sample
activities of, 129–32; teacher-training
through, 50, 114, 121–22, 126–28, 134; as a
tool to promote literacy, 6, 105, 111–13, 123,
133, 155; underlying philosophy of, 113–14,
126. *See also* Cartoneras; classics; literacy;
reading; writing
Pro-Test Lab (Lithuania), 73–78, 155, 173n101
public space: gentrification of as a civic prob-
lem, 76; graffiti in, 30, 49–51, 57, 71–72, 104,
121; muralists and, 30, 32, 41, 49, 50; and
pride of ownership, 110; privatization of
as a civic problem, 73–74, 75, 77; as socio-
political objects, 26, 36, 67, 73–74, 78; as
venues for agents of change, 64–65, 66–68.
See also architectural works as socio-
political objects
Puerto Rico, 38, 50, 79, 112, 124, 127

Rama, Edi, 33–37, 48, 164n73
Rancière, Jacques: on the aesthetic regime in
politics, 10–11, 90–91, 148; on cultural am-
nesia, 100, 148; on education, 132, 134; *Igno-
rant Schoolmaster* (1987), 90, 134; on social
change, 139, 187n17; *The Politics of Aesthetics*
(2004), 91, 148, 187n17
reading: of classic literature, 117, 118–19, 133;
as a cultural tradition, 108; and interpre-
tation, 114–15, 124–27, 130–31; publicly
among political activists, 63, 64, 73; as a
rigorous mental process, 7, 111–12, 131–32,
183n20; spiral relationship of with writing,
112, 115, 126; in tobacco factories, 123–24,
125, 184n38; as a tool for understanding, 38,
99–100. *See also* Cartoneras; classics; liter-
acy; Pre-Texts; writing
reason: dangers inherent in, 6, 9, 18; as an
insufficient road to freedom, 9, 136, 138,
145, 154; Kant on, 87, 152; productive ten-
sion of against passion, 3–4, 19, 144–45,
152; scientific rationality interpreted as,
96–97; versus irrational sensuality, 12, 137,
142–43, 149, 150; versus judgment, 85–86,
87, 94, 142, 146
Renaissance, 95–96, 100, 133
Reyes, Pedro, 52, 81–84, 94, 104–5
Rio de Janeiro, Brazil, 35, 58–60
ripple effects: of art, 3, 11, 38, 64, 79, 102; of
innovation and social change, 7, 31, 67, 72,
99, 124
risk-taking and personal development, 8, 127,
133, 143–44, 148, 156
rooftop gardens, 48, 52, 78
Roosevelt, President Franklin Delano, 10, 12,
37, 38, 42, 45

Schiller, Friedrich: on art as an independent
entity, 32; on art and reason, 9, 18, 136,
144–45, 154; on the barrenness of utility,
137, 148; on beauty, 88, 143–44; on the con-
nection of art to freedom, 35, 135, 142–44,
146, 148, 150; critics of, 152–54; on cultural
agency, 5, 153, 154–56; on the human drive
to play, 136–38, 140, 152, 154; on the impor-
tance of trial, error, and failure, 143–44, 151,
156; influence of, 10, 19, 90, 135, 140, 145–53;
Letters on the Aesthetic Education of Man
(1794), 5, 9, 11, 88, 137–45, 150–54; opposi-
tion of to molding human beings, 30, 153;

on the power of art, 89, 141–42; theoretical divergences of from Kant, 89, 90, 141–42, 144, 145, 150

science: autonomous character of, 32, 99; as a complement to the humanities and arts, 6, 7, 100, 104, 145, 147; in education, 79, 145; Enlightenment concept of scientific reason, 85, 87, 96–97; role of judgment in, 3; scientific method, 21

Shklovsky, Viktor, 19, 89

social change: art as a provocation of, 51–52; *Atlas de intervenciones*, 105; bottom-up model of, 2, 12, 36, 48, 52, 109; Cartoneras as agents of, 107–9, 115–17; case of ACT UP, 61–68; case of Edi Rama (Tirana), 33–37; case of Pedro Reyes (Mexico), 81–84; case of the Plastic People (Prague), 71–72; and civil rights, 62, 65, 68, 78, 99; and cultural revolution, 24, 99, 138, 139, 148; experiments in, 6–7, 27, 56, 73–76, 148; grassroots projects for, 12, 37, 58, 78; importance of individual perspective to, 54–55, 138, 139; interconnections of socio-economic problems, 79; limitations of political protest in effecting, 93; limitations of vanguardism in effecting, 53–54, 147, 155; pleasure as a necessary ingredient of, 4, 18, 25, 35, 155; and political revolution, 23, 60, 70–71, 72, 145; role of counterfactual thinking, 24, 148, 151; silence and apathy as threats to, 63, 102–3; skeptics' responses to, 17, 29, 112, 139, 152, 154; top-down model of, 2, 48, 54, 60, 109, 146; urban revival, 16–17, 34, 46, 48, 60, 78. *See also* collective action; interventions; poverty; violence

social sciences, 7, 47, 91, 104, 139, 150

spect-actors' role, 25, 55–58, 64, 114, 131, 155

Spivak, Gayatri Chakravorty, 152, 183n21

students: attracting at-risk to school, 47, 110, 120; as cramped in conventional academic environments, 5–6; need of to learn to think critically, 6; revival of civic consciousness among, 102; self-educating capacities of, 132, 133, 134; social activism of, 99, 102, 110

subjectivity: civic-minded, 85, 93–94, 96–97, 100, 139, 142; as a complement to objective realities, 86–87, 138–39, 140, 141; and inter-subjective behavior, 86, 105, 140, 141, 150, 151–52; private, 18, 45, 92, 100

Surrealism, 51, 98, 149

Sustainable South Bronx project, 78–79

taste as a precursor of judgment, 12, 85–88, 90, 96, 146. *See also* judgment

teachers: as cultural agents, 12, 37, 50, 63, 111–13, 126; importance of risk-taking for, 8; interpretive role of, 28, 91–92, 117, 119, 132, 133–34; in medieval Western Europe, 95–96; pitfalls for, 60, 113, 120, 124–25, 128, 133–34; students as, 50, 134; training of, 119, 128, 134

theater: Boal's use of, 2, 21, 53–60, 145, 155; *Cradle Will Rock, The*, 41–42; as an educational tool, 31, 58, 60; Federal Theatre Project, 41–44; forum-style, 54, 56; interactive as a tool for situational intervention, 53–55, 60–61; Legislative Theatre, 51, 58–59; "Living Newspaper," 44; mental, 53, 149; as psychological therapy, 53, 57–58; Theatre of the Oppressed, 56, 58, 60, 110; as a tool for effecting social change, 59–61, 145, 155; as a tool for social protest, 41–44, 53, 58; vanguard-style, 53–54, 58

thinking: art as a complement to, 3, 9–11, 50, 88, 99, 127; civic, interpersonal powers of, 88, 114, 124, 132, 142; counterfactual, 19, 24, 148, 151, 153–54; creative and adaptive, 6, 24, 107, 113, 154; development of higher-order, 107, 112–14, 119–21, 142, 183n20; free, 6, 85, 88, 125; interpretation and judgment as complements to, 5, 10, 85, 87, 121; literature as a means of facilitating, 111–12, 124–25, 130; Pre-Texts exercises to facilitate, 129–32

Tirana, Albania, 33–35, 36, 47, 164n75

trial and error. *See* risk-taking

truth: comparative value of, 94–95, 141, 142, 148; and morality, 87, 91, 152

urban farming. *See* rooftop gardens

urban revival, 16–17, 34, 46, 48, 60, 78

Urbonas, Nomeda and Gediminas, 73, 78, 155